African Filmmaking

AFRICAN FILMMAKING

FIVE FORMATIONS

Edited by Kenneth W. Harrow

Michigan State University Press | *East Lansing*

♾ The paper used in this publication meets the minimum requirements of
ANSI/NISO Z39.48-1992 (R 1997) (Permanence of Paper).

Michigan State University Press
East Lansing, Michigan 48823-5245

Printed and bound in the United States of America.

26 25 24 23 22 21 20 19 18 17 1 2 3 4 5 6 7 8 9 10

LIBRARY OF CONGRESS CATALOGING-IN-PUBLICATION DATA
Names: Harrow, Kenneth W., editor, author.
Title: African filmmaking : five formations / edited by Kenneth W. Harrow.
Other titles: African humanities and the arts.
Description: East Lansing : Michigan State University Press, 2017.
| Series: African humanities and the arts
| Includes bibliographical references and index.
Identifiers: LCCN 2016027893| ISBN 9781611862454 (pbk. : alk. paper)
| ISBN 9781609175276 (pdf) | ISBN 9781628952971 (epub) | ISBN 9781628962970 (kindle)
Subjects: LCSH: Motion pictures—Social aspects—Africa. | Motion picture industry—Africa.
Classification: LCC PN1993.5.A35 A366 2017 | DDC 791.43096—dc23
LC record available at https://lccn.loc.gov/2016027893

Book design by Charlie Sharp, Sharp Designs, East Lansing, Michigan
Cover design and artwork by Shaun Allshouse, www.shaunallshouse.com

Michigan State University Press is a member of the Green Press Initiative and is committed to developing
and encouraging ecologically responsible publishing practices. For more information about the Green
Press Initiative and the use of recycled paper in book publishing, please visit www.greenpressinitiative.org.

Visit Michigan State University Press at *www.msupress.org*

For Josef Gugler,
who initiated this project,
and to whom we all gratefully
dedicate this work

Contents

Preface

Kenneth W. Harrow

A ny attempt to present African cinema as a unified body of films will immedi-
ately run into the same objection to any singular notion of African culture, be
it literature, music, or art. There are many African cinemas, and the attempt
to join such disparate worlds as Egyptian Cinema and South African Cinema,
or Francophone and Anglophone African Cinema under one heading of "African" is
to do them severe violence. This volume risks small violence since we are attempting
to present only five "formations" of African cinema, that is, the cinemas that coalesce
around key features of geography and language. The dominant Anglophone and
Francophone cinemas are presented in two chapters, but others, such as Lusophone,
Yorubophone, Igbophone, and Swahiliphone are not given independent chapters,
and in fact it is important to recognize at the outset that we make no attempt to
be comprehensive in our treatment. Rather, we are considering five "areas" of
African cinema to be of importance—the cinemas of Egypt, the Maghreb, South
Africa, Francophone Africa, and Anglophone West Africa. Of course we have to
leave out many areas (notably East Africa), languages (Portuguese, most African
languages), or other approaches, such as genre. The volume is useful for its focus
on five key formations, not for an attempt at comprehensiveness that would be
thin, if encyclopedic.

In each case we recognize that the history of these cinemas can go back very close to the beginning of cinema itself, as the Lumière brothers brought their images and cinematic apparatus to the continent as early as 1896, the year after the first public screening in France where admissions were charged. The brothers had traveled in 1896 to Bombay, London, New York, and Buenos Aires, and eventually to Egypt that year. Not long thereafter exhibition halls were created in South Africa and North Africa. The early years of the twentieth century saw mobile *cinématographes* traveling throughout colonial Africa, and eventually colonial mobile units were deployed throughout the countryside A few sites were established so that colonial films could be produced, serving the colonial project.

The history of colonial Africa that obtained in each region of the continent shared certain traits, especially as the colonial project broadly espoused the goals of "civilizing the natives"—that is, constructing rationalizations for the conquest of the continent, especially as framed in terms of the "modernization" of African peoples. "Modernization" had many sides to it, but often it meant something like transforming African people into "civilized" Europeans—with the favored French terms for this being "assimilés" or "évolués." Film was considered a pedagogical instrument that would serve to transform Africans into "well-disciplined" colonial subjects—that is, to behave according to colonial ideological precepts—and as an entertainment medium, serving not only for the amusement of African subjects but also, and especially, to provide cinema halls for Europeans in locations where European urban settlers lived. Theaters were built in South African cities, and on the Plateau in Dakar, or its equivalent in other white enclaves.

We tend to think of colonialism's vast enterprise, with its far-reaching impact, as having been monumental in the recent history of Africa, but in fact between the early advent of cinema and the "high" colonialism of the 1930s, a mere twenty to thirty years had passed. Another generation, and independence, was just around the corner: in Ghana, the Sudan, Tunisia, Morocco, it occurred by 1956 and 1957. The technology of cinema had modernized; the world of cinema had become not simply one in which films were to be viewed as novelties but also as commercial products to be made on a regular basis. The first films to be made in Africa date quite far back. One of the earliest examples is a film by Albert Samama Chikly in Tunisia, who organized showings of Lumières' films in 1897. He worked for a variety of French and North African entities making films, and in 1922 made the first Tunisian fiction film, *Zohra*.

In South Africa, as early as 1913 the entrepreneur I. W. Schlesinger began building

his empire with theaters, and eventually production companies. Earlier still, Edgar Hyman's production of films dated back to the nineteenth century, when he shot scenes of Johannesburg and activities concerning the mines, with such titles as *A Rickshaw Ride in Commissioner Street* (1898/99) and *The Cyanide Plant on the Crown Deep* (1898/99).

Each corner of the continent had its own different, fascinating trajectory that passed from these early screenings to the introduction of filmmaking itself. As this was tied to colonialism, the next important feature was the incorporation of African technicians into the process of assisting European filmmakers (as in the Gold Coast Film Unit, which produced *The Boy Kumasenu* in 1952), and then of making their own films (Paulin Vierya, "Afrique sur Seine" 1955). Inextricably tied to this development was the historical trajectory of colonialism. Films were made to serve the colonial project, and major studios outside the continent took note at an early period. A notable example is the Hungarian Korda brothers, who worked in Hollywood and Britain in the 1920s and 1930s, and proceeded to make *Sanders of the River* (1935), notable not only for its process of filming and setting in Nigeria but also, and especially, for its starring "African" role being played by Paul Robeson. Twenty-eight years later Sembène Ousmane made *Borom Sarret*, after having studied filmmaking at the Gorky Film Studio in Moscow in 1962–63 (the French having refused his requests to learn filmmaking in France).

There were weird projects undertaken in the back corners of colonial Africa. In the 1950s, Albert Van Haelst, a Belgian missionary and film aficionado, made a series of some twenty films in the Congo titled *Matamata and Pilipili*, named after two comic heroes who played slapstick roles with broad comedy. Each episode emphasized some desired social behavior, such as thrift or serious work, that the colonial administration promoted. The films disappeared at the close of the colonial period, until their recovery by the documentary filmmaker Tristan Bourland.[1] In their style (likened to Laurel and Hardy), the films could have been made in the 1930s, and the distribution by Van Haelst in the backwaters of the Belgian Congo evokes the edges of a colonial modernism that embraced cinema not only as a pleasant amusement and pedagogical tool but also functioned coevally with its ascension as a rising industry that would seize the imaginary of much of the continent in the course of the twentieth century.

In this volume we explore, in different ways, how that imaginary took hold. Our chapters emphasize the historical side of the industry, in some instances empha-sizing production, regulation, and exhibition. In other chapters the emphasis falls

on recent developments (especially in Nigeria) or on close readings of exemplary films (especially in Francophone films). The five formations provide an entry for the reader into five major areas of African cinemas. If they have commonalities, it is due to the way that colonialism and modernity shaped the twentieth century interaction between the European colonizers and their African subjects, and to the way that the postcolonial developments of the past half-century have seen the Seventh Art take off with the departure of colonial disciplinary institutions.

The conception of a study of African cinemas, looking at major regions of production, originated with Josef Gugler. We are all grateful to him for his initiative, and for his many major contributions to the study of African cinemas.

NOTE

1. Bourland recovered the original negatives from archives in Belgium and produced *Matamata and Pilipili* in 1996, with First Run/Icarus distributing them in 1997.

Introduction

Kenneth W. Harrow

T he "Five Formations" of African cinemas under study in this volume all had beginnings shortly after the invention of cinema. This introduction examines the historical background of African cinemas in South Africa; North Africa, including Egypt and the Maghreb; and the Anglophone countries of Ghana and Nigeria, as well as Francophone cinema.

South Africa

Jacqueline Maingard begins her overview of film production in South Africa with an account of Edgar Hyman, who produced the first moving images in South Africa in 1898 and 1899, with a camera purchased from the Warwick Trading Company in England. Hyman produced films about the Boer War in 1899–1902. Within short order I. W. Schlesinger began to construct a cinema empire in South Africa in 1913. Schlesinger's vast holdings included much more than cinema production facilities or movie theaters, but what he established in film production and exhibition lasted more than four decades and matched Hollywoodian models of vertical integration. Film production was also marked by the racial structures of South Africa, which his

industry sustained, just as, according to Maingard, "he perceived, and believed in, the economic potential of the new tools of modernity and their ability to attract audiences." Modernity under colonialism: a tool to train the "natives," to entertain the colonial classes, and an economic imperative that entangled the growth and changes of the colony with the visual arts. A series of melodramas and historical films emerged.

Harold Shaw, a collaborator of Schlesinger, directed *De Voortrekkers* (1916), which Shaw, based on the "Great Trek" and the murder of the Zulu chief Dingane in 1838. According to Maingard, "it attained cult status in Afrikaner circles, where it was screened annually on December 16 to celebrate the *voortrekkers*' defeat of the amaZulu on that day in what became known as the 'Battle of Blood River' (the Ncome River)." Other films based on this model of white South Africa's racialized history were to follow.

Black audiences were a major consideration in South Africa, and Schlesinger's studios, African Film Productions, obliged with many documentary films intended to assist in the recruitment of African laborers for the mining industry. "Afrikaner-dom" was constructed as the South African equivalent of colonial empires to the north, with Schlesinger's *They Built a Nation/Bou van 'n Nasie* in 1938. Its production was timed "to coincide with the Afrikaner centenary celebrations of the 1838 trek and the *voortrekkers*' battle with the amaZulu, memorialized in the unveiling of the Voortrekker Monument, near Pretoria. . . . [It provided] a large-scale historical tribute to Afrikanerdom, as well as to the Union of 1910" (Maingard).

A body of films that addressed the black experience within the period of the 1940s and 1950s included *African Jim* (aka *Jim Comes to Joburg* 1949), *The Magic Garden* (1951), and *Cry, the Beloved Country* (1951). Colonial filmmakers shared visions of the colonial subjects and naturalized them in the representations of "good" native subjects. Zoltan Korda's *Cry, the Beloved Country* best exemplifies the earnestness of an ideological project that embraced Westernized idealizations of the civilizing mission.[1]

White audiences grew with a diet of Hollywood and genre films, but political, resistance films were rarities until the late 1970s and early 1980s. What emerged were films that targeted black audiences or had political agendas, as well as films that implicitly sustained the apartheid regime by skirting over the implications of representation, like Jamie Uys's *The Gods Must Be Crazy* (1980). The full picture of how South Africa addressed the politics of representation requires an understanding of the mechanisms established by the government in fostering production, in

incentivizing young, women, or black filmmakers. Blockbuster films eventually emerged, in a few instances, but more pertinent to the politics first of struggle and eventually of national development, government support for targeted groups of directors began to implement the new vision of an independent South Africa under the leadership of Nelson Mandela.

Film subsidies, local film productions, and the encouragement of South African talent grew substantially from the early efforts of the 1950s down to the present. Afrikaans films received considerable assistance in the 1950s, including films by Uys. Maingard details how the state's propaganda goals were well served by films that demonized African guerrilla fighters, playing on perceptions of "black danger." White filmmakers received the aid, while blacks like Lionel Ngakane found themselves obliged to leave for Britain to be able to continue their work in the 1960s and 1970s. Nonetheless, it was possible for some films of resistance, either surreptitiously or more overtly, to be made. A well-known example is Lionel Rogosin's *Come Back, Africa* (1959). The film deals with the demolition of Sophiatown and features a number of actors, journalists, and writers whose names came to be associated with the anti-apartheid struggle (Can Themba, Bloke Modisane, Lewis Nkosi, and even Miriam Makeba, who made her debut in the film). Judged a "landmark" in South African cinema, the film includes this marked observation by Nkosi about the white liberal position embodied in Alan Paton's famous *Cry, the Beloved Country*: "[He] just doesn't want a grown up African. He wants the African he can sort of patronize, pat on his head you see, and tell him that with just a little bit of luck you see, someday you'll be a grown up man, fully civilized. He wants the African from the country, from his natural environment, unspoiled." Not surprisingly, the film was banned, but has since become a classic example of the South African struggle—a struggle that both exemplified the spirit of anticolonial resistance, and yet bore the marks of it local South African context.

The movement toward liberation, from the time of Mandela's incarceration until his release, also affected film production, with the growing repressiveness of the late apartheid regime seen in increasing censorship and efforts by anti-apartheid filmmakers to document the conditions. The 1970s and 1980s saw the rise of resistance films that led to an anti-apartheid documentary movement. Also under the radar, a major anti-apartheid fiction film managed to get made, *Mapantsula* (Oliver Schmitz 1988), a film that purported to dramatize the life of a gangster while relatively transparently using the genre apparatus to represent the street violence against the regime. The film was banned, replicated widely in VHS format,

and circulated broadly at community events, including trade union meetings and small showings in private homes. The tide of opposition flowed from the streets to inspire the creation of cinematic images and clandestine viewing spaces, in line with the ideology of Third Cinema that had inspired Latin American and sub-Saharan filmmakers.

The history of South Africa cinema, increasingly marked by efforts of the liberated black majority government to subsidize culture, has been influenced by the inspiring work of past generations. For instance, the highly successful *Tsotsi* (Gavin Hood 2005) returned to the neighborhood gangster as the figure whose drama would embrace a liberal ideology of social meliorism. The film won an Academy Award in 2006—instead of being banned, as would have been the case in previous decades.

The support for South African cinema accounts for the continual production of films that have entered into "World Cinema" circuits, while also retaining the goal of addressing social issues (for example, *Zulu Love Letter* 2004, *Hijack Stories* 2000, *Gangster's Paradise: Jerusalema* 2008). The strength of Maingard's chapter can be seen in her meticulous detailing of the institutional support for production. One instance of this, which again seems quite particular to South Africa, is "Filmmakers Against Racism." Formed in 2008, Maingard describes it as a "collaborative venture" that "led to a series of documentaries about xenophobic attacks on migrants from neighboring countries." Committed filmmaking has continued, with both fictional works—including the powerful documentary *Miners Shot Down* (2013), which "documents the brutal crushing of striking miners, known as the 'Marikana Massacre,' when police shot and killed thirty-four strikers in August 2012." Maingard claims that "the film has kept this tragic event and its aftermath in the public eye, and has also sparked protests about broadcasters in South Africa not screening the film, despite its multiple awards, including an Emmy in 2015." Yet, ironically, *District 9* (2009), a film that sought to reverse white/black positions so as to create consciousness of racial privileges, leans on the ugly stereotyped images of Nigerian gangsters, foreigners labeled with the dreaded vernacular term "Makwerekwere." A cinema of struggle and repression, with complex racial, ethnic, and political positions, South African film is unique on the continent, and yet shares much with its counterparts to the north.

Egypt

As with South African film, Egyptian film was integrated into the worldwide creation of cinema practically from the outset. In 1896, Lumière brothers' films were being shown in Egypt, and the following year a cinematograph was screening films on a regular basis in Alexandria. Fifteen years after the initial film showing, eleven movie theaters had been built in Alexandria and Cairo and provided Arab translations for foreign films. Eventually a local film industry itself was started, and since 1923 some 3,000 films have been made, many tailored to the format of what came to be known as "Hollywood on the Nile."

Like many other such "Hollywoods" around the world (for example, Hollywood in Havana, on the Tiber, in Mexico, not to mention Bollywood and Nollywood), Egyptian cinema developed as a commercial cinema and gained a wide regional appeal. The favored genres that developed included melodrama and realism—the former tailored for mass audiences and the latter for "art" theaters. That division, between popular cinema and auteur cinema, continued down the decades of the twentieth century. The realism spoke to social issues, at times borrowing techniques of neorealism, poetic realism, and social realism; these films were considered reflections of the broad social and political changes of their times, from the colonial period down to the present.

Egyptian film's popularity may be due to the widespread adaptation of Egyptian Arabic as a regional lingua franca, as well as to its musical traditions, enabling figures like Umm Kulthum to reach vast audiences. Her appearance in the 1936 Studio Misr's first production, the musical *Widad* by Fritz Kramp, billed her as the "Star of the Orient." According to Viola Shafik, the film was a huge success. Egyptian cinema emerged during the 1920s and 1930s and led to a star system that favored genre films: "first of all the musical, the melodrama, farce and comedy, the historical, and the Bedouin film, became more canonized during this period" (Shafik).

Studio Misr was financed by Misr bank in 1934, making it possible for films to be produced in Egypt. Further small studios followed, and by 1948, 345 full-length features had been produced. Realism entered into the canon around 1939 with *Determination/al-'azima* by Kamal Selim (Salim). After World War II, there was a boom, and "cinema became the most profitable industrial sector after the textile industry in terms of sales" (Shafik), with an average of forty-eight films produced a year, "a pace that was more or less maintained until the early 1990s" (Shafik).

As was the case with sub-Saharan Africa when colonialism ended, and as was the case, too, with South Africa when it passed from white minority to black majority rule, Egypt experienced its watershed moment in 1952 when Nasser overthrew the monarchy, bringing an end to British influence. Nationalist sentiments grew apace, and religious films started to appear: *The Victory of Islam/intisar al-Islam* was produced in 1952 (Ahmad al-Tukhi), depicting the inception of Islam in the seventh century.

While lightweight fare continued to be produced, including music hall comedies, gangster films, and thrillers, during the two decades of the Nasser regime a new generation of directors arose, including Youssef Chahine (Yusuf Shahin), Salah Abu Seif (Saif), and Taufiq Salih, who developed "Third Worldist realism" (Shafik). "Egyptian Realism" was born with the rise of "serious" cinema for the newly independent Third World nations, a cinema of "engagement" participating in the struggle for national liberation, and the end of colonialism, neocolonialism, and social injustice. Mainstream directors of the 1960s included Henri Barakat and Kamal El-Cheikh (al-Shaykh), whose works included, interestingly enough, political films, on the one hand, and gangster films and thrillers, on the other.

Nasser's policies of nationalization led to a reduction in the number of productions and an exodus of Egyptian stars to Lebanon, where producers in the region turned to invest. The industrial doldrums were also the result of corruption and nepotism (Shafik), and the most talented directors left for Syria with Salih and Chahine, while Barakat went to Lebanon. The new wave of Third World cinema did not take root in Egypt, as government support proved antithetical to *engagé* cinema, or auteurist avant-gardism. Nonetheless, one of Egypt's major classics did manage get produced: Chadi Abdessalam's (Shadi 'Abd al-Salam) *The Mummy: The Night of Counting the Years/al-mumya'* was produced in 1969 by the national General Film Organization, and, according to Shafik, was absolutely exceptional. The film's surface plot entailed the illegal excavation of ancient tombs in Upper Egypt, and the musical score highlighted the film's gesturing toward the esoteric. However, the dramatic play of forces between the local grave-digging thieves, the Egyptian effendis, and British officials lays the groundwork for an Egyptian nationalist theme underscored by the use of classical Arabic dialogue. The British Orientalist sentiments of the Antiquities Division of the government are set against the strained circumstances of the local population, whose economic well-being has come to depend upon their looting of the ancient tombs. The appeal to a nationalist spirit in the film came two years after the devastating defeat of Egypt in the Seven

Days War with Israel in 1967. The year after the film was exhibited Nasser died, and was succeeded by Sadat.

Sadat reversed much of Nasser's Pan-Arabic politics, and pro-Soviet orientation. He turned to a policy of *Infitah*, or Open Door Policy, favoring private investment, with pro-American politics and a reversal of nationalizations. Cinema was able to survive, but with a limited number of productions. The major technological innovation of the 1970s and 1980s that was to shape much of African and world cinema was the invention of video film, the development of informal distribution networks alongside television networks and home video systems. Shafik's vivid description of this moment points to its dramatic impact on Egyptian cinema. This conjuncture of technological shifts in the 1980s led to a worldwide revolution in the industry that opened informal distribution networks to B-films, and was determinant in shifting African, and many other world cinemas, away from auteurism, committed cinema, and Third World or Third Cinemas, in the direction of popular, often melodramatic or genre cinema. It had a huge impact on Egyptian cinema, similar to much of the rest of world cinema. Popular genres boomed, along with home viewing on VCR players. In Egypt, in particular, melodrama, realism, and gangster films merged into "social drama" (Shafik).

At the same time that these developments were taking hold, another wave of "serious" filmmakers emerged in a countertendency that led to the second wave of Egyptian "New Realism" cinema. The struggle for dominance between commercial and serious directors became secondary, as satellite TV emerged, and as in Nigeria where Nollywood came into its own in 1990, the conventional modes of celluloid film production diminished. Egyptian satellite channel television, Egyptian Radio and TV Union (ERTU), developed wide regional networks throughout the Arab world, and began to produce serials, shows, as well as film productions. Egyptian cinema studios became venues for TV productions. Like Nollywood, Egyptian films were sold to TV and satellite distributors for extremely low prices, and this drove the quality of production down until the turn of the millennium. European coproductions became more common, as was the case elsewhere with independent filmmakers in Africa, marking films for world cinema consumption rather than for local audiences. Exceptionally Chahine's *Destiny* (1997) was able to bridge the two worlds and, as was becoming more common, focused on historical realism in its depiction of Averroes, promoting a progressive view of medieval Islamic thought in its struggle against religious obscurantism.

Once again, in the 1990s musicals were revived, and women directors like Inas

al-Dighidi became more prominent. Al-Dighidi focused more on social drama, while New Realism still had its followers in the 1990s with Muhammad Kamil Qalyubi, Ussama Fawzi, Munir Radi, Magdi Ahmad 'Ali, Radwan al-Kashif, and, more recently, Khaled Youssef (Khalid Yusuf), while Tariq al-'Iryan's work included police and gangster films. The greatest box office hits were the Sudanese Sa'id Hamid's comedies starring Muhammad al-Hinidi (Shafik). New Realism eventually died out, while realism itself remained central to many productions focusing on social inequalities and injustices.

The close of this historical period has been marked by the revolutionary struggle and violence of 2011, Tahrir Square, which temporarily almost stopped film productions. The rapid shifts in the political sphere, with the election and then ouster of the Muslim Brotherhood, affected most filmmakers. Some were in the opposition and fled; others supported the military coup.

In her chapter on this cinema, Shafik devotes considerable attention to the growth of a star system, its role in the development of a popular regional cinema, of the musicals with world famous performers like Umm Kulthum, and of the shifting alliances brought about by the dramatic changes in Egypt's powerful political role in Pan-Arabism, Cold War politics, and the struggles with Israel. A cinema focused on realism and class representation developed distribution mechanisms, including theaters devoted to the working class. The most successful of all Middle Eastern popular cinemas, it also fostered New Realism and auteurism.

Much of the history of cinema in Egypt was subject to censorship, whose controls have slipped considerably in the twenty-first century. In her relation of these features, Shafik provides a detailed, highly informative account whose considerations have considerable relevance to the same issues of choice of genre and political struggle in South Africa, Morocco, and other parts of the continent. While Egypt occupies the extreme northeast corner of Africa, its long-term, prolific production over the years and its broad regional appeal have made it into one of the most successful film industries in the African continent.

The Maghreb

In the conclusion to her chapter on Maghrebian cinema, Valérie Orlando states, "Since the 1960s, the films of Algeria, Morocco, and Tunisia have served as a mirror for societies that have been constantly remaking themselves." In this claim she

establishes a considerable difference between the dominant trend in the cinemas of Morocco, Algeria, and Tunisia, and those of Egypt and South Africa. Both Egypt and South Africa embraced commercial, genre films—especially Egypt, with its focus on musicals and melodramas. South Africa has, of course, produced many politically engaged films, but many of its films were devoted to historical representations intended to support apartheid's racist claims, or lighter fare, like *The Gods Must Be Crazy* or crime films. The conditions of colonialism and postcolonialism in South Africa did not align with those of North Africa. This was especially the case in that the regime inaugurated by Nelson Mandela in 1994 was nominally a revolutionary one, albeit one that came to align itself closely with neoliberal globalized features, and as such differed considerably from the postrevolutionary or postcolonial regimes of Tunisia and Algeria in the 1950s and 1960s, or indeed the monarchy in Morocco following independence.

Unlike the long history of cinema in South Africa and Egypt, the history of cinema was more truncated in the Maghreb. The colonial period was less propitious for the development of film production, in contrast again to Egypt. In addition, the three countries on the western half of North Africa—"the Maghreb," which means the West in Arabic—could be said to face more to the north, toward France and Europe, than east to Libya. Egypt, however, does "face" to the east, is "Middle Eastern" in a real sense in that its language plays a central role in Arabic culture, just as its films are the most popular and numerous in the same region. It constitutes, with Libya, the "Mashrek," the East (literally, the place where the sun rises), in contrast to the Maghreb, where the sun sets.

The Maghreb has been treated, often, as the space of some shared cultural unity. For instance, its literature has been anthologized since the 1960s as that of one region (Déjeux 1973; Arnaud 1986). This amalgamation of the three countries can be said to derive from the fact that they are all "Francophone," that is, not simply French speaking, but, more important, all former French colonies.[2] The impact of French colonization was determinant in shaping their historical development, beginning in the nineteenth century in Algeria. The conquest of Algeria dated to the 1830s, and the French ruled until 1962. Tunisia was colonized in 1881 and remained a protectorate until 1956; Morocco became a protectorate of Spain and France in 1912, although France effectively dominated since the beginning of the twentieth century, and ultimately imposed its rule throughout the country. In all three countries the educational system, and thus the production of literary and intellectual works, was heavily influenced by the French language. The best-known writers of the twentieth

and twenty-first centuries have written primarily in French, and have had major readerships in France. In all the Maghrebian countries, the ties to France resulted in a large immigrant population in France, especially after World War II, with many writers and intellectuals taking up residence in Paris.

The cinema has followed suit, with French-language films initially dominating indigenous film productions when they began in the 1960s. With time that situation has changed, and now, although French is still widely spoken, and has marked the various regional versions of Arabic, it is more meaningful to speak of Moroccan, Algerian, and Tunisia Arabic becoming the dominant film languages, with Berber-language productions also coming on the scene. It is still the case, however, that Maghrebian cinema gets classified with Francophone film and is widely distributed in France.

As with most sub-Saharan African films, it was independence that marked the effective beginning of Maghrebian cinema proper, even though there were scattered initial endeavors that preceded independence. The project of national liberation birthed national cinema, especially in Algeria where the revolution was supported by "moudjahid cinema": "Algerian cinema was born out of the war of independence and served that war" (Austin 2012, 20). The close ties between France and the Maghreb meant that cinema bridged the cultural and geographical spaces during the colonial period,[3] just as the end of colonialism meant a more radical break, especially in Algeria, which marked the project of Maghrebian cinema. One only has to consider one of the most celebrated and foundational of all Third Cinema films, *The Battle of Algiers* (1966), to appreciate this distinction. The film was made by Gillo Pontecorvo four years after the end of the Algerian Revolution; the film was banned in France for five years, despite the settlement of Algerian independence in 1962 with De Gaulle, and has been presented in cinema studies as an emblem of revolutionary cinema. The screenplay by Pontecorvo and Solinas was based on a memoir by the Front de libération nationale (FLN) leader Saadi Yacef, and although it shows the violence employed by the FLN in bombings in Algiers, the ultimate thrust of the film is to celebrate the revolutionary struggle. It is, then, a pro–Algerian independence film, made by an Italian director, financed by Italian producers, and shot in Algeria with Algerian and French actors. History has made it the classic Algerian film of the time.

Similarly, French films shot in Morocco, or using sets called "Morocco," with the casbah, the harem, and the desert, deploy an idea of Arab people and landscapes based upon a mutually constructed history inflected by colonial values. Classical

films that have invented and purveyed these notions are widespread, from *Pépé le Moko* (1937) to Hollywood's *Casablanca* (1943).

As a consequence, French and Francophone cinema deployed a certain strain of Orientalism—one might think of it as "Maghrebianism"—in which its imagery functioned as metonymies for the Arab or Islamic world and were marked by colonialism, invariably making Arab subjects subordinate to "civilized" European values. The filmic imaginary was writ large, and unlike the British counterparts, for example, Korda's *Sanders of the River* (1935), created a familiar, naturalized cultural habitus that generated a cinematic gaze that one could say looked south from France, across the Mediterranean to Tangiers, Algiers, and Tunis, as well as north from the Maghrebian coast to Paris and Marseilles. This might explain Ukadike and Diawara's distinction between Francophone and Anglophone cinemas in Africa, as shown here by Orlando:

> Unlike Britain which, upon independence in many of its former African colonies, left little in the way of a film industry, preferring to invest in television and radio, France did leave an enduring model. Countries such as Nigeria, Kenya, and Zimbabwe did not cultivate national cinema models like those found in West and North Africa which had been under French colonial rule (Ukadike). This historic fact attributes to the general consensus underscored by Manthia Diawara that countries where national film institutions were established at the time of independence led more quickly to many "films directed by Africans." (Orlando)

Orlando goes on to explain how this imbrication of the French in Maghrebian culture was led by such institutions as the La Fémis (L'école nationale supérieure des métiers de l'image et du son), formerly known as the IDHEC (Institut des hautes études cinématographiques), and L'école supérieure d'études cinématographiques (ESEC), which Orlando identifies as having been the leading schools of training for Maghrebi filmmakers since independence. Similar national film institutes were established in the Maghrebian countries, and became state apparatuses for the promotion and inculcation of national identities.

Albert Chikly made the first Tunisian film, *Zohra*, in 1922, but he was an exception. In general, the pre-Independence period was marked by French films that purveyed the colonial exotic. Although colonial films now strike the contemporary spectator as anachronistic, Orlando indicates that *pied-noir* productions and the continuing fascination with the past have marked films of the postcolonial

period. She cites Philip Dine, whose work demonstrates "how the Algerian war is represented in films made by predominately *pied-noir* filmmakers [and] is revealing of a historical era that refuses to die." If the war has "entered both the mainstream of French historiography and the broader national consciousness" as a staid moment in history (Dine 256), nonetheless it has been a major feature in Algerian films. Tunisia and Morocco, having come to independence in 1956 without a revolution, have not been marked as deeply by such films as Mohammed Lakhdar-Hamina's *The Winds of the Aures* (1967), which depicts a rural farming family whose lives are destroyed by colonialism, and Mohammed Lakhdar-Hamia's *Chronique des années de braise* (1975), both of which heavily influenced early Algerian film productions.

When Boumedienne came to power in Algeria by a coup d'état in 1965, he was determined to utilize the national cinema to celebrate the revolution that had put the FLN in power. Ebaum observes, "Indeed, for several years after 1968 the Third World-oriented Marxist and revolutionary nationalist currents developed in tandem and interpenetrated to such an extent that the boundaries between them were quite unclear" (2002, 41).

The situation in Morocco was somewhat different from that of Algeria. Its national film institute, the Centre cinématographique marocain (CCM), was founded in 1947 and became more active as a state agency immediately after independence. It specialized in the production of documentary films. In the post-Independence period, one of the best-known films to emerge was *Mille et une mains* (A Thousand and One Hands, Souheil Benbarka, 1972). Influenced by Pasolini's neorealism, the film "attacked the Western exploitation of those who weave the Moroccan carpets so prized by foreign buyers" (Armes 2006, 83).

All three countries had thus established a potential for significant film production by the time the struggle for independence and its turmoil had ended, and especially by the time "postcolonialism"—roughly the period beginning with the 1970s and 1980s—had set in. Tunisia, the smallest of the three, produced some brilliant filmmakers, such as Nouri Bouzid, Ferid Boughedir, and Moustifa Tlatli, but the output of films, though steady, was modest. The filmmakers were progressive: issues of history, with the thorny questions of women's oppression (as in Tlatli's *Les Silences du palais* [1995]), or of gay rights and representation, could be evoked without Tunisian government repression or social stigmatization. This can be particularly seen in Raja Amari's *Satin Rouge* (2002), which celebrates women's sexual independence in the face of stifling patriarchal opposition. In Morocco and Algeria, this freedom might be seen as more contested, but in fact with the

challenges of films dealing with prostitution, or the disreputable associations of belly dancing, there has come a new generation of filmmakers determined not to bow to religious pressures.

Algeria's film production came to a halt by the end of the 1990s, during which period the brutal war with the Front Islamique du Salut resulted in the deaths of hundreds of thousands. And in Morocco the king continued the delicate negotiation between conservative and progressive tendencies, especially during the Arab Spring. But the continuing work of Allouache (*Les Terraces* 2013) and Moknèche's *Viva L'aldjerie* (2004) attest to a resurgence of major filmmakers.

In Morocco, from the 1990s on an impressive body of socially conscious films has been made, and the filmmakers' assertiveness in defying censorship has resulted in a large number of challenging, even daring films.[4] Although France remains an important market, Maghrebian filmmakers are looking primarily to audiences at home for their films. Orlando stresses the way that issues dealing with women have been at the heart of contemporary Moroccan cinema: "numerous films made by women have been socially engaged and thought-provoking, promoting women's emancipation and free speech, social enfranchisement, and equality." She cites Denise Brahimi, for whom the Algerians seemed, at first, to be more vociferous: "When comparing Moroccan cinema to Algerian [we note] . . . pain is expressed by silence, rather than by screams." Orlando dryly observes, "this might be true to a certain extent for films made in the 1980s–1990s, certainly those made by men about women." However, she continues, "*L'Os de fer* (The Iron Bone, 2007) by one of the newer generation's filmmakers, Hicham Lasri, depicts a young heroine who is sure of herself and is able to stand up and hold her own with the male characters in her entourage." Recent films by Leila Marrakchi (*Marock* 2005; *Rock the Casbah* 2013) and Narjiss Nejjar *L'Amante du Rif* (The Rif Lover 2012) capture women on screen as fighting many of the same battles as their sisters do in the West: the right to control over their bodies, to political enfranchisement, and to live their lives by following their dreams." Other films, like those of Nabil Ayouch, address hot topics like Islamism (*Cheveux de dieu* 2013), prostitution (*Much Loved*, Ayoub 2015), and homosexuality, with Abdellah Taia's *L'Armée du salut* (2013) widely seen at home and abroad, despite Islamist protests.

Orlando provides considerable coverage to censorship and women's roles in her chapter, noting the courage needed to continue to make films at certain historical moments. "In 1990s Algeria, certain directors risked their lives to continue their work. However, major filmmaking was virtually halted. In 2000, 'not a single

film image was shot in Algeri'" (Orlando). Not all filmmaking is *engagé*; but for Maghrebian cinema, born in the times of revolution, the heritage of Third Cinema has never been very far behind.

Nigeria and Ghana

Anglophone filmmaking in West Africa began during the colonial period. In 1948, the Gold Coast Film Unit in Accra was established and run by colonial British film-makers who trained Ghanaians as technicians. Their films were shown throughout the colonies using mobile film units. The presence of cinema in urban centers like Lagos or Accra dated back to the early years of the century, creating an audience for action and dramatic films. As was the case throughout the continent, their appetite was fed on foreign imports, including Hollywood films in particular.

Early noteworthy efforts at filmmaking in Anglophone Africa include the relatively rare feature film *The Boy Kumasenu*, made at the Gold Coast Film Unit by Sean Graham in 1952. The film deals with a village boy struggling to survive in the big city. He steals, is caught, and is remanded into the custody of a doctor who rehabilitates him. Its colonial message might be seen as relatively naive, but the film was highly awarded, and survives in the BFI archives as a classic of the colonial period.

Five years after *The Boy Kumasenu* was made Ghana became independent. To mark that period we might consider that it was in 1955 that Jean Rouch made *Les Maîtres fous* in Ghana, and in 1958 made *Moi, un noir*, starring Oumarou Ganda. Soon Ganda and other directors like the Senegalese Safi Faye followed in his footsteps in the creation of *cinéma vérité* and an important body of Francophone fiction films. In contrast, the Gold Coast Film Unit trained Ghanaians in all aspects of filmmaking, but it wasn't until the 1965 that the first Ghanaian, Sam Aryeetey, directed a film, *No Tears for Ananse*.

In the 1960s, Kwaw Ansah studied theater arts in the United Kingdom and the United States. He returned to Ghana in 1965 and wrote and produced plays. He also worked for the Ghana Film Industry Corporation, where he learned the techniques of filmmaking. His first film, Ghana's first independent feature film, was *Love Brewed in an Africa Pot* (1980).[5] The film was a considerable success and became the first Anglophone film to win an award at Festival Panafricain du Cinéma de Ouagadougou (FESPACO). He went on, nine years later, to win the grand prize

at FESPACO for *Heritage Africa*. That was a time, the end of the 1980s, when video films got their beginnings, in Ghana, and were soon to revolutionize Anglophone film production.

The first Nigerian feature film produced in the colonial era was *Palaver* (1926), directed by Geoffrey Barkas, and employing Nigerian and British actors.[6] In the 1930s and 1940s, cinema houses sprang up in Lagos—the Rex, the Regal, the Royal—as was to become the case in most other larger cities on the continent, where Hollywood and some European feature films were regularly shown. Yoruba traveling theater troupes also began during this period, but it wasn't until the 1980s that their performances were being recorded on VHS, and screened. This had an important influence on the ascension of Nollywood.

Alongside these performances, the Nigerian Film Unit—the successor to the Colonial Film Unit—made documentary films and newsreels. With independence, the cinema halls flourished and featured American B-movies, Indian romances, and Hong Kong action films. Pioneers in Nigerian filmmaking included Herbert Ogunde and Ola Balogun, who studied at the French Institut des Hautes Etudes Cinematographiques. Balogun's films of the 1970s and 1980s included the earliest Yoruba and Igbo movies. His feature film *Alpha* (1973) was the first full-length film to be made by a Nigerian filmmaker. His protagonist was the Senegalese comic actor James Campbell-Badiane, and the film dealt with the difficulties of an African intellectual to adapt to life in Paris. His 1976 adaptation of Duro Ladipo's Yoruba play *Ajani Ogun* was one of the first musicals in sub-Saharan African film. His Igbo-language film *Amadi* (1975) dealt with a villager who returns home to organize the villagers to develop rural life. *Aiye* (1980), based on Duro Ladipo's play, was important in shaping Nigerians' taste for horror films, and it starred the Yoruba actor Hubert Ogunde, who subsequently became a major director. Balogun's *Cry Freedom*, made in 1980, celebrated Africa's wars of independence.

Balogun was trained in celluloid, formal filmmaking practices. He and Ansah found the transition to video filmmaking, with its privileging of entertainment and commercial values, and amateur actors and technicians, antithetical to their own conception of serious film. Before making feature films, Balogun made documentaries and directed *River Niger, Black Mother* in 1989. He also made the first Brazilian-Nigerian coproduction, *A Deusa Negra* (Black Goddess, 1978), which turned on the return of Yoruba ancestors from Brazil to Nigeria after the slave period. In 2001, he turned to the music industry as Nollywood was supplanting the celluloid filmmaking practices to which he had been accustomed.

The production of a relatively small number of Anglophone films was about to change as video films revolutionized filmmaking in Africa, and indeed throughout the world in the late 1980s. Within eleven years of the first major Nigerian video film—*Living in Bondage* (Kenneth Nnebue, Chris Obi Rapu 1992)—Africa Magic, a South African television channel devoted to Anglophone Nollywood films, was launched. By 2004, it was being broadcast in forty-one countries, and, according to Jonathan Haynes, two more channels, in Yoruba and Hausa, were added in 2010. In 2011, a Swahili channel was added, and a year later its English-language programming of video films (by then not "video" proper, but digital films, sold in hard copies in video compact disc [VCD] format) was increased to five channels broadcasting primarily Nollywood films continuously. The production that feeds this enormous distribution system has been based on thousands of films created since *Living in Bondage*—with somewhere between 1,000 and 2,000 made annually in Nigeria. African filmmaking, having been dominated by the serious Francophone *cinéastes*, most of whose films had not succeeded in reaching any significant markets on the continent, and which had been labeled as Third Cinema, or committed, political, or social realist films, now was overtaken by Nollywood and its imitators—Ghallywood in Ghana, Kannywood in northern Nigeria, and so forth. Haynes reports that the Internet streaming site iROKOtv offers more than 4,000 Nollywood and Ghanaian titles, and thousands more can be screened on YouTube.

In film studies, we have gone from close analyses of the political relevance of African films, viewed in a context of revolution and postrevolutionary conditions, to consideration of the conditions of post–Structural Adjustment Africa, as seen in the indictments of African debt and the World Bank's control over African resources, to neoliberal capitalism and globalization, in Sissako's *Bamako*.[7] The old guard, still producing Francophone *engagé* films for FESPACO, has been made redundant. The Durban Film Festival of 2016 has twenty-five pages of feature films, seventeen of documentaries, and six pages of "surf films." The grand days of Sembène at the Hotel Indépendance, which Diawara has celebrated with great nostalgia in his 2010 *African Film: New Forms of Aesthetics and Politics*, have now passed the baton, and the combination of South African economic power and Nigerian video film have supplanted the dominance of African Francophone cinema.

Along with that change has come the shift in African cinema studies predicted by Haynes (1995)[8] where we would begin to look more seriously at genre and distribution. Now, with such studies as Krings and Okome's 2013 *Global Nollywood*, the focus on material conditions of production, exhibition, and distribution have risen

to the fore, replacing hermeneutic analysis. The study of genre—with occultism, melodrama, romance, and Pentecostalism—has replaced work on ideology and psychoanalytical or feminist criticism. Haynes's reports of the extent of Nollywood distribution takes us from Bed-Stuy to Jamaica, signaling not only its popularity, but the shift in to popular studies' attention to genre forms: "In the Bedford-Stuyvesant section of Brooklyn, where there is a large African population, Nigerian and Ghanaian films are sold alongside Malian and Jamaican music videos, Senegalese Wolof-language dramas made for television by theater troupes, and recorded soccer matches of African teams" (Haynes 2000). Haynes calls this "globalization from below," but with issues like piracy and local networks of distribution we are located in in what Lobato in *Shadow Economies of Cinema* dubs the gray, "shadowy" areas of "informal" media economies (2012). The simple technological shift from celluloid films viewed in cinema halls or theaters to videos viewed on VHS players, and later DVD players, at home, made possible sea changes in viewing practices. Films that women could comfortably view at home replaced those seen at dilapidated downtown movie palaces that became increasingly unsafe, and even rat-infested (as I heard about The Abbia in Yaounde). This resulted, eventually, in the demise of almost all movie theaters on the continent, except in South Africa. With the influence of telenovelas (soap operas from Latin America) and African television comedies, the market opened up to romances and occult films heavily marked by the rise of Pentecostalism. Viewed at home, or before the television of a neighborhood viewing parlor for a low fee, the markets for videotapes rapidly expanded in the 1990s. Neighborhood shops rented the films at a low cost; markets in the urban downtowns sold the VCDs, and street sellers made the pirated films readily available. Informal distribution made it essential for the distributors who owned the rights to sell as many copies quickly—in a week or two—in order to realize their profits. Filmmakers scrambled, producing cheaper and cheaper versions, churning out films in three weeks, or even one week, with minimal rehearsals, one camera, and location shooting. The genre formulas provided the skeletons for familiar plots, and the use of sequels guaranteed that popular films, with rising stars, would continue to attract audiences. The move to Africa Magic was inevitable.

Haynes quotes McCall's prescient claim that Nollywood represents "the Pan-Africanism that we have" (2007)—a claim that Haynes elegantly describes as representing the vast gap between the politics of the founders of Pan-Africanism and Nollywood's "garish melodramas" that have so successfully captured the popular imagination. In writing about Sembène Ousmane's last works—especially *Faat*

Kine but also *Moolaade*—I described the old master's work as embodying "the feminism of the old man." He was committed to meaningful social change, but the gesture of burning radios in the village in order to stop Western feminism from influencing the women (in *Moolaade*) was relevant to the media of the twentieth century–early twenty-first century. With the coming of the computer revolution, 419 scammers, and virtual reality, radios had become monuments to another age. What could Sembène have said to the women who were watching the Brazilian and Argentinean telenovelas in Dakar, while the men were desperately trying to find pirogues that might take them across to Europe. Globalization from below marked the age of neoliberal politics.

The growth of video filmmaking in Ghana, first, and then Nigeria was based on the work of specific individuals, none of whom had been trained in filmmaking. Haynes details how Willie Akuffo launched the enterprise in Ghana, as did Kenneth Nnebue in Nigeria. Fairly rapidly industrial growth followed, with Safo creating production systems in Ghana that churned out roughly one film a week. The rough-and-tumble of Nigerian video filmmaking quickly outpaced that of Ghana in the 1990s, not only in number but especially in postproduction values, threatening Ghanaian filmmakers at home.

In the past decade or more, increasingly talented and sophisticated filmmakers have emerged (notably Tundi Kelani, who initially resisted being assimilated under the label of Nollywood, and Afolayan, Gyang, and many others), now engaging professional actors, utilizing increasingly sophisticated digital cameras and professional postproduction. Within a generation Nollywood has been succeeded by "neo-Nollywood," and the work of the current generation is being viewed not only on satellite channels but in university classrooms and at film studies conferences where video-film studies have become dominant (except, perhaps in France).

The phenomenon is not generated by state support, foreign agencies, or foundations, as has been the case with Francophone African cinema. Rather, the raw competition of capitalist markets has continued to govern Nollywood production, reflecting, still, the contrasting aspirations of filmmakers like Teno and Bekolo, concerned with serious social issues and the quality of the well-made film, and those of the market-driven Nollywood directors for whom the absence of a profit would mean the end of the wild ride, the closing of the enterprise. For the latter, the challenge remains to make a profit, despite piracy and despite the intense competition that has resulted in low payments for their work. For the former, for what had been known as "African cinema," the challenge is still survival

in an age where the distribution of their work remains predominantly outside the continent, and where the question of funding remains vexed by dependencies on such European entities as Arte and BFI.

In considering what this means for the current crop of major Nollywood directors, Haynes summarizes their views of the industry in this way:

> Old Nollywood and new [directors] were completely united and vehement in their rejection of the kind of luxurious official support they were hearing about. They were not interested in filmmaking that is based on grants, the filmmakers supporting themselves not from the profits their films have earned but through funding provided by a cultural bureaucracy for the process of filmmaking. They were proud to be commercial filmmakers, utterly dependent on their instinct for what an audience, an African audience, would want to see. They said this relationship with their audience kept them honest.

Francophone Cinema

In his account of the changes from yesterday to tomorrow, Haynes rehearses the story of the difference between British and French colonial practices, underlining the British intent to create film production in its colonies:

> The contrast between French and British modes of support for cinema in the colonial and postcolonial epochs is a familiar theme in the scholarship on African cinema. The British Colonial Film Units created a filmmaking infrastructure of equipment and trained personnel, but the British government never encouraged fictional feature filmmaking either before or after decolonization. Nkrumah's cultural nationalism included ambitious plans for film production in Ghana, using cinema as a means to defend and propagate African values, but after his ouster the Ghana Film Industry Corporation (GFIC) lapsed into decrepitude. Similar nationalist rhetoric accompanied the establishment of the Nigerian Film Corporation, but feature filmmaking in Nigeria, as in Ghana, was effectively left to the commercial sector.

Haynes concludes that "in both countries and across the continent, commercial theaters showed foreign films exclusively." Nonetheless, Francophone Africans

were determined to make films, with or without French help, and succeeded long before the Anglophones.

After Independence, the newly nascent nations in the Maghreb, especially Algeria, followed the model of Cuba in establishing a state film institute charged with producing films—documentaries primarily, but eventually fiction films as well—that would support the project of creating new national identities and validating the nation's revolutionary history. In sub-Saharan Africa, there was considerable interest in pursuing careers in filmmaking, but when the earliest candidates sought French support, most were turned down, which explains why Sembène, Cissé, and Sissako turned to Moscow for their training.

There were also ideological reasons for both Moscow and the leftwing African filmmakers to support each other: "socialism" was the byword for independent African states, especially Francophone ones. Even Senghor, who embraced neocolonial ties with France, preached the need for an "African socialism"—a label Sembène deeply mocked in *Xala* (1974). However, in the absence of a viable film industry, or consistent state support, filmmakers had to turn to the French for support—usually the French Minister of la Francophonie, as well as to nongovernmental organizations (NGOs) or private foundations.

How can we assess the vexed question of how far the influence of the financing bore on the contents and ideology presented in each film? This question applies in general to all filmmakers who don't finance their own projects—and virtually all filmmakers fall into this category. The parameters of the African filmmakers' proposals were largely determined by the willingness of the French Ministry of Cooperation, its Film Bureau, or of "la Francophonie,"[9] to support them. Andrade-Watkins's conclusion in 1993 holds for today as well: "As black African cinema moves into its third decade, the obstacles to financial and technical self-sufficiency in production, distribution and exhibition have largely remained unresolved" (32). Ironically, as she was penning these words in the early 1990s, Nigerian and Ghanaian video filmmakers were beginning the revolution in African film by creating a cheap, commercial, popular form of cinema that eschewed the ideological commitments and aesthetic choices of what had been the dominant forms of African cinema—so-called FESPACO films.

As a result of Sembène's, Maldoror's, Cissé's, and Sissako's training in Moscow, the naissance of African cinema from its earliest idealized version was inspired by Russian socialist values.[10] African cinema of the 1960s and 1970s dealt with issues of social/political engagement, and especially the struggle against neocolonialism. By

1963, with *Borom Sarret*, Sembène was already questioning where independence was leading Senegal. By 1968, Ayi Kwei Armah had written *The Beautyful Ones Are Not Yet Born* (1968), indicting the corruption in Ghana, and by the 1970s it had become commonplace to find novels and films that took on one-party states, corruption, and rule by force. The immediate need was to confront the challenge of the new nations facing their future, and the dreams of creating the New Africa, the New African Man and Woman.

France and several European agencies have continued to provide subventions for African cinema, making "it easier for French distributors to maintain their monopoly on the African market" (Diawara 2010, 31). Investment of this type has not been mirrored in former British Anglophone regions, although the BFI has had a role. Many scholars have argued that France's omnipresence in "Francophone" cinema on the continent has contributed to the different, some say, even neocolonial, tendencies represented in postcolonial films, as notes Frank Ukadike in *Black African Cinema* (1994):

> Different patterns of film production within Francophone and Anglophone regions derive from the contrasting ideological pursuits of the colonial French and British governments. For example, while the French pursued the so-called assimilationist policy, British involvement with its colonies was pragmatic business. Similarly, observers point out that while the French "gave" feature film to its colonies, the British "gave" theirs documentary. This notion supports the argument that the cultural policy adopted by France encouraged film production in the Francophone region whereas in the Anglophone region, where film production did not pass the economic priority test . . . the tradition of British documentary filmmaking [remained]. (109)

Whatever the French politics, Africans were deeply committed to exposing the failures of an abusive authoritarianism. By the 1970s, when Sembène attacked neocolonialism, others like Dikongue-Pipa challenged a patriarchy associated with traditional society in *Muna Moto* (1975) and *Le Prix de la liberté* (1978). By then Negritude was viewed as passé; *engagement* changed, but its underlying ideology remained relatively steady.

In retrospect, that project of a committed cinema can be seen as a subset of modernist thinking: progressivist in nature and ameliorist in ambition. Modernism's binary of modern versus traditional, as seen in *Touki Bouki* (1973) or *Xala* (1974),

dominates all the films of the period. "Old Africa" was associated with rural ways (*Tauw* 1970) or oppressive paternal/patriarchal figures: with issues of fathers marrying off their daughters; husbands silencing, beating, and confining their wives; fathers oppressing their sons. This vision appeared frequently in Dikongue-Pipa's films, with the love between younger couples complicated by the fathers' desires to marry their daughters to their old age–mates. Similarly, marabouts, cast as charlatans, exploited children, exposing them to danger; they also represented Old Africa's tired, retrograde religious authority (Traore, *Njangaan* 1975). The New Africa was located in cities, in the younger generation, in revolutionary youth, modeled historically after the Originaires[11] in Senegalese communes. The idea of being modern can be traced to figures like the youthful Rama and her comrades in *Xala* (1974), or the younger generation in *Finye* (1982). Are these youth still looking to France for a model of modernity, even in revolting against it? According to Orlando, it is France, in a sense, that relies on the Francophone world for its cultural production, rather than the other way around:

> The fact that all three Maghrebi countries founded national institutes of film shortly after independence has set them somewhat apart from other African countries which have had to rely more heavily on funding from France. Indeed, Maghrebi cinema as "Francophone" has generated much debate, particularly in academic French departments in the United States that have sought to claim the region's films for their own in order to increase interest in literatures and cultures from the former, "French-speaking," colonial world. Francophone scholars note that today, two-thirds of all writing published in French is produced outside the nation of France–from Africa, the Caribbean, North America, and Oceania.

In our chapter on Francophone cinema, Olivier Barlet and I organized the films into three paradigms or phases, following a chronological, thematic scheme. This is not intended as teleological, but rather is closer to what Russian formalists understood by the dominant as a tendency that marked a period, even as other paradigms and cultural approaches were simultaneously deployed.

The first paradigm follows the pattern of *cinéma engagé* as detailed above: the subject matter is typically framed in relation to colonialism or neocolonialism. Often the rural countryside appears, from an urban or Marxist perspective, as old and stagnant, or as collaborative with colonialists. Alternatively, as in *Wend Kuuni*, it is idealized as the location of the authentic Africa in the precolonial period. The

oppressive French or foreign dominant order is to be opposed, resisted, and fought. Resistance often turns on the figure of an oppressed woman, or less often a youth, with patriarchy seen as corrupted. The exemplary figure we study is Sembène Ousmane, who establishes both a stylistic model and a vision of political commitment that was widely embraced and followed. His films often tracked a dialectical path to truth, following a trajectory at the end of which the audience is enjoined to see and understand the realities dramatized by Sembène—the goal of Third Cinema itself frequently being described as "lucidity." The terms of this framing are set by a modernist paradigm of progress. Gikandi (1996) has convincingly shown that this progressivist temporality also informed colonialist ideologies, so that we can say Sembène has absorbed the model, has redeployed it for liberationist purposes, but has stayed within its parameters.

A shift in dominant paradigms came in the 1980s–1990s with the move away from representations of colonialists, colonialism, or neocolonialism, with the few exceptions of revolutionary Lusophone cinema. Increasingly there developed concern over local autocracy, still couched in patriarchal terms, as seen in the older teacher in Bassek Ba Kobhio's *Sango Malo* (1990). But old and new were reoriented away from the old parameters of the cinema of engagement, away from discourses defined by their relationship to Europe or to neocolonialism; the bourgeoisie is less presented as a subaltern class than a class of oppressors in their own right.

Examples of second phase include *Sango Malo*, Jean-Marie Teno's *Chef* (1999), and *Afrique je te plumerai* (1993). The African cinematic apparatus that began in the 1960s with the reformist or revolutionary agendas of the disciplinarians of a didactic cinema met little or no resistance from those who were redrawn into its gaze. *Sango Malo* is their heir, and Lebamzip, which the teacher tries to transform into a kind of Potemkin village, the model for its knowledge. What we can recognize in this is what might well be called the technology of contemporary African protest cinema. Ba Kobhio deploys a cooler, unobtrusive apparatus than does Mbembe: the presence of the technology of his cinematic mechanism is never betrayed, as in classic forms of social realism.

Jean-Marie Teno moves us in another direction with his short film *Chef* on the variant forms of the African Big Man. In his description of the film, he summarizes succinctly the project of this second phase: "CHIEF! brings these events together to allow us to reflect upon the current state of Cameroonian society with its hierarchies, inequalities and lack of respect for human rights—all the byproducts of a dictatorship" (http://jmteno.us/films/chef.html). In the playful, semipostmodern

approach to these issues, taken in *Afrique, je te plumerai* (1992), Teno establishes the distance between the two phases, while still retaining the importance of *engagement*. *Afrique, je te plumerai*'s techniques lead it beyond the early forms of oppositional literature and cinema: with its own technologies of postcolonial cinema, it expands the potentialities for reading beyond those of the closed classic realist text using pastiche, irony, and self-reflexivity. Between reality and simulation, we are no longer with the first paradigm of African cinema, but in a new mode.

By the 1990s–2010s, our third phase, we enter a fully global age. Europe and colonialism now are in the distant past. African authoritarianism is increasingly heavy, with rulers treated more and more in an irreverent fashion, as in Bekolo's *Les Saignantes* (2005). Postcolonialism becomes the dominant signifier of the diminished African state now seen as shrunken in importance vis-à-vis larger international entities like the World Bank and the International Monetary Fund (IMF). Mambéty returns from Europe and makes *Hyènes* (1992); Sissako makes *Bamako* (2006). Often the local supplants the state as the locus of the action, as in *Puk Nini* (1995), *La Vie sur terre* (1999), and *La Pirogue* (2012).

The global-local paradigm has replaced the former Old-New paradigm, and it is marked by hybridity at both poles (Bhabha 1994; Jameson 1991). This is not an absolute change, but one in which the parameters have morphed: the dominance of the neocolonial state has been supplanted by the more distant and overpowering globalized institutions like the World Bank and international NGOs. Similarly, Old Africa has become more distant and nostalgically evoked. Everyday life is associated with the quartier, the local scene.

Simultaneously, the paternal/patriarchal power of the first paradigm is now diminished, shown as corrupted and ineffectual, or simply not there at all. In its place we see women, now rising to center stage and ruling the men (*Puk Nini* 1995), dismissing the men (*Faat Kine* 2000; *Moolaade* 2004), dominating the scene no longer simply as heroines or heroically but also viciously, as phallic mothers (*La nuit de la verite* 2004). The motif of this change is summarized with the following dominant tropes: diminished state, diminished patriarchy, rise of women and of youth who have morphed here into the audience for global cinema, like the *tsotsis* of *Aristotle's Plot* who occupy what is left of the dilapidated cinema halls of yesterday.

Whereas Teno's subject position is heard through the narrator's voice, the source of truth at the time of the failed, mocked patriarchy in Biya's Cameroon, there is no such conception of truth, or its mouthpiece, in *Quartier Mozart* or *Aristotle's Plot*, where patriarchy has fallen. What accounts for the regimes of truth in this

third phase is to be sought in what "counts" *outside* the frame of the cinematic representation where finances dictate who is to come to life again. It gestures toward the third paradigm of contemporary African filmmaking whose break is signaled in *Aristotle's Plot* when the ironic narrative voice comments on ET's showing of "real African cinema" by asking, when will African filmmakers no longer be "emergent," when will we be free to make movies about something other than the revolution, when we will be free from the dictates of committed cinema?

Bekolo focuses on the role of cinema in self-reflexive positions that function as a rescripting of postmodernism in an African guise, and *not* simply as an example of some *universal* postmodernist filmmaking. The referencing of Africa's role in the creation of film is really an act of reconstituting an African postmodernism. Much postcolonial theory is often ill at ease with postmodernist formulae because they would seem to vitiate the central concerns of those cultures formed around long-standing revolutionary struggles. But as far back as the 1950s–1960s, with the protomagical realist novel and Maghrebian literature, it was seen as not only possible but necessary to disrupt the language of the colonizer along with that of the classic realist text as a prerequisite to any effective revolutionary stance. Similarly, the Third Cinema and "Imperfect Cinema" of the late 1960s–1970s in Latin America disrupted the conventions and sheen of commercial Hollywood film, carrying forward the notions of a nonrealist or nonmimetic cinema of revolt.

With contemporary, global African film there is an increasing tendency to evoke the dark side of the individual, as with Edna in Fanta Nacro's *Nuit de la verité* (2004). We have films turning on genocide, on child soldiers, with imaginary locations situated in another realm where death and hideous magical forces menace the disempowered individual. We see this especially with Nollywood, which returns this most recent paradigm to the melodramatic versions of truth in which *engagement* has no place, but where in its place we find powerful affect and spectacle evoking a universe of forces that are unknowable and all powerful—in other words, a vision of paranoia's truth, appropriate for the culture of globalization. In the debris of neoliberal capitalism, the newest paradigm for recent African cinema is being forged.

Nacro presents a note of hope when Fatou teaches the children about their country and their lives that lie before them. The "old" is reborn in fantasmic terms, once shunned by Teshome Gabriel and Ferid Boughedir as inauthentic film practices. The ending of Nacro's *Nuit de la verité* presages a new, postgenocidal order that the next generation is charged to create—an optimistic glimmer of hope that

also marks Bekolo's latest film, *Le Président* (2014), in which, quasi-ironically, the president who has been in office seemingly forever sees the light and steps down, making way for the youth to inaugurate the future—a trope that resembles, as well, the ending of Wanuri Kahiu's sci-fi *Pumzi* (2009), where the heroine sacrifices herself so that a new world, literally, might be reborn.

NOTES

1. Not surprisingly, it was this same Hungarian turned British director Korda who, with his brother Alexander, produced the West African/British colonial classic *Sanders of the River* (1935) that brought Paul Robeson to the screen as an African chief who learned to appreciate the beneficial effects of the British colonial order.

2. Technically there were political distinctions (*départements* in Algeria, protectorates in Morocco and Tunisia), but in French eyes they were all, effectively, ruled by the same "mother country"—France—effectively colonies.

3. Colonial films used North Africa, or an image of North Africa, as their setting for the construction of the colonial other. Josephine Baker's films used the colonial exotic settings as preliminary to the action in France where the colonial era films concluded her stories—passages from "native girl" to "civilized" (e.g. *Princesse Tam Tam* 1935, which begins in Tunisia, before a white man rescues her and brings her to France).

4. For instance, Nabile Ayouch's recent *Much Loved* (2015), dealing with sex workers from Marakkesh, has incited death threats against Loubna Abidar, who starred in the film, which was banned in Morocco.

5. Thanks to Carmela Garritano for helping me with the details on this early history.

6. "Throughout August 1926, *Bioscope* ran a series of editorials and articles assessing the state of the British film industry and emphasising the importance of presenting British films throughout the Empire. The Prime Minister Stanley Baldwin had called for action in 1925 after noting the 'danger to which we in this country and our Empire subject ourselves if we allow that method of propaganda [film] to be entirely in the hands of foreign countries' (*Royal Society of Arts, Journal*, June 3 1927, 685). In August 1926 Sir Phillip Cunliffe-Lister, President of the Board of Trade, proposed in the House of Commons that 'the whole question [of British films] should be discussed at the Imperial Conference', after the Joint Trade Committee failed 'to find a solution to the British film problem.'" (*Bioscope*, August 5, 1926, quoted in "Palaver: A Romance of Northern Nigeria," Colonial Film, http://www.colonialfilm.org.uk/node/1342).

7. The central text that analyzes the pertinent conditions of this period is Comaroff and

Comaroff's *Millennial Capitalism and the Culture of Neoliberalism* (2001).

8. His first volume on Nollywood in 1995, was coedited with Onookome Okome, *Cinema and Social Change in West Africa*. See especially the expanded 2000 Ohio University Press edition.

9. The official title would be Ministre déléguée auprès du ministre des Affaires étrangères, chargée de la Francophonie.

10. "The 'father' of African cinema, Ousmane Sembène, along with Sarah Maldoror . . . , Souleymane Cissé and [Abderrahmane] Sissako all studied in Moscow. 400 000 other Africans also studied in the USSR throughout the period 1950–1990. Where France shunned the artistic development of its colonized countries while it still had the power, Moscow embraced them. Whether for diplomacy, advocacy, as a form of soft power or as a means of propaganda, it is clear that cinema was a tool through which the Soviet Union wanted to extend itself; through images it saw its own expansion into Africa.

 "So, what emerges from an investigation into African filmmaking and its relationship with the Soviet Union—particularly in West Africa during the 1960s–1990s, and cinema cultures in Lusophone countries in the 1970s—is a *cinegeography* of socialist friendship" (Basia Lewandowska Cummings, "Soviet Cinema and African Filmmaking," Africa Is a Country (blog), April 20, 2012, http://africasacountry.com/2012/04/soviet-cinema-and-african-filmmaking/.

11. Sometimes called "assimilés," the Originaires were Senegalese inhabitants of the four communes, granted French citizenship, and viewed as an avant-garde of progressivism in Africa under colonialism. They were Africans who modeled their notions of progress largely on European models of "civilization."

FILMOGRAPHY

Abdessalam, Chadi (Shadi 'Abd al-Salam). 1969. *The Mummy: The Night of Counting the Years/al-mumya'*. Egypt.

Allouache, Merzak. 2013. *Les Terraces*. Algeria.

al-Tukhi, Ahmad. 1952. *The Victory of Islam/intisar al-Islam*. Egypt.

Amari, Raja. 2002. *Satin Rouge*. Tunisia.

Ansah, Kwaw. 1980. *Love Brewed in an Africa Pot*. Ghana.

———. 1988. *Heritage Africa*. Ghana.

Aryeetey, Sam. 1965. *No Tears for Ananse*. Ghana.

Ayouch, Nabil. 2013. *Cheveux de dieu*. Morocco.

———. 2015. *Much Loved*. Morocco.

Balogun, Ola. 1975. *Amadi*. Nigeria.

———. 1976. *Ajani Ogun*. Nigeria.

———. 1979. *A Deusa negra*. Brazil.

———. 1980. *Aiye*. Nigeria.

———. 1980. *Cry Freedom*. Nigeria.

———. 1989. *River Niger, Black Mother*. Nigeria.

Barkas, Geoffrey. 1926. *Palaver*. Ghana.

Bassek Ba Kobhio. 1991. *Sango Malo*. Cameroon.

Bekolo, Jean-Pierre. 1992. *Quartier Mozart*. Cameroon.

———. 1996. *Aristotle's Plot*. France/Zimbabwe.

———. 2005. *Les Saignantes*. Cameroon.

———. 2014. *Le Président*. Cameroon.

Benbarka, Souheil. 1972. *Mille et une mains*. Morocco.

Blomkamp, Neill. 2009. *District 9*. South Africa.

Bourland, Tristan. 1955. *Matamata and Pilipili*. The Belgian Congo.

Chahine, Youcef. 1997. *Destiny*. Egypt.

Chikly, Albert Samama. 1922. *Zohra*. Tunisia.

Cissé, Souleymane. 1982. *Finye*. BFI, Mali.

Curtiz, Michael. 1942. *Casablanca*. United States.

Desai, Rehad. 2013. *Miners Shot Down*. South Africa.

Dikongué-Pipa, Jean-Pierre. 1975. *Muna Moto*. Cameroon.

———. 1978. *Le Prix de la liberté*. Cameroon.

Duvivier, Julien. 1937. *Pépé le Moko*. Algeria.

Graham, Sean. 1952. *The Boy Kumasenu*. Ghana.

Hood, Gavin. 2005. *Tsotsi*. South Africa.

Hyman, Edgar. 1898/99. *The Cyanide Plant on the Crown Deep*. South Africa.

———. 1898/99. *A Rickshaw Ride in Commissioner Street*. South Africa.

Kahiu, Wanuri. 2009. *Pumzi*. Kenya.

Korda, Zoltan. 1935. *Sanders of the River*. Nigeria.

———. 1951. *Cry, the Beloved Country*. South Africa.

Kramp, Fritz. 1936. *Widad*. Egypt.

Lakhdar-Hamina, Mohammed. 1967. *The Winds of the Aures*. Algeria.

———. 1975. *Chronique des années de braise*. Algeria.

Lasri, Hicham. 2007. *L'Os de fer*. Morocco.

Mambéty, Djibril Diop. 1973. *Touki Bouki*. Senegal.

———. 1992. *Hyènes*. Senegal.

Marrakchi, Leila. 2005. *Marock*. Morocco.

———. 2013. *Rock the Casbah*. Morocco.

Moknèche, Nadir. 2004. *Viva L'aldjerie*. Algeria.

Nacro, Fanta. 1995. "Puk Nini." Burkina Faso.

———. 2004. *La Nuit de la vérité*. Burkina Faso.

Nejjar, Narjiss. 2012. *L'Amante du Rif*. Morocco.

Obi Rapu, Chris (Vic Mordi). 1992. *Living in Bondage*. Part 1. Nigeria.

Pontecorvo, Gillo. 1966. *The Battle of Algiers*. Algeria.

Rogosin, Lionel. 1959. *Come Back, Africa*. South Africa.

Rouch, Jean. 1955. *Les Maîtres fous*. Ghana.

———. 1958. *Moi, un noir*. Ghana.

Schlesinger, I. W. 1938. *They Built a Nation/Bou van 'n Nasie*. South Africa.

Schmitz, Oliver. 1988. *Mapantsula*. South Africa.

———. 2000. *Hijack Stories*. South Africa.

Selim, Kamal. 1939. *Determination/al-'azima*. Egypt.

Sembène Ousmane. 1963. *Borom Sarret*. Senegal.

———. 1968. *Mandabi*. Senegal.

———. 1970. *Tauw*. Senegal.

———. 1974. *Xala*. Senegal.

———. 2000. *Faat Kine*. Senegal.

———. 2004. *Moolaade*. Senegal.

Shaw, Harold. 1916. *De Voortrekkers*. South Africa.

Sissako, Abderrahmane. 2006. *Bamako*. Mali.

Suleman, Ramadan. 2004. *Zulu Love Letter*. South Africa.

Swanson, Donald. 1949. *African Jim* (aka *Jim Comes to Joburg*). South Africa.

———. 1951. *The Magic Garden*. South Africa.

Taia, Abdellah. 2013. *L'Armée du salut*. Morocco.

Teno, Jean-Marie. 1993. *Afrique, je te plumerai*. Cameroon.

———. 1999. *Chef*. Cameroon.

Tlatli, Moutifa. 1995. *Les Silences du palais*. Tunisia.

Traore, Mahama Johnson. 1975. *Njangaan*. Senegal.

Touré, Moussa. 2012. *La Pirogue*. Senegal.

Uys, Jamie. 1980. *The Gods Must Be Crazy*. South Africa.

Vierya, Paulin. 1955. "Afrique sur Seine." France.

Ziman, Ralph. 2008. *Gangster's Paradise: Jerusalema*. South Africa.

BIBLIOGRAPHY

Andrade-Watkins, Claire. 1993. "Film Production in Francophone Africa 1961–1977: Ousmane Sembène—An Exception." *Contributions in Black Studies* 11:26–32.

Armes, Roy. 2006. *African Filmmaking: North and South of the Sahara*. Edinburgh: Edinburgh University Press.

Arnaud, Jacqueline. 1986. *La littérature maghrébine de langue française*. [Paris]: Publisud.

Austin, Guy. 2012. *Algerian National Cinema*. Manchester: Manchester University Press.

Bhabha, Homi K. 1994. *The Location of Culture*. London: Routledge.

Comaroff, Jean, and John L. Comaroff. 2001. *Millennial Capitalism and the Culture of Neoliberalism*. Durham, NC: Duke University Press.

Déjeux, Jean. 1973. *Littérature maghrébine de langue française: introduction générale et auteurs*. Sherbrooke: Naaman.

Diawara, Manthia. 2010. *African Film: New Forms of Aesthetics and Politics*. Munich: Prestel.

Dine, Philip. 2002. "(Still) à la recherché de l'Algérie perdu: French Fiction and Film: 1992–2001." *Historical Reflections/Réflexions Historiques* 28(2): 255–75.

Ebaum, Max. 2002. *Revolution in the Air: Sixties Radicals Turn to Lenin, Mao and Che*. London: Verso.

Gikandi, Simon. 1996. *Maps of Englishness: Writing Identity in the Culture of Colonialism*. New York: Columbia University Press.

Haynes, Jonathan. 2000. *Nigerian Video Films*. Athens: Ohio University Center for International Studies.

Jameson, Fredric. 1991. *Postmodernism, Or, the Cultural Logic of Late Capitalism*. Durham, NC: Duke University Press.

Krings, Matthias, and Onookome Okome, eds. 2013. *Global Nollywood: Transnational Dimensions of an African Video Film Industry*. Bloomington: Indiana University Press.

Lobato, Ramon. 2012. *Shadow Economies of Cinema: Mapping Informal Film Distribution*. London: Palgrave Macmillan [on behalf of the] BFI.

McCall, John C. 2007. "The Pan-Africanism We Have: Nollywood's Invention of Africa." *Film International* 5.4 (28): 92–97.

Orlando, Valérie. 2011. *Screening Morocco: Contemporary Film in a Changing Society*. Athens: Ohio University Press.

Ukadike, Frank Nwachukwu. 1994. *Black African Cinema*. Berkeley: University of California Press.

African Francophone Cinema

Olivier Barlet and Kenneth W. Harrow

The question of influence and horizon of possibilities for Francophone filmmakers is similar to that of other independent filmmakers. The need to finance a film has meant that they have had to turn to government agencies or ministries, nongovernmental organizations (NGOs), or funding agencies or sources, each of which has had its own agenda. The degree of freedom any filmmaker might have is partly determined by his or her own autonomy or stature in the profession, and by his or her stubbornness as well as reputation. Thus Sembène Ousmane was largely able to determine the content and direction of his films, but could not finance his magnum opus, a historical film on El Hadj Umar, despite his long-expressed desire to do so. The most famous anecdote involving the constraints placed on his work concerns *Mandabi* (1968), which had been funded by the French *Centre National de la Cinématographie* and coproduced with his own company, Domirev, and *Comptoir Français du film* (Gadijgo 1993, 35). Having shot the film in Wolof, Sembène was told he had to produce a Francophone version, which required shooting the entire film in French (as *Le Mandat*) as well as Wolof (*Mandabi*).[1] The decision to shoot a Wolof version, which has become the standard version today, attested to Sembène's commitment to respond to the needs of his Senegalese audience to understand a film without subtitles, a film in their language. However,

his means were limited, and when the actor playing the postman left before the shooting of the film had been completed, Sembène was obliged to reconfigure an ending and produced the montage of earlier shots with voice-over, which is how the film now concludes.

These constraints are examples of the myriad limits placed upon directors who cannot finance projects with their own money. The speculation of what influence the sources of funding have on a director's choice of style and topic, and what audience to target (what implied audience to construct), has been heightened in the case of Francophone African cinema, which has long depended upon subventions from various French governmental or commercial agencies. We might adopt Raymond Williams's (1983) description of the relationship of the superstructure to the base as one of "relative autonomy"—following Gramsci, and later adopted by Althusser (1972). "Relative autonomy" might mean that an African filmmaker might have a vision of a project, and then would have to shop it around the various funding agencies, knowing the kinds of projects they had financed in the past, the weight his or her name might carry, the possibilities of arguing for the likely success of the project with African or European audiences, and so forth. This pattern is true for all filmmakers, but in the case of Francophone literature, its parameters were largely set by the willingness of the French Ministry of Cooperation, its Film Bureau, or of "la Francophonie,"[2] situated in one location or another over the years. Andrade-Watkins's conclusion in 1993 holds for today as well: "As black African cinema moves into its third decade, the obstacles to financial and technical self-sufficiency in production, distribution and exhibition have largely remained unresolved" (32). Ironically, as she was penning these words in the early 1990s, Nigerian and Ghanaian video filmmakers were beginning the revolution in African film by creating a cheap, commercial, popular form of cinema that eschewed the ideological commitments and aesthetic choices of what had been the dominant forms of African cinema—FESPACO films—that had been established since Vieyra's "L'Afrique sur Seine" (1955) and Sembène's *La Noire de* . . . (1966).

Efforts to duplicate the new digital revolution have been made in Burkina Faso, Côte d'Ivoire, Mali, and Senegal, and throughout many other African countries, with a wide shift in the direction of films with high entertainment values, commercial priorities, and often emotional, melodramatic, personal storylines once considered inappropriate for newly independent African states (Boughedir 1976). The term "genre" films, which encompass telenovela-style series, action and crime dramas, as well as films focusing on magic, Evangelical Christian baselines, love potions,

poisonings, and especially lush, luxurious settings, have reconfigured the horizon of possibilities, driving many of the Nigerian marketers to demand conformity to these selling points in the creation of quickly made, inexpensive films.

In what follows, a chronological structure of dominant paradigms, or phases, will be set out. This is not intended as teleological, but rather is closer to what Russian formalists understood by the dominant as a tendency that marked a period, even as simultaneously other paradigms and cultural approaches were deployed.[3] Here we should understand that even as filmmakers set out to create an African cinema in the 1960s, their signature work continued during subsequent periods that developed new trends, and that those dominant trends never totally eclipsed earlier approaches and trends. During any decade, one might see different approaches continue, even as some emerged and dominated the screens for a time.

The naissance of African cinema from its earliest idealized version was inspired by Russian socialist values.[4] African cinema of the 1960s and 1970s dealt with issues of social/political engagement, the need to confront the immediate problems of nationhood, the challenge of the new nations facing their future, and the dreams of creating the New Africa, the New African Man and Woman. Sembène's early films *Borom Sarret* (1963), *Tauw* (1970), and *Xala* (1975) contain shots that highlight the time since independence. This is the optic through which African cinema was viewed as serious, political, and, most of all, *engagé*, the key term for the 1960s–1970s.

The first films by African directors, including Paulin Vieyra, Sembène Ousmane, and Oumarou Ganda, occurred at the time of the struggle for the end of colonialism and for independence—a time that defined its values around the works of Fanon, Memmi, Cabral; around the war in Algeria, whence the great importance that came to be attached to *The Battle of Algiers* (1966) as the signature piece of revolutionary filmmaking; around Marxist belief in class struggle and Engel's analysis of imperialism; around the solidarity of the black struggle, whence the embrace of C. L. R. James's *The Black Jacobins* (1938). It was a period that laid the foundation for the soon-to-develop struggle against neocolonialism, and with the compromised new leadership that introduced one-party states or corruption, and rule by force, and that collaborated with the former colonial master. Thus, whereas Senghor ascended to the presidency of Senegal, and other African leaders espoused a rhetoric of negritude or black authenticity, such leaders following in the wake of Nkrumah, Lumumba, Azikiwe, or Ben Bella, came to be regarded as tyrants. Mobutu in Zaire, Idi Amin in Uganda, Ahidjo in Cameroon, or the Emperor Bokassa of the Central

African Empire, all deployed versions of this rhetoric while instigating severely repressive regimes.

The project of the early filmmakers was to expose the failures of an abusive authoritarianism. By the 1970s, when Sembène attacked neocolonialism, most famously in *Xala*, others like Jean-Pierre Dikongue-Pipa challenged a patriarchy associated with traditional society, as in *Muna Moto* (1975) or *Le Prix de la liberté* (1978). By then, Negritude was viewed as passé or worse, as heard in the mocking, dismissive words of Mphahlele or especially Soyinka. Civil rights rhetoric, likewise, belonged to the past, especially as militant liberationist struggles continued and intensified in Portuguese Guinea, Angola, and Mozambique. During that period, Mandela and Mbeki languished on Robbin Island, while the armed wing of the ANC, and especially the Black Consciousness movement and the PAC, carried on the fight. National independence was determined by a path whose foundations were laid on the concept of the modern nation-state that colonialism had denied to its African subjects.

In retrospect, that project of a committed cinema can be seen as a subset of modernist thinking: progressivist in nature and ameliorist in ambition. Modernism's binary of modern versus traditional, as seen in *Touki Bouki* (1973) or *Xala* (1974), dominates all the films of the period, providing a frame for casting the narratives and characters into a familiar world, a territory inhabited by claims of oppression, exploitation, and evil neocolonialist antagonists, as well as authenticity with authentic African figures and truths. The inauthentic figure takes the form of the assimilated capitalist; the authentic speaks Wolof to her father, participates in the publication of a Wolof journal, and, more broadly, participates in the embrace of African culture over Europeanized, imitative culture. Modernism gave definition to the New that stood in relation to a notion of the Old Africa that had to be discarded.

Old Africa was associated with rural ways (*Tauw* 1970) or paternal/patriarchal figures who oppress women—with issues of forced marriages and husbands silencing, beating, and confining their wives and oppressing their sons. This vision appeared frequently in Dikongue-Pipa's films (*Muna Moto* 1975; *Le Prix de la liberté* 1978)—with young women forced into marriages with old, unsympathetic patriarchal figures, and the love between younger couples complicated by the fathers' desires to marry off their daughters. Similarly, marabouts as charlatans who exploited children, exposing them to danger, represented the Old Africa, tied to the past, to rural values, and to Muslim religious orders (Sembène, Traore). Religion was associated with charlatanism or marabouts, either foreign, Moors, or simply

exploiters. In Senegal, Old Africa was rural, dominated by a stagnant version of Islam—as in Sembène's novella *Vehi Ciosane* (1966), where old men, old imams or muezzins, countenanced the incestuous acts of a father who impregnated his young daughter. For her, liberty came with flight to the city.

Other versions of these tropes can be seen in the opening of *Touki Bouki*, with the passage of the rural pastoral setting into the urban abattoir, or in *Xala*, with El Hadj crawling toward a new young wife with a gris gris in his mouth. Though these were two radically different movies, they still thematized the Old Africa facing the New, beyond issues simply cast as engagement.

The New Africa was located in cities, in the younger generation, in revolutionary youth (*Xala*), modeled historically after the Originaires[5] in Senegalese communes. The idea of being modern can be traced to figures like the youthful Rama in *So Long a Letter* (1980), to the figures of intellectuals, closer to European intellectuals or leftists than to Muslim or African intellectuals or oral traditions. This model of the "New" is not located in Europe, but grounded in a notion of Europe, of France, generating mixed messages. It is seen as both liberating from debilitating conventions or rituals, as represented repeatedly in Sembène's or Traore's work; yet this New African figure can also often be seen as emasculating, with men rendered ridiculous in their submission or subordination to women, to their wives who ought to be obeying or admiring their husbands (we get a whiff of that still in as late a film as *Faat Kine* [2000], as well as in Mambéty's earlier work *Touki Bouki* [1973]). The image of the New "modern" African often denotes young men and women seeking to create a New Africa, free from both the past country ways and colonial European forms of oppression. There is a shift in the 1970s and later when this New African begins to feel the burdensome weight of the older revolutionary class that took control on independence and who abused their prerogatives. We see this not only in the members of the Chamber of Commerce in *Xala* (1974) or in the fathers in *Faat Kine* but also in the revolutionary old guard in *The Blue Eyes of Yonta* (1991), the latter to be seen in contrast with the earlier revolutionary *Sambizanga* (1972)—both set in Lusophone Africa, and therefore at the final edge of revolutionary cinema.

This first paradigm of Francophone African cinema[6] is often defined in relation to colonialism or neocolonialism, as well as to the rural countryside viewed as old and stagnant, or as collaborative with colonialists. The relation to an oppressive French or foreign dominant order is to be opposed, resisted, fought. Resistance often turns on the figure of an oppressed woman, or less often a youth, with patriarchy seen as corrupted (*Muna Moto* 1975, *Tauw* 1970, *Finye* 1982). Ultimately this phase

engendered a cinematic ideology understood as anticolonial or revolutionary, with heroic examples in the cinema of Sembène Ousmane, Med Hondo, Sara Maldoror, and subsequently Malian, Burkinabe, and Senegalese filmmakers, including Souleyman Cissé, Idrissa Ouédraogo, Mahama Johnson Traore, Cheick Oumar Cissoko, Gaston Kaboré, and Safi Faye. Frequently their works trade on a binary that sets the old, traditional, authentic version of Africa over against urban modernity. Engagement is situated within these parameters, without acknowledgment of the debt to the colonialist discourses of modernism.

Exemplary Case of First Paradigm: Sembène Ousmane

Sembène's films lent themselves to this first paradigm, and were so successful that they provided models for much of what followed with other Sahelian directors. The narrative structure of most of Sembène's films followed a similar pattern. The films begin with the presentation of a problem, usually involving a crisis that crystallizes around some opposition to the film's protagonist. This is usually followed by a false solution in which the prospects of the removal of the obstacle are shown to be inadequate. Eventually a true solution is found, with the issues related to the film's underlying rhetoric resolved and explicated. This is the threefold or dialectical path to truth, following a trajectory at the end of which the audience is enjoined to see and appreciate the truth uncovered by Sembène, and, ideally, be motivated to act.

Each film constructed according to this model must silence some figures, must occlude contrary or alternative perspectives that might have led to an alternative direction, and this is the small term in the price to be paid for accepting the underlying system of values. Finally, the question of the larger system of values may also be seen as leading us to conclusions that are equally limiting in the interpellations of the viewer. We can see these questions of larger systems of value as having pertinence to the field of postcolonial studies as it passed from its earlier years of struggle for national independence to the more recent period of globalization, with the concomitant postcolonial crises of the African nation. Sembène has been there throughout this entire period, and his films continue to have a huge impact, if not on other younger filmmakers then on Africanists in general, as well as on that narrowly specialized audience for African film.

Sembène's career begins with short- or medium-length films, *Borom Sarret* (1963), *La Noire de ...* (1966), and *Tauw* (1970), where the basic pattern is established.

Borom Sarret concerns a cartman who hauls goods or people for a living. The initial problem is that he doesn't earn enough money to make a decent living. The implied solution for him is better pay, a problem related to the fact that his clientele is generally drawn from the relatively impoverished class of ordinary Senegalese. Eventually the cartman is convinced to take a wealthy client to the Plateau, the expensive, formerly European quartier of Dakar, as the apparent solution to his need for cash. There he is in infraction of the rules forbidding *charrettes* (or horse-drawn carts) from going to the Plateau, and despite the rich client's promise to help, his cart is confiscated. He returns home on foot, as his personal dilemma is now portrayed as the consequence of an unjust economic and social system based on class division. The implied solution lies in working through the injustices of class difference, a solution in harmony with the general acceptance of the socialism widely embraced by African intellectuals in the 1960s.[7] In the final scene, the cartman's wife leaves him with their child, telling him she will find money for the food they need. The false solution of the cartman trying to extend his income by daring to go onto the Plateau for a higher fare, and trusting the nouveau bourgeois client to protect him, is replaced by the determination of the no-nonsense wife, who might be seen to represent a more idealized proletariat figure. There are other small elements in the film that relate to this, but the gist of the film lies in its presentation of class values along the lines of a revolutionary socialist point of view.

The same might be said of *Tauw*, a film that takes an unemployed young man for its protagonist, and that highlights the failures of independence to provide Senegalese society with economic development for the poor, ordinary people. The immediate, apparent problem is unemployment, and the inadequate solution would be simply for Tauw to find a job. The ultimate resolution could only be accomplished with a broader change in the economic and social system. En route to this we have two interesting social issues that deserve mention. The first appears in a scene of children begging in the street, a common if scandalous issue in the 1970s when Qur'anic teachers were thought to be responsible for sending their students out to beg (a recurrent public issue in Dakar). In this scene, we hear the reflection made by a passing driver who sees the monument to independence and states that in the ten years since independence they haven't come very far.

The second issue involves the family relations. Tauw, the unemployed youth, is the son of a "traditional" father—a patriarch who fails to provide for his family but who still dominates the mother and children as a tyrant, and who claims the rights to his position on religious or customary grounds. The film's critique of this

patriarch remains grounded in Sembène's socialist modernism. What is occluded in this critique can be seen in much later developments in postcolonial thought that demonstrate the constructed nature of the notion of tradition and the simple reductive nature of Sembène's notion of a feminist protest.

Fourteen years after the onset of the "independences" and Senghor's presidency, after the failures of the early national governments and leaders have become the subject of many novels and plays, Sembène achieved a major success with *Xala* (1974). The earlier clear focus on socialism as the correct answer to the problems of comprador capitalism, posed in the works of *engagé cinéastes*, became blurred by the critiques of corrupt and oppressive Senegalese leadership. The representation of a failed ruling class, both political and economic, dependent on the powers from the *Métropole* still exerting control over the African state, is figured within the new paradigm of neocolonialism.

The initial problem in *Xala* is El Hadj's impotency, which emerges early in the film as he fails to achieve an erection on the day of his wedding to his much younger, third wife. The solution is to find a marabout, or sorcerer, who will have the power to restore his manhood. But even when he succeeds in accomplishing this, his finances collapse, revealing the imperfection, or even falseness, of this solution. In the end we are led to understand that the problem has not been properly posed, that his impotency, or *xala*, is indicative or symbolic of a larger symptom, that of the unprincipled neocapitalist ruling class. The final scene in the film presents the solution for El Hadj: he is made to submit to a ritual of degradation carried out by the city's beggars, which will restore not only his virility but also effect his reintegration into his African family—a family not to be defined by the thoughtless imitation of foreign ways, but by adherence to its African values.

Again the message is somewhat muddied. We understand that the class values of the rich are signs of their corruption, and that the corruption consists in imitations of Western ways, performed to the point of ludicrousness, at times even implying racial self-hatred. Notions of authenticity ground the critiques of acculturation, as seen in the national bourgeoisie's preference for French over Wolof. Simultaneously, the film's progressive, Westernized first-wave feminism entails a rejection of polygamy and of El Hadj's justifications for it on the basis of traditional and Islamic custom, "la patrimoine africaine," the very rallying cry for the nationalists' struggle for independence. The revolutionary daughter, Rama, who insists on speaking Wolof but also on attacking her father's polygamy, is trapped at the end by her fidelity to her family, which leads her to suffer at the hands of the

beggars who invade her parents' house and subject El Hadj to their indignities. In the end, cultural nationalism and female liberation clash.

The true dialectical solution is presented, clear in its opposition to neocolonialism, but somewhat fuzzier in its placement vis-à-vis tradition or Africanité. The perspective that guides the issues, that frames all the film's questions, returns us to the film's "McGuffin," El Hadj's penile inerectibility—providing the film with a classic phallocentric issue. The restoration of his virility, even if now figured in terms of a valid African identity, doesn't alter this perspective, and in this regard it is interesting to speculate on the role of El Hadj's third wife. She is the object of the male gaze, of the sexual challenge, but also of sexual prohibitions since El Hadj cannot have relations with her, even when his virility is restored by the marabout, because she is having her period. By the time her period is over, his virility is gone.

Throughout the film she almost never speaks, so we hear nothing from her about how she views her marriage and its consummately failed nature. Nothing of what she sees or wants is expressed. We have the gifts El Hadj makes to her and her family—the house, the wedding, the trappings in which he wraps his story of success. *Her* success and failures, *her* ambitions or desires, go unexpressed. She is primarily presented as an image, one caught in the photograph of her posing naked, placed over the marriage bed. Yet without her El Hadj cannot achieve his proper position as dominant male: she functions as the excluded term—the supplement—on which the male center depends.

The film's phallocentrism carries over to Oumi, El Hadj's highly vocal second wife, who is presented to us in terms of how her relationship with El Hadj is affected by the third marriage, as is also the case of Awa, the first, more sympathetic wife. All the wives, and indeed all the characters, wind up as figures caught in a plot that turns on El Hadj's preoccupation with his "manhood." Their other issues disappear, are silenced. So if *Xala* is a film about neocolonialism and how it unmans Senegalese leaders, it also posed the question of why neocolonialism is framed through that narrow optic. *Xala* is perhaps the most quintessentially anti-neocolonialist film of the period or perhaps of the whole canon of African cinema, and it is built around this series of relations of women turned toward a man whose problem lies in his failed sexual performance. Could it be that this silence of the third wife, and the broader silencing of the other wives as having lives with import besides that which relates to their husband's sexual performance, is indicative of the silencing engaged in the presentation of neocolonialism in this pure form? If so, we need to ask about the price of presenting Africa's failures in terms of such readings of neocolonialism,

just as Radhakrishnan (1992) asked questions about the presentation of the Indian woman as symbol for the nation. We might begin by asking, similarly, if this is a question also of the price of remaining within the optic of a first wave feminist politics preoccupied with the notion of women oppressed by husbands for whom African traditions or customs, ensconced in religion or village values, justify their patriarchal positions. Indeed, both the neocolonial and feminist positions taken here are based on straightforward binary opposites that systematically work on exclusionary political perspectives. Both positions are articulated by the implied narrator, who alone possesses the Truth and speaks for the oppressed. When El Hadj, somewhat out of character, articulates this Truth at the Chamber of Commerce when he is about to be ejected from the Chamber, his speech implies a relationship with an audience who are passive recipients of his "lucidity." The magisterial site of the film's message interpellates the viewers so as to align them with a historicist perspective on the sexual and political economies, the terms of which are set by a modernist paradigm of progress. Gikandi (1996) has convincingly shown that this progressivist temporality also informed colonialist ideologies, so that we can say Sembène has absorbed the model, redeployed it for liberationist purposes, but has stayed within its parameters. By doing so, he has had to develop exclusions, occlusions, silencings that prefigure an eventual embrace of an authoritarianism on the part of those who possess the correct vision or truth (this emerges in a later novel, *Le Dernier de l'empire* [1981]). This is the price of staying within a phallocentric paradigm, a modernist paradigm, and especially a progressivist paradigm that fails to acknowledge the Enlightenment rationalism and historical basis on which that model depends. The modern "self" that accounts for what is occluded or silenced is to be found within the structures of classic realism or social realism, whose narrators provide the terms of a natural, normal order of reality and of self-evident truth.

Catherine Belsey provides this key description of the closure that characterizes the classic realist text: "The story moves inevitably towards closure which is also disclosure, the dissolution of enigma through the reestablishment of order which is understood to have preceded the events of the story itself" (2002, 70). She adds further that "the movement of classic realist narrative towards closure ensures the reinstatement of order, sometimes a new order, sometimes the old restored, but always intelligible because familiar" (Belsey 2002, 75). This movement is characteristic of all of Sembène's work, and this is because his embrace of a fixed ideological position precedes the characters' entry onto the scene. In other words, Sembène is in the position of what Lacan calls the one supposed to know (*censé*

savoir), and that positions the viewer as the passive recipient of that knowledge rather than an active participant in the discovery of knowledge, as the advocates of Third Cinema like Tomas Alea Guttierez or Solanas and Gettino would have had it.[8]

Second Paradigm

A shift in dominant paradigms came in the1980s–1990s with the move away from representations of colonialists, colonialism, or neocolonialism, except with revolutionary Lusophone cinema. Increasingly, there developed concern over local authoritarian or despotic rule, as in *Finye* (1982), *Yeelen* (1987), *Zan Boko* (1998), and *Sango Malo* (1990) (as was also the case with the literature of the late 1960s and 1970s and 1980s, with Armah, Achebe, Soyinka, Laye [*Dramouss*], and so forth). The passing of the old order came to be seen increasingly as nostalgic, most famously in *Wend Kuuni* (1982) with Kaboré's pastoralist portrayal of precolonial Africa, but also in *Finye* (1982); *Yaaba* (1989), with its setting of the isolated rural village; or semifantastically in Cissé's *Yeelen* (1987). This is an Old Africa that no longer threatens the New since it is past—as the griot narrative voice in *Wend Kuuni* intones, the good old days before the white man came. As in *Yaaba*, the old world seems to have no contact with the city; in *Finye*, most famously, the old gods take their departure, as the grandfather marks the passing of the old guard to the new. In Sembène's *Faat Kine* (2000), the old generation of revolutionaries is now presented as passé, needing a younger generation to move the country forward. The Lusophone Flora Gomes's *The Blue Eyes of Yonta* (1991) thematizes this, showing the old and new now in terms of generations of revolutionaries and their children. The hypocrisy of the old anticolonialists was already depicted marginally in *Xala* (1974) and becomes central to *Finye* (coming twelve years after *Tauw*), with the new governor now portrayed as corrupt and oppressive of his wives and daughters.

This second paradigm has not yet left the political frame of the first paradigm; it still operates around figures of oppression, increasingly associated with the older generation and often played as an acculturated or semiacculturated man—(for example, the cousin in *Mandabi* 1968)—in ways that are mocked. The New is struggling to define itself against both a patriarchal past and a local authoritarianism that presents itself as the locus of a valid notion of Africa and its authority, as in the older teacher in *Sango Malo*. But Old and New are redefining themselves away from

a cinema of engagement per se, away from discourses defined by their relationship to Europe or to neocolonialism, and the bourgeoisie is presented less as a subaltern class than as a class of oppressors in their own right, or as figures more enmeshed in contradictions than in purely selfish modes of domination (to note the change, see Barthélémy in *Guelwaar* [1992]).

Examples of Second Phase: Bassek Ba Kobhio's *Sango Malo* (1990), Jean-Marie Teno's *Chef* (1999), and *Afrique je te plumerai* (1993)

Old and New confront each other in the person of Sango Malo, a teacher whose opponent is the old village chief; the teacher's knowledge serves as the support through which the audience's sympathies are rallied. For Teno, it is the abuse of power first experienced through the person of the village chief, and then through his reincarnation as the "father of the nation" that is the subject of *Chef*. Ba Kobhio and Teno are both concerned with such oppositional situations. What is visibly exposed in gross details in their films is the abusive nature of the chief, the despot.

Technologies of power and knowledge are inscribed into *Sango Malo* with the arrival of the teacher, Bernard Malo, in the village of Lebamzip. He has just graduated from the university with a teaching degree, and has been assigned to the one school there. As he arrives, the director of the school is teaching what is to become Malo's class. The first image we have of the director's authority is that of a classroom of students singing the national anthem and then repeating the director's words, sit-stand-sit, and so forth, as they obediently stand and sit. Meanwhile another student is being punished at the front of the room by having to touch one of his toes, bending over while the others repeat the director's instructions. The "discipline" of this old-fashioned figure of authority is instantly placed into a familiar mocked space of French assimilation: he has the children recite a poem entitled "Jours d'hiver" (Winter Days). Malo arrives alone and on foot, and after being installed at the school quickly encounters the familiar figures of the village: the greedy shopkeeper; the village drunk; the obtuse, overweening, patriarchal village chief, and so on. There is also the shopkeeper's assistant, whose two drinking friends always manage to con him into putting more drinks on the tab for them. That's as close as we get to a trickster in this serious drama, whose point is to locate the key issues of contestation between the authoritarian features of the old patriarchal order and the new African modernism brought into town by Malo.

What the trickster would bring is something closer to the vagabond truth of what Foucault (1995) calls the plague, that is, indiscipline, mixture. Rather, Malo brings discipline into the village: in place of the shop owned by the exploitative, fat, mocked "chaud gar" (hot shot) of a shopkeeper, he institutes a cooperative; in place of meaningless, old-fashioned pedagogy, he institutes a pragmatic curriculum of farming, carpentry, and similar practices. If the director's conventional curriculum was aimed at the "talented tenth," Malo's practical revolution brought in a familiar land-grant curriculum. And at every single point of village life there was an equivalence in the issues setting an old, authoritarian, or useless traditionalism over and against the correct, modern version he came to impose. Even the "bois sacrée" (sacred wood) was to become the new farmland for the cooperative, under his direction. Eventually Malo's own absolutism does him in, alienating him from the very villagers he came to save. And in the process, he pays a high price: he loses his position in the school system; his father-in-law commits suicide in shame over his daughter's marriage to him without a dowry or festivities; and in the end the chief succeeds in having him arrested and carted off.

In the end, his defeat is only temporary and ostensible; the real triumph is realized by the conscientization of the audience, as well as that of the villagers, thanks to Malo's willingness to go so far as to be sacrificed for the greater good. The real discipline of modernity prevails: not the false modernity of a glitzy Eurocentric nature, but the "valid African modernism" of those who have shaken off the deference to authoritarianism and tradition.[9] In short, the authenticity of the new discipline, the normalcy of the new discipline, and inevitably the power of this new pedagogy, the new science, prevail without any serious contestation.

In many African traditions, the element of disorder is represented by the trickster. In *Sango Malo* we have a drunk, two con-artist drinkers, a fat shopkeeper, and so on; but the prevailing gesture is not vagabondage but recuperation. The drunk is saved; the capitalist, exploitative shopkeeper is defeated; the paternal position is reappropriated by Malo, who impregnates his wife who becomes a "modern-thinking" schoolteacher and takes his place. The new order is anticipated, prepared, installed. We have thrust before our eyes the inevitability of its truth, especially as a normalized set of values. The more this is the case, the more the film insists upon its modernist norms at every turn, and provides every question with an obvious answer, the more the disciplinary mechanism that has set up this procedure is both *exposed* and *dissembled*. This is because the true hidden mechanism that drives the disciplinary values of the film is not the overt pedagogical program

of Malo, but the cinematic apparatus that highlights his presence. His visibility, eventually his sacrifice, is made all the more insistently as the operations of the cinematic apparatus are obscured.

The camera functions in conjunction with the procedures that direct the audience's gaze. It is not only a racialized, acculturated, or gendered gaze that is inscribed in its look: it is productive of a space in which a normalized knowledge is installed with enormously more authority and force than that imposed by the worst excesses of the autocrat, the despot who is, after all, reduced to the image of a "chaud gar" patriarch whose fat belly, bloated verbiage is all the more easily dismantled. The African cinematic apparatus that began in the 1960s with the reformist or revolutionary agendas of the disciplinarians of a didactic cinema met little or no resistance from those who were drawn into its gaze. *Sango Malo* is their heir, and Lebamzip the model for its knowledge.

What we can recognize in the above description might well be called the cinema hall of contemporary African cinema, and more precisely its technology. This is not a product of some sort of thoughtless imitation of European values. This apparatus has a history that is particular to the African experience, and this is precisely what colonialism, neocolonialism, and now globalization have brought. If Mbembe brings an excessive logorrhea to the vision of the autocrat, Ba Kobhio deploys a cooler, unobtrusive apparatus: the presence of the technology of his cinematic mechanism is never betrayed. It functions ideologically, that is, normatively—in generic terms, as a form of realism. The autocrat—here the chief, in all his apparitions—is the true plague, the true leper, not the tame drunk, not the obviously exploitative shopkeeper, but the autocratic chief, and behind him the *sous-prefet*, and behind him the grand *chef d'etat*. The *chefferie* of autocracy figures both disorder and exclusion, because they are set off from the normalcy instantiated by the cinematic apparatus.

We are in the grips of that cinematic apparatus, that is, one that aims to cure, that partitions and assigns meaning to power, as we direct our gaze to those green hills, that red earth, those naturalized villagers—and especially that portrait of a distant power whose authority we are called to displace, in *Sango Malo* as well as in Teno's *Chef*. The historical investments that situate that gaze are what make the village scene the product of a colonial past—the dead whose bones are continually protruding in the skeletal disposition of the village landscape, the *bois sacrée* (sacred wood)—and a postcolonial present, the living whose visibility is made to carry the burden of an invisible ideological functioning. The more conscious and permanent

the visibility of the apparatus of despotism, the more generalized, normalized, and irresistible the force of the cinematic mechanism—and the self-evident nature of its political assumptions. The cannons of the conqueror have been replaced by the cinematic apparatus, just as the camera as a gun shooting twenty-four frames a second has been replaced by the technology of realist protest cinema.

In the process of resisting the grosser movements of dictatorship, its imprisonments, torture, and militant mechanisms of control—or in this case, the beating and arrest of Malo toward the end of the film—we absorb a post-Enlightenment discipline that places us in line with Foucault's (1995) trajectory of the eighteenth-century transition from the one extreme of "discipline-blockade" to the "discipline-mechanism." This is the same passage from the autocracy of Ahidjo to the discipline of the new order instituted in Lebamzip by the well-meaning, serious Malo.

The discipline blockade for Ahidjo was Tchilloré—a fearsome prison; the new discipline mechanism in *Sango Malo* may be expressed as the new school, the pedagogy for the people, but its unexpressed mechanism is the cinematic apparatus. *Sango Malo* is made to work for the project of liberation; it is in the service of a new society grounded in nonpatriarchal liberties.

Jean-Marie Teno moves us in another direction with his short film *Chef* on the variant forms of the African Big Man. Here is his website description of the film, encapsulating his political project:

CHIEF! [*Chef*] is a documentary chronicle of the trials and tribulations of daily life under a dictatorship.

During the month of December, 1997, I witnessed several troubling events in Cameroon: In my village a young boy was nearly lynched by mob "justice" in a lawless state. I went to a wedding and learned that, by law, the husband is the ruler of the family. A highly respected journalist was imprisoned without a trial for writing an article about the health of the president.

While seemingly unrelated, these incidents bear witness to disturbing tendencies in Cameroon today: they are all point to the ways in which the abuse of power permeates everyday life in an authoritarian society.

CHIEF! brings these events together to allow us to reflect upon the current state of Cameroonian society with its hierarchies, inequalities and lack of respect for human rights—all the by-products of a dictatorship.

We all know that dictators act like all powerful chiefs, marshalling the law to

their own ends, ruling with total impunity, pillaging and plundering their nations' wealth, diverting millions into Swiss bank accounts, enriching themselves endlessly at the expense of their countries' miserable populations.

CHIEF! asks us to see beyond the cult of personality created by the dictator, allowing us to see that a dictatorship is also a system with a logic, a vast machinery of corruption and irresponsibility, a state of mind that pervades an entire population. In every town, office, police station, institution we find autocratic chiefs ruling over their fiefdoms, extorting from their subordinates. CHIEF! examines how the authoritarian model is replicated from top to bottom, transforming all social exchanges into relationships of power and inequality. (http://jmteno.us/films/chef.html)

Shortly after the opening scenes of *Chef* dealing with the celebration of the *chefferie* of Bandjoun, Teno records a crowd's interpellation of a young thief on the last day of the festival. The celebration had crowned the inauguration of a statue of Kamga Joseph II, the ruler who saw the invasion of the colonialists as the opportunity to modernize his state. Now, in the words of Teno's ironic voice-over commentary, his golden statue stands exposed to the elements, looking across at beer and cigarette advertisements on billboards. The crowds dance, the male elders sing his praises; the chief is visibly moved. He extends his protective hands to his supporters, and guarantees his benevolent reign will be with them.

The following morning the intersection is cold, misty, empty. Teno has set out to capture the feel of the after-celebration at the deserted place, but instead encounters a crowd. It is there that the drama of the panopticon's eye is brought to light with the ambiguities of Teno's role as committed filmmaker. We see a sixteen-year-old boy held by the crowd, and then threatened and hit. We see his closed face, and his body as he is stripped. We see all this, which the camera captures and which the narrator's voice describes at the same time. The narrator, who identifies himself as the grandnephew of the chief of Bandjoun, is manifestly our filmmaker Jean-Marie Teno. From other films, if not from person-to-person encounters, one can recognize the voice to be that of Teno, though he never directly identifies himself. He is the one who speaks to us, while we see what the camera is showing. Thus it is all the more telling that he speaks the following words at the beginning of the film: "Toi qui fait des images, ne manque pas ce weekend au *chefferie*. Ca va chauffer" (You who make images, don't miss this weekend at the chief's celebration. It's going to really be something). Soon after, we learn the words were addressed to Teno by a

friend at Douala who was informing him about the celebration at Bandjoul. We are thus made aware of the presence, and personal investment, of the one who speaks to us without ever being seen. An invisible presence, an unseen voice made present through the implied mechanism of an interpellation.

When the filmmaker uncovers the events in the early morning, at the crossroad, for a while the individuals who are there speak without any narrative intervention. We are brought into the episode by the immediacy of the camera's gaze, as if there were no mediating presence. However, that immediacy is broken first by Teno's voice, as he increasingly excoriates the authoritarian and cruel nature of what he terms popular justice, and then by the interruption in the filming. That occurs at the moment that a large man gives the boy a powerful blow to the head. Warned that expedient village justice might well mean death, Teno states that he then stopped filming to intervene. The screen goes black. Then the images return, and we see the boy still there, about to be led off by the crowd, first to the neighborhood *chef de quartier*, and then to the police station, where those with the "right" to beat with the thief will deal with him. The others observe his "human rights" by refraining from meting out expedient justice.

Teno's presence is made clear by his direct use of voice-over, by his act of calling attention to the act of filming, by his personal references to his own position as grandnephew to the chief and later as investigator of the authoritarian practices within the culture and society. His signature voice-over technique highlights the difference between a visibly evoked subject and the position of the one who is audibly evoking that visibly evoked subject. That is, there is a difference between the subject of the enunciation and the *énoncé*.

The Teno-narrator who becomes present to us is a guide—in fact, the native guide whose return home provides us with the insider's information that we are about to see in such dances as the *mwouop*, the *mugo*, and especially the *tso*, which has not been seen since 1975. As his presence becomes more accented, we see the costumed dancers indeed pass before our eyes, the voice now identified as that of the one who "likes to make images." The technique of power of the cinematic apparatus, and in this case the technology of a cinema of contestation, vies for power with the system of chiefs. That system is described as a large *chefferie* that constitutes Cameroonian society in all its manifestations, and at all levels: the village society, the village justice, the husband as chief over his wife, the nation's *chef d'état* who imprisons or liberates prisoners at his arbitrary will. The stronger the movement of contestation, the more moving the stories of patriarchal power that

run through society, the more we are drawn into the diegesis, the more we follow along the path naturally cleared for us by the workings of the camera.

The honesty of Teno in admitting the awkwardness of his position as relative to the chief of Bandjoul whose power is being celebrated and who rules over the festival with evident self-satisfaction, functions to turn our gaze on Teno, his world, his presence. The technique itself is a sign of this second paradigm and its complexities of self-reflection, marking its distance from the first, straightforward technologies of African realism that never saw the necessity to turn the interrogative lens on itself.

As *Chef* continues after the opening scene at Bandjoul, a series of feminist talking heads evoke the unjust relations between men and women, stressing the fact that the men have advantages and privileges over the women. The final judgment they pronounce is that the men are the chiefs and the women slaves: the former have the right to decide—for instance, where the couple will reside; the latter are obliged by law to obey. Similarly, when Teno as narrator intervenes to save the youth from the vengeance of the crowd, he recounts to his film audience that this is an instance of a "justice inhumaine," a cruel practice tolerated under a corrupt system. When the last half of the film leads us to focus on the unjust imprisonment of Pius Njawe, again it is to bring to light the *inhuman*, degrading, bestial conditions under which prisoners are held in Newbell prison in Douala. This is the language of the reformers who have supplanted the initial wave of filmmakers for whom revolution and national liberation were the political ideals.

Where justice had been implicitly defined as anticolonial initially, now Teno highlights the term "popular justice," that is, the quick, dirty, physically retributive and abusive justice of the mob. It is ugly; it is inscribed on the head and naked skin of the thief. In contrast with the retrograde *chefferie* under which all of Cameroon lives, according to Teno, true justice must stand in opposition. Justice is not evoked in this film in the form of a grand institution, with neoclassical shapes and an indomitable woman holding aloft a symbol of equal weights. Instead, it is in the more pathetic figure of "Justice N.," to whom the film is dedicated. We learn that Justice N. is Justice Njawe, the daughter that Pius Njawe's wife lost when she was beaten outside the prison where he was held while she was in her ninth month of pregnancy. We are shown that Pius Njawe, imprisoned for reporting that the head of state might have been ill, learned, during his year of imprisonment, of the absolutely horrendous conditions under which the prisoners were held and of the absolute corruption of the judicial system that held them in thrall. We also learn

of Njawe's determination to create a foundation on the prisoners' behalf, on his release, one dedicated to the amelioration of the prisoners' dire conditions. The name of the foundation is the Justice Ndawe Foundation.

Njawe's words about the judicial and penal system echo when he states, "J'ai appris que le prison, c'est l'affaire des pauvres" (I learned that prison is the affair of poor people), and that the legal system consists of nothing so much as a bartering over bribes at all levels. Njawe refers us to a predisciplinary system of injustice, one in which it would seem that only reform, if not revolution, can address its ills.

The great cry of *Chef* is "Qui est le chef?" The film answers this question for us, over and over, and ends with a powerful appeal to right the wrongs experienced by Pius Njawe, and more generally by all the people of Cameroon forced to live under "démocratie apaisé," another name for dictatorship.

On the surface, *Afrique je te plumerai* (1992) continues with the tradition of African *engagé* cinema. Utilizing the techniques of cinematic *témoignage*, it puts before our eyes the images of truth, of reality: interviews and archival footage from the colonial period enable us to hear the old voice-over of colonial films with their unabashed European, imperialist biases. We witness directly how films of past colonialists presented colonialism to themselves—the historians or activist talking heads are presented as direct transmitters of truth, eye-witnesses, givers of accounts that finally reveal reality as seen through the eyes of Africans, and thus counter the biased accounts of the colonialists. The space of a hybridity grounded in difference, where the ambiguity of the colonial discourse renders ambiguous or contradictory its subject position, cannot be established here where the very act of filming, the cinematic articulation, is as transparent as the image of the unseen narrator's voice, that of Jean-Marie Teno.

Afrique is not a child of the Sembènean *engagé* film tradition as say *Le Prix de pardon* (2001) or *Sango Malo* might be: as a nonfiction account it attempts to give directly the message that Sembène always couched within his fictional narrative. Sembène believed that even the most didactic message should be housed in an entertaining form. Teno is closer to Achebe-cum-pedagogue here and in *Chef*: he openly embraces the role of filmmaker as educator and militant.[10] He made this film to respond to all those French, and even German, films he excavated from the colonial archive that so openly, naively, and directly vouchsafed the values of the colonial project. *Afrique* offers a response to racism, to the historical abuses of colonialism, and to the rhetoric of the civilizing mission, as well as to its extension into the post-Independence period with the regimes of Ahidjo and Biya.

Afrique also reconstitutes the history of Cameroon, the "true" history, first obscured by the colonialists and then by the puppet neocolonialist regimes. It is positioned as a regime of truth in response to past regimes of lies; it offers an enlightened view of the revolutionary, resistant, progressive past, an African view by an "indigène," as Teno calls himself—a native tour by a native guide who sets out the images, stories, interviews, and footage of a Cameroon made familiar by the mainstream Cameroonian voices beginning with Oyono and Beti in the 1950s.[11]

Afrique's strength as a historical reconstruction depends on the rallying of facts and on its rhetoric, on which the ultimate message of liberation depends. The voice-over narrator leaves no doubt as to his intention: "un homme qui prend la parole est ainsi un homme libre" (a man who speaks up is thus a free man). Speaking out is defined by the notion of giving an African voice where previously there had been only European or assimilated, imitative voices (see Ukadike's baseline, "From the beginning, the major concern of African filmmakers has been to provide a more realistic image of Africa as opposed to the distorted artistic and ideological expressions of the dominant film medium" [1994, 3]); and now speaking out is set against the silencing of the opposition press embodied in Pius Njawe's *Le Messager*, the open letter of Celestin Monga, and all the testimonials recorded in the film, in the teeth of the Biya's regime's censorship (seen as a continuation of Ahidjo's, and before him the colonialists'). Freedom is set in opposition to the forced labor, the virtual imprisonment and enslavement of Cameroonians by the German and French colonialists, and by the actual imprisonment, beatings, and slaughter of the opposition carried out by the same historical forces of colonialism, Ahidjo and Biya. Freedom is thus the condition of resistance and is defined by struggle against oppressive regimes.

Afrique's techniques lead it beyond the early forms of oppositional literature and cinema: it is complicated by its own technologies of postcolonial cinema that expand the potentialities for reading beyond those of the closed classic realist text. Its very elements of pastiche, irony, and self-reflexivity strain at the leash of didacticism. Like the cartoons in *Le Messager*, it pushes to the limits of the frame (Mbembe 2001). It might be possible to approach these limits through the mimetic fashioning of gender—the imitativeness that highlights performance, introducing a feminist challenge to the dominant logocentric nature of the Message film. We can achieve this through the irony that governs the narration, especially with the role of Marie. But Marie points us to more than ironic disenchantment and the playfulness of the sign in revolt against the dominant signifying order. The clear-cut divisions

of the binary that underlie the struggle, the revolt, the movement, become blurred by the scenes in which Marie and her ghostly boyfriend (the narrator, whom we are led to associate with Jean-Marie Teno himself), appear, and that convince us that their investigation is a mere ruse, a simulacrum of a real commission of inquiry. It is rather "as though"—as though Marie's demeanor, her questions, were a cover. For instance, as she asks the administrator in charge of the library at the Centre Culturel Français about his library's holdings, he quickly interprets her indirect questions and states, I think what you really want to know is how many African authors we have.

Similarly, the staged scenes, like the one at the national television station where Teno is simulating a request to air a program on Cameroonian television, are intended not to deceive but to highlight with humor the ironies of the situation in which Western imported shows dominate the airways. The pretense of Teno in presenting a manuscript to SOPECAM, the government publishing house, is likewise intended to give us access to the information that Cameroonian authored texts are not being accepted for distribution within the only real market for books in Cameroon, the school system, because corrupt ministers are bought off by French publishers whose books become required for the national educational curricula.

The protest is real, but the presentation of the protest is simulated, and it is the simulation that masks the real interviews, the real footage, the real photos—in short, the entire apparatus of representation of reality—much as that representation is intended to both mask its role as re-presentation and convince the audience of its unmediated view onto reality. Between reality and simulation, we are no longer with the first paradigm of African cinema, but in a new mode.

Similarly, "Alouette, gentille alouette," the refrain that haunts the film, is the real song "Alouette," but distanced by the irony of disavowal. The memory of Teno's grandfather's account of colonialism and independence, the true oral tradition, is already framed by this ironic distance from its outset. The grandfather's oral tale is about *alouettes*—swallows—the *alouettes* of the traditional French song whose altered refrain provides the African film with its title. It is a refrain to which the film often returns, usually with the visual or narrative evocation of children, and thus it highlights the pedagogical function of the narration. The positioning of this tale is central to the narrative, and although it is presented without much fanfare, it occupies a position of centrality in more than one way.

The tale is preceded by a long sequence dealing with the role of the book in Cameroon. We learn from the outset that Teno had wished, with this film, to give the real history of his country because "qui mieux que les écrivains sont les

témoins de leur époque?" (who better than writers as witnesses to their times?). He continues, following directly along the direction of Achebe, "les phrases révèlent ou déforment la réalité" (the sentences reveal or deform reality). Marie leads us to the *marché des livres*, the sidewalk sellers of books who spread out their titles on the ground—what Teno refers to as the cemetery of books. There in the market he comments on the foreign dominance of the book trade that brings "la mort de literature dans le pays," and with that death the end of thought: "à travers la littérature c'est la réflexion qu'on assassine. C'est la mort de notre mémoire collective—une mort programmée, organisée" (through the literature it is reflective thinking that is killed. It is the death of our collective memory—an organized, programmed death). Then he cites a Chinese proverb: those who have no past have no present, and can't have a future. As he sees among the books on the ground *bandes dessinées* (extended comic book stories—graphic novelettes), he is reminded of his youth. We follow his memories and associations to the action, scenes, animals that roared, the close-up kiss of a glamorous white couple, the white adventurer-explorer who comes across the "natives" and throws one up against a wall and commands, "Tu connais notre langue! Réponds!" (You know our language! Answer!). The chain of associations continues. We enter a classroom where the teacher commands the students, Sit!, Stand!, Sit, and so forth, a scene right out of *Sango Malo*. Then, with the children, we escape to the neighborhood movie theater and watch while the beautiful Mangala, the Indian singer, dances seductively for us. Who would not have dreamed, Teno recalls, to have her for one's wife? We are in full alienation: French, Indian, anything-but-African culture—all this in preparation for the grandfather's sad account of betrayal—*alouette*. First came the Europeans, missionaries, educators, purveyors of civilization. Then, with independence, their successors to the colonial rulers.

The ground is primed for the response to this the conquerors' version of history, to the child's miseducation—a history for the children raised in the colonial city, with the colonial school, one that he calls a history "non-assumée où la trahison, la forberie et la censure semblent être les valeurs reines" (without responsibility where betrayal, trickery and censorship seem to be the reigning values). This long setting of the stage for the *alouette* tale then comes to an end as the dialogical response is provided: "Alors que la tradition orale pourvoie des histoires magnifiques des héros dont la probité et le sens du bien collectif étaient exemplaires" (While the oral tradition provides magnificent histories with heroes whose uprightness and sense of the collective well-being were exemplary).

In the story that follows, the grandfather's account resembles most closely a tale like Birago Diop's semiallegorical tale "Maman Caiman" or even more closely Kofi Awoonor's poem "The Weaver Bird," in which the invading European colonialists are compared with the selfish weaver bird that takes over the nests of birds that have already built their own nests and laid their eggs. The weaver birds push out the native birds' eggs, lay their own, take over the country, as it were. "The weaver bird built in our house / And laid its eggs on our only tree / We did not want to send it away / We watched the building of the nest / And supervised the egg-laying" (Awoonor 2014).

Here it is the *alouettes* who suffer at the hands of a foreign group of hunters, those of another race who also abuse the hospitality of the natives, take over their prosperous lands, force them to work for the hunters who, when they leave, put in place false leaders. Teno introduces it as a story his grandfather would recount to him often as complicated, and always sad:

> This occurs in a country where abundance and prosperity reigned, in those days—the country of the swallows. One day hunters arrive from a far-off land. They are of another color. The swallows offer them all the good things they have in their village. The hunters, delighted, decide to stay in the country where they have found such abundance, things that are lacking where they come from. They say to the swallows, we are brothers. Your home is my home.[12]

What follows is the allegorical account of colonialism and its replacement with the neocolonial regimes of Ahidjo and Biya.

With the images shifting from a child climbing through the fields to those of fierce-looking Bamoun masks, Teno concludes: "Cette histoire triste mon grand-père me racontait souvent pour m'expliquer l'indépendence" (This sad history was often told to me by my grandfather to explain independence to me). This allegory completes the logic of the film. That is, in the relationship between the series of historical simulacra, the re-created scenes, the reconstituted memories, the footage to which sound effects are added, the juxtapositions of pertinent scenes that function to comment on each other like narrative lines in a plot already defined at the outset as one of betrayal, we have an elaboration of the documentary's strategy of simulation.

At the end of this sequence delineating his childhood, with his passage to adulthood and the country's passage from colonialism to independence, comes

maturity; and ironically independence is evoked with the footage of colonial soldiers beating a man. The sound of the truncheon is another echo-effect: the original soundtrack is suppressed, and the man's surprised expression, the clunky sounds, the repetition of blows and sound, all have the effect of a slightly comic, slightly horrific exposure of some hidden secret. This is reinforced after we had been treated to the conventional style of the 1940s and 1950s French documentaries, with their informative, all-knowing voice-over commentaries. The tie-in to reality is reinforced by the inclusion, following the beating of the unidentified man, of footage of Lumumba seen first being celebrated by the masses as he assumed the presidency, and then humiliated by soldiers who stuffed a cloth into his mouth as the young Mobutu looks on approvingly.

The demystification of colonialist rhetoric is not new. But Teno wished to extend the technique to the mystifications that carried over into more recent Cameroonian history. Thus the tragedy of Lumumba in the Congo is shown as having its counterpart in Cameroon, where the images of the leaders of the Union of the Peoples of Cameroon (UPC), Ruben Um Nyobé, Ernest Ouandié, and Felix Moumié, are presented as anticolonial figures of resistance, in contrast with Ahidjo, who was installed in power by the French—the foreign chasseurs (hunters).

It is ironic that the grandfather's tale, Teno's one tie to the authentic village tradition, the oral tradition, the village artisanship, the heritage uncontaminated by colonial influences and propaganda, is about a country of *alouettes*. We recognize that it is an allegory about the colonial takeover of Africa, about the false premises on which the takeover was based, and which provided the conditions that enabled Ahidjo, the French puppet, rather than the UPC, authentic Cameroon national leaders, to assume power on independence—that there was no real passage to independence, just as there was no real civilizing mission. "Alouette" carries all this weight of demystification, rebellion, resistance, and struggle.

Its ironic usage creates a response to the French—*alouette* sung back. As such, it is of a piece with Marie's ironic response to De Gaulle's pompous pronouncement to "his" Africans at Brazzaville, where he made the famous declaration that he intended to provide African colonial subjects with their rights. Demystification is performed by the ironic, smiling simulation of Marie, who raises her arms and intones like De Gaulle, "Je vous comprends" (I understand you). "Alouette" becomes more than a refrain. It becomes the locus of the camera's own attitude or expression, one that pieces together an image of the truth as a performed, silly, ironic, humorous gaze: history as a comic act—such as the one performed by Essindi Minja that concludes

the film. The filming of Essindi is real. He parodies the African dictator in his club act, and even sings a song about returning to the movies the day he can watch an African film made in Africa by an African. We can call this reality a "témoignage," as does Teno early in the film: a revealing or revelation of "réalité," in contrast with the deforming of reality by the French. But we can also call it a virtual reality, one that is set up by its very technique of pastiche-effects.

The message of *Afrique* is recognizably one that was developed in opposition to colonialism and neocolonialism from the 1950s to the 1970s—as with Sembène's influential writings and films, including *Mandabi* and *Xala*. But the technique and ruling sensibility are marked by the passage from parody (as in *Xala* and *Mandabi*) to pastiche, where the classic realist closures of form and meaning of the earlier generations have now entered into contestation with the sly mimicry, the open structure, with its winks and nods accompanying the serious or seemingly serious deliverance of the Message—the simulation of the Message. On one level that simulation-effect occurs because of the self-referentiality of irony, again that wink—as in Essindi's comic song routine, where he states he would pay for a film only when it is made by an African in Africa. This is ironically averred as he is performing in front of Teno's camera.

Fredric Jameson (1991) would view this passage from parody to pastiche as concomitant with the succession of postmodernism following modernism. But he concludes his famous piece on "Postmodernism and Consumer Society" with the concession that there might be many postmodernisms, and here we see how the conjunction of Teno's serio-simulacra message and simulacra-seria form create a postmodern postcolonialism that opens up the possibilities to which Jameson alluded. Following Gikandi (1996), we can view this African cinematic phase not as imitative or reductively political, but precisely as Teno would have it: the expression of an African sensibility that is not only in tune with its times but is actively formative of those times.

Afrique produces a new kind of cine-postmodernism. It deploys a pastiche not quite as detailed by Jameson; a nostalgia not quite so comfortably retro mode as Jameson would have it. Yet the retro mode, the pastiche of blank irony, the movement and space of the postmodern constructed environment, all depend on their constructions of an Other space, Other past, Other memories of colonialism, struggle, postcolonialism, and independence, for their own self-reflexive formulations to hold. Africa's participation in Western constructions of itself does not stop with postmodernism any more than it was excluded from constructions of

modernism. What *Afrique* forces us to come to terms with is the remystification of power in a globalized economy. And it is with that economy and its power that the second phase came into existence.

Third Paradigm

By the 1990s–2010s we enter a fully global age: Europe and colonialism now are in the distant past. African authoritarianism is increasingly heavy, with rulers treated increasingly in an irreverent fashion, as with the minister in Bekolo's *Les Saignantes* (2005). Postcolonialism becomes the dominant signifier of the diminished African state (Mbembe 2001), now seen as less important vis-à-vis larger international entities like the World Bank and the International Monetary Fund (IMF). Mambéty returns with *Le Franc* (1994) and *Hyènes* (1992) to indict the morals of a period in which the "age of the hyenas" has come. At the same time, the local supplants the state as the locus of the action, as in *Puk Nini* (1995) or in *La Vie sur terre* (1999), where the drama is played out in terms of dialectic between France's celebration of the millennium versus events in the small town of Sokolo, Mali. In Sokolo, the sense of everyday life is local, and yet the local is imbricated with news/techniques/ books/phone calls that extend to and from France. The local is now also hybrid. At the same time, movement from Europe to Africa and back is increasingly seen as a Brownian motion rather than unidirectional, as in old-fashioned notions of emigration. France is now less the neocolonial power than a presence both remote, especially in terms of wealth, and close, especially in terms of culture and language—as seen in the touching scenes in *La Vie sur terre* in which Césaire's poetry is read. Binary oppositionality yields, as in *Hyènes*, to difference; Ramatou is hybrid, pieced together with parts and people from all over.

First Example of Third Phase: Djibril Diop Mambéty's *Hyènes*

In Djibril Diop Mambéty's *Hyènes* (1992), adapted from Dürrenmatt's *The Visit* (1956), Ramatou is presented as the figure that introduces the nefarious effects of globalization to Africa. The townspeople of Colobane are desperately poor and easily corrupted by money. They have fallen on hard times from whatever meager heights they might have attained in the past, as is brought home in the repeated references to the trains that now pass them by, that whoosh past their town to

more prosperous and important cities. Even worse, they are in the process of all this: becoming nobodies, their town failing, the final blows falling—all this even more devastating than that it would be if they had definitely fallen.

Ostensibly, Colobane embodies African poverty. The film begins with the "gueux" (people in tatters) emerging out of the dust of a horizon that had been filled with the heavy marching feet of a herd of elephants. The dusty men are headed for Draman's shop, where they will settle in for a day of loafing. If they are lucky, he will offer them a drink since they don't have a sou, and maybe he will join them in a dance. There is nothing in their lives and nothing in their future, nothing to resist if someone were to offer them money. Indeed, the minute Ramatou offers the railway official money for breaking the company rules by causing the train to stop at Colobane where there is no officially scheduled stop, they all cry out, "take the money."

Ramatou and Draman had been lovers when they were younger. When Ramatou became pregnant, Draman bribed two men to testify that they had had sexual relations with her, and she was thrown out of Colobane. Now old, held together by prostheses, but immensely rich, she has returned to take revenge. She offers a vast sum to the townspeople in exchange for Draman's life.

No sooner has Ramatou made her offer to the townspeople than they are dancing and singing about eating from her handouts and marrying her. To be sure, the establishment of Colobane and Draman's wife, Khoudia Lo, immediately declare their fidelity to Draman, but in the subsequent scenes we see them succumbing, one after another, to Ramatou's offer of money.

She is as "rich as Croesus" for Dürrenmatt's Swiss town of Guellen, but as "rich as the World Bank" for Colobane. Unlike Claire Zachanassian, whose departure and return are not fundamental expressions of Switzerland's dependency on a wealthy outside world, Ramatou's flight and return form part of the familiar pattern for a postcolonial Africa—"postcolonial" in that loose sense of an Africa marked by the colonial experience. We can see the pattern of been-tos extending from the time of Senghor and Birago Diop's generation, who sought education and therefore status abroad, to the postwar exodus of the elite, along with the impoverished emigrants who came to be associated with the lowest class of laborers—street-sweepers and housekeepers of a wealthy Europe.[13]

Ramatou is surrounded by her exotic servants, her Japanese guard, her ex-magistrate chamberlain. She had become a prostitute, and by virtue of her selling out to Western materialism, including its capitalism and its judicial and insurance systems,

now has become as rich as the World Bank—practically *is* the World Bank as she now owns everything of value in Colobane (read Africa), and has come home to buy the last thing left in Colobane, its justice system, and with it the remainders of its sense of honor. She wants revenge, but from the point of view of Colobane brings wealth. They want her wealth, or actually her charity, and are indifferent to her desire for revenge.

This initial reading of the film gives us the spectacle of how the global debacle is read as allegory, and we risk thus *reducing* Mambéty's work to the straightforward translation of the politics of Third Worldism. This would be to strip Mambéty of his most compelling quality, that of the moralist, that is, one for whom the fundamental issues are seen as involving ethics rather than narrow readings of politics or ideology. Such might be seen as appropriate to the first paradigm of African cinema, but as inadequate to this third phase.

Ramatou had left Colobane as an impoverished, disgraced, pregnant, rejected, and unmarried seventeen-year-old girl. She returned an old woman, ready to take charge. She appears completely exotic. When she makes the astounding offer of 100 billion francs to have justice for what had been done to her, the townspeople say they cannot sell justice, cannot betray their Draman. She smiles and responds, "I'll wait." She understands the townspeople. She buys the people off as Draman had bought off his two witnesses in the past and as he continued to buy the good favor of all his customers in the present, with candy for one woman's baby, with friendly chatter, with the drinks he offers Lat and the *gueux*—with all that made him the most popular man in Colobane. Ramatou ups the stakes dramatically, wildly outbidding him, winning easily as if there were no contest, buying justice along with all the surrounding lands and factories, purchasing with them the means of foreclosing the town's hopes and Draman's life. She buys death.

The announcements of her arrival, the crates of goods she provides, the transformation of every single inhabitant of the town into a "hyena," all are marked by the two words used to describe her wealth: the "World Bank." And the symbolism suggested by her entourage, including a Japanese female personal guard, three Fulani-looking "Amazons," and her magistrate-chamberlain, all embody that status, concretize it in the form of the "grande's" personal servants. They indicate there is nothing and no one she can't buy, even if she has to wait. As the doctor and teacher visit her, begging her assistance to let the town rebuild itself on its own by facilitating their acquisition of the lands and factories across the river, she responds that she already owns them (along with the towns, the roads, the houses) and has shut the

factories. Don't come to the lion's banquet, she tells them, unless you have a ticket. She sets the stage, she owns the banquet, so that even her hairstyle sets the trend for the wigs that will ultimately be worn by the townspeople as they congregate in the final scene to judge and condemn Draman.

The only continuity between the beautiful seventeen-year-old "wildcat" of Draman's memory and this elderly prosthetically reconstructed figure lies in the voyage of the been-to. This is not the "voyage of the hyena," the title of Mambéty's first feature length film, *Touki Bouki* (1973), because she is not the cowardly, herdlike figure of the hyena-trickster. She evokes the lion, the killer, the ruler—Linguère, the Queen of Darkness—not the scavenger eater of leftovers.[14] But when she pauses to look one last time out across the ocean, as she is about to descend into the darkness, the setting dramatizes a more poignant ambiance, one associated with a past marked by suffering and victimization, not domination and rule. In fact, the steps she descends form part of a bunker.[15] She looks across the sea, and her gaze falls on an island shimmering in the water. Her bunker appears to be on Gorée, the setting of a number of scenes shot in the film. But more important, Gorée is the location of the most infamous of slave forts, the last step for thousands of slaves shipped across the ocean. These shots of Ramatou are cross-cut with those of the townspeople marching solemnly along the edge of the escarpment: they are walking single-file, in silhouette, hands behind their backs—evoking nothing so much as a line of slaves, a cordel, bound and marching to their fate.

Ramatou's triumph is thus marked by death, entirely defined by images of enslavement and death—both her own and Draman's, and that of the people in the past and the present. The void that she embraces is total, totalizing, demanding what Badiou (2001) calls fidelity to a simulacrum, one that successfully defines the totality of death in terms of the infinite wealth associated with the capitalist, globalized corporate World Bank.

The void that sets off life in *Hyènes* are the dark images of death. Drought in Senegal, so devastating in the 1970s, is evoked by the teacher and mayor. The images of scavengers abide along with the notion that the people of Colobane are who they are because they are not "bouki"—hyenas, scavengers. "We are poor," says the mayor in his initial rebuttal to Ramatou's offer of money for Draman's life, "We're in Africa, but the drought will never turn us into savages." Scavengers live off the kill of other animals, and *Hyènes* is filled with shots of hyenas, vultures, as well as hawks and owls, the predator birds.

When Draman's death is carried out, we can't see it, and when the crowd disperses after having pushed in on him as though to crush him, there is no corpse, only his coat. It is as if they had been transformed into scavengers, hyenas, who picked his body clean, like vultures who performed the task of making the corpse disappear. But they leave a void at the center. He is the object of death than cannot be rendered in the Symbolic order, the lack in the real.

The two responses to the void are what mark the difference between Draman and Ramatou. Ramatou's response to death, to the void, is totalizing—totalitarian. Her role as World Bank is of a piece with the vision of the globalized capitalist system that has forced Africa to its knees and reduced its people to scavengers. But she was, and in the recovery of the past, still is a woman who had been abused systematically, and not just by Draman. She was also the victim of a patriarchy she returns to overthrow. Reading with resistance, we can view her and her entourage as that which the patriarchy fears in the woman whose sexuality is constructed as dangerous, deadly, to men. Further, if she makes available to Colobane the option of selling out, it is selling out when there is nothing left to sell: they have nothing. In the opening shots the monkey draped across the wheels' axle in Draman's shop sets the tone for a place that has become empty, and the crosscutting of the seizure of the town hall reemphasizes this. Thus she is not presenting much of a dilemma for most of the people. The poor sing, "I would marry her," in the scene *immediately* following her proposition to the town. And if the mayor and Draman's wife, Khoudia Lo, protest their allegiance to Draman, it is that same Khoudia Lo who states at the fair that she will buy *all* the appliances, an act whose gesture is commended by the announcer-griot as a sign of her stature. It also signifies the dimensions of the betrayal of all those closest to Draman. Having nothing to sell, no real integrity, no objects of value, no "ineffable African soul or spirit," they sell the town grocer, the one who describes his life to Ramatou as empty, meaningless, and totally unsuccessful. If the intercut shots of the bull being sacrificed occur as Ramatou presents her proposition to the town to kill Draman, he is now miles and years from the figure of the black panther she remembers him as having been. He is only Draman; he cuts a silly figure when nominated by the mayor as his successor, when he "herds" the cattle again for Ramatou, when he hides from Khoudia Lo the bottle of wine behind his back so he can serve his friends, and so forth. He is what Djibril calls, in the trilogy he set out to make after *Hyènes*, one of the "petites gens." He has nothing to bargain with in a deal worth billions.

So her gifts really can be taken as such, and the move to dismiss the "time of the hyenas" resonates, as do the international donations in *Guelwaar*, in an Africa that has known real hardship and deprivation, real drought, starvation, and misery (highlighted by the TV images of lines of emaciated people lining up for food in what seems to be Ethiopia). The World Bank's "good offices" bring real subordination, and finally real enslavement, both historically and actually. That history of the West and Africa is what gives the tension to Mambéty's adaptation; it is what makes credible Ramatou's engagement with death as much more than idealistic or purely spiritual, or even allegorical. It is also real, in the material sense of real. Djibril puts the void, the hole, the death into this real because he refuses the Sembène solution of in materialist terms.

When Ramatou tells the doctor and the teacher who to come to the lion's feast they must first have a ticket, she provides the material basis for the void—emptiness—that had been there all along. Even more, as the film begins with the emptying out of the town hall, we can say her goods provide the acts of filling that make visible the acts of emptying that had been at the core of all the institutions of Colobane (teaching, governing, religious practice, economy, and especially personal relations). The failures of the past, its "emptying" out, are still taking place in the present. Ramatou makes it visible when she fills the lives of the people with "useless" commodities whose lack they never felt before. Having not had air conditioners, they never missed them and had fans they could wave. Now the "ladies" at the fair are told they won't need their fans any more: the air conditioners are the lack that they bring into existence the moment they come into the scene. Their name, of course, is "modern life," and it is that which Ramatou introduces with her wealth, gifts, and power.

Happiness provides the *simulacrum of truth* in *Hyènes*, but not in the sense that a John Stuart Mills would dismiss as the happiness of a self-satisfied pig as opposed to the higher aspirations of intellectual and spiritual beings. Rather, it is because the happiness is presented as completely filling the emptiness created by Colobane's poverty and vacuity, its silliness. If the material happiness suffices to fill the void, it can do so only by totally denying the void. When the crates are presented at the fair, and the women sign up for their share (and especially with Khoudia Lo taking "all"), their presence fills the screen, as do the heavy bodies of the herd of elephants at the beginning and the end of the film. The situation in which Colobane finds itself is fully resolved by Ramatou's billions—the void disappears under the weight of the material goods she imports. As the townspeople gradually dismiss

Draman's pleas, the community of hyenas is formed, recapitulating the racial politics of slavery and colonialism. At the same time that Ramatou's billions drive away Colobane's miserable existence, they leave in place a structural relationship that addresses the general problem of poverty or "underdevelopment," presented in African terms at numerous reprises, for example, when Draman sees the TV images, when the mayor says we are Africans, but we are not savages. Here is where simulacrum, terror, and evil coincide, since the address of developmental progress that forms the simulacrum of truth in the film is *actually addressed only to the hyenas,* that is, those whose fate is always to be that of the eater of leftovers. Ramatou sets the model, she wears the hairstyle, and they *imitate* her in the final scene in their roles as judges; but they are only imitations of power, imitations of wealth. She has already stated, don't come to the lion's feast unless you have a ticket, and hyenas must wait until the lions finish eating. The extraordinary entourage with which she surrounds herself—the Asian woman, the three Amazons, and the chief justice—are the *only* ones besides Ramatou invited to the feast, the only ones *actually* addressed by a prescription of material wealth. The nature of the terror on which the prescription rests derives from the structural imbalance guaranteed by the processes of globalization that become instantiated in the very community constituted by the killers of Draman. The tragedy is deeply pathetic as we see the isolated figure of the hunter throw away his hunting rifle and walk away in disgust and despair at the sight of Draman's lonely coat on the ground at the end, at the "Hyena's Hole."

The final work of Ramatou's intervention in Colobane is to effect the changes of modernity that bring to an end the lives of such figures as Draman Drameh and the hunter. The "work" we are encouraged to perform by the song heard as the final credits roll is not to resist modernity, but to resist being enslaved in a process in which the only role made available to the community, to Colobane's people, is submission and conformity.

> Get up and work;
> Get to work and stop talking;
> Get up and work in the fields
> Get up and work the soil.

These words signify what resonates most as the inspiration of Mambéty's work, a fidelity to that which we have seen in his earlier films as well, and that is a certain

insubordination. The surrealist moments of his earlier work effect that same break with the real as we see in the excessive, carnivalesque moments and the animal imagery in *Hyènes*. But Mambéty lifts us and carries us along with him, pushing us to ask for more, to insist on more, both in response to the challenges of globalization but also to those of a cinema that would evoke a vision of a New Africa that is more than what the bulldozers will create in the final scenes of *Hyènes*.

The global-local Paradigm has replaced the former Old-New paradigm, and it is marked by hybridity at both poles (Homi Bhabha, Jameson). This is not an absolute change, but one in which the parameters have morphed into new dimensions: what had been a dominant neocolonial state is gone, but a more distant and overpowering force is associated with the globalized institutions presented as the World Bank and the IMF, now with the donor nations and international NGOs. Similarly, the Old Africa has become more distant and nostalgically evoked. As it has become distant from the sense of everyday life, it has morphed into the quartier, the neighborhood, the local scene. Films that signal this confinement of the action to the quartier include Bekolo's *Quartier Mozart* (1992), Teno's *Lieux sacrés* (2009) (the quartier of St. Leon), and Sissako's *Bamako* (2006) (Hamdallaye), where the neighborhood encircles the primary site for the action, which is the compound where the trial occurs and where the principals and their drama are played out. Notably, Mark Dornford-May's 2005 remake of *Carmen* is titled *U-Carmen e-Khayelitsha*, Carmen of the neighborhood called Khayelitsha.

Simultaneously, the paternal/patriarchal power of the first paradigm is now weakened, limited, shown to be corrupted and ineffectual, or simply not there at all. In its place we see women, now rising to center stage and ruling the men (*Puk Nini* 1995), dismissing the men (*Faat Kine* 2000; *Moolaade* 2004), dominating the scene no longer simply as heroines or heroically, but also viciously, as phallic mothers (*La nuit de la verite* 2004 [see the scene in which Edna is seen celebrating as she braises the colonel on a spit). Simultaneously, children now rise in power. Instead of being pure victims, they are now child soldiers (*Ezra* 2007) or dangerous criminals (*Tsotsi* 2005). The motif of this change is summarized with the following dominant tropes: diminished state, diminished patriarchy, rise of women, rise of children. Powerful women now appear in two different versions of Carmen: *Karmen Gei* (2001) and *U-Carmen e-Khayelitsha* (2005), with the former also evoking the Senegalese female water spirit, Kumba Kastel. Karmen's power appears particularly in her dance performances. In the South African version, Carmen is solid, powerful, undaunted, unconquerable. In the former, she is head of a smugglers' gang. Edna

in *Nuit de la verité* rises to the stature of a Medea next to whom all the other men are reduced to ciphers.

There are films that straddle these paradigms: *Bamako* is partly a throwback in its direct indictments and the speeches at the trial; but the narrative of Mele and Chaka that runs parallel to the trial is again marked by the male's decline and ultimate death—mirroring the indictment of the most powerful of men in the global imaginary, the World Bank's president Paul Wolfowitz.

Bekolo announced a New African Cinema with his insouciant *Quartier Mozart* (1992). However, it was with his subsequent film, *Aristotle's Plot* (1996), that the full move into the third paradigm, where the postcolonial met the postmodern, took place.

Third Phase, Second Paradigmatic Example: Bekolo's *Aristotle's Plot* (1996)

The ideological apparatus of African cinema in an age of globalization can be tracked back to the shot of the heavy boot of the policeman coming down on Borom Sarret's medal and on the coin El Hadji tossed to the beggars in *Xala*; the plowing and the long diagonal shot of the peasant farmer who labors to ascend the hill so as to greet his master in *Harvest: 3000 Years* (1976)—these and the thousand and one dense signs of obvious messages eventually came to mark the screen with didacticism. Similarly, the heavily structured class conscious characterization performed a similar function. The model is seen in films like Traore's *Njangaan* (1974) or Sembène's *Tauw* (1970), where the plot invariably was built around the oppressive patriarch, the oppressed mother, and either the rebellious son or the son as victim. When the child is young enough, as in *Nyamaton* (Sissoko 1987), we see him or her turn to begging, garbage picking, or thievery. The pattern might have been established in a tradition of such films that date back to Bunuel's *Los Olvidados* (1950) or Truffaut's *Les 400 coups* (1959) and that has been developed more recently in a series of African films that depict street children with increasing harshness—again the international model suggests the Brazilian film *Pixote* (1981); *Salaam Bombay* (1988), with some African equivalents seen in *Dole* (Imunga Ivanga, 2001); *Nyamaton*; and *Everyone's Child* (Tsitsi Dangarembga, 1996). When these films are read just for their representations of the children, and not in terms of the principal plot line, one could add many more films to this list, including such films as *Mapantsula* (1987), *In a Time of Violence* (1994), *La Petite vendeuse de Soleil* (1999), *Pièces d'identité* (1998), and others in which street children figure. With

globalization, child soldiers, street children, and the truncation of childhood itself have become thematized.

The above films not only contain images of children having "turned bad" but also having been forced into desperate circumstances, a notable example being *Everyone's Child*. The "Bad Seed" has morphed here into the audience for global cinema, represented in *Aristotle's Plot* as the *tsotsis*—the gangster youth of today who have come to occupy what is left of the dilapidated cinema halls of yesterday. We enter the theater "Cinema Africa" and are soon greeted by the audience, the "tsotsis" whose names are reflections or imitations of gangster actors or even their characters: Nikita, Van Damme, Sadam [sic], Schwarzenegger, Cobra, Bruce Lee, and the leader of the pack who calls himself "Cinema." Their taste runs only to gangster action movies that provide them with their role-playing subject positions, their monikers, their language and style, or at least the dress of that style. They organize their own subject-positions around the absent projected images whose fragments of words we hear and whose light flickers off their faces.

Essomba Tourneur, their nemesis, is just the opposite. He is presented as the serious African filmmaker or *cinéaste*—the Sembène Ousmane, Haile Gerima, Med Hondo, for whom a cinema *engagé* implies a political commitment, whose vision of an "authentic" Africa supplies the basis for the cinematic image. Instead of entertainment, or pure aesthetic image, faithfulness to the image of reality— mimesis—provides the rationale for their approach to African cinema. We access these films through the reactions they generate with the audience. For instance, at one point the tsotsis are showing "authentic" African films in a village. We hear their ironic comments about chickens and other animals providing the action, with the sounds of the barnyard supplying the acoustic accompaniment. Earlier, as they were watching a violent film in the city, we saw their fascination with the gangsters and heard their commentary on the action.

The film's protagonist, ET, cannot escape the framing of cinematic reality any more than the others. As we are introduced to him early in the film, we learn he is a recent returnee whose intention is to bring serious, committed film to Africa. He encounters the reality of kung fu, martial arts, and popular Hollywood action films being shown in the movie theater (itself named Cinema Africa), and resolves to substitute serious African films for the "junk." He is the presumed genuine African filmmaker, the social realist of our first paradigm whose progenitors constituted that first generation of authors and filmmakers whose vision of Africa signaled their commitment to social change—Sembène Ousmane, Souleyman Cissé, Idrissa

Ouédraogo, Gaston Kaboré. In Cameroonian terms, the first generation included Dikongue-Pipa and Daniel Kamwa, and the subsequent generation, influenced by the "fathers," includes Jean-Marie Teno and Bassek Ba Kobhio.

ET is already, by his name, both Africa (Essomba) and non-Africa (Tourneur, French for one who "tourne" [shoots films]); someone who is real (visually a person, "there" with the others) and an outsider (a been-to; and not only the parody of the been-to but the image of that been-to). In other words, not only real (after all, the government is wary of him, is keeping its eye on him), but extraterrestrial, an "ET," an imitation of an imitation of an imitation of reality. If this is "Aristotle's" plot, the plot that holds the highest form of literary creation to be an imitation of reality, it is severely deficient in Platonic terms, for each one of those "imitations" signals another degree of removal from the only reality worth pursuing, the true, eternal forms of the ideal realm, the realm of ideas.

But even that doesn't suffice to frame ET. He has to take his place with respect to the cinematic real, and that is not simply as the serious filmmaker, the "cinéaste," but the cinéaste as seen through the eyes of those for whom film is everything, the tsotsis. And for them, thanks to their power of creating movie monikers—stage names in lieu of real names—he is simply "silly ass." This not only mocks his pretensions in calling himself a cinéaste, but ensconces him in their film world where the rapper, and his rhymes, takes precedence over the political or cultural idealist. He is defined in relation to them, and they in relation to him.

ET and Cinema (the head of the band of tsotsis) are joined by the policeman (in fact, handcuffed to him), both at the beginning and toward the end of the film. The policeman is thoroughly unreal. His helmet looks like a masquerade; his authority is portrayed as silly, as a mockery in keeping with slapstick comedy. He fits in with the vision of authority presented so well by Mbembe (2001) as belonging to the realm of the Popaul type autocrat. The figures of an obsessive patriarchy, the butts of the attack in many novels, plays, and films (like Teno's *Chef*), are now rendered in the ridiculous impotent form of Bekolo's "chef." The form this figure took in Bekolo's earlier film *Quartier Mozart* was "Chien Méchant," another authoritarian figure with a silly nickname and a style so funny that his ultimate demotion, like that threatening the policeman in *Aristotle's Plot*, seems inevitably joined to his bluff and swagger. With the reduction of authority figures to comic status comes a shift away from the earliest forms of serious political commitment whose own authority rested entirely within the sense of an Old Africa dominated by the figure of the patriarch. Whereas Teno substitutes his own subject position through the

narrator's voice as the source of truth in place of the failed, mocked patriarchy in Biya's Cameroon, there is no such conception of truth, or its mouthpiece, in *Quartier Mozart* or *Aristotle's Plot*, where the fall of the patriarchy is accompanied by its regime of authority, knowledge, and truth.

Standing over against Bekolo's failed fathers are the mocking, unserious, unauthoritarian figures of the sons. In *Quartier Mozart*, the mothers provided something of a maternal superego: we see this with the witch, Mama Thécla; Samedi's two mothers; and the generation of their daughters, all of whom provide a focus of resistance to the phallocentric symbolic order with their own mockery of the Name of the Father as well as their own access to powers, at times mysterious, at times sexual. On the other hand, in *Aristotle's Plot* that maternal superego is largely absent. In its place is yet one other incarnation of the cinematic project, the figure of the actual filmmaker himself, Jean-Pierre Bekolo, who plays a cameo role, like Hitchcock, though here more thoroughly integrated into the plot. Bekolo appears as the barman whom the cop approaches to ask his key question, why do actors who die in one film reappear alive in another? If the cop can't distinguish between real and make-believe, this is not an issue of stupidity (though the Bekolo-barman does call him stupid), but because his absence of knowledge implies the absence of the basis for the symbolic order (his ridiculousness functioning here like a form of paranoia—"Are you saying I'm stupid?" he asks). The chief, like the cop, is represented in equally slapstick fashion as he sits on high, like a lifeguard, dispensing irrational orders in authoritarian style—Mbembe's autocrat in cartoon form again, the marker for a postcolonialism forged in an age of globalization.

By the end of the film, the news from Hollywood spreads that no one is dying anymore. Initially the cop was mocked because he couldn't distinguish reality from make-believe; by the conclusion of the film, the end of the real world comes with its replacement by the imaginary order. The cop is seen now as not alone or handcuffing suspects, but drinking with others in a bar. And when he emerges and tries to apprehend a suspect, his bullets can't stop the driver, just as ET can't be killed when run over by a car. Thus, like the "real" ET, his authority and powers that are joined to a world of cops and criminals now become inoperative in a world of cinematic magic, a world that actually comes closer to evoking the pathetic posture of the Mbembean-type autocrat than say Tauw's father in Sembène's *Tauw* (or El Hadj, when he slaps down his daughter Rama in *Xala*, or the father figure who marries off his daughter in *Muna Moto*).

But *Tauw* and *Xala* came out in the 1970s, and in Sembène's more recent works we have a wife telling off her dead husband's suit in place of the real man (*Guelwaar* 1992), and in a mistress dismissing her ex-husband ("Dehors") and lover ("entre toi et moi c'est fini"), only to choose another man of her fancy (*Faat Kine* 2000). Decidedly the oppressive figure embodying the Name of the Father of say Bassek Ba Kobhio, or of Wade's *Ndeysaan* (Le Prix de pardon 2002), is all too passé.

The barman character, played by Bekolo, becomes the ironic source of knowledge. When asked by the cop why dead characters are seen alive in subsequent films, he hedges his answer, giving the impression that he knows ("There is a special kind of knowledge"), and yet won't state why. He says only a very few people die in his movies (we have to reflect here: this character Bekolo is now indistinguishable from the real filmmaker-*cinéaste* Bekolo in whose *Quartier Mozart* there are a few deaths). These include the man who falls over dead in the taxi at the beginning, and the trope of death with respect to the transformation of Chef de Quartier into Mon Type about whom the narrative voice says, "Un garçon est mort le jour il est né" (a boy died the day he was born). In *Aristotle's Plot*, ET wipes out all the tsotsis, but as that ending is judged inappropriate ("As my grandfather used to say, death never kills anybody. Frightened, I decided to abandon Aristotle's methods. I had to bring the dead back to life. I had to change the rules"), the scene had to be "reshot." This time not only does no one die after the cop leads ET and Cinema away in handcuffs, by the end *no one can die* anymore. So in a sense Bekolo is wrong in his serious response to the cop on both counts: finally, no one dies in *Aristotle's Plot*, and the "special knowledge" to which he alludes as explanation for the resurrection of dead characters becomes irrelevant. Death and truth are conveyed through farce, something anticipated in the bizarre, hilarious scenes in *Touki Bouki* (1973), where the taxi driver opens the stolen trunk to find a skull, or in *Guelwaar* (1992), where Mame addresses the missing Guelwaar by speaking to his suit laid out on his bed in anticipation of the dressing of his corpse.

What accounts for the regimes of truth in this third phase is to be sought in what "counts" *outside* the frame of the cinematic representation, in the space where finances rather than philosophy—global cultural flows more than verisimilitude—dictate who is to live again and who is to die. On one level that extradiegetic space defines a postrealism associated with avant-gardist "world cinemas" more than "African cinema." But more to our point, it gestures toward the third paradigm of contemporary African filmmaking—a paradigm whose break is signaled in *Aristotle's Plot* when the ironic narrative voice comments on ET's showing of "real

African cinema" by asking, when will African filmmakers no longer be "emergent," when will we be free to make movies about something other than the revolution, when we will be free from the dictates of committed cinema?

We see this point rendered over and over—this need for some new approach—as in the scene where Cinema and two other tsotsis take a break from the "African" film they are showing in the rural countryside. Cinema turns from mocking the unsophisticated nature of the film and its audience to speculate on its opposite, a realism in which there would be scenes of him pissing. This dialogue occurs as he turns to urinate, and points with his finger as if in place of his penis. "African Cinema" now takes the form provided by the gangsters creating a commercial enterprise, the "New Africa," based on their stolen reels of African film, ostensibly the very reels ET had shot. Their shift from being spectators in an audience to entre-preneurial exhibiters leads the gangsters to assume the roles of producers, directors, and actors. They create their own mock scenes of chases/races, with donkeys and oxen supplying the carts' horsepower; Cinema (the character) re-creates the scene of a car racing with squealing tires and dust trails—a mock, virtual scene.

Bekolo focuses on the role of cinema in self-reflexive positions that function to empty out the distinctions between diegetic/extradiegetic, or insider/outsider, Africa/Aristotle. The hare and the tortoise meet in the final scene with the cop: ET and Cinema are joined by his handcuffs, so that the distinctions are not only blurred between reality and cinema, but in such a way as to place us inside the scene, that is, in the place of the absent cameraman. In this regard, we are obliged to follow the same trajectory from spectator to characters and technicians as that of the tsotsis.

ET had told them he is a *cinéaste*, that he makes serious African films, not "shit" like the films they admire and in which they locate their ideal subject positions. But even if commercial Hollywood or martial arts films are set in contrast to those of African filmmakers like Med Hondo, Sembène Ousmane, Souleymane Cisse, and so forth, still it is their names that appear on the cards the gang leader Cinema shows to the cop at the beginning when asked for his identity papers; and further, the African *cinéaste* ET blurs the distinction between European and African since he had acquired his training in Europe, where he learned to become an "African" filmmaker. If it is paradoxical that Cinema holds the deck of cards with African *cinéastes'* names and faces, ET's name is also divided between those that are African (Essomba), French (Tourneur), and Hollywoodean (ET). If he is an outlaw who forges an expulsion order from the Ministry of Culture to get the tsotsis out of Cinema Africa, he is also considered dangerous by the government that has him

followed. The blurring and crossing of stereotyped character lines carries over throughout the film: the tsotsis become entrepreneurs by exhibiting "African" films in the bush, whereas ET becomes a vengeful, Rambo-type lone killer who takes on the gang one at a time and defeats them in a series of Hollywood-style duels.

It is essential to read this film as a rescripting of postmodernism in African guise, and *not* simply as an example of some *universal* postmodernist filmmaking in which the point of the crossovers and confusion is to highlight self-reflexivity and the ambivalent qualities of the floating signifier. Rather, it is important to distinguish this film from the quintessentially postmodern label by calling attention to the crucial site of enunciation occupied by the narrator as he indicates that space in which African film itself comes to occupy the place of the desired, if unseen, object. It is important to note that both the site of enunciation for the narrator and the unseen film in the cans occupy and give definition to the space we define as "Africa." What is at stake here is not some essential Africanness, but rather a challenge to the universalism implied by any definition of *the* postmodern as lying outside of its social, historical, and cultural context.

Bekolo is engaging in a rewriting of postmodernism, from a self-consciously assumed African point of view. The tsotsis provide the vehicles for the postmodern, postideological, decentered subjects of Africa's marginalized youth, ones who are obviously neither "authentic" nor assimilated to any symbolic order. They occupy places that they themselves define only in terms of the Hollywood imaginary, and that are summed up in the name of their leader, Cinema, a name that corresponds both to the theater where they see their films and the films we see them viewing (without being able to see the films ourselves). Still, they escape the quintessential blurring of boundaries between fantasy and the real. The cop tries to resist the confusion between name and object evoked by Cinema's name with his example of Thomas Sankara. (When ET explains that the cinema theater is called Cinema, and that the gangster is also called Cinema, the cop says, "Which comes first, the boulevard named Thomas Sankara, or Thomas Sankara?") But if the cop can't distinguish between signifier, signified, and referent, ET, the "real" African *cinéaste*, cannot distinguish between the idea and reality, or, in this case, between the name and the object, and can only identify Cinema by his name (and not as any actual physical being). The characters appear in the spotlights for us to gaze at them, and in that *crossed* moment, when we know they are somehow playing at characters, we construct them as postmodern characters—but only by situating, uneasily, our gaze on them as emblematic of modern African youth, as the "lost generation."

Were this film molded in the manner of Sembène's *Ceddo* (1976), Faye's *Peasant Letter* (1976), Kaboré's *Wend Kuuni* (1982), or Achebe's *Things Fall Apart* (1958) for that matter, classic protest or historical testimonial films or novels, the positions assumed by the spectators would not be troubled by the texts' address, not be troubled by the parodic positioning of a narrative voice. This would be the conventional case of the classic realist text in which the purity of the gaze can remain untroubled only by ignoring the margins or frame of the text for which this pure gaze, this unified subject position, cannot account. Here, instead, we have the quintessential postmodern concerns, including that of the position of the subject, and especially the subject as marked by *différance*, as marked by the inscriptions of a system already present in its attempts to constitute the pure gaze.

Bekolo's spectators are not the same as those of Sembène or Kaboré, not simply because they lack a self-presence of a universal unified subject, but because they occupy a split site of viewing, a site that is not clearly or comfortably identified through the certitudes of the film, but that is constituted "asymmetrically"—that is, in a location that is unseated, jostled off-center, *by the gaze of the film back onto us.* This is how Žižek describes this effect: "I can never see the picture at the point from which it is gazing at me, i.e. the eye and the gaze are constitutively asymmetrical" (1991, 125). By "gaze" here, Žižek is not referring to that of the spectator, nor of the gendered viewer, but of the objects or points in the film from which the spectator is viewed or addressed. This point is clearly present when the narrator in *Aristotle's Plot* addresses us; a narrator who is not seen, and whose place and whose points of reference ("my grandfather") only serve to dislocate the narrator, especially dislocating him as *the African filmmaker.* We become objects for this voice, and by extension for those figures in the film whose performance can be seen, at the least indirectly, as being addressed to us; and in the process our relationship to the film's narrative becomes split.

For the postmodern critic, nostalgia films domesticate or "gentrify" this process—commodifying the "gaze *qua* object" (Žižek 1991; Jameson 1991) through the illusory sense of command constituted as self-referentiality. This is where Bekolo's narrative voice complicates the attempt to construct his films as Jamesonian or Lyotardian postmodern. The referencing of Africa's role in the creation of film is really an act of reconstituting an African postmodernism, or postmodernism itself, and this is possible through the relationship of the narrator's voice-over and the spectators.

Much postcolonial theory is often ill at ease with these postmodernist formulae because they would seem to vitiate the central concerns of those cultures

formed around long-standing revolutionary struggles. But as far back as the 1950s–1960s, with the protomagical realist novels of Alejo Carpentier followed by those of Gabriel Garcia Marquez and Maghrebian authors like Kateb Yacine and Mohammed Dib, it was seen as not only possible but necessary to disrupt the language of the colonizer along with that of the classic realist text as a prerequisite to any effective revolutionary stance. Soon Amadou Kourouma and Gabriel Okara were refashioning French and English in search of an African voice, and later Syl Cheney-Coker, Sony Labou Tansi, and Ben Okri turned to magical realism. The Third Cinema of the late 1960s–1970s in Latin America, frequently shaped by the ideals of an "Imperfect Cinema" that disrupted the conventions and sheen of commercial Hollywood film, carried forward the notions of a nonrealist or nonmimetic cinema of revolt. In a sense, Bekolo takes us beyond this tradition, with the contrapuntal relationship between the narrator and the diegetic world of the characters in which he breaks the flow of the action with the voice-over commentary. This heightening of the narrative commentary directs our attention to the complicated relationship between Aristotle and his grandfather, and more specifically between Hollywood and African film.

The narrator's voice-over states at one point, concerning the tsotsis: "They thought they were going back to Hollywood. In fact they were going back to their roots." And adds, "You can't be black one day and white the next. Nor was cinema born twice." If cinema wasn't "born twice," and if this sequence represents the African tsotsis' return to their roots, it is significant that Bekolo's choice of style and montage technique constitutes his "African" response to the charge he assumed with this project of celebrating 100 years of cinema.[16]

After all, says the narrator when enumerating the qualities of the African narrative (or initiation rite), in response to the claim that Aristotle provided the origins for drama, "what don't we got?": "My grandfather's words started to fill my mind: What is an initiation ceremony? Crisis, confrontation, climax, and resolution. Sound. Story. Images, narration. Rhythm. Is there anything in this, in cinema, that is not African?" He continues:

> Fantasy, myth, we got. Walt Disney, we got. Sex, action, violence, we got. Comedian, music, we got. Aristotle, catharsis, and cola nut, we got. What don't we got? Why don't we got an African Hollywood? Probably because we don't want to produce our cinema outside of life. Because when it is out of life, it is dead. Like a difficult childbirth. Which do we choose? The mother or the child? Life or cinema? Because

when cinema becomes your life, you're dead. It is dead. We are all dead. (Eke et al. 2000, 23 [my corrections])

Conclusion

Sembène's *Moolaade* (2004) is his last film. The state and its corruption have disappeared, and in fact the setting isn't even in Senegal. The action is entirely built around the local, where the men try to remove the source of hybridity—radios—and the global, with the new young man returning from France. The paradigm shift in *Faat Kine* (2000) had been remarkable, with Sembène now featuring a pro-neoliberal Kine, who supplants all the dominant men of her youth, including her two former partners, her current lover, and her father. For her family she is father and mother. Along with dominant tropes and themes, gender roles, and political visions, the concept of the African subject is no longer the same as it was when the "fathers of African cinema" set out to create a distinctive, authentic African cinema.

With contemporary, global African film there is an increasing tendency to evoke the dark side of the individual, as with Edna in the ironically titled *Nuit de la verité* (Nacro 2004). But more especially we have films turning on genocide, child soldiers, anomie, phantasms of morbidity, imaginary locations situated in another realm where death and hideous magical forces menace the increasingly disempowered individual. We see this especially with Nollywood, which returns this most recent paradigm to the melodramatic versions of truth in which engagement has no place, but rather where we find emotional violence, coincidences, and spectacle. The neo-baroque versions of New Nollywood and its Francophone equivalents dismantle the monadic subject and simultaneously evoke a universe of forces that are unknowable and all-powerful—in other words, a vision of paranoia's truth, appropriate for what Jameson would call the culture of late capitalism, the culture of globalization seen from below where, finally, it is in the debris of neoliberal capitalism that the newest paradigm for a recent Francophone African cinema can be forged.

In Rachid Bouchareb's *Little Senegal* (2001), nostalgia and despair compete in the drama where Alloune portrays the African who has come to New York in quest of his dispersed family members, where he confronts the alienation of African Americans in the diaspora, and where he must return to Senegal, at the end, bearing the corpse of his nephew. In Alain Gomis's *Tey* (2012), the return home to Senegal proceeds like Abbas Kiarostami's *Taste of Cherries*, where the protagonist

faces his imminent demise with a certain equanimity, but where the false notions of an Africa to which a return can be imagined are dissipated by the confrontation with a demystified sense of the real. The global home can be configured only in the diminished local home in the age of hyenas: the final image of *Hyènes* is that of the bulldozed space between Colobane—between the Old Africa, and Dakar, the New, where a commodity capitalism has transformed the world into the spaces designed by the World Bank.

Sissako ends his magnum opus on this topic, *Bamako* (2006), with the death of Chaka (whose funeral is filmed by Falaï in dead silence, which distances us from its "virtual reality") evoking the postmodern blankness of bare life. Haroun ends *Un Homme qui crie* (2010) with the even bleaker scene of the death of Adam's son and the evacuation of N'djamena under the impress of war and violence. In both scenes we can mark the distance African cinema has traveled since those early years when the sight of the monument of independence signaled the hopes for the new African nation.

But the tropes of melodrama refuse the eternal gloom a postcolonial Afropessimism might impose. Instead, Fanta Nacro insists on a new day at the end of her version of contemporary African conflict, *La Nuit de le vérité* (2004). Despite the miseries of the war, the horrors of the roasting of Colonel Theo, and Fatou's rape, despite the demonic features and mutilation of the children, Nacro ends on a note of hope when Fatou teaches the children about their country and their lives that lie before them. The "old" now is reborn in fantasmic terms, once shunned by Teshome Gabriel and Ferid Boughedir as lower inauthentic film practices. Fanta Nacro's "Night of Death" seeks to establish a new order beyond the old representative regime of art, one in which it has become possible to mobilize a range of violent, naked, and ultimately melodramatic, neobaroque images in the service of a doctrine that hopes to accomplish a new accommodation between warring factions—be they cinematic factions or armed men vying for power. In her vision there is now room for a New Nollywood, and with it, a new African cinema as well.

NOTES

1. "How did Sembène Ousmane go about making his first film of true feature-length? After the critical success of *La noire de . . .* (1966), he was able to attract financing more easily. Already well recognized as a novelist, he was proving that he could also make interesting films. Even though he had hoped to avoid relying on the 'goodwill' of French producers,

he knew that for the time being he would still have to accept outside assistance. He proclaimed, 'I am ready to make an alliance with the devil if this devil gives me the money to make films. But I will not disavow any of my political convictions.' Fortunately there was not much pressure or interference from the French producer, who didn't argue about or change anything in the script. However, since Sembène wanted to make the film in Wolof, the principal language spoken by 85% of the Senegalese, the producer demanded a second version in which the actors spoke French—not a dubbed version, but literally a second film with the same content, but all spoken in French. So, as each scene was shot, after a 'take' was perfect in Wolof, then the same scene had to be shot until there was a perfect 'take' in French. So, the two versions were made in parallel. Fortunately the version of *Mandabi* (1968) seen in the US is in Wolof with subtitles. By sticking to his guns, even when making a compromise by working twice as hard, Sembène was able to present to the world the first feature film spoken in an African language." Chale Nafus, Review of *Mandabi* (Money Order), Austin Film Society, http://www.austinfilm.org/page.aspx?pid=3585.

2. The official title would be Ministre déléguée auprès du ministre des Affaires étrangères, chargée de la Francophonie.

3. "The *dominant* [is] one of the most crucial, elaborated, and productive concepts of Russian Formalist Theory. The dominant may be defined as the focusing component of a work of art: it rules, determines, and transforms the remaining components. It is the dominant which guarantees the integrity of the structure." Jakobson 1990, 41.

4. "The 'father' of African cinema, Sembène Ousmane, along with Sarah Maldoror, Souleymane Cissé and Abderrahmane Sissako all studied in Moscow. 400 000 other Africans also studied in the USSR throughout the period 1950–1990. Where France shunned the artistic development of its colonized countries while it still had the power, Moscow embraced them. Whether for diplomacy, advocacy, as a form of soft power or as a means of propaganda, it is clear that cinema was a tool through which the Soviet Union wanted to extend itself; through images it saw its own expansion into Africa.

 So, what emerges from an investigation into African filmmaking and its relationship with the Soviet Union—particularly in West Africa during the 1960s–1990s, and cinema cultures in Lusophone countries in the 1970s—is a cinegeography of socialist friendship." (Basia Lewandowska Cummings, http://www.filmafrica.org.uk/blog/african-cinema-and-soviet-filmmaking).

5. Sometimes called "assimilés," the Originaires were Senegalese inhabitants of the four communes, granted French citizenship, and viewed as an avant-garde of progressivism in Africa under colonialism. They were Africans who modeled their notions of progress

largely on European models of "civilization."

6. In what follows, a series of paradigms will be delineated. We should think of them somewhat along the lines of what the Russian Formalists described as dominant phases of literature. That means that when one phase is succeeded by another as dominant, traits of the first will persist, but subordinate to the new dominant trend. There is no teleology in this process, but rather a model for change in which a dominant paradigm will be seen as characterizing films of a period, without excluding the possibility that other forms of film will coexist with those of the dominant paradigm.

7. "African Socialism" became a commonplace for a state-controlled economy, and in the cases of Nkrumah and Senghor, who led the advancement of the term, became associated increasingly with statism in the former case and neocolonialism in the latter. In no case was a liberal economic system replaced by socialism, and, except for Tanzania, in no case did this not engender economic and political dependencies.

8. The seminal piece that establishes the manifesto of Third Cinema in 1969 was Solanas and Getino's "Towards a Third Cinema."

9. In an interview with Teno, Olivier Barlet records the following comment on modernism: "Je ne parle pas de la modernité telle que la conçoivent les gens dans les rues africaines pour qui avoir une voiture ou un beau costume sera moderne, dit le Camerounais Jean-Marie Teno. La modernité est toujours associée au système occidental et non comme une forme de progrès qui ne serait pas forcément un mimétisme" (personal interview with Barlet). (I am not speaking of modernity such as the man in the African street conceives of it: to be modern would be to have a car or a nice suit. Modernity is always associated with the West, and not as a form of progress that wouldn't necessarily entail imitation.)

10. See Achebe's well-known statements: "Many of [my readers] look to me as a kind of teacher" (1975, 2); and "The past needs to be created not only for the enlightenment of our detractors but even more for our own education" (1975, 9).

11. Mongo Beti's *Main basse sur le Cameroun* (1972) is a kind of ghost whose vision of Cameroon haunts this film. Even though Beti is not interviewed in the film, his point of view prevails. He is among those Teno thanks in the film's credits. His specter would seem to be present. In this sense we can acknowledge that same Marxist presence termed a specter by Derrida, in his *Specters of Marx* (1994), a specter that appeals to justice.

12. "Ça se passe dans un pays où regnaient ce temps-là abundance et prospérité, le pays des alouettes. Un jour d'un pays lointain arrivent des chasseurs, ils sont d'une autre couleur. Les alouettes leur offrent toutes les bonnes choses qu'ils ont dans leur village. Les chasseurs ravis décident de rester au pays où ils trouvent dans l'abundance les choses

qu'il leur manque chez eux. Ils disent aux alouettes: nous sommes frères; chez toi c'est chez moi." The tale concludes: "Tu va travailler pour moi parce que moi en ce moment j'ai beaucoup de besoin. Les chasseurs arrivent de plus en plus nombreux, et continuent de s'installer. Tous les jours, parfois sans manger, sans boire, les alouettes travaillent. Tout le village doit travailler, même les femmes et les enfants. Leur chant n'est plus qu'un complaint qu'on entend souvent très tard dans la nuit. Un jour les chasseurs repartent chez eux. En partant ils installment au village un nouveau chef. C'était un chef comme voulaient les chasseurs. Certains disent même que c'est un chasseur-sorcier qui très vieux, voyant venir la mort, avait trouvé la force de sortir de son envelope terreste. Il s'est précipité dans la première case et s'était introduit dans le corps d'un petit alouette qui venait de naître. Depuis ce jour-là, il y avait dans ce village une race d'alouettes très bizarre qui n'avaient aucun respect pour leurs frères qu'ils traitaient comme des esclaves. Qui acceptaient même de stocker dans leurs villages les déchets toxiques que d'autres villages ne voulaient pas. (You are going to work for me because, me, I really need this a lot. More and more hunters arrive and continue to move in. Every day, sometimes without eating, sometimes without drinking, the swallows work. The whole village has to work, even the women and children. Their song is only a sad refrain which you can hear, very often, late at night. One day the hunters leave for home. While leaving they install a new chief in the village. It was a chief of the sort the hunters wanted. Some even say that he is a hunter-sorcerer, who, in his advanced years can see death's arrival having found the force to depart from his earthly envelope. He threw himself into the first hut, and inserted himself into the body of a small swallow who had just been born. Since that day a very strange race of swallows came to live in the village who had no respect for their brothers whom they treated like slaves. Who even agreed to store toxic waste in their village which other villages refused." Translation by Kenneth W. Harrow.

13. In *Guelwaar* (1992), Sembène gives us the conventional figure of the successful been-to in Barthélémy, Guelwaar's son, who has been a "Frenchman," a "whiteman," due to his acculturation to Europe: he now despises Africa and mimics the words of the Western critics of Africa's corruption and laziness, and so forth. He is also conventionalized as the lost son whose recuperation for Africa is represented as the desired goal.

14. In his brief comments on the film, Mambéty identifies a time when he was young man living in poverty in Dakar. Notes on the website http://spot.pcc.edu/~mdembrow/ hyenas_program_notes.htm repeat the story that "every Friday night a beautiful prostitute would come to the port district from her palatial home and treat the poor to a lavish meal. They named her Linguère ("Unique Queen" in Wolof) Ramatou (the red bird of the dead in Egyptian mythology). One Friday she failed to appear, and Mambéty

decided that she had perhaps returned to her native village, the village which he imagined had at one time driven her out and to which she had now returned in triumph."

15. One of a number that were built along the coast of the peninsula where Dakar is located and on the island of Gorée, to defend the city during World War II.

16. In 1996, the British Film Institute commissioned Bekolo as the African filmmaker for its series celebrating the first 100 years of film.

FILMOGRAPHY

Bassek Ba Kobhio. 1991. *Sango Malo*. Diproci, Fodic, Les Films Terre Africaine, Cameroon.

Bekolo, Jean-Pierre. 1992. *Quartier Mozart*. Kola Case, Cameroon Radio Television, Cameroon.

———. 1996. *Aristotle's Plot*. JBA Production, BFI, France/Zimbabwe.

———. 2005. *Les Saignantes*. Quartier Mozart Films, é4 Television. France/Cameroon.

Bouchareb, Rachid. 2001. *Little Senegal*. Cinema Libre Studio, United States and Senegal.

Cissé, Souleymane. 1982. *Finye*. BFI, Mali.

Dikongué-Pipa, Jean-Pierre. 1975. *Muna Moto*. Avant Garde Africaine, Cameroon.

Mambéty, Djibril Diop. 1973. *Touki Bouki*. Cinegrit, Studio Kankourama, Senegal.

———. 1992. *Hyènes*. ADR Productions, Thelma Film AG, Senegal.

Dornford-Mays, Mark. 2005. *U-Carmen e-Khayelitsha*. Spier Films, South Africa.

Gomes, Flora. 1991. *The Blue Eyes of Yonta*. Guinea Bissau.

Gomis, Alain. 2012. *Tey*. Belle Moon Productions, Senegal.

Haroun, Mahamat. 2011. *Un Homme Qui Crie: A Screaming Man*. Film Movement, Chad.

Kaboré, Gaston. 1982. *Wend Kuuni*. California Newsreel, Burkina Faso.

Nacro, Fanta. 1995. "Puk Nini." Burkina Faso.

———. 2004. *La nuit de la verité*. Les Films du Defi, Burkina Faso.

Ouédraogo, Idrissa. 1989. *Yaaba*. Les Films de l'Avenir, Burkina Faso.

Ramaka, Joseph Gaï. 2001. *Karmen Geï*. Les Ateliers de l'Arche, Senegal.

Sembène Ousmane. 1963. *Borom Sarret*. Senegal.

———. 1966. *La Noire de . . .* Films Doomireew, France/Senegal.

———. 1968. *Mandabi*. Comptoir Français du Film Production, Films Doomireew, Senegal.

———. 1970. *Tauw*. Films Doomireew, Senegal.

———. 1974. *Xala*. Filmi Doomireew, Senegal.

———. 1992. *Guelwaar*. Films Doomireew, Senegal.

———. 2000. *Faat Kine*. Films Doomireew, Senegal.

———. 2004. *Moolaade*. Films Doomireew, Senegal.

Sissako, Abderrahmane. 2006. *Bamako*. Chinguitty Films, Mali.

Teno, Jean-Marie. 1993. *Afrique, je te plumerai*. Les Films du Raphia, Cameroon.

———. 1999. *Chef.* Les Films du Raffia, Cameroon.

BIBLIOGRAPHY

Achebe, Chinua. 1975. "The Novelist as Teacher." In *Morning Yet on Creation Day: Essays*. New York: Anchor/Doubleday.

Althusser, Louis. [1969]. 1972. "Ideology and Ideological State Apparatuses." In *Lenin and Philosophy, and Other Essays*. New York: Monthly Review Press.

Andrade-Watkins, Claire. 1993. "Film Production in Francophone Africa: 1961–1976: Ousmane Sembène—An Exception." *Contributions in Black Studies* 11: 26–32.

Awoonor, Kofi. 2014. "The Weaver Bird." In *The Promise of Hope*. Lincoln: University of Nebraska Press.

Badiou, Alain. 2001. *Ethics: An Essay on the Understanding of Evil*. Trans. Peter Hallward. New York: Verso.

Belsey, Catherine. 2002. *Critical Practice*. London: Routledge.

Beti, Mongo. 1972. *Main Basse Sur Le Cameroun: Autopsie D'une Décolonisation*. Paris: les Éditions François Maspero.

Boughedir, Ferid. 1976. *Cinéma africaine et decolonization*. Paris: Université Paris III.

Eke, Maureen, Kenneth Harrow, and Emmanuel Yewah. 2000. *African Images: Studies in Cinema and Text*. Trenton, NJ: African World Press.

Foucault, Michel. [1977]. 1995. *Discipline and Punish: The Birth of the Prison*. New York: Vintage Books.

Gadijgo, Samba, et al. 1993. *Ousmane Sembène: Dialogue with Critics and Writers*. Amherst: University of Massachusetts Press.

Gikandi, Simon. 1996. *Maps of Englishness: Writing Identity in the Culture of Colonialism*. New York: Columbia University Press.

Jakobson, Roman. [1935]. 1990. "The Dominant." In *Language in Literature*. Trans. Krystyna Pomorska, ed. Krystyna Pomorska and Stephen Rudy. Boston: Belknap Press.

Jameson, Fredric. 1991. *Postmodernism, Or, the Cultural Logic of Late Capitalism*. Durham, NC: Duke University Press.

Mbembé, J.-A. 2001. *On the Postcolony*. Berkeley: University of California Press.

Radhakrishnan, R. 1992. "Nationalism, Gender, and the Narrative of Identity." In *Nationalisms and Sexualities*, ed. Andrew Parker, Mary Russo, Doris Sommer, and Patricia Yaeger. New York: Routledge.

Solanas, Fernando, and Octavio Getino. [1969]. 1997. "Towards a Third Cinema." In *New Latin

American Cinema, ed. Michael Martin. Detroit: Wayne State University Press.

Ukadike, N. F. 1994. *Black African Cinema*. Berkeley: University of California Press.

Williams, Raymond. 1983. *Culture and Society, 1780–1950*. New York: Columbia University Press.

Žižek, Slavoj. 1991. *Looking Awry: An Introduction to Jacques Lacan Through Popular Culture*. Cambridge, MA: MIT Press.

Anglophone West Africa: Commercial Video

Jonathan Haynes

n 2003, the South African media conglomerate Multichoice, through its television channel M-Net, launched Africa Magic, a channel devoted to English-language Nigerian Nollywood films (with an admixture of Ghanaian ones), on its subscription Direct Satellite Television (DStv) platform. Africa Magic was being broadcast to forty-one countries in Africa by 2004. Two more channels were added in 2010, showing Nigerian films in the Yoruba and Hausa languages, and in 2011 a channel showing East African movies in Swahili was created. In 2012, M-Net expanded its English-language programming on Africa Magic to five channels, including programming from South Africa and across the continent, but still with a preponderance of Nigerian content.[1]

Africa Magic is immensely powerful in itself as a cultural form, and it is emblematic of the future in its combination of South African technology and highly capitalized business structures with Nigerian creative energy. All these channels, broadcasting twenty-four hours a day, seven days a week, are possible because of the immense quantity of films churned out in Nigeria and Ghana—literally thousands a year, more titles each year than the total number of celluloid films Africa has produced from the 1960s to date. These films are produced as a form of popular culture in a way that has nothing to do with corporations. Before they

were bounced off satellites, they had found their way across the African continent on the ground, "informally"—mostly through the agency of pirates. They were on sale in markets and by hawkers in traffic jams, rented from hole-in-the-wall shops and businesses operated out of private homes.

Nollywood is a mass entertainment industry, and it saturates Nigerian social space. There are some new multiplex cinemas catering to the elite, and the most prestigious halls and auditoriums in Lagos and Abuja are rented for film openings, awards ceremonies, and conferences. New films are shown at the National Theatre in Lagos and taken around to university campuses and other informal venues. But these are primarily "home videos," as Nigerians often call them, viewed in domestic space. Given the glut of films on the market, people tend to rent them from ubiquitous neighborhood video clubs rather than buying them. The films, trailers for them, and programs devoted to the industry, its new releases, and its stars appear regularly on terrestrial broadcast television as well as the satellite channels to which the middle class subscribes. Africa Magic is permanently playing in many restaurants, bars, and offices. The urban poor gather in small video parlors, where they sit on wooden benches or metal chairs to watch a TV monitor. Even remote villages with little or no electricity are served by itinerant exhibitors with a television, a DVD player, and a generator. The nation's leading newspapers regularly cover developments in the industry, review films, and interview actors and directors. Tabloids and the proliferating fashion magazines feature film celebrities, and fan magazines devoted solely to the film industry come and go. Stars and producers have slick websites, there are numerous online discussion groups, and professional (often mercenary) bloggers have become at least as important as print reviewers in influencing the fortunes of a new movie.

Outside of Africa, Nollywood films also have a huge market. The Odeon cinema chain in London regularly hosts premiers of Nigerian films with Nollywood stars on red carpets (Jedlowski 2013). In Houston, Texas, two local cable television stations show them; my own cable television provider on Long Island, New York, offers a Nollywood channel; in Paris, a new channel broadcasts them dubbed into French; Nollywood films turn up on in-flight entertainment systems of major airlines. One Internet streaming site, iROKOtv, offers more than 4,000 Nollywood and Ghanaian titles, and thousands more are up on YouTube. In North America and Europe, distributors reproduce them (sometimes paying for the rights, sometimes not) and sell them through African grocery stores, hair salons, and video shops that normally also sell a range of other videos. To take one example, in the Bedford-Stuyvesant

section of Brooklyn, New York, where there is a large African population, Nigerian and Ghanaian films are sold alongside Malian and Jamaican music videos, Senegalese Wolof-language dramas made for television by theater troupes, and recorded soccer matches of African teams. In other parts of Brooklyn, vendors report that most of their customers for Nollywood films are not African but rather Caribbean immigrants and African Americans; the African movies are flanked by Jamaican gangster films, Jamaican and African American pornography, pirated Chinese films, and pirated Tyler Perry films. Nigerian films are wildly popular across the Caribbean and in Suriname and Guyana.

This global distribution network runs underneath or parallel to that of "legitimate" corporate-dominated commerce and Nigerian and Ghanaian videos are also excluded from the niche market of small-scale American distributors specializing in foreign films, and even from the specialists in African cinema such as California Newsreel or ArtMattan. The worldwide spread of Nigerian films is a remarkable instance of globalization from below.

There is a little genre of anecdotes about presidents of African nations being upstaged in their own countries by Nollywood stars. Jibrin Ibrahim, in Malawi as an election observer, reports one instance:

> I realised the visit of Rita Dominic was causing as much frenzy as the elections we had come to observe. She is known as the lady with the silky skin and the whole country was so emotionally charged to see the silky skin from Nigeria. Indeed, the highlight of late President Bingu wa Mutharika's re-election campaign was the unveiling of a mausoleum in honour of the late dictator, Kamuzu Banda, and Rita was the star attraction that had been invited to launch it. (Ibrahim 2012)

Once when the president of Sierra Leone was on his way out of the country he crossed paths with a party of Nigerian film stars, including Genevieve Nnaji, who were drawing far larger and more enthusiastic crowds than he ever did. The president turned around in order to entertain them at his palace. Genevieve Nnaji was invited back to be the patron of the country's breast cancer awareness campaign. Soon after, her image graced billboards all over the continent advertising Lux soap.

Nollywood is the giant of the African video revolution, as Nigeria, with its huge population, a quarter of all sub-Saharan Africans, is the giant of Africa. Video filmmaking has appeared all over the continent, as it doubtless would have done even had Nollywood not existed; but given Nollywood's nearly universal

penetration, in many places it has played an important role as inspiration and model, reflected in the proliferation of "woods": Ghallywood (Ghana), Jollywood (South Africa, centered in Johannesburg), Bongowood (Tanzania; "Bongo" is slang for Dar es Salaam), Riverwood (Kenya, where River Road in Nairobi is the center of video distribution). The influence is clear in the films of the Kenyan Judy Kibinge, such as *Project Daddy* (2004); Nigerians have participated in coproductions in many countries, including Ghana, Sierra Leone, Liberia, and Cameroon, and have been invited to help jump-start local production in Gabon and elsewhere (Haynes 2007c).

Nollywood travels so easily and so far because it has the enormous advantage of working in English, with its huge global linguistic community. English is of course not a native language almost anywhere in Africa, but, as Moradewun Adejunmobi argues, that does not impede its use in African popular culture, where English is seen less as a legacy of colonial or neocolonial domination than as "the language of success" (Adejunmobi 2002). And Nollywood films have spread far beyond Anglophone Africa because audiences recognize cultural affinities that are more important than the language barrier (Katsuva 2003).

Global Nollywood: Transnational Dimensions of an African Video Film Industry, edited by Matthias Krings and Onookome Okome, collects fascinating accounts of reception, cultural influence, and imitation (Krings and Okome 2013). Krings, an anthropologist, studies the role of a video disc jockey as a cultural intermediary between a Nigerian film and a Tanzanian audience:

> In Tanzanian video parlors, narrators are performing live translations of foreign films into Kiswahili so local audiences can follow the story. They are also ad-libbing, adding observations and personal commentary, and adapting the stories to a local hermeneutical framework. Pirated video copies of foreign films are thus subject to a profound practice of remediation. (Krings 2013, 306)

His essay and the following one by Claudia Böhme describe the emergence of the Tanzanian video film industry—a major source for the Africa Magic Swahili channel—in a fluctuating relationship with Nollywood. Nigerian films appeared in Tanzania around 2000, provoking intense interest. By 2005, homegrown Tanzanian films in Swahili that mix Nollywood and indigenous elements in a process Böhme calls "bricolage" had nearly driven Nigerian films from the market. But then by 2009, the excitement over the Swahili films had cooled, and piracy and overproduction of films for the small market led to a decline in their budgets and quality. So Nollywood

films reemerged, spurred by interest in the overlaid narration of the video disc jockeys (Krings 2013; Böhme 2013).[2]

"Home videos" are mostly watched in normally invisible, private, domestic spaces (and extremely dispersed spaces at that), making the meanings generated as they are consumed hard to get at. The externalization of an interpretive narration by the Tanzanian video disc jockeys, or by the Congolese dubbers described by Katrien Pype (Pype 2013), is therefore valuable evidence. The analysis of syncretic cultural forms created in response to Nollywood, such as Böhme performs, is another method; so is the kind of careful interviewing that underlies the essays in the same volume by Jane Bryce (Bryce 2013) and Heike Becker, who try to explain the popularity of Nollywood films in Barbados and South Africa and Namibia, where, Becker writes, the films have "begun to shape speech patterns and habits, in a Bourdieuian sense, of young highly educated people" (Becker 2013, 181). Jean-François Werner, writing earlier on the viewing of Latin American telenovelas in Senegal, points to the stakes in understanding the ethnography of media consumption: African children are raised from infancy in front of televisions, women may watch TV nine hours a day, and when telenovelas are viewed and discussed in the family setting, culture and morals are defined, reinforced, subverted, and problematized; traditional channels of communication are mobilized; and new ones are formed (Werner 2006). Brian Larkin's exemplary studies of the media environment in northern Nigeria have shown how women have gone from being almost entirely excluded from cinema culture, because theaters were rowdy and profane places where respectable women could not go, to being the primary patrons of Hausa videos (which are sometimes called "women's films"), and how Indian films and the Hausa videos influenced by them help to construct "parallel modernities" as an alternative to both traditional culture and Westernization (Larkin 1997, 2000, 2002, 2008). Africans have been watching movies for several generations now, with manifold effects, but the video revolution has enormously intensified these processes and given them an unprecedented reciprocity: for the first time, it is relatively easy for Africans to reply in kind to the films they watch. The mass of the African population is young and lives in a media-saturated world. African video films have become an essential component of their culture, and the study of African culture cannot ignore this fact.

As John C. McCall puts it, Nollywood films are "the Pan-Africanism we have"—a phrase that perhaps wistfully measures the distance between Nollywood's sometimes garish melodramas and the ideological consciousness of the fathers of

Pan-Africanism, but also celebrates the actual existence of this powerful common form of imagination (McCall 2007). Film has always played a crucial role in colonialism and neocolonialism; the African video revolution is truly revolutionary in that it finally broke the hegemony of foreign media. A rare and exemplary success in the old projects of industrial import substitution and South-South commerce, it is far more important on the level of imagination. African video films provide the primary audiovisual representation of life—of how to fall in love, of how gender relations should look, of what kind of house to desire, of how meals should be taken, of what to do with African hair—for many millions of black people.[3]

How Did This Happen?

The contrast between French and British modes of support for cinema in the colonial and postcolonial epochs is a familiar theme in the scholarship on African cinema (Martin 1982; Diawara 1992; Ukadike 1994; Shaka 2004). The British Colonial Film Units created a filmmaking infrastructure of equipment and trained personnel, but the British government never encouraged fictional feature filmmaking either before or after decolonization. Nkrumah's cultural nationalism included ambitious plans for film production in Ghana, using cinema as a means to defend and propagate African values, but after his ouster the Ghana Film Industry Corporation (GFIC) lapsed into decrepitude (Meyer 1999; Garritano 2008, 2013). Similar nationalist rhetoric accompanied the establishment of the Nigerian Film Corporation, but feature filmmaking in Nigeria, as in Ghana, was effectively left to the commercial sector (Ekwuazi 1991). In both countries and across the continent, commercial theaters showed foreign films exclusively.

Ghana

By 1987, when Willie Akuffo's *Zinabu* (1987) launched the Ghanaian video film era, the old regime of celluloid film production was ending. The feature filmmaking efforts of the GFIC had ground to a complete halt, and the well-publicized problems of Ghana's most distinguished director, Kwaw Ansah, in getting his independently produced *Heritage Africa* (1988) to the screen and turning a profit on it pointed to a state of terminal crisis (Meyer 1999; Garritano 2008).

Meanwhile, by 1987 there were 300 video centers in Accra, some equipped with video projectors, some simply with a VCR and a television monitor. They showed pirated cassettes of the same range of foreign films from Hollywood, Bollywood, and Hong Kong that were shown in cinemas across Africa, and also took advantage of the conjuncture of the new technologies of video recording and satellite broadcasting with an (anxiously) liberalized political climate that allowed access to the global media environment to show such things as videotaped international sports events and CNN news. Churches rented these centers to screen American religious programming (Garritano 2008).

The first feature film to be shot on video, *Abyssinia*, was produced in 1985 by Allen Gyimah, a businessman who owned a video center and employed staff from the Ghana Broadcasting Corporation (the state-owned television station) to videotape social events. He hired these technicians and members of the Osofo Dadze concert party group, who were in a television serial also called *Abyssinia*, to make a film capitalizing on the popularity of the serial and of the actors. This film, in Twi (the most widely understood Ghanaian language), was only screened in Gyimah's video center and never circulated, and consequently it has been mostly forgotten (Socrate Safo, personal communication; Garritano 2013).

Willie Akuffo is generally credited with inaugurating the Ghanaian video boom. He was a film projectionist and distributor by trade; as he told me, he watched audiences turn irritable and then violent when the scratched old prints of American and Chinese action films he was showing jammed and broke. Onerous import and licensing restrictions made these the only films available. So it occurred to him to make a feature on video. The original story idea for his inaugural film, *Zinabu*, came from an African American who took the name Juma Kangwana (he was originally known as Alfonso Miller). Akuffo met him in Lagos, where Kangwana had come to sell photocopiers. He had been trained as a filmmaker and had film books with him as well as a 16mm projector and some African American films. He had been duped and was stranded. Akuffo brought him to Ghana to make money with the films and soaked up his knowledge. Akuffo assembled a cast for *Zinabu* in 1981 and—because they all knew they were not professionals—they rehearsed for six months. But Akuffo could not get the video camera he wanted. He finally shot the film in 1985 and showed it to a critic whose judgment he respected, who condemned everything, so Akuffo reshot it. When he took the completed film to the GFIC, which ran a chain of theaters, the board refused to watch it because it was on video. In 1987, Akuffo rented a private theater, built a box around the video

projector to disguise it, and wired it to the projection booth, thereby fooling the audience into believing they were watching a celluloid film. The movie was a huge hit, but the GFIC still refused to screen it, so Akuffo took it around to the video centers. (For an excellent reading of this film, see Garritano 2013.)

The third filmmaker into the field was Socrate Safo, who made *Unconditional Love* in 1987, at the age of nineteen. He would become one of the mainstays of the Ghanaian video industry: by 2007 he had written, produced, and directed over sixty films and, with his partner, Danfo B. A., had created the first functioning film studio in West Africa, a four-story building housing facilities for all stages of filmmaking from scriptwriting to postproduction work and training, cranking out a film a week, assembly-line fashion. But his entrance into filmmaking is an example of spontaneous combustion, a pure passion creating its medium. This is the story he told me:

> Growing up, I had a love for film. I was good at storytelling so it got to a point where I decided to make a film—a film in the sense that in the evening I would gather my friends in my house and I would perform the stories we had in our school books. I would draw the characters, the Chimera, the Medusa, I would draw those characters and then cut them out on cardboard paper, use them as shadow puppets with our kerosene lamp and a piece of calico hung over the table. I was charging them something small to buy kerosene for the lantern. So that became popular and I began adding certain things like sound effects, using the short wave band of my father's radio for horror scenes. I don't know where I was getting all these ideas from.

Safo's family lived in a middle-class neighborhood, but he had friends from Bukom, one of the oldest and poorest places in Accra, right on the seashore, home to fishermen and boxing champions. Its sandy streets are so packed with liveliness on a Friday evening that a car cannot pass without pausing while benches full of gin drinkers are moved out of the way. Late at night vehicles cannot pass at all because the streets are taken over by people sleeping on mats: the tiny houses, many of them simple one-room cells of rough planking, are too small for large families to lie down in them all at the same time. Drawn by his friends' anecdotes, Safo went to have a look at Bukom when he was sixteen and stayed for six years, fascinated by the immediacy of life there, the lack of privacy, the constant flow of stories. "Bukom I'd say is the best and most interesting place to stay in the whole world. It's a city with twenty-four hour life, so you don't sleep." The Sam Bea Video Centre

opened in Bukom, screening cassettes of the usual Indian, Chinese, and American action films for a rowdy audience—mostly boys and young men—sitting on rough benches. (They liked the Indian films best.) Safo lived there, writing the program of the day's movies on the chalkboard outside, sweeping out the little theater, and then sleeping in it. He wasn't paid, but he got to watch the films. One day his boss hired a cameraman to make a "social video" of a family celebration, and Safo got the idea that he could use the video camera to make a movie.[4]

He went to technical school to become an auto mechanic but spent his time writing down ideas for films in his notebook and reading books about filmmaking in the library. His friends caught his excitement about making a movie, though none of them had any idea what it involved. For six months they rehearsed what became *Unconditional Love* on the basis of Safo's two-page scenario. Safo spent a day watching someone shoot a film and learned to call "action!" at the beginning of a take. Finally they hired the camera, using some money "borrowed" by one of the actors from his mother's fishmongering business, for which he kept the accounts, and $10 that Safo's brother had sent him from America. They shot the whole film in one day since they couldn't afford to rent the camera for longer. Safo edited it in the most rudimentary fashion. Inspired by the success of Akuffo's *Zinabu*, he hired a cinema hall and took out newspaper ads. He nervously set the admission price very low, but raised it when a crowd of people showed up. The idea that he'd dared to make something to which people would bring their whole families terrified him so much he couldn't stay in the hall, but from outside he heard applause and cheering. He was launched.

Like Akuffo, Safo discovered that popular success did not mean acceptance by the filmmakers who had been working on celluloid, government officials, or the rest of the cultural establishment. The new art form was studiously ignored or violently denounced. Technical and artistic deficiencies were scorned, and there was an element of indignant jealousy toward the "interlopers" who had successfully invited themselves into Ghana's audiovisual culture. There was also a deep-seated difference in ideologies between the cultural establishment and the video filmmakers (Meyer 1999, 2010a, 2010b; Garritano 2008, 2013).

Because celluloid film production is capital-intensive and requires an extensive apparatus and advanced technical expertise, it has always been obvious that in the African context it needs governmental support to flourish. Its power as a tool for nation-building and the cultural and ideological dangers of forfeiting control over the film medium have been a constant theme of discussions of cinema in

Africa. African states have, on the whole, done a very poor job of supporting film production; in Nigeria and Ghana, government efforts had, by the period in question, reached a point of absolute failure.

But video technology—cheap and easily operated—does not need state support, and video filmmaking found another basis in the "African popular arts." As defined by scholars such as Biodun Jeyifo (1984), Karin Barber (1987), and Johannes Fabian (1978), these arts include such things as paintings on the walls of bars or on the sides of trucks, popular musical styles, fashions emanating from small tailoring shops, or—an instance that has attracted sustained scholarly attention of the highest quality—the Yoruba traveling theater (Jeyifo 1984; Barber 1982, 1987, 2000). Such arts require little training or capital and so are open to all comers, resulting in an intensely competitive market with many small producers. They spring from and are patronized by the heterogeneous masses of African cities and have few links with formal-sector institutions. Like the cities themselves, the popular arts mediate between the rural/"traditional" hinterland and the "modern"/Western world of international commerce and politics.

The popular arts have their own style of cultural brokerage and their own set of cultural and political concerns. One might compare, for example, Wole Soyinka's literary drama *Death and the King's Horseman* (2003), which combines a fierce defense of a deep and authentic Yoruba worldview with a mastery of the traditions of Greek and Shakespearean drama and a bravura display of the English language so elevated as to be incomprehensible to most Nigerians, with the founding films of the Ghanaian video boom, Willy Akuffo's *Zinabu* and *Diabolo* (1991). Akuffo's stories are closely related to urban folklore, appeal directly to popular fears and desires, express themselves with rough demotic energy, and, with the cheerful syncretism characteristic of the African popular arts, seem unconcerned with any notion of authenticity, drawing on foreign commercial popular culture rather than on foreign masterpieces imported by the educational establishment. *Zinabu*'s story has obvious affinities with the stories told along the coast of West Africa about the mermaid goddess Mami Wata: a poor auto mechanic is seduced by a glamorous witch, who gives him wealth but at the price of sacrificing his sexuality. Akuffo's next string of hits, the *Diabolo* series, was, Akuffo says, inspired by *An American Werewolf in London* (personal communication; Wendl 1999), again assimilating it to Ghanaian witchcraft beliefs: it is about a man who transforms himself into a snake to practice money rituals on prostitutes. Safo's first film told the story of a poor boy—another auto mechanic—in love with a rich girl, the resurgence of his

ex-girlfriend, and redemption through Christian faith. Neither filmmaker thought or worked in or fit into the horizon of previous Ghanaian, or African, filmmaking, where the dominant concerns were with answering the racist slurs generated by centuries of slavery and colonialism, dignifying the African heritage, and taking part in the postcolonial project of nation building and modernization. The cultural establishment was embarrassed by the video films' technical deficiencies and felt these tales of witchcraft, crime, and squalid domestic situations were bad for the nation's image.

Garritano (2013) divides the early history of Ghanaian video production into an initial phase from 1987 to 1992, dominated by amateurs like Safo and Akuffo who worked for a lower-class audience and represented the poverty of their lives, followed by a period shaped by the entrance of more highly trained filmmakers who aspired to make a professional commercial product aimed at a more middle-class audience.

Nigeria

In Nigeria, video filmmaking also began as a grassroots phenomenon, but from the beginning it grew out of and was shaped by two large and powerful professional institutions: the Yoruba traveling theater and Nigerian television.

The Yoruba traveling theater tradition, which dates back to the 1940s, continued in the new video medium, having already adapted its stage performances to television and celluloid film. Yoruba traveling theater artists were responsible for the vast majority of the more than 100 celluloid films that were made in Nigeria between 1970 and 1992 (Balogun 1987; Ekwuazi 1991; Adesanya 1992), when the structural adjustment program and the consequent devaluation of the Nigerian naira made importing film stock and processing it abroad prohibitively expensive, and when armed robbery, which flourished in the general political, social, and economic chaos of the end of the Babangida military dictatorship, made it dangerous to go out at night to see a film. Nearly all of the 5,000 cinemas in the country shut down. The closing of the cinemas was not a hard blow for the traveling theater artists, since they had been shut out of the cinema distribution system anyway and were used to screening their films in the improvised venues—schools, town halls, hotels—where they had previously performed their stage plays (Ricard 1983). As the economic situation deteriorated, they began to use video projectors to screen their films,

the last step in a process of adopting ever-cheaper technologies (such as shooting on video, from which they made a 16mm print). Finally, they were in an all-video environment. At first they continued to think of video as a way to screen their films to paying audiences rather than selling them as cassettes (Haynes 1995).

The established Yoruba stars exploited their reputations, held on to much the same audience (seldom bothering to subtitle their films for non-Yoruba audiences), mined their stage repertoire for new films, and continued existing genres, both the comedies and dramas of contemporary life and those that drew on ancient cosmographies and cultural traditions. Improvisation around a sketchy scenario remained the basic technique, and virtuoso displays of the Yoruba verbal arts continued to be a major attraction. The original social organization of the traveling theater troupes was built around the necessity to maintain stability through the stresses of constant travel: a central actor/manager needed to keep a core of loyal long-term associates and often married many of the actresses to prevent their defection. This structure was modified for television, film, and video production into a system where members of various troupes would appear in one another's films as reciprocal favors, so that films could be made virtually without paying the cast, and so on remarkably low budgets (Haynes and Okome 1998; on the current system of "caucuses," see Adesokan 2009). Another distinctive feature of the Yoruba filmmaking sector is that public screenings remain a major source of revenue: films are typically debuted at the National Theatre in Lagos and then shown elsewhere before being released for sale as cassette or video compact discs (VCDs), which around 2000 became the standard form in which films are sold.

The Yoruba branch of the video film industry continues to thrive, and it provided a model for Nollywood as a popular art form. But Nigerian television is the most important influence on Nollywood.

The Nigerian government invested heavily in television from very early on: the first television station in sub-Saharan Africa, WNTV in Ibadan, began broadcasting in 1959, the year before independence. The Nigerian Television Authority played an immensely important role in creating a sense of Nigerian national culture and identity, not least through its popular serials (Olusola 1986; Lasode 1994; Esan 2009). In 1983, an Organization of African Unity study found that Nigerian television had the lowest percentage of foreign content of any nation in Africa (cited in Lasode 1994). By 1990, there were thirty-four television stations (Bourgault 1995), and in 1992, when the video boom began, an estimated eight million television sets, the highest number in Africa (Tudesq 1992). Today there are more than 200 television stations

in Nigeria. These stations are chronically underfunded, but they have sponsored the growth of a large population of professional cameramen, directors, actors, and other experienced personnel, and encouraged the ownership of television sets to spread widely through the population.

At the high point of the Nigerian oil boom in the 1970s and early 1980s, owner-ship of a VCR became a defining feature of the Nigerian middle class—in 1984, an estimated 20 percent of television owners also had VCRs (Tudesq 1992). Ghanaians who were working in Nigeria and were forced out in 1983 took VCRs home with them (Ogunleye 2003a, quoting from a lecture by Yaw Boache), sparking a culture of privatized movie watching in Ghana. This pattern of video player ownership is markedly different from that in Senegal, for instance, where video players remained rare even as televisions became common (Werner 2006). A whole infrastructure of piracy, as Brian Larkin puts it, arose to service these machines, importing blank cassettes, pirating foreign films (again, a mix of Hollywood, Bollywood, and Hong Kong martial arts films), reproducing them locally, and distributing them through a network of shops, peddlers, and rental clubs. The Nigerian government has never shown any real interest in controlling this sector of the informal economy. It was on this basis that the indigenous video film industry would be built (Larkin 2004).

Living in Bondage

The release of the Igbo-language film *Living in Bondage* in 1992 is generally taken as the inaugural moment of Nollywood. In that year, the whole audiovisual sector was unsettled or in full crisis, the disastrous structural adjustment program-induced economic situation affecting everyone. Celluloid filmmaking had become mani-festly impossible, and the cinemas were closing down. Declining sponsorship had put an end to a golden age of television serials. Reduced funding and misguided policies caused personnel to leave the NTA in droves (Lasode 1994; Adejunmobi 2003; Amaka Igwe and Zeb Ejiro, personal communications). The government, responding to pressure from international lending bodies to fall in line with the new global regime of liberalized media environments, had announced that it would license private television broadcasting, but it had not yet done so (Bourgault 1995). Even the video rental market was no longer profitable.

There were a few Nigerian films shot on video and released as videocassettes before *Living in Bondage*, but there is no question that this film "opened the market,"

as Nigerians say: its sensational success brought Nollywood into being as an industry. It also laid down much of the thematic foundations of Nollywood. *Living in Bondage* was a collaborative project in which three men played key roles (I have interviewed all three). Their collaboration may be taken to symbolize, with striking clarity, the elements that went into Nollywood's emergence.

Okechukwu Ogunjiofor, a young graduate of the NTA training college, had the initial idea for the film, which was based on his own experiences. Unemployed as the result of a hiring freeze at the NTA and the general crisis, his career blocked, Ogunjiofor was reduced to hawking things in the street. A chance encounter led to a meeting with Kenneth Nnebue.

Nnebue was a trader in electronic goods with a primary-school education who had become an important player in the "infrastructure of piracy." Nnebue saw the potential of putting Nigerian content on videocassettes and had produced twenty films with Yoruba traveling theater troupes—this even though Nnebue is Igbo and did not speak Yoruba well. These films were as cheap and basic as can be imagined: a camera was set up to film already-existing stage plays in simple locations. Nnebue once produced two such films in one day.

Chris Obi Rapu was the third collaborator: the top director of the NTA, brought in because Ogunjiofor realized he did not have the experience to direct the film as well as produce it and act a major role. Obi Rapu worked under a pseudonym—his wife's name—because the NTA forbade this sort of side job.

So, symbolically, all three men had at least one foot in the informal sector: two of the three came from television; one was connected with the popular arts and with the commerce of informal-sector markets; no one was connected with celluloid cinema. Prefiguring much else, the collaboration exploded in quarrels over money before the second part of this two-part film was made. Nnebue found another television director for the sequel and awkwardly wrote Ogunjiofor's character out of it. Subsequent recriminations and the desire to take credit for this historically important film make it difficult to establish some basic facts about *Living in Bondage*, including credit for the story and the script, or even what kind of script there was. The scenario was in English while the actors performed in Igbo, with extensive rehearsal and coaching by Ogunjiofor.

The astonishingly low budget of the film—$12,000!—was possible because Nnebue was paying the actors almost nothing. The actors mostly had been playing minor roles on the most popular television serials of the day. Everyone was working out of a spirit of experiment and adventure; no one understood what the film would

lead to, the profits it would make, or that Nollywood would be built on and driven by a star system. Compared with the general run of subsequent Nollywood films, the production values were fairly high and the film was carefully made.

The film exploited the glamour, terror, and moral disorientation of urban Nigeria through a tale of a man who joins a secret cult and sacrifices his wife in a money ritual, which catapults him into the flashy Lagos elite but causes his psychic disintegration as his wife's ghost haunts him. The story intertwines what would become three of the central and distinctive thematic complexes of Nollywood.

The first is domestic (and in particular, marital) problems rendered in the idiom of televisual melodrama: a virtuous wife betrayed by a loving but weak and eventually remorseful husband, and, opening out behind this central story, a landscape of grasping and dangerous women, philandering and sometimes polygamous men, and a general sense of intimate relationships terribly strained by the pressures of urban life and social and moral disorientation.

The second is the money ritual. As critics of Nigerian videos constantly point out, the films are saturated with magical practices, ranging from divinations to discover the cause of a sickness or fertility problem to witchcraft attacks by wicked mothers-in-law.[5] The money ritual, in which an innocent victim is sacrificed to gain access to unlimited wealth through magical means, became the hallmark of Nollywood films. The money ritual is a central figure through which the Nigerian popular imagination understands the mysterious, unearned wealth of the oil boom and the simultaneous rise of violent crime (Barber 1982), and the notion of secret, bloody, powerful cabals practicing such rituals fits the opaque practices and structures of military rule and civilian kleptocracy (Geschiere 1997; Smith 2001).

The third is Pentecostal Christianity, which appears in *Living in Bondage* in the form of a born-again prostitute whom the protagonist had attempted to substitute for his wife in the money ritual and who rescues him when he has become a madman eating garbage on the street, taking him to a church for exorcism. In Nigeria, Ghana, and elsewhere in Africa, Pentecostalism has become a major force in the liberalized media environment. Beyond the Nigerian "Christian videos" discussed below, the Pentecostal influence informs many other films in Nigeria and Ghana where a pastor does battle with a range of evil spiritual forces, providing a general framework for representing the spiritual anxieties besetting these societies (Meyer 1998, 1999, 2002, 2003, 2004, 2005, 2006).

Students of celluloid African filmmaking from elsewhere on the continent will note that none of these thematic complexes appears with such frequency or

in these forms. Domestic conflicts certainly abound in celluloid African films but are not usually handled in such a highly melodramatic idiom, which is associated with "lower" televisual genres. Filmmakers tend to be secular-minded and therefore treat magic, when they do so at all, in ways that are easy to read as allegory; and they tend to steer away from open allegiance to Christianity in order to emphasize more "authentic" indigenous African spiritual beliefs and practices. These differences are signs of the video filmmakers' close relationship with the popular imagination. Nnebue told me his stories come from what he reads in the newspapers and hears people around him talking about. Formally his films borrow elements from television and popular forms of fiction as well as oral narrative traditions, but above all it is the rich soil of popular urban discourses that gives his films their mythic power as well as their absolute contemporaneity.

After *Living in Bondage*'s sensational success, about fifteen producers immediately got into the business of making Igbo-language films. The actors of *Living in Bondage* became stars, appearing in many of the subsequent films and inaugurating Nollywood's habit of overusing the same faces. In 1994, Nnebue made the first English-language video film, *Glamour Girls*, causing another, even larger explosion of imitation. Until the late 1990s, Nnebue drove the development of Nollywood as its most powerful marketer and one of its most powerful creative imaginations.[6]

Nollywood

Nollywood is essentially a network for marketing films on videocassette or, after about 2000, on VCD, and a system of production geared to that marketing network. The marketing network is controlled by Igbo businessmen based in Idumota Market and Alaba International Market in Lagos and in the eastern Nigerian city of Onitsha. The films are made by small producers, who may be able to arrange their own financing or (more often) get money from the marketers. The business aspect of Nollywood is a distillation of the rough cash-and-carry entrepreneurialism of Nigeria's markets. From the beginning, piracy has been a major structuring factor. Video is inherently vulnerable to piracy, and in the absence of serious policing, producers have to assume successful films will be pirated immediately. Overproduction has also always been a major factor. Films are released in batches every two weeks; in Lagos in 2012, there were about sixty English-language films and almost that many Yoruba ones in each batch. Nobody can watch so many movies.

Films need to recoup their expenses and make most of their profit in the two weeks before the next batch sweeps them away or they are displaced by pirated versions. In this system, the only business model that works is to produce a rapid stream of films on very low budgets. The average budget of a Nollywood films has gradually risen to about $65,000.

From *Living in Bondage* on, Nigerian (and Ghanaian) films have tended to be very long and are released in two parts, or sometimes more. This is fundamentally a way of making consumers pay for the same film twice, but it also expresses an aesthetic preference for complex stories that do not have a simple linear development, and embodies a braided structure of parallel plots inherited from television serials. Adejunmobi describes this form of movie as a "short serial": unlike Hollywood sequels, in which the first part reaches a self-sufficient resolution, in Nigerian multipart movies the first part ends at a crisis point, with the central secret or tension unresolved; but since the unstable video film market does not guarantee the long-term relationship with consumers that television or newspapers do, this serial form must be sharply limited in scope, normally to two or four episodes (Adejunmobi 2003).[7]

Once English-language production was established, there was a massive influx of people from all over southern Nigeria who had been making television serials, notably Amaka Igwe and Zeb Ejiro, his brother Chico, and their associates. Igwe's *Violated* (1996), featuring the stars of her popular television serial *Checkmate*, sold a record 150,000 copies and set the standard for sophisticated writing of a sort related to international prime time serials and telenovelas. (Igwe was a television writer and producer before she became a director.) It also set the standard for classy settings and a deliberate appeal to an up-market audience. The 1990s was a period of explosive growth in Nollywood, and it was, as people complained, an "all-comers affair." But the new industry was unquestionably led by the cohort of directors and actors who had come over from television. They were concentrated in the Lagos neighborhood of Surulere.

They established, as a central genre, the "family film," which centers on tensions arising within marriages. The typical setting was in a middle- or upper-middle-class Lagos neighborhood, relatively "detribalized" and naturally speaking English. This image of the good life that most Nigerians aspire to—expensive cars, cell phones, big televisions, a spacious house in which a modern nuclear family takes meals together around a dining room table—was designed to appeal to a multiethnic national market. It turned out that this generalized image appealed to people across

the African continent and beyond, though at first Nollywood films spread abroad without the producers being aware of it, in the luggage of travelers, in the loads of merchants, or through the agency of pirates.

The problems besetting these families often involve extramarital affairs, fertility issues, cruel twists of fate, or pressures from the extended family. Sometimes the nuclear family, and the companionate marriage at its core, must resist pressures from retrograde rural relatives, perhaps for the husband to take a second wife since his spouse is being slow to produce a male child; sometimes pathologies within the nuclear family require the intervention of traditional wisdom or spiritual forces.

As Pierre Barrot has observed, unlike the Latin American telenovelas and American soap operas that are popular on Nigerian television, Nollywood films do not turn away from social problems and in fact dwell on them (Barrot 2009, 64–65). Poverty and economic dislocation, social and political corruption, deficient social services—such things appear constantly. We might also note the contrast with Jyotika Virdi's characterization of Bollywood films: "Despite its permeating Indian culture, Hindi cinema's stylistic conventions are paradoxically in complete disjunction from everyday reality: the films use dialogues instead of speech, costumes rather than clothes, sets and exotic settings, and lavish song and dance routines—hardly everyday familiar surroundings" (Virdi 2003, 2). However extravagant the settings of Nollywood films sometimes are, they are always shot on location—the budgets cannot pay for studio time—and the realism of location shooting permeates and grounds the Nollywood aesthetic.

Around 2000, Nollywood's center of gravity shifted toward the east. In the early years of the industry, nearly all films were shot in or around Lagos, but in the late 1990s filmmakers began to take their productions to Enugu and other places in eastern Nigeria that were much cheaper and more tranquil than Lagos. The new genre of the "cultural epic"—films set in the precolonial past and therefore requiring thatched-roofed villages that were hard to find around Lagos, but could be found or cheaply constructed in Igboland—encouraged this move, as did the genre of the "village film," set in Igbo towns and villages. Some village films express the acute social and spiritual turmoil of contemporary Nigeria, with shrines of indigenous deities being destroyed by Bible-wielding Pentecostals or pillaged of their carved masks to be sold on the international art market (until the offended deity takes his revenge). Other village films overlap with the "vigilante films" that chronicled the brief flourishing of the Bakassi Boys, a vigilante group that began in the eastern Nigerian city of Aba and spread to the great commercial city of Onitsha

and other places, combating, with their magical machetes and amulets that shine in the presence of evil-doers, armed robbers and the cabals of wicked "big men" (who often practiced money rituals) that held terrified towns in their grip (McCall 2004). Still other village films overlap with the genre of comedy, which became hot commercially after the turn of the millennium. By coincidence, the comedians whose popularity drove the comedy boom—Nkem Owoh ("Osuofia"), John Okafor ("Mr. Ibu"), Chinedu Ikedieze ("Aki") and his partner Osita Iheme ("Pawpaw"), Patience Ozokwor ("Mama G."), and others—all came from Enugu.

Onitsha had always been second only to Lagos as a movie distribution center, and Onitsha-based marketers became increasingly important in funding films. Improved filmmaking technology—digital cameras and high-powered, easily-learned editing software—encouraged them to think they could do without the Lagos-based, often television-trained Nollywood establishment, and they became much more involved in the making of films as producers or in other roles. Asaba, a quiet (and cheap) city right across the Niger River from Onitsha, became popular as a place to shoot—by some estimates, more than half of all Nollywood films are now made there.

Nollywood is fundamentally one system with several nodes. It is normal for a marketer with offices in Onitsha and in Idumota and Alaba Markets in Lagos to hire a Lagos-based producer, director, and two or three stars for a film shot in Asaba with locally based technicians and actors. But there are differentiations within this system. The term "Asaba films" is used to describe a kind of film produced by the Onitsha-Asaba axis: their budgets average $20,000, a third that of Lagos films; none of the personnel have professional training; the films go straight to the VCD market, relying on word of mouth recommendations by video shop salesmen or a glimpse of the famous faces on the jacket as a hawker shoves the film in the face of a motorist stuck in a traffic jam. A Lagos producer is more apt to organize a publicity campaign involving a premier and other screenings before the film is released on VCD, trailers are shown on television, and celebrity gossip and reviews appear in newspapers and on popular blogs. Sales of rights for television broadcast, Internet streaming, and North American DVD distribution may be integral to the Lagos producer's business calculations.

Christian videos are another, semiautonomous sector of Nigerian film production. Christian influence is pervasive in Nollywood—it is standard for movies to end with a title declaring "To God Be the Glory"—but from early on there have been Christian groups making videos for evangelical reasons, which have their own

particular modes of organization (Ogunleye 2003b; Oha 2000, 2002; Ukah 2003, 2011). Most of these groups began as church drama troupes and are still amateur. But one of the most powerful of Nigerian film producers is Helen Ukpabio, a self-confessed former witch turned evangelist who has built up one of the largest congregations in West Africa, with churches in Calabar, Lagos, and Accra. She writes, acts in, and sometimes directs films, such as *End of the Wicked* (1999) and *Highway to the Grave* (2003), working with important Nollywood directors and stars and releasing her films through the Nollywood distribution system but also selling them in large numbers to her congregations in their churches (Okome 2004, 2007, and personal communication). As an element in the Nollywood commercial system, Christian films seem to have declined lately, but Pentecostal churches are an enormously powerful institution in contemporary Africa, and evangelism through video feature films remains an important strategy within them.

Hausa Films

Hausa-language film production, centered in the northern Nigerian city of Kano, is more different and detached from southern Nigerian Nollywood than is Yoruba film production or, for that matter, the Ghanaian industry. The same distribution system carries Nollywood, Yoruba, and some Ghanaian films, but Hausa films are never included. To international audiences, except for the Hausa- and Yoruba-speaking populations of neighboring countries, "Nigerian video" means English-language, Nollywood films—most foreigners are unaware of the Hausa and Yoruba branches of the Nigerian industry (or were, before the advent of the Africa Magic channels in those languages), though between them they account for more than half of Nigerian film production.

Hausa filmmaking began with two social bases: one was amateur drama groups, the other authors of the pamphlet love stories known as "soyayya," who would hire television-trained personnel to make films (Larkin 2000; Y. Adamu 2002). It has since grown into a large, professionalized industry (Adamu et al. 2004). Hausa videos are locked in a sometimes tense negotiation with the conservative norms of Hausa culture and of Islam (Adamu 2010a; McCain 2013). The filmmakers see themselves as exponents of both Hausa culture and Islam, offering culturally appropriate entertainment to their audiences, but the stories of romantic love that are the uniform subject of their films are also active interventions in social debates

over issues like polygamy, the freedom of children to choose their spouses, and so on (Larkin 1997, 2000; Adamu 2009). The introduction of Sharia'a law in Kano State in 2001 was followed by a moratorium on filmmaking and then by the creation of a new Kano State censorship board, which, for example, bans any touching between the sexes in films (Adamu 2004; McCain 2013). Couples demonstrate their affection, then, by singing together, or singing separately and being spliced together. The influence of Indian films, which have always been popular in northern Nigeria, is strong (Adamu 2007a, 2007b, 2011)—stronger than the pull of Hollywood films, American soap operas, and Latin American telenovelas, which help to mold the aesthetic of Nollywood and Ghana. As in India, but unlike in Nollywood or Ghana, there is a large market for music cassettes of film music (Adamu 2007, 2010b).

The Nollywood juggernaut has tended to draw everyone into its orbit. Hausa filmmaking is in some sense a deliberate reaction against the wilder, profane excesses of Nollywood, but Nollywood films are sold in the north, and there is a widespread awareness of them (McCain 2012; Adamu 2013). On the margins of northern Nigeria, in Kaduna and Jos and in Kano's Sabon Gari (the "stranger's town" inhabited by Igbos and Yorubas), films have been made in Hausa that closely resemble Nollywood models, such as Suleiman Sa'eed's *Nasara (Victory): A Violent Love Story* (2001) and Izu Ojukwu's *Jan Wuya* (2001).[8] When the Kano State Government temporarily banned film production in Kano, the filmmakers dispersed to Jos, Kaduna, Sokoto, and Abuja. *Confusion Na Wa* (2013), directed by Kenneth Gyang and produced by Tom Roland-Rees, is an example of "Middle Belt" filmmaking that straddles north and south: Gyang and his director of photography, Yinka Edwards, are graduates of the National Film Institute in Jos, and the film features Ramsey Nouah, one of the biggest Nollywood stars, and Ali Nuhu, the biggest Hausa industry star.

Ghana Again

The Ghanaian industry and Nollywood have always been in contact with one another (for an overview of this relationship, see Aveh 2014), though the relationship is unequal: Ghanaian films tend to get lost in the huge Nigerian market, and Nigerian films threatened at a certain point at the beginning of the new millennium to smother Ghanaian production altogether. The Ghanaian video industry shrank from some fifty producers in the mid-1990s to a dozen in 2001 and, Garritano reports, to as

few as three by 2005 (Garritano 2008, n.9). This was the result of an overwhelming invasion of Nigerian films and of the collapse of revenues from theatrical screenings. Ghana had had a system of screening new films in a chain of government-owned cinemas, which gave filmmakers a guaranteed profit and was the envy of Nigerian producers. But then television stations broke their agreement not to program Nigerian and Ghanaian films in the evenings when the cinemas were doing their business, and the audiences decided to stay home and watch films for free.

The Ghanaian market is far smaller than Nigeria's, so sales and therefore budgets for Ghanaian films fell short of even the tiny Nigerian numbers; the consequence was lower production values in Ghanaian films. Ghanaian filmmakers also found it hard to compete with the brasher, racier, more extravagant, and more violent content in Nollywood productions, which Ghanaian audiences found both shocking and mesmerizing. (As Ghanaian filmmakers complained, their films had to pass through the Ghanaian censors, while imported Nigerian ones did not.) Family melodrama was at this point even more dominant as a genre than in Nigeria because such films are cheaper to make than other genres practiced by the Nigerians, such as crime films and cultural epics. The ghosts and orphans who so densely populate Ghanaian highlife songs and the dramatic performances of the Ghanaian Concert Party stage tradition continue to weep their copious tears alongside mistreated wives and daughters-in-law and erring husbands (for valuable thematic surveys of early Ghanaian films, see Aveh 2000 and Sutherland-Addy 2000).

Ghanaian films reemerged by pursuing several different strategies. Filmmaking in Accra became highly consolidated around six main production companies, known as the "G-6," that coordinated their efforts, amassed a considerable infra-structure, and began to churn out films at a great rate (Carmela Garritano, personal communication). Socrate Safo's studio system has already been mentioned. If Safo's films correspond roughly to the Nigerian "Asaba films," the Nigerian Amaka Igwe, who moved back and forth between television and making high-end video films, has her Ghanaian counterpart in Veronica Quarshie. A young director, Shirley Frimpong-Manso, has been making slick films in the same mold; her *A Sting in a Tale* (2009) displays a fresh, witty, auteurist sensibility as she works with material—ghosts and the travails of the unemployed—that could hardly be more typical, or more rooted in West African film culture.

Meanwhile, very low-budget films began to be produced in Kumasi (hitherto film production had been almost entirely confined to Accra), made in the Twi language and aiming, successfully, at capturing a local market (Edmondson 2011).

(There had been a few earlier experiments with making films in Twi, notably those of Kofi Yirenkyi and the performances of the late standup comic Bob Santo shot by Socrate Safo.)

And the relationship with Nollywood began to work in the Ghanaians' favor. Ghanaian filmmakers had complained that their market was swamped by Nigerian films while Nigerian distributors were reluctant to pick up Ghanaian ones, and that coproductions meant a few Ghanaian actors were paid insultingly small amounts to lend their faces to productions controlled by Nigerians. But in 2006 and 2007 the Nigerian director Frank Rajah Arase made two films in Ghana, *Beyoncé, the President's Daughter* (2006) and *Princess Tyra* (2007), that exploited the luxurious mansions and shopping malls of Accra's construction boom (a result of neoliberal economic policies) to out-glamour the Nigerians. These films also showcased several of a cohort of young actors—Van Vicker, Majid Michel, Jackie Appiah, Nadia Buhari and Yvonne Nelson—who crossed over to Nollywood and became some of its biggest stars. Vicker and Michel, who were classmates at Accra's most elite secondary school and who both have a European parent and light complexions, are the current embodiments of Nollywood male cosmopolitan romantic suavity.

Where Is This Going?

The video industry has grown like kudzu, the invasive vine that now covers much of the southeastern United States, ineradicably carpeting Nigeria and sending creepers off toward the horizon in every direction but without creating any large capitalist structures of its own. The central, enduring paradox of the Nigerian film industry is that it is a juggernaut composed of tiny production outfits, in great contrast to other regional hegemons such as Mexico's Televisa or Brazil's Globo TV, which are responsible for many of the telenovelas seen in Africa and around the world. Even the largest producers run very modest operations and can claim only a small share of the market. Until very recently, there were no large-scale investors, and filmmakers still generally do not have access to funding through banks or other formal-sector financial institutions. This situation began to change dramatically around 2014, when Africa Magic, other channels carried on the DStv platform, and the dominant Internet streaming company iROKO Partners ambitiously launched into the production of original films and televisions serials in Lagos (Haynes 2016a).

The same set of blockages has kept the industry remarkably the same over the years, in spite of its enormous growth. Distribution is largely controlled by marketers who are bitterly accused by the filmmakers of being mere traders aiming at immediate, short-term profits, who have no knowledge of or interest in cinema, and who do not act as real distributors willing to pay for publicity campaigns. Since the marketers often put up the money for productions, they are in a position to impose actors and stories, which leads to constant repetition of previous successes until they are utterly worn out. Even when the marketers are not the financiers, they can kill films that do not interest them. In spite of the enormous growth and the hundreds of small producers, therefore, there is an often-expressed sense that the movie industry is tightly controlled by a small mafia, and that the industry suffers from stagnation in the midst of overproduction.

Cheating is endemic within the distribution system, and there is no mechanism for the thousands of video clubs to return royalties from their rentals to the filmmakers, thereby depriving them of what should be their most lucrative revenue stream. The export market, which has always mostly been in the hands of pirates, also normally returns little or nothing to the filmmakers. Television broadcast and Internet streaming rights are sold for such small amounts that they do not compensate filmmakers for the reduction in the sale of discs that they have caused (Jedlowski 2013; Haynes 2014; Adejunmobi 2014).

And generally there are the difficulties of accomplishing anything in the roiling chaos that is Nigeria. The "epileptic" character of the national electricity supply is the most salient of problems and accounts for the habitual roar of generators in the background of Nigerian films—if not the filmmaker's own generator (there are only a few in the country that are baffled for sound) then those of the neighbors. The seriocomic adventure of trying to make a film in Nigeria is nicely captured in the spate of documentary films that appeared around 2007 (*This Is Nollywood, Welcome to Nollywood, Nollywood Babylon*), which also convey the depth and power of the filmmakers' commitment to express themselves and the ambient poverty that explains why so many young Nigerians chase dreams in this hard business.

The Nigerian government has taken steps to intervene in the industry, but, so far, without much effect. The government's initial indifference gradually gave way to an unstable mixture of pride and shame, as it had to admit that Nollywood was by far the most important force in determining Nigeria's image abroad and that the film industry had become a major industry and source of employment. In his 2004

budget speech, President Obasanjo identified the film industry as one of the key drivers of national economic development, and soon after he attended the premier of a Nollywood film, Kingsley Ogoro's *Across the Niger* (2004). The current president, Goodluck Jonathan, has taken a personal interest in Nollywood since he was a state governor hosting the African Movie Academy Awards, the most important of a number of annual film festivals and awards ceremonies.

In 2007, the National Film and Video Censors Board announced a new framework for film distribution that was designed to formalize the business so that it could attract formal-sector investors (National Film and Television Censors Board 2007; Obiaya 2013). But the informal-sector marketers who built and run Nollywood saw these requirements—that they not only keep books but demonstrate a certain level of capitalization and have legal representation, for example—as a way of putting them out of business, and they resisted. The result was a protracted standoff, a temporary sharp decline in film production, and not much change. The banks, corporations, and businessmen that the authorities were hoping would invest in the industry never appeared, partly because of the global economic crisis but mostly because potential investors realized they did not have the expertise to negotiate the difficult terrain of the actually existing film business.

In 2010, the government announced a $200 million fund to encourage the entertainment business, but again, the cultural gap between Nollywood and the government has prevented much of anything from happening. As of 2013, no filmmaker based in Nigeria had managed to deal with the daunting paperwork and meet the requirements for collateral in order to get a loan.

The first loan made from this fund was to a company (FilmHouse Cinemas) set up by a group of Nigerians who had recently returned to Lagos from London, where they worked for the Odeon cinema chain. They used the money to open new multiplex cinemas. The security situation, which had caused cinemas to close in the 1980s, is much better in most places, and some sectors of the society are profiting from an economy that has been growing at 7 percent a year for a decade. Multiplexes have begun to appear in upscale shopping malls, and there are plans for many more. There is a lot of talk about smaller, cheaper community cinemas, to be located in popular neighborhoods. People talk of there being a thousand screens in Nigeria within a decade. The potential profits are enormous. Nollywood would have a far larger revenue stream than it has ever had, and a more dependable one, largely immune to piracy. Larger budgets and the challenge of making films that are fit for big screens should lead to steady improvements in quality.

A "New Nollywood" has already appeared, of films made more slowly and carefully, with larger budgets, usually by filmmakers with more professional training than has been the Nollywood norm (Haynes 2014; Bud 2014). Their complex business model is based, precariously, on screenings at the handful of new Nigerian cinemas, on premiers at the London Odeon cinemas and elsewhere overseas, on sales of foreign DVD distribution, television broadcast, Internet streaming rights, and eventual broadcast and release on disc in Nigeria. The two most famous of these New Nollywood productions, Kunle Afolayan's *The Figurine* (2009) and Mahmoud Ali-Balogun's *Tango with Me* (2010), were both rescued while in production by grants from telecom companies operating in Nigeria—rare instances of corporate support for Nigerian filmmaking.

In 2012, Ali-Balogun and Afolayan were invited to a film festival in Rio de Janeiro, along with two of the founders of Nollywood, Zeb Ejiro (one of the television directors who made the transition to video films) and Bond Emeruwa (for years the president of the Directors Guild of Nigeria and the central character in the documentary *This Is Nollywood*). The four of them are used to hearing about the system of European support that underlies most of the films that are shown at FESPACO, and now they were learning about the even more generous support the Brazilian government gives its national cinema. Tax laws require corporations to channel large amounts of money into supporting culture, including filmmaking; the government requires a percentage of Brazilian content in cinemas and on television; it underwrites the ticket price for Brazilian films; it funds studies of why Brazilian audiences would rather go to Hollywood movies rather than Brazilian ones.

The old-school Nollywood directors had endured decades in the grind of low-budget, fast-paced filmmaking with narrow profit margins. Ejiro goes back and forth between film and television, as the film industry sometimes does not provide a living. The New Nollywood directors had still not made back the money they had invested in the films being shown in the festival. Both of them had taken large risks: it is normal for New Nollywood directors to gamble with their life savings and perhaps put up their houses as collateral on a bank loan. Each film project is an unpredictable and dangerous adventure; if it fails, it is a large personal disaster. All four of the directors have spent years as advocates for the film industry, going to endless meetings, trying to get the Nigerian government to put the structures in place that would permit the industry to develop.

But all four, old Nollywood and new, were completely united and vehement in their rejection of the kind of luxurious official support they were hearing about.

They were not interested in filmmaking that is based on grants, the filmmakers supporting themselves not from the profits their films have earned but through funding provided by a cultural bureaucracy for the process of filmmaking. They were proud to be commercial filmmakers, utterly dependent on their instinct for what an audience, an African audience, would want to see. They said this relationship with their audience kept them honest.

Digitalization is rapidly eroding the technological distinction between celluloid film and video; the construction of multiplexes in Nigeria is eroding the distinction between "home videos" and cinema. But the commercial orientation of Nollywood seems permanent, and the rich film culture Nollywood has established in 10,000 films—a whole array of stars, genres, and themes—will surely endure and continue to influence the culture of the whole continent.

NOTES

1. Multichoice, the parent company, sponsored a research project on the Nollywood audience and the Nollywood model; the results of the research were presented at the 2012 Durban Conference of the International Association for Media and Communication and published as a special issue of *Journal of African Cinemas* edited by Matthew H. Brown and Nyasha Mboti (Brown and Mboti 2014).

2. Such rapid fluctuations are typical of African popular culture and its assimilation of foreign forms. For parallels in African music industries, see Charry 2012 and the contributors to his edited volume.

3. How many? Two hundred million? Three hundred million? More? As far as I know, no one has dared to try to calculate the size of the audience for African video films. Because of the geographical dispersal and mostly "informal" character of the African video films, all the numbers involved—of the size of the audience, the number of films produced, and the profits—are very elusive.

 Nollywood is centered in a city whose population is variously estimated by official sources as 15 or 21 million. The number of films registered by the National Film and Video Censors Board (NFVCB) is the most solid figure available; on the basis of NFVCB publications including Abua, 2002, 2004; Gana and Edekor, 2006. I calculate that between 1994 and the end of 2010, Nigeria (including Nollywood and the Yoruba and Hausa industries) had produced over 14,000 video films. Since the 2007 standoff between the NFVCB and the film industry described below, the NFVCB has become a much less useful and reliable source of information.

There is probably an element of irrational exuberance in some of the figures bandied about even in normally sober publications like *The Economist* for revenues (US$200–300 million a year in sales) or the number of people employed by the industry (one million, split equally between production and distribution, *The Economist* says, quoting the National Film and Video Censors Board, which talks of filmmaking being the second largest employer in the country after agriculture) "Nollywood Dreams" 2006.

4. Inexpensive and easily operated video cameras were introduced into both Nigeria and Ghana in the 1970s, and businesses were soon established to record important social occasions for prosperous clients. Femi Shaka, writing about Nigeria, points out that still photographers were the first to exploit this new possibility, and he characterizes the typical "video man" as "a semi-literate urban youth" (Shaka 2003).

5. There is by now a large literature on the "modernity of witchcraft" in Africa; seminal texts include Comaroff and Comaroff 1993, 2000; and Geschiere 1997.

6. For a fuller profile of Nnebue, see Haynes 2007a. For a much more extended treatment of *Living in Bondage* and *Glamour Girls*, see Haynes 2016b.

7. The Ghanaian Veronica Quarshie, who also directs television serials, extended her *Stab in the Dark* (1999) into five films.

8. I owe this point to Matthias Krings, to whom I am also grateful for translating the films for me.

FILMOGRAPHY

Addelman, Ben, and Samir Mallal. 2008. *Nollywood Babylon.* AM Pictures, Canada.

Afolayan, Kunle. 2009. *The Figurine.* 2009. Golden Effects, Nigeria.

Akuffo, William. 1987. *Zinabu.* World Wide Motion Pictures, Ghana.

———. 1991. *Diabolo.* World Wide Motion Pictures, Ghana.

Ali-Balogun, Mahmood. 2010. *Tango with Me.* Mahmood Ali-Balogun, Nigeria.

Ansah, Kwaw. 1988. *Heritage Africa.* Film Africa, Ghana.

Arase, Frank Rajah. 2006. *Beyoncé: The President's Daughter.* Venus Films, Ghana.

———. 2007. *Princess Tyra.* Venus Films, Ghana.

Benson, Teco. 1999. *End of the Wicked.* Liberty Films, Nigeria.

———. 2003. *Highway to the Grave.* Liberty Films, Nigeria.

Frimpong-Manso, Shirley. 2009. *A Sting in a Tale.* Sparrow Productions, Ghana.

Gyang, Kenneth. 2013. *Confusion Na Wa.* Cinema Kpatakpata, Nigeria.

Igwe, Amaka. 1996. *Violated.* Moving Movies, Nigeria.

Kibinge, Judy. 2004. *Project Daddy.* Baraka Films, Kenya.

Meltzer, Jamie. 2007. *Welcome to Nollywood*. National Black Programming Consortium, United States.

Obi Rapu, Chris (Vic Mordi). 1992. *Living in Bondage*, Part 1. NEK Video Links, Nigeria.

Ojukwu, Izu. 2001. *Jan Wuya*. Tropicon Media, Nigeria.

———. 2004. *Across the Niger*. Kingsley Ogoro Production, Nigeria.

Onukwufor, Chika (Christian Onu). 1993. *Living in Bondage*, Part 2. NEK Video Links, Nigeria.

———. 1994, 1996. *Glamour Girls*. NEK Video Links, Nigeria.

Owusu, John. 1985. *Abyssinia*. Allen Gyimah, Ghana.

Quarshie, Veronica. 1999. *Stab in the Dark*. Princess Films, Ghana.

Sacchi, Franco. 2007. *This Is Nollywood*. Eureka Film Productions, United States.

Sa'eed, Suleiman. 2001. *Nasara (Victory): A Violent Love Story*. Rahama Film Productions, Nigeria.

Safo, Socrate. 1989. *Unconditional Love*. Movie Africa, Ghana.

BIBLIOGRAPHY

Abua, Ferdiand O., ed. 2002. *Film and Video Directory in Nigeria*. Vol. 1. Abuja, Nigeria: National Film and Video Censors Board.

———, ed. 2004. *Film and Video Directory in Nigeria*. Vol. 2. Abuja, Nigeria: National Film and Video Censors Board.

Adamu, Abdalla Uba. 2007a. "Currying Favour: Eastern Media Influences and the Hausa Video Film." *Film International* 5(4): 77–89.

———. 2007b. *Transglobal Media Flows and African Popular Culture: Revolution and Reaction in Muslim Hausa Popular Culture*. Kano: Visually Ethnographic Productions.

———. 2009. "Media Parenting and the Construction of Media Identities in Northern Nigerian Muslim Hausa Video Films." In *Media and Identity in Africa*, ed. Kimani Njogu and John Middleton, 171–84. Bloomington: Indiana University Press.

———. 2010a. "Islam, Hausa Culture, and Censorship in Northern Nigerian Video Film." In *Viewing African Cinema in the Twenty-First Century*, ed. Ralph Austen and Mahir Saul, 63–73. Athens: Ohio University Press.

———. 2010b. "The Muse's Journey: Transcultural Translators and the Domestication of Hindi Music in Hausa Popular Culture." *Journal of African Cultural Studies* 22(1): 41–56.

———. 2011. "Transnational Flows and Local Identities in Muslim Northern Nigerian Films." In *Popular Media, Democracy, and Development in Africa*, ed. Herman Wasserman, 223–35. New York: Routledge.

———. 2013. "Transgressing Boundaries: Reinterpretation of Nollywood Films in Muslim

Northern Nigeria." In *Global Nollywood: Transnational Dimensions of an African Video Film Industry*, ed. Matthias Krings and Onookome Okome, 287–305. Bloomington: Indiana University Press.

Adamu, Abdalla Uba, Yusuf M. Adamu, and Umar Faruk Jibril, eds. 2004. *Hausa Home Videos: Technology, Economy and Society*. Kano: Centre for Hausa Cultural Studies/Adamu Joji Publishers.

Adamu, Yusuf M. 2002. "Between the Word and the Screen: A Historical Perspective on the Hausa Literary Movement and the Home Video Invasion." *Journal of African Cultural Studies* 15(2): 203–13.

Adejunmobi, Moradewun. 2002. "English and the Audience of an African Popular Culture." *Cultural Critique* 50:74–103.

———. 2003. "Video Film Technology and Serial Narratives in West Africa." In *African Video Film Today*, ed. Foluke Ogunleye, 51–68. Manzini, Swaziland: Academic Publishers.

———. 2014. "Evolving Nollywood Templates for Minor Transnational Film." *Black Camera* 5(2): 74–94.

Adesanya, Afolabi. 1992. *The Nigerian Film/Tv Index*. Lagos: A-Productions.

Adesokan, Akin. 2009. "Practising 'Democracy' in Nigerian Films." *African Affairs* 108/433: 599–619.

Aveh, Africanus. 2000. "Ghanaian Video Films of the 1990s: An Annotated Select Filmography." In *Matatu 21–22: Fontomfrom: Contemporary Ghanaian Literature, Theatre and Film*, ed. Kofi Anyidoho and James Gibbs, 283–300. Athens, GA: Rodopi.

———. 2014. "The 'Nigerianization' of Ghanaian Eyes." *Journal of African Cinemas* 6(3): 109–22.

Balogun, Francoise. 1987. *The Cinema in Nigeria*. Enugu, Nigeria: Delta.

Barber, Karin. 1982. "Popular Reactions to the Petro-Naira." *Journal of Modern African Studies* 20(3): 431–50.

———. 1987. "Popular Arts in Africa." *African Studies Review* 30(3): 1–78.

———. 2000. *The Generation of Plays: Yoruba Popular Life in Theater*. Bloomington: Indiana University Press.

Barrot, Pierre. 2009. "Video: The Nigerian Experience." In *Nollywood: The Video Phenomenon in Nigeria*, ed. Pierre Barrot, 1–59. Bloomington: Indiana University Press.

Becker, Heike. 2013. "Nollywood in Urban Southern Africa: Nigerian Video Films and Their Audiences in Cape Town and Windhoek." In *Global Nollywood: Transnational Dimensions of an African Video Film Industry*, ed. Matthias Krings and Onookome Okome, 179–98. Bloomington: Indiana University Press.

Böhme, Claudia. 2013. "Bloody Bricolages: Traces of Nollywood in Tanzanian Video Films."

In *Global Nollywood: Transnational Dimensions of an African Video Film Industry*, ed.
Matthias Krings and Onookome Okome, 327–46. Bloomington: Indiana University Press.

Bourgault, Louise M. 1995. *Mass Media in Sub-Saharan Africa*. Bloomington: Indiana
University Press.

Brown, Matthew H., and Nyasha Mboti. 2014. "Nollywood's 'Unknowns': An Introduction."
Journal of African Cinemas 6(1): 3–9.

Bryce, Jane. 2013. "'African Movies' in Barbados: Proximate Experiences of Fear and Desire."
In *Global Nollywood: Transnational Dimensions of an African Video Film Industry*, ed.
Matthias Krings and Onookome Okome, 223–44. Bloomington: Indiana University Press.

Bud, Alexander. 2014. "The End of Nollywood's Guilded Age? Marketers, the State and the
Struggle for Distribution." *Critical African Studies* 6(1): 91–121.

Charry, Eric. 2012. "A Capsule History of African Rap." In *Hip Hop Africa: New African Music in a
Globalizing World*, ed. Eric Charry, 1–25. Bloomington: Indiana University Press.

Comaroff, Jean, and John Comaroff, eds. 1993. *Modernity and Its Malcontents: Ritual and Power
in Postcolonial Africa*. Chicago: University of Chicago Press.

———. 2000. "Millenial Capitalism: First Thoughts on a Second Coming." *Public Culture*
12:291–343.

Diawara, Manthia. 1992. *African Cinema: Politics and Culture*. Bloomington: Indiana University
Press.

Edmondson, Scott M. 2011. "Akan-Esque Niches and Riches: The Aesthetics of Power and
Fantastic Pragmatism in Ghanaian Video Films." *Critical Interventions* 8:98–119.

Ekwuazi, Hyginus. 1991. *Film in Nigeria*. 2nd ed. Jos: Nigerian Film Corporation.

Esan, Oluyinka. 2009. *Nigerian Television: Fifty Years of Television in Africa*. Princeton, NJ: AMV
Publishing.

Fabian, Johannes. 1978. "Popular Culture in Africa: Findings and Conjectures." *Africa* 48(4):
315–34.

Gana, D. R., and Clement D. Edekor, eds. 2006. *Film and Video Directory in Nigeria*. Vol. 3.
Abuja, Nigeria: National Film and Video Censors Board.

Garritano, Carmela. 2008. "Contesting Authenticities: The Emergence of Local Video
Production in Ghana." *Critical Arts* 22(1): 21–48.

———. 2013. *African Video Movies and Global Desires: A Ghanaian History*. Athens: Ohio
University Press.

Geschiere, Peter. 1997. *The Modernity of Witchcraft: Politics and the Occult in Postcolonial Africa*.
Charlottesville: University Press of Virginia.

Haynes, Jonathan. 1995. "Nigerian Cinema: Structural Adjustments." *Research in African
Literatures* 26(3): 97–119.

————. 2007a. "Nnebue: The Anatomy of Power." *Film International* 5(4): 30–40.

————. 2007b. "Nollywood in Lagos, Lagos in Nollywood Films." *Africa Today* 54(2): 130–50.

————. 2007c. "Nollywood: What's in a Name?" *Film International* 5(4): 106–8.

————. 2014. "'New Nollywood,' or Kunle Afolayan." *Black Camera* 5(2): 53–73.

————. 2016a. "Neoliberalism, Nollywood and Lagos." In *Global Cinematic Cities: New Landscapes of Film and Media*, eds. Johan Andersson and Lawrence Webb, 59–75. New York: Wallflower Press/Columbia University Press.

————. 2016b. *Nollywood: The Creation of Nigerian Film Genres*. Chicago: University of Chicago Press.

Haynes, Jonathan, and Onookome Okome. 1998. "Evolving Popular Media: Nigerian Video Films." *Research in African Literatures* 29(3): 106–28.

Ibrahim, Jibrin. 2012. "Nigeria: Security, Development and National Transformation." *Ministry of Foreign Affairs*. Abuja, Nigeria.

Jedlowski, Alessandro. 2013. "From Nollywood to Nollyworld: Processes of Transnationalization in the Nigerian Video Film Industry." In *Global Nollywood: Transnational Dimensions of an African Video Film Industry*, ed. Matthias Krings and Onookome Okome, 25–45. Bloomington: Indiana University Press.

Jeyifo, Biodun. 1984. *The Yoruba Popular Travelling Theatre of Nigeria*. Lagos: Nigeria Magazine.

Katsuva, Ngoloma. 2003. "Nigerian Home Video Films and the Congolese Audience: A Similarity of Cultures." In *African Video Film Today*, ed. Foluke Ogunleye, 91–104. Manzini, Swaziland: Academic Publishers.

Krings, Matthias. 2008. "Conversion on Screen: A Glimpse at Popular Islamic Imaginations in Northern Nigeria." *Africa Today* 54(4): 45–68.

————. 2010. "Nollywood Goes East: The Localization of Nigerian Video Films in Tanzania." In *Viewing African Cinema in the Twenty-First Century*, ed. Ralph Austen and Mahir Saul, 74–91. Athens: Ohio University Press.

————. 2013. "*Karishika* with Kiswahili Flavour: A Nigerian Film Retold by a Tanzanian Video Narrator." In *Global Nollywood: Transnational Dimensions of an African Video Film Industry*, ed. Matthias Krings and Onookome Okome, 306–26. Bloomington: Indiana University Press.

Krings, Matthias, and Onookome Okome, eds. 2013. *Global Nollywood: Transnational Dimensions of an African Video Film Industry*. Bloomington: Indiana University Press.

Larkin, Brian. 1997. "Indian Films and Nigerian Lovers: Media and the Creation of Parallel Modernities." *Africa* 67(3): 406–40.

————. 2000. "Hausa Dramas and the Rise of Video Culture in Nigeria." In *Nigerian Video Films*, ed. Jonathan Haynes, 209–41. Athens: Ohio University Press.

————. 2002. "The Materiality of Cinema Theaters in Northern Nigeria." In *Media Worlds: Anthropology on New Terrain*, ed. Faye D. Ginsburg, Lila Abu-Lughod, and Brian Larkin, 319–36. Berkeley: University of California Press.

————. 2004. "Degraded Images, Distorted Sounds: Nigerian Video and the Infrastructure of Piracy." *Public Culture* 16(2): 289–314.

————. 2008. *Signal and Noise: Media, Infrastructure and Urban Culture in Northern Nigeria.* Chapel Hill, NC: Duke University Press.

Lasode, Oafemi. 1994. *Television Broadcasting: The Nigerian Experience (1959–1992)*. Ibadan: Caltop.

Martin, Angela. 1982. *African Films:The Context of Production*. London: BFI.

McCain, Carmen. 2012. "Video Exposé: Metafiction and Message in Nigerian Films." *Journal of African Cinemas* 4(1): 25–57.

————. 2013. "Nollywood, Kannywood and a Decade of Hausa Film Censorship in Nigeria: 2001 to 2011." In *Silencing Cinema*, ed. Daniel Biltereyst and Roel Vande Winkel, 223–40. New York: Palgrave Macmillan.

McCall, John C. 2004. "Juju and Justice at the Movies: Vigilantes in Nigerian Popular Videos." *African Studies Review* 47(3): 51–67.

————. 2007. "The Pan-Africanism We Have: Nollywood's Invention of Africa." *Film International* 5(4): 92–97.

Meyer, Birgit. 1998. "The Power of Money: Politics, Occult Forces, and Pentecostalism in Ghana." *African Studies Review* 41(3): 15–37.

————. 1999. "Popular Ghanaian Cinema and 'African Heritage.'" *Africa Today* 46(2): 93–114.

————. 2002. "Occult Forces on Screen: Representation and the Danger of Mimesis in Popular Ghanaian Films." *Etnofoor* 15(1–2): 212–21.

————. 2003. "Ghanaian Popular Cinema and the Magic in and of Film." In *Magic and Modernity: Interfaces of Revelation and Concealmen*, ed. Birgit Meyer and Peter Pels, 200–22. Stanford, CA: Stanford University Press.

————. 2004. "'Praise the Lord': Popular Cinema and Pentecostalite Style in Ghana's New Public Sphere." *American Ethnologist* 31(1): 92–110.

————. 2005. "Mediating Tradition: Pentecostal Pastors, African Priests and Chiefs in Ghanaian Popular Films." In *Christianity and Social Change in Africa: Essays in Honor of John Peel*, ed. Toyin Falola, 275–304. Durham, NC: Carolina Academic Press.

————. 2006. "Impossible Representations: Pentecostalism, Vision, and Video Technology in Ghana." In *Religion, Media, and the Public Sphere*, ed. Birgit Meyer and Annelies Moors, 290–312. Bloomington: Indiana University Press.

————. 2010a. "Ghanaian Popular Video Movies between State Film Policies and Nollywood."

In *Viewing African Cinema in the Twenty-First Century: Art Films and the Nollywood Video Revolution*, ed. Ralph Austen and Mahir Saul, 42–62. Athens: Ohio University Press.

———. 2010b. "'Tradition and Colour at Its Best': 'Tradition' and 'Heritage' in Ghanaian Video-Movies." *Journal of African Cultural Studies* 22(1): 7–23.

National Film and Video Censors Board. 2007. "Comprehensive Document on the Distribution, Exhibition and Marketing of Films and Video Works in Nigeria." Abuja, Nigeria: National Film and Video Censors Board.

"Nollywood Dreams." 2006. *The Economist*, July 29, 58–59.

Obiaya, Ikechukwu. 2013. "Taking Nigeria to the Movies: The Innovative Regulatory Role of the National Film and Video Censors Board." *Journal of African Media Studies* 5(3): 261–74.

Ogunleye, Foluke. 2003a. "Christian Video Film in Nigeria: Dramatic Sermons through the Silver Screen." In *African Video Film Today*, ed. Foluke Ogunleye, 105–28. Manzini, Swaziland: Academic Publishers.

———. 2003b. "Video Film in Ghana: An Overview." In *African Video Film Today*, ed. Foluke Ogunleye, 1–22. Manzini, Swaziland: Academic Publishers.

Oha, Obododimma. 2000. "The Rhetoric of Nigerian Christian Videos: The War Paradigm of *The Great Mistake*." In *Nigerian Video Films*, ed. Jonathan Haynes, 192–99. Athens: Ohio University Press.

———. 2002. "Yoruba Christian Video Narrative and Indigenous Imaginations: Dialogue and Duelogue." *Cahiers d'Études africaines* 165: 121–42.

Okome, Onookome. 2004. "Women, Religion and the Video Film in Nigeria." *Film International* 7(1): 4–13.

———. 2007. "'The Message Is Reaching a Lot of People': Proselytizing and Video Films of Helen Ukpabio." *Postcolonial Text* 3(2). http://postcolonial.org/index.php/pct/article/view/750/419.

Olusola, Segun. 1986. "Film-Tv and the Arts—the African Experience." In *Mass Communication in Nigeria: A Book of Reading*, ed. Onuora E. Nwuneli, 161–78. Enugu: Fourth Dimension.

Pype, Katrien. 2013. "Religion, Migration and Media Aesthetics: Notes on the Circulation and Reception of Nigerian Films in Kinshasa." In *Global Nollywood: Transnational Dimensions of an African Video Film Industry*, ed. Matthias Krings and Onookome Okome, 199–222. Bloomington: Indiana University Press.

Ricard, Alain. 1983. "Du Theater Au Cinema Yoruba: Le Cas Nigérian." *CinémAction* 26:160–67.

Shaka, Femi Okiremuete. 2003. "History, Genres, and Nigeria's Emergent Video Film Industry." *Black Renaissance/Renaissance Noire* 5(2): 51–64.

———. 2004. *Modernity and the African Cinema*. Trenton, NJ: Africa World Press.

Smith, Daniel Jordan. 2001. "Ritual Killing, 419, and Fast Wealth." *American Ethnologist* 28(4): 803–26.

Soyinka, Wole. 2003. *Death and the King's Horseman*. New York: Norton.

Sutherland-Addy, Esi. 2000. "The Ghanaian Feature Video Phenomenon: Thematic Concerns and Aesthetic Resources." In *Matatu 21–22: Fomtomfrom: Contemporary Ghanaian Literature, Theatre and Film*, ed. Kofi Anyidoho and James Gibbs, 265–82. Atlanta: Rodopi.

Tudesq, André-Jean. 1992. *L'afrique Noire Et Ses Télévisions*. Paris: Anthropos/INA.

Ukadike, Frank Nwachukwu. 1994. *Black African Cinema*. Berkeley: University of California Press.

Ukah, Asonzeh F.-K. 2003. "Advertising God: Nigerian Christian Video-Films and the Power of Consumer Culture." *Journal of Religion in Africa* 33(2): 203–31.

———. 2011. "Mediating Armageddon: Popular Christian Video-Films as a Source of Conflict in Nigeria." In *Displacing the State: Religion and Conflict in Neoliberal Africa*, ed. James Howard Smith and Rosalind I. J. Hackett, 209–39. Notre Dame, IN: University of Notre Dame Press.

Virdi, Jyotika. 2003. *The Cinematic Imagination: Indian Popular Films as Social History*. New Brunswick, NJ: Rutgers University Press.

Wendl, Tobias. 1999. "La Retour De L'homme Serpent: Films D'épouvante Realisés Au Ghana." *Revue Noire* 32:48–51.

Werner, Jean-François. 2006. "How Women Are Using Television to Domesticate Globalization: A Case Study on the Reception and Consumption of Telenovelas in Senegal." *Visual Anthropology* 19:443–72.

Egypt: Cinema and Society

Viola Shafik

With a total output of more than 3,000 full-length films since 1923, the Egyptian film industry, or the "Hollywood on the Nile," created a commercial and export-oriented genre cinema based on a local star system and on private investment. Since then, its primary customers have been the neighboring Arab-speaking countries. More recently, Egypt's cinematic output has been complemented by electronic media productions, including talk shows, quiz shows, variety shows, TV serials (*musalsalat*), and numerous Arab TV channels, in particular those of the cinema Arabian Peninsula, and this despite of an increasing competition in the Arab market and a visible diversification of products and services in the Arab media industries: Syria excelling in high-quality TV serials, Lebanon (during its regeneration phase until 2006) in the production of music clips and advertisements, and Dubai in running an effective, up-to-date media city that is much less restrictive and bureaucratic than Egypt's media city.

From the late 1920s, Egypt's industry relied on the "mass" appeal of its star system and succeeded in becoming the source of national pride and constant media concern, its billboards filling the streets of Egyptian and Arab cities. Moreover, as a technical achievement of a then-colonized people, it has also given self-esteem to

audiences in other Arab countries, such as Algerians, for example, during French occupation. Then, during the time of decolonization and the temporary spread of socialist ideology, Egyptian mainstream films started embodying decadence and cultural alienation to some of the more radical *cinéastes* in and outside of Egypt and thus became a battlefield for different ideological currents. As this did not affect the films' popularity among common Arab audiences, particularly the lower classes, quite unlike the European-funded *cinéma d'auteur* or art house films of the Maghreb and the Fertile Crescent that circulate in film festivals and Western art house theaters that started developing since the 1970s, a new polarization became evident: Western-oriented individualist high-brow culture as opposed to local trivial low-brow culture. This dichotomy was further enhanced by the fact that Egyptian films do not make it to any of the international A-festival competitions and very rarely to any of the special art house programs.

Many aspects of Egyptian cinema and its development seem worth discussing. For the purpose of this chapter, however, I start out with Egyptian cinema's rich history, its films and directors, its economic vagaries, and the changing political context. Subsequent discussion focuses on domestic and foreign markets for Egyptian films, the star system, and film audiences. What seems to me really worth exploring, though, are the social and political implications of different film genres, the formal characteristics and the reception of the three major genres—melodrama, realism, and action film—and their development over the years with regard to issues of class difference and social distinction.

Encounter with a New Medium, 1896–1925

Egypt's traditional excellence in the media field is due to several factors. It is rooted in a vivid theater movement that flourished in the late nineteenth century, and a music industry that developed during the 1920s and facilitated the spread of the Egyptian vernacular. Bowing to Arab customers' needs, with Levantine rhythms, characters, and locations in the 1940s and 1950s, and allowances for the moral conservatism of the Gulf region in the 1980s and the new morality and family orientation that has spread since, Egyptian film was able, just like the American studio film, to keep a strong local flavor, despite the fact that Hollywood has always been a source of open or hidden inspiration. Its beginnings, however, were very much related to Europe.

In 1896, only a few months after the initial screenings in Europe, films by the Lumière brothers were shown in Egypt. Already in 1897 the Cinématographe Lumière in Alexandria started to offer regular projections. The construction of special sites for screenings soon followed. By 1911, eleven movie theaters had been established in the two major Egyptian cities, Cairo and Alexandria. Starting in 1912, they provided Arabic translations for the foreign films.

In general, the first cinematic activities, as elsewhere in the Arab world, were undertaken by foreign, mostly European, residents. In 1907, the first "native" Egyptian documentaries, *The Visit of the Khedive 'Abbas Hilmi II at the scientific institute of the Sidi Abu al-'Abbas mosque/La Visite du khedive Abbas Helmi II à l'Institut scientifique de la mosque Sidi-Aboul-Abbas*, and *Festivités sportives au Collège des Frères/Sports festival at the Collège des Frères*, were shot by two acknowledged photographers from Alexandria, 'Aziz Bandarli and Umberto Dorès (Abou Chadi 1995, 18).

Many short fiction films made in the following years by Europeans were realized in cooperation with Egyptian actors, such as Fawzi al-Gazayirli, who starred with his troupe in Léonard La Ricci's *Madame Loretta* in 1919. The year 1923 witnessed the screening of Victor Rosito's full-length fiction film *In Tut Ankh Amon's Country/Fi bilad Tut 'Ankh Amun*.[1] Muhammad Bayumi, who was based in Alexandria, operated the camera. He became one of most prolific film pioneers: in 1923 he established his newsreel *Amun*, shot numerous documentaries, and directed his first short fiction screened in 1924, *Master Barsum Looks for a Job/al-mu'allim Barsum yabhath 'an wazifa*, the first native Egyptian to direct a short fiction film in the country.

The Emergence of National Cinema, 1925–1935

In 1925, the first national attempt of organized investment in the realm of cinema was undertaken by Talaat (Tal'at) Harb, a member of a nationalist-oriented group of entrepreneurs. As the founder and director of Misr Bank, he established in 1925 the *Sharikat Misr lil-sinima wa-l-tamthil* (Misr Company for Cinema and Performance), which was to produce advertising and information films. The company hired Bayumi as its director, bought his equipment, founded a laboratory, and issued the newsreel *Jaridat Misr/Egypt Journal*.

The first full-length feature film considered genuinely Egyptian, *Layla*, was produced, if not directed, by a native Egyptian, and released in November 1927. The Turkish director Wedad Orfi had persuaded the theater actress 'Aziza Amir to

finance the film. After a quarrel, Amir put Stéphane Rosti in charge of directing it. Production increased steadily after the release of this work and *Kiss in the Desert/ qubla fil-sahra'* (1928) by Ibrahim Lama, which followed only a few weeks later, so that the years 1927 and 1928 may be considered the real genesis of Egyptian cinema. Three full-length films made their way to the audience in 1928, among others the adaptation of Amin 'Atallah's popular theater play *Why Does the Sea Laugh?/al-bahr biyidhak lih?* by Rosti. From 1930 to 1931, seven full-length films were produced, seven were released in 1932, and another seven in 1933 (Qasim 2002, 14–22).[2.]

Production in these years was dependent on individual interest and moderate investment. The absence of institutional structures is one reason why foreign residents, indigenous minorities, and women dominated film production. 'Aziza Amir, Assia Daghir, Fatima Rushdi, Bahiga Hafiz, and Amina Muhammad acted, produced, and/or directed one or two films each. The Lebanese actress Assia Daghir, for example, released her first film in 1929, *Lady of the Desert/ghadat al-sahra'* by Wedad Orfi and Ahmad Galal. She remained for decades Egypt's largest producer, the spectacular *Saladin Victorious/al-nasir Salah al-Din*, directed by Youssef Chahine (Yusuf Shahin) in 1963, her most acclaimed production.

Another characteristic in the genesis of Egypt's filmmaking was the close relation to popular theater. In the course of the 1930s, the stars of popular Egyptian theater, Fawzi al-Gazayirli, Nagib al-Rihani, 'Ali al-Kassar, and Yusuf Wahbi, attained great influence. They appeared during the pre–World War II era and shortly after in a large number of feature films which were developed to present popular theater characters. After the introduction of sound, these performers contributed to the formulation of film dialogue, and at times to the script as well. Yusuf Wahbi came to direct numerous films. He was also the producer of *Zaynab* (1930) by Muhammad Karim, the first full-length feature film directed by a native Egyptian.

Sound, like elsewhere, was a decisive turning point for Egypt's film industry. It gave a unique chance to further local production by using the local vernacular and music, and to develop film genres, such as comedy and the musical, that rely essentially on language. The distribution of Egyptian films in the whole Arab world was facilitated by the immense popularity of Egyptian songs, which used to be distributed on discs in the region. This despite the strong linguistic barrier, namely the profound difference between the spoken Arabic dialects in both Arab Maghrib (West) and Mashriq (East)—to which Egypt belongs—and which render them mutually almost incomprehensible. In 1932, the first two sound films appeared almost simultaneously, *Sons of Aristocrats/awlad al-dhawat* by Yusuf Wahbi and

Song from the Heart/unshudat al-fu'ad by Mario Volpi. Although Mohsen (Muhsin) Szabo, an engineer of Hungarian origin, had succeeded in 1931 in constructing his own recording machine, the sound of the first Egyptian talkies was recorded in Europe.

The Consolidation of the Film Industry and Its Heydays, 1935–1952

The proper foundation of the Egyptian film industry was laid in 1934 when the Misr Bank under the management of Talaat (Tal'at) Harb established the fully equipped Studio Misr and films began to be entirely produced in Egypt. This studio, inaugurated in 1935, was actually not the first one to be established. Already between 1926 and 1931 Alvise Orfanelli, Yusuf Wahbi, and Togo Mizrahi had each created a small studio in Alexandria. Six further studios were established, and a total of 345 full-length features had been produced by 1948. Moreover, the foundation of Studio Misr was responsible for shifting the entire film production from Alexandria to Cairo, which became the main cultural metropolis of the country. New directors, mostly native Egyptians, appeared. The star system as well as a variety of film genres, first of all the musical, the melodrama, farce and comedy, the historical, and the Bedouin film, became more canonized during this period.

Unlike the major studios in the United States, Studio Misr was not able to dominate the Egyptian film industry. Rather, it seems to have worked as a catalyst for the rest of the Egyptian industry, as it set new technical and artistic standards. Its first production, released in 1936, was the musical *Widad* by Fritz Kramp starring the "Star of the Orient," singer Umm Kulthum. This film was the second historical spectacle produced in Egypt. It turned out to be a huge success, ran in cinemas for five weeks, and represented Egypt at the Venice Film Festival. The studio's following production, *Salama Is Fine/Salama fi khayr* (1937) by Niazi Mustafa, starring the popular comedian Nagib al-Rihani, was also very successful at the box office. Moreover, in 1939, Studio Misr produced *Determination/al-'azima* by Kamal Selim (Salim), which is considered by Egyptian critics to be one of the earliest realist attempts in Egyptian film. The directors who emerged through their work for Studio Misr were Ahmad Badrakhan, later known for his melodramatic musicals, and Niazi Mustafa, the most prolific Egyptian director with a total of more than a hundred films so far, as well as Kamal Selim, whose promising debut was cut short by an early death.

In contrast to earlier establishments, Studio Misr was equipped with various workshops, a laboratory, and sound studios offering the possibility to record sound and music. It employed several European specialists, among others two Germans, the director Fritz Kramp and the set designer Robert Scharfenberg, along with the Russian photographer Sami Brel. At the same time, it took care to provide native Egyptians with the required qualifications by sending them on scholarships to Europe. The directors Ahmad Badrakhan (Badr Khan) and Niazi Mustafa were among the beneficiaries.

After the end of World War II, the lifting of import restrictions and increased investments, undertaken among others by war profiteers, brought a sudden boom. Cinema became the most profitable industrial sector after the textile industry in terms of sales. Between 1945 and 1952, output doubled, reaching an average of forty-eight films a year, a pace that was more or less maintained until the early 1990s. Cinematic styles and techniques grew in sophistication. In 1950, color was introduced, but it took another fifteen to twenty years until the majority of Egyptian productions were shot in color.

Melodramatic musicals, comedy/farce, and to a lesser extent Bedouin films were the most prevalent genres of the time. In the late 1930s and early 1940s, Husain Fawzi, Ibrahim 'Imara, and Henri Barakat helped develop the first two genres, whereas Bedouin films were primarily the specialty of Ibrahim Lama and Niazi Mustafa. Barakat remained until the 1970s one of Egypt's most industrious and talented directors, known for some outstanding melodramas, musicals, and realist films. Kamil al-Tilmissani and Ahmad Kamil Mursi displayed a realist, if not socialist, orientation in their works dealing with the economy and the working class, whereas Anwar Wagdi (Wajdi), who directed his first film in 1945, contributed a dozen light musicals to Egyptian cinema. He was one of those who introduced a rather syncretistic genre that was characteristic of the post–World War II boom, operating with a multitude of contradictory elements such as comic acting in a basically melodramatic plot, creating a cheerful and entertaining mixture.

National Independence and the Nationalization of Cinema, 1952–1971

In 1952, the Free Officers led by Muhammad Naguib (Najib) and Gamal 'Abd al-Nasir (Nasser) seized power, abolished the monarchy, and declared the end of British interference in Egypt. This marked also a new era in the Egyptian film

economy, which was characterized now by state interference in the arts and industry, and the advent of new genres and topics, including a "Third Worldist" realist cinema. The whole development can be traced back to the time before the nationalist coup d'état, when works with a clear anticolonial stamp made their appearance, among others *A Girl from Palestine/fatat min Filastin* (1948) by Mahmud zu-l-Fiqar dealing with the Zionist occupation of Palestine, *Mustafa Kamil* (1952) by Ahmad Badrakhan, and *Down with Colonialism/yasqut al-isti'mar* (1952) by Husain Sidqi. Nationalism and the need of postcolonial cultural purification generated also a wave of religious films starting with *The Appearance of Islam/ zuhur al-Islam* (1951) by Ibrahim 'Izz al-Din and *The Victory of Islam/intisar al-Islam* (1952) by Ahmad al-Tukhi. Both depicted the appearance of a victorious Islam in the seventh century AD.

While the Bedouin film practically vanished during the two decades of the Nasserist regime, light music hall comedies, gangster films, and thrillers came to the fore. A small number of filmmakers, notably Youssef Chahine, Salah Abu Seif (Saif), and Taufiq Salih, showed an inclination to what came to be called Third Worldist realism, and tried to realize it both within and outside the public sector. Their political and artistic commitment raised issues ranging from foreign domination and social injustice to patriotism and gender inequality, and informed Egyptian Realism. This wave came to be highly appreciated at home and abroad. During the 1960s, the production of realist and political films spread to a certain extent among mainstream directors, such as Henri Barakat and Kamal El-Cheikh (al-Shaykh). Thus, Barakat directed some of the most accomplished musicals and melodramas, along with acclaimed realist films. El-Cheikh's works ranged between the two poles of gangster film and thriller, on the one hand, and political film, on the other.

Hasan al-Imam, in contrast, was entirely mainstream oriented, and specialized in musical melodrama mostly featuring belly dancers. Director Hilmi Halim's name became linked to the popular musicals starring the singer 'Abd al-Halim Hafiz, whereas 'Izz al-Din zu-l-Fiqar, Ahmad Diya' al-Din, and later Sa'd 'Arafa directed mostly romantic love stories. Hilmi Rafla and Fatin 'Abd al-Wahhab became known for their light comedies, and Kamal El-Cheikh for his sophisticated thrillers. In contrast, Husam al-Din Mustafa, who was described as the most vulgar Egyptian director, started his career with dramatic literary adaptations and ended it with espionage films in the 1990s. The commercial orientation of most of these directors persisted in spite of the increasing state interference in the cinema industry.

Special decrees were issued to reorganize the taxation on imported films in favor of national production and to found the Organization for Film Aid in 1957, whose objective was to raise the artistic standard of cinema and to support its distribution abroad; in 1958 it changed its name to become the Public Egyptian Film Organization. In 1960, Misr Bank was nationalized. So was the Misr Company for Cinema and Performance, Studio Misr, along with all the other private studios in the country, and around one-third of movie theaters. The studios were placed under the supervision of the film organization, which was encouraged to start production. It released the first public full-length feature film in 1963 after it had been restructured under the name General Film Organization (today the National Film Center). It comprised four different societies that held responsibility for the production of feature films and documentaries, international coproduction, the administration of the studios, and the administration of movie theaters and film distribution.

The period of state ownership did not bring about a real rise in artistic or technical standards. In spite of the attempt to promote a national film culture, in particular the efforts of Tharwat 'Ukasha while he was minister of culture, production remained dominated by commercial interests. In order to prevent the loss of foreign markets, the products of the General Film Organization followed the same guidelines as the private sector, which meant that they lacked neither stars nor popular entertaining formulas. Yet the nationalization policy led Egyptian, Syrian, Lebanese, and Jordanian producers and distributors to withdraw from Egypt and invest in Lebanon instead. This resulted in a temporary increase of Lebanese productions during the 1960s that made extensive use of Egyptian stars and technical talent. In Egypt, production decreased after the establishment of the General Film Organization, and with thirty-four films in 1967, reached its lowest level since the 1940s.

Eventually, the total number of feature films remained at around forty-five films per year until 1974. The General Film Organization did not manage to produce more than thirteen feature films a year; the rest were private productions. Corruption and nepotism contributed to the waste of public money. By the time the Anwar al-Sadat government started reprivatization in 1971, the debts of the General Film Organization are said to have reached seven million Egyptian pounds. Under these unfavorable conditions, art films like Chadi Abdessalam's (Shadi 'Abd al-Salam) *The Mummy: The Night of Counting the Years/al-mumya'* (produced in 1969), striving for

the development of a specific national film language and produced by the public sector, remained absolutely exceptional.

Also, their experiences with the public bureaucracy convinced some of the most talented and politically committed directors to leave Egypt. Taufiq Salih went to Syria, Youssef Chahine and Henri Barakat to Lebanon. In terms of quantity, their realist output remained anyway marginal in comparison to the common mainstream. Thus, unlike the situation in Syria and Algeria, the Egyptian public sector did not become the godfather of the kind of politically committed, modernist, anticolonial Third Worldist cinema that in other Arab countries was setting itself apart from the products of the Egyptian "dream factory."

The Advent of Electronic Media, 1971–1991

Reprivatization of the film industry has remained a strongly contested topic in Egypt since Sadat came to power in 1970 and started his *Infitah*, or Open Door Policy, thus putting an end to Egypt's quasi-socialist orientation and its isolation from the West. One of the first steps toward reprivatization was the 1971 decision to terminate public feature film production. On the other hand, the General Film Organization still invested in the industry. In 1973, it inaugurated a color laboratory in its Film City in Gizeh (al-Jiza). Additional attempts at privatization followed, but they amounted to no more than selling some theaters. The rest of the technical infrastructure, including laboratories and studios, remained public property until the late 1990s when they were privatized gradually or just leased on extended terms. This situation presented a serious obstacle to the updating of technical equipment and infrastructure, but it served the interests of private producers who profited from the low fixed prices offered by state-run laboratories and have therefore always objected to further privatization.

Apart from the Open Door Policy and the accompanying attempts at privatization, two other factors shaped Egypt's cinema decisively during the 1970s and 1980s: the introduction of national television and the spread of the VCR. Egyptian public television run by the Egyptian Radio & TV Union (ERTU) started broadcasting in July 1960. It is not clear how much its introduction contributed to the drop in film production and the closing of movie theaters. One of the positive effects of television was that it contributed to the preservation and dissemination of old

Egyptian movies by constantly airing them, helping to transform them into the cultural legacy of the new generations of filmmakers.

In contrast to television, the introduction of the VCR had doubtless a strong economic and cultural effect on cinema. Its spread in the Gulf region, and particularly in Saudi Arabia where public theaters are still prohibited, opened new markets for Egyptian films, leading eventually in 1984 to a boom of the so-called *muqawalat,* or entrepreneur film. Directed by mediocre directors and featuring second-rate actors, these films were mostly shot and distributed on video whose most important task was to carry advertising spots of various consumer goods.

At the same time, there was a marked change in genres. The traditional musical and melodrama decreased in favor of action and gangster films and a few low-quality karate imitations. As during the late 1940s, some genres tended to merge in this period. Now it was melodrama, realism, and the gangster film that mixed and developed into a kind of "social drama" still prevalent today. Nonetheless the early 1970s was marked by various attempts in artistic innovations. The so-called Third Worldist cinema gave way to more individualist cinematic expressions. Young directors, who later were mostly absorbed by the mainstream, made their first interesting experiments, like Husain Kamal, Khalil Shawqi, 'Ali 'Abd al-Khaliq, Ghaleb Chaath (Ghalib Sha'th), Mumduh Shukri, Sa'id Marzuq, and Muhammad 'Abd al-'Aziz. At the same time, the huge success of *Take Care of Zuzu/khalli balak min Zuzu* by the master of Egyptian melodrama Hasan al-Imam signaled in 1972 the temporary economic revival of Egyptian mainstream cinema and an increase in production to around fifty films a year.

The early 1980s saw the initiation of a second wave of realism—the first had begun in the 1950s—with so-called Egyptian New Realism (*al-waqi'iyya al-jadida*). Heavy criticism of the Open Door Policy was expressed in such films by Atef El-Tayeb ('Atif al-Tayyib), Khairy Beshara (Khayri Bishara), Mohamed (Muhammad) Khan, Daoud Abd El-Sayed (Dawud 'Abd al-Sayyid), the scriptwriter and director Bashir al-Dik, and to a certain extent 'Ali Badrakhan, who had already made a name for himself in the 1970s. Scriptwriter Ra'fat al-Mihi also directed a few realist-oriented films but specialized subsequently in a kind of black and absurd comedy, described by Egyptian critics as "fantasy" (not to be confused with the American fantasy).

More commercially oriented directors of the same period were Muhammad 'Abd al-'Aziz, one of the few directors who, after the demise of Fatin 'Abd al-Wahhab, still contributed light comedies of some quality to mainstream cinema. Sa'id

Marzuq, Muhammad Radi, and Ahmad Yahia worked mainly on social drama films. In contrast, Nadir Galal and Samir Saif excelled primarily in action and gangster films, in the case of the latter at times combined with comedy and farce. Muhammad Fadil appeared during this period too but switched soon to television, where he directed social and historical dramas.

The Satellite and Shopping Mall Era after 1990

The Egyptian film industry experienced a new serious crisis in the mid-1990s. Production rates decreased dangerously, and releases dropped from a high of seventy-one films in 1992 to thirty-five films in 1994, thirty-one in 1995, twenty-eight in 1996, sixteen in 1997, and eighteen in both 1998 and 1999. This development started first with the Iraqi invasion of Kuwait in August 1990, which affected Egypt's distribution to the Gulf countries for a few months. Yet the major setback was the advent of satellite television. The number of Arab satellite channels, including those of the Egyptian ERTU, which are run all over the Arab world and Europe increased rapidly and multiplied the need for new Arab programs, such as series, talk shows, and other entertaining material. Egypt's own first satellite channel started broadcasting during the Gulf War and was quickly followed by others in foreign languages. Since 1992, ERTU has cofinanced Pay-TV CNE (Cable Network Egypt). It has furthermore increased the number of Egyptian satellite channels, profiting from the ministry's investment, in the first Egyptian satellite, Nile Sat, which started operating in 1998.

ERTU, supervised by the Ministry of Information, began to compete with the private film sector during that period. In addition to the large number of shows and serials, which have been exported to all over the Arab world, it financed expensive feature films (with budgets up to five times higher than the average film for theatrical release only). In 1994 alone five TV productions were released in movie theaters. One of the best received was Muhammad Fadil's historical spectacle *Nasser 56/Nasir 56* presented in 1996. This boom temporarily caused a serious shortage in studios, equipment, and technicians. In 1995, for example, 80 percent of cinema studios were rented for TV and advertisement productions. In response, ERTU invested millions in the construction of a huge studio complex outside of Cairo in the City of 6th of October, which began operating in 1999 but led to huge public and private debts and high studio rents.

For a while the film industry lost out in these developments. Due to insufficient trade regulations, Egyptian movies were sold to TV and satellite at rock bottom prices, usually a few hundred U.S. dollars, until the turn of the millennium, when there has been a slight improvement. An additional and more important reason for the stagnation of the film industry was that the producers of several so-called New Comedy box office hits began to dominate the market, making huge profits without reinvesting in the industry. Average film budgets rose constantly from about 1 million EGP in the early 1990s to up to the exceptional amount of 17 million. in part because of improved technical standards, with some services such a lab work and computer animation carried out abroad.

Eventually ERTU began to put cinema producers in charge of producing TV feature films designed for prior theatrical release. In 1998 and 1999, the first coproduction between a private producer and the national television was undertaken, Youssef Chahine's film *The Other/al-akhar* (1999). The 1990s saw also an increasing tendency toward European coproductions. But, unlike the situation in Europe, television did not become one of the main film financiers of film, boosting the industry or at least helping it to survive. In addition to Chahine's historical spectacles, *The Emigrant/al-muhajir* (1994) and *Destiny/al-masir* (1997), young directors such as Yousry (Yusri) Nasrallah, Asma' al-Bakri, Radwan al-Kashif, Khalid al-Haggar (al-Hajjar), and Atef Hetata ('Atif Hatata) received Western support for their projects. Spectacular topics of major interest to the West such as Islamism, obvious in most of Chahine's films, among others *Destiny*, as well as in Hetata's *Closed Doors/al-abwab al-mughlaqa* (2000) (produced by Chahine's company Misr International), helped of them gain funding overseas. However, except for Chahine's, none of these European coproductions have had much success with Egyptian audiences.

One of the peculiarities of the 1990s was the appearance of "Coptic" (Christian) filmmaking. Professional Coptic directors, most notably Samir Saif, started in 1987 to direct devotional films produced largely by the Coptic Orthodox Church and some Protestant institutions. The majority of these videos—sixteen full-length films by the end of 1996—feature the lives and ordeals of native Egyptian saints and martyrs, thus echoing even in their mise-en-scène the Muslim religious films of the 1960s and 1970s. By law, they are supposed to be distributed only within the churches, thus creating a sort of confessional counteraudience.

In general, the late 1980s had seen the revival of old genres, such as the musical, along with the emergence of some new directors—among others, Muhammad Shibl and Hani Lashin—who in spite of their attempts to innovate and achieve a certain

standard remained marginal. Contrary to that, Sherif (Sharif) 'Arafa as well as the woman director Inas al-Dighidi became the most successful mainstream directors of the 1990s. 'Arafa's work stretches from light musicals and comedies to social dramas and includes several box office hits, whereas al-Dighidi focuses more on social drama. New Realism still found followers in the 1990s such as Muhammad Kamil Qalyubi, Ussama Fawzi, Munir Radi, Magdi (Majdi) Ahmad 'Ali, Radwan al-Kashif, and, more recently, Khaled Youssef (Khalid Yusuf). Tariq al-'Iryan contributed several quick-paced police and gangster films, and the Sudanese Sa'id Hamid presented comedies starring Muhammad al-Hinidi, which became the greatest box office hits of the late 1990s. Directors who have shaped the so-called shopping mall film, which started spreading since 2000, are Hani Khalifa and three women, Sandra Nash'at, Kamla Abu Zekry (Zikri), and Hala Khalil. Their films focus partly on young middle-class couples and their emotional problems, such as *Sleepless Nights/sahhar al-layali* by Hani Khalifa, which became a box office hit in 2003.

Clean Cinema and Revolution: The New Millennium

New Realism died out in the late 1990s despite veteran Mohamed Khan's constant endeavors, among others, to revive it with his independently produced *Factory Girl/fatat al-masna'* (2014), his latest work. Realist motivation and related stylistic approaches have persisted though in the work of Magdi Ahmad 'Ali, female director Kamla Abu Zekry, Ussama Fawzi, Yousri Nasrallah, 'Amr Salama, Muhammad Diab, Ahmed Abdalla (Ahmad 'Abd Allah), El-Batout (Ibrahim al-Batut), and even at times Khaled Youssef (Khalid Yusuf), the codirector of Youssef Chahine's *Chaos/ hiyya fawda*, 2007. Youssef's *Until Further Notice/hina maysara* (2008) needs to be mentioned as well. Situated in the informal neighborhoods or slums, it displays the immense degree of social injustice and human rights violations and ends in an explosive situation that brings about the destruction of the neighborhood, an image that seems to have foreseen the 2011 uprising. Muhammad Amin, who has specialized in social and political criticism through black comedy, is an exceptional case. Exclusively mainstream oriented directors are Sherif 'Arafa, Marwan Hamid, Sandra Nash'at, Wa'il Ihsan, Samih 'Abd al-'Aziz, and Akram Farid, among others.

The new millennium brought a certain diversification in genres and stylistic approaches. Khaled Youssef directed a (moderate) horror-thriller in 2006 called *Ouija*, for example. Sherif 'Arafa, who signed, among others, for the sequel *The*

Island/al-jazira (2007 and 2014) or the espionage film *Cousins/wilad al-'amm* (2009), Sandra Nash'at with *The Hostage/al-rahina* (2007), and newcomer Marwan Hamid tried to catch up with international standards in their action movies in importing South African expertise for action-scenes and special effects. On the other hand, shooting abroad—for example, Nash'at's comedy *Thugs in Thailand/haramiyya fi Thailand* (2003)—a trend that had started earlier with *Hamam in Amsterdamn/ Hamam fi Amsterdam* (1999) by Sa'id Hamid, died out gradually.

True that budgets had been allowed to rise, but costs did too as the economic situation in Egypt deteriorated, particularly after 2011. A regular budget lies currently between 7–8 million EGP, that is, more than US$1 million. In some very exceptional cases production costs reached 30 million EGP before the uprising (Ali 2013, 56). Technical standards have remained high after the introduction of digital technology for shooting and projection, as producers are increasingly making use of postproduction services abroad.

This made artistic standards rise, likewise achieving a certain international visibility with films such as the adaptation of Alaa (Ala') al-Aswany's novel *The Yacoubian Building/'Imarat Ya'qubian*, (2006) by Marwan Hamid. This entailed also the rise of technical standards of action films. *Ibrahim Labyad* (2009), another film by Marwan Hamid that had one of the highest budgets of that period, includes complicated chases, fights, special effects, and very particular sets. Hamid directed also one of the first Egyptian horror movies, *The Blue Elephant/al-fil al-azraq* (2014), that successfully applies genre specific effects. Even harmless comedies, like Sandra Nash'at's *Thieves in KG2/haramiya fi KG 2* (2001) and *Molasses/'assal aswad* (2010) by Khaled Marei (Khalid Mar'i), show evidence of expensive effects, props, and locations.

At the box office, comedy and musical farce have remained highly successful—for example, the box office hit *El-Limby/al-Limbi* (2002) by Wa'il Ihsan, starring comedian Muhammad Sa'd. It was strongly attacked for its supposed triviality presenting a constantly drugged, infantile male lower-class character. *Omar and Salma/'Umar wa Salma* (2007) by Akram Farid, a soap opera–like comedy about a quarrelsome young bourgeois couple, was so popular that two sequels followed. Also new generation comedian Ahmad Helmy (Hilmi), who was well received in *Snakes and Ladders/sulum wa thu'ban* (2001), among others, rose to the top with *Keda Reda/kidda Rida* (literally: Rida like that, 2007) and later *X-Large* (2011).

The new comedies, as well as action films in the style of Sherif 'Arafa, however, are impregnated with conservatism particularly with regards to gender relations and sexuality and have been subsequently dubbed "clean cinema," or *al-sinima al-nazifa*.

Notwithstanding, several directors approached quite daring topics without being necessarily exploitative. *Girls' Secrets /asrar al-banat* (2001) by Magdi Ahmad Ali, for example, touched upon female genital mutilation and teenage pregnancy, Yousry Nasrallah's *Sheherzade, Tell Me a Story/ihky ya Shahrazad* (2009) on domestic violence, *1:0* (2009) by Kamla Abu Zekry on the personal status of Coptic women, *678* (2010) by Mohamed Diab on sexual harassment, *Asmaa/Asma'* (2011) by 'Amr Salama dealing with the moral stigmatization of Aids/HIV-positive patients.

Muhammad Amin presented two politically critical and sexually quite uninhibited—not on the graphic but on the verbal and symbolical level—satires, *The Night When Baghdad Fell/laylat suqut Baghdad* (2005) and *Black February/Fibrayir al-aswad* (2013). The bitter social satire *Ant Scream/sarkhat namla* (2011) by Samih 'Abd al-'Aziz is more realistic in style. It was conceived before the revolution but added some revolution-related scenes during its realization. The outbreak of the January 25 Revolution and the following political unrest were portrayed as well, right on the spot, in *18 Days/18 yaum* (2011), an episode film by ten directors including Nasrallah, Abu Zekry, Hamid and 'Arafa, moreover *After the Battle/ba'd al-mawqi'a* (2012) by Yousri Nasrallah and *Winter of Discontent/al-shita illy fat* (2012) by Ibrahim El-Batout. Together with Ahmed Abdalla, El-Batout represented, more than anyone else, the independent and alternative film scene that had started to develop in the mid-2000s, that is, before 2011. This wave was joined by others and crystallized in a number of independent, sometimes collectively produced art house films of varied quality.

In 2011, film industry came to a temporary, almost complete halt largely for security reasons because of the massive uprising. On the ideological and moral level, the rebellion has shaken up and polarized everybody involved. During the different sit-ins on the Tahrir Square, numerous film professionals participated, including directors and performers, to name only Daoud Abd El-Sayed, Yousri Nasrallah, Khaled Abu al-Nagga, 'Amru Wakid, and Basma, not the representatives of clean cinema though and not the very top stars. The aging Egyptian "King of Comedy" 'Adil Imam, for example, whose films since the end of the 1970s constantly resulted in box office hits, strongly supported Mubarak in a television interview during the uprising. With Mubarak's resignation on February 11, Imam lost so much of his popularity that a Vodafone advertising campaign launched a short time earlier with him at the helm had to be cancelled. In spring 2012, however, when the Muslim Brotherhood started to gain ground politically, this very same Imam was charged and convicted because he supposedly defamed Islam in a work created decades ago,

thus once again assuring for him the solidarity of his fellow actors, artists, and parts of the public. Also, some who were very outspoken supporters of the revolution, like Khaled Youssef, backed the military coup in June 2013. Abu El-Nagga, the lead player in films by Mohamed Khan and Daoud Abd El-Sayed who did not budge in his demands for free speech, was confronted with a smear campaign in 2014 with regards to his sexual orientation, among other things.

Audiences, Star System, and the Issue of Class and Morality

The structure of markets and the star system have been the major factors in shaping the industrial and commercial character of Egyptian cinema. The export of Egyptian feature films started with the introduction of sound. Given poor domestic distribution, which excluded the countryside almost entirely, producers were heavily dependent on foreign markets. Later these exports came to be seen as a cause of the Egyptian industry's constantly recited artistic ailments. At the same time, Egyptian exports hampered efforts at large-scale production in other Arab countries. Egypt's oldest market, the Mashriq countries from Iraq to Lebanon, has remained more or less stable with Lebanese distributors monopolizing exports until 1975, when Kuwaiti distributors took over as the video format was introduced. Exports to the Maghreb have been rather marginal due initially to French colonialism and subsequently to the popularity of Bollywood movies. While 60 to 70 percent of Egyptian theatrical releases were exported to the Gulf States in 1991, only some 6 to 8 percent went to the Maghreb (Thabet 2001, 51).

Egyptian film industry works below capacity today with an annual release of around thirty full-length feature films. However, since the turn of millennium the country has seen a remarkable growth in technically most up-to-date movie theaters. Moreover, Egypt has kept its market share in the Middle East and North African (MENA) region between silver screens and video sales, reaching between 1 percent up to 45 percent in Saudi Arabia, for example. In its own homeland, thanks to restrictive legal measures that confine the number of copies permitted for foreign films, Egyptian productions exceed at times 80 percent of the local share—for instance, in 2011 they made up 83 percent. The rest were primarily, as elsewhere on the globe, American films (Ali 2013, 61).

Since the 1940s, American films and then Indian movies regularly presented strong competition. The conflict was usually resolved by official, largely legislative

interference. During the Nasser era, distribution channels controlled by American companies were nationalized. Indian films became popular first with *Sangam* (1964, also known as *Confluence*) by Raj Kapoor. They put Egyptian films at jeopardy as they offered a similar genre mix while meeting higher technical standards and featuring bombastic landscapes that are not available in Egypt. A second wave of Indian movies hit Egypt in the late 1970s and early 1980s starring Amitabh Bachcham. While Indian film became synonymous with trivial entertainment for Egyptian *cinéastes*, the legislature reacted harshly to their box office success. The official decree no. 181 of 1973, still operative today, made the export of Egyptian films to India and Hong Kong a precondition for any imports from these countries. Indian movies or Chinese karate films could only be released in an Egyptian movie theater if the Bureau for Cinema, Theater, and Music (*hay'at al-sinima wal-masrah wal-musiqa*) received documentation from a bank that the Egyptian distributor was paid at least 2,000 pounds Sterling in exchange for an Egyptian film exported to Hong Kong or 5,000 pounds Sterling for a film exported to India (al-Naggar 2002, 322). Egypt tried to curtail non-Asian imports too, but in their case the measures were less rigorous, vaguely demanding that movie theaters give preference to Egyptian films if available and reserving the days of the Muslim feasts *Bairam* and *al-Fitr* exclusively for national productions. Bollywood has nevertheless remained popular in Egypt, getting distributed primarily on VHS and DVD. One measure of its popularity was the euphoric welcome given one of its megastars, Amitabh Bachcham, during his visits to Egypt in 1990 and in 2001.

Apart from international market forces, Egypt's internal social structure has been an ever-present and ever-determinant factor in Egyptian film distribution and reception. The question of class has not only shaped sequels of film narratives and was thus associated with certain genres to the extent that it has contributed to film form through generic vocabulary developed for different audiences, but it has also played the role of a symbolical signifier regarding the appearance and status of film performers. The traces it has left on film spectatorship have been most visibly underlined by the common division of movie theaters into "classes," from the early third-class "*tirsu*" to the up-to-date shopping mall theater. Moreover, the distribution system has always worked in favor of the more privileged regions, that is, the cities.

Going to the movies has remained an urban form of entertainment in Egypt ever since the early *cinematographs* and then the Pathé movie theaters in Alexandria and Cairo. The number of theaters grew constantly, but their numbers remained low in comparison to the country's population, pushing Egyptian producers to

become heavily dependent on foreign distribution. When the number of cinemas reached its peak in 1954, it probably did not exceed 360 theaters (al-Naggar 2002, 311). The 1960s brought television and the nationalization of around one-third of all cinemas. The number of theaters decreased continuously from there on—by 1992 only 147 were left—and so did the technical standard of theaters. The distribution of theaters remained uneven, with more than one half of all cinemas in Cairo (fifty-nine theaters) and Alexandria (twenty-one theaters) (al-Naggar 2002, 311). No theaters exist in plainly rural areas, and regular film consumption in villages started only with the introduction of television and VCRs in the 1960s and 1970s.

Movie theaters reflect the highly stratified structure of society in their division into three categories. The distinction between first-, second-, and third-class movie theaters was established early on, probably during the first wave of movie theater construction in the late 1910s, at a time when Alexandria, with its strong Levantine and Mediterranean population, was the center of production and distribution. Third-class theaters, still colloquially referred to as *al-tirsu* (derived from the Italian *terzo*, that is, third), do not present first releases but offer film packages that usually comprise one Egyptian and one or two foreign films. They are repeated for days. The predominantly male audience enters the screening at any time, often knows the films by heart, and interacts vigorously with the action, commenting on it loudly or reenacting it during the projection. An accurate description of the vivid atmosphere of those movie theaters is found in Yousri Nasrallah's feature film *Mercedes*, which represents them likewise as a place for gay encounters. Today third-class theaters are run primarily in the outskirts, like the industrial Cairo-district Helwan, and the provinces, while in the inner cities of the metropolises almost none exist anymore (al-Naggar 2002, 311–17).

With the introduction of the VCR in the late 1970s, middle- and upper-middle-class audiences, and in particular women, increasingly watched films at home, so that the male dominance of film audiences became even more pronounced. This development was reinforced by the deteriorating condition of the old first- and second-class movie theaters, particularly in Cairo's and Alexandria's inner cities, as a result of the 1963 nationalizations. After two decades they had worsened to such an extent that suburban middle-class families began avoiding them, their increasingly male lower-class audience presenting a further deterrent.

First releases are offered only by first- and second-class theaters. They distinguish themselves through ticket price, choice of program, furnishings, and technical standard of equipment and projection. Their decline came to a halt in the early 1990s

as state-run cinemas, some of them leased or sold to private entrepreneurs, were renovated, and an increasing number of first-class theaters, equipped according to the most modern standards, including Dolby stereo and digital sound, appeared in Cairo's affluent suburbs. Some of them are placed in the new shopping malls that spread all over town. A ticket currently costs up to 25 EGP, around US$5, almost twice as much as in second-class theaters. In multiplex cinemas the ticket price for a 3-D projection may reach 50 EGP.

In Egypt, the star system is intrinsically related with the film industry. Popular actors and actresses quite often hold more power than producers and directors. From its very beginning, the Egyptian film industry served not only the national market, but with musical stars such as 'Abd al-Wahhab, Umm Kulthum, Farid al-Atrash, Asmahan, Layla Murad, and Huda Sultan was able to attract audiences from all over the Arab world. With the foundation of Studio Misr in 1934, which marked the beginning of the industrialization of Egyptian cinema, stars became even more important. They have remained essential to the promotion of cinematic products not only in Egypt but also in neighboring countries. In turn, to this day, some of the most urgent structural production and distribution problems of the ailing film industry, such as producers' dependency on the distribution guarantee system, have been due to its star system and became quite pronounced in the 1980s and 1990s.

Unlike in the United States, where the star system evolved gradually, along with a special discourse of acting, and almost independent from the theater, the formation and consolidation of the Egyptian film industry was right from the beginning highly dependent on established theater and music stars. Thus the short theater adaptation *Madame Loretta* (1919) by Leonard la Ricci starred Fawzi al-Gazayirli, and *The American Aunt/al-Khala al-amirikaniyya* (1920) by Bonvelli introduced the comedian 'Ali al-Kassar. Some of the first movie stars actively contributed to the formation of early Egyptian genres. The popular comedians Nagib al-Rihani and 'Ali al-Kassar decisively influenced comedy and film farce during the 1930s and 1940s. Each developed a specific persona, ranging from ethnic to social stereotypes, such as the naive Nubian and the average little working-class man.

The stars of early Egyptian musicals, then the pivotal mainstream genre, were major representatives of contemporary Arab-Egyptian music, foremost among them the *kawkab al-sharq* (Star of the Orient) singer Umm Kulthum and the congenial singer and composer Muhammad 'Abd al-Wahhab. They were mostly involved in melodramatic plots. Layla Murad appeared during the late 1930s, often

embodying charming and innocent aristocratic girls. She, together with Sabah, Shadia, Farid al-Atrash, and Asmahan, replaced the first generation of singers. 'Abd al-Halim Hafiz became the idol of teenagers in the 1960s and early 1970s, uniting an attractive appearance with musical and dramatic talent. He was the last truly adored music star of Egyptian cinema. Like no other singer of the time, he got tied to the nationalist agenda of the Nasserist era with some highly patriotic songs. His demise in 1977, and that of Umm Kulthum two years earlier, terminated the golden age of the Egyptian musical. No major singers have established themselves since, despite repeated attempts to revive the musical.

The Egyptian musical soon incorporated, along with elements of classical Arab and local Egyptian musical traditions, features of the Western musical, including the music hall film, fostered by multitalented dancers such as Na'ima 'Akif during the 1950s and Sharihan during the 1980s. Yet one of the more consistent features of Egyptian film was the so-called belly dance that appeared in most films since the 1930s, even those outside the musical genre. This early period saw the appearance of two gifted dancers trained by Badi'a Masabni, Tahiyya Carioca and Samia Gamal, who in fusing several traditions and dance forms were largely responsible for the development of what is known as Oriental dance today. The glamour of early dancing vanished, however, from the 1970s onward with the appearance of Suhair Zaki, Nagwa Fu'ad, and finally Fifi 'Abdu, who gave belly dance an air of seduction and vulgarity that presents but another face of the new morality and conservatism that began to spread at that time and affected primarily the image of female actresses.

The most powerful female star had been Fatin Hamama, who had appeared in the 1950s and had retained her leading position as grande dame of Egyptian cinema until the early 1990s. The highly gifted Su'ad Husni became a star in the 1960s, but she was emotionally less stable and retired already in the late 1980s. The stars that followed in the 1980s and 1990s started to enjoy a more ambivalent popularity. Such was particularly the case of Nadia al-Gindi, who liked to star as a crafty female vamp, popular probably mostly with lower-class male audiences but not with the critics.

As for male stars, romantic lovers such as 'Imad Hamdi, Anwar Wagdi, Ahmad Mazhar, and eventually Omar Sharif prevailed from the 1930s to the 1950s. They were followed by tough guys such as Rushdi Abaza and Farid Shauqi. Comedians such as Isma'il Yasin had become prominent in the 1950s and the 1960s. 'Adil Imam, the King of Comedy, appeared in the late 1970s. A theater actor like most of the other comedians, he introduced the nihilist young urban underdog. Denounced as trivial, he remained the best-paid Egyptian star actor until the mid-1990s. His position was

later challenged by a younger successor, Muhammad al-Hinidi, in his role as the harmless funny and natural character. It is noteworthy that in contrast to other comedians, Imam was less characterized by a specific mask. He starred in many action films, moving between the two seemingly opposed genres. Three lower-class underdog personae, Ahmad Zaki, Nur al-Sharif, and Mahmud 'Abd al-Aziz, came to the fore with so-called Egyptian New Realism in the 1980s.

Since the 1970s, actors have been increasingly placed in a hierarchy loosely divided into three classes. Responsible for this is the distribution loan system, also known as minimum guarantee, through which distributors contribute to the film budget depending on the box office popularity of the involved star(s). Categorizations of performers have of course been relative, temporary, and flexible, and they did not necessarily coincide with critical esteem. In some cases popularity and high earnings have been detrimental to a star's reputation in terms of the acting capabilities and artistic quality they imply, depending on film genre and the directors with whom a star works. Other players in the top category have enjoyed high esteem in the eyes of local critics. Such was the case of Ahmad Zaki, Mahmud 'Abd al-'Aziz, Nur al-Sharif, Mahmud Himida, Yusra, Nagla' Fathi, and, at times, Layla 'Ilwi in the 1980s and 1990s.

The prevalent characters of Egyptian mainstream cinema have primarily been constructed according to conservative moralism ruled by a sort of Manichaean dualism: good and evil, virtue and viciousness. The essential conflicts are often engendered by cathartic threats and dangers. In this context, males are likely to be threatened socially whereas females are often exposed to moral dangers. As Malkmus and Armes (1991, 106) noted, many "films concerned with women imply the illegal (using such words as morals, licit, proof, law, arrest) and many of those concerned with men imply the asocial (bully, smoke, hashish, beasts, bums)." Thus, women tend to be associated with emotions, love, passion, and the body, men with strength, power, and violence.

Egyptian film criticism in turn has often juxtaposed moral considerations to the high-brow/low-brow dichotomy. In the eyes of the critics, this schism runs commonly through genres and directors, and along gender lines. Thus the "moral" record of actors and actresses, as reflected in their on- and off-screen personae, has complemented artistic evaluation. The paradigm of morality has been additionally combined with the ideal of social commitment usually seen to be expressed in a largely rhetorical realism. Consequently the prestige of actors and actresses could also rise, at least for film critics, with their participation in committed realist films

or other privileged works, such as Youssef Chahine's foreign coproductions, but not necessarily for the audiences. Of course politics have also played an occasional role in the evaluation and image of stars, as we saw earlier in the case of the political rift that went through the cinematic community during and after the revolution. There are also historically decisive cases such as the defamation of singer and former Jew Layla Murad in 1953, who was falsely accused of having donated money to Israel even though she had converted to Islam years ago.

Censorship and Taboos

Doubtless, the major obstacle to an artistically ambitious and intellectually critical cinema in Egypt is the economic structure of the film industry rather than censorship. This does not mean that commercial production and criticism are mutually exclusive. In fact, numerous mainstream productions have voiced political criticism and have or have not encountered objections depending on the circumstances and conditions of the time. The significance of censorship in Egypt has been often overinterpreted in the West, as it is assumed to reflect the state of freedom and democracy; in fact, however, things are much more complicated, as the history of Egyptian censorship shows clearly.

State interference in the realm of cinema dates back to the birth of cinema. A law issued in 1904 to regulate the press was likewise applied to cinema. In 1911, the Cairo governorate charged the chiefs of police to control strictly whatever was screened in the movie theaters. In 1918, the first case of censorship occurred, prohibiting *Mortal Flowers/Les fleurs mortelles* because of wrongly reproduced Quranic verses. Official censorship was eventually introduced in 1921 with a decree stating that all imported films have to pass the General Security Department of the Ministry of Interior before projection.

Today, every feature film produced in Egypt passes censorship twice. First, the screenplay, or in the case of a documentary a treatment, has to be submitted to the censor to receive approval. That approval is a prerequisite to acquire shooting permissions from the Ministry of Interior. After completion, another official license, a so-called visa, is required in order to screen the film in public and to export it. Both steps leave much space for interference as well as negotiation.

The principal taboo zones kept under state surveillance are religion, sexuality, and politics. The latest censorship law issued in 1976 prohibits first of all the

criticism of heavenly religions, the justification of immoral actions, the positive representation of heresy, images of naked human bodies or an inordinate emphasis on individual erotic parts, sexually arousing scenes, alcohol consumption and drug use, and obscene and indecent speech.

Of course, not all prohibitions are respected. Filmmakers do represent drug abuse and alcohol consumption, for instance, even though it is often associated with immorality, and a good deal of eroticism and indecent speech occurs on the screen. Some restrictions are circumvented through negotiations with the censors. Another strategy is the codification of messages and actions by symbolic or stylistic means. For example, in his films *Alexandria Why?* and *Alexandria Now and Forever*, Youssef Chahine veils his protagonists' homoerotic inclination by representing sexual desire as murderous hate or by replacing a man with a woman with masculine behavior.

The first cases of political censorship occurred in the late 1930s. Bahiga Hafiz's *Layla Daughter of the Desert/Layla bint al-sahra'*, completed in 1937, was banned, to be released only in 1944 under the title *Layla, the Bedouin/Layla al-badawiyya*. By an unlucky coincidence, the film had presented the story of an unjust rapist Persian king in the same year that the Egyptian princess Fawzia celebrated her wedding to the Shah of Iran. The second film affected was a Studio Misr production, *Lashin* (1938), by Fritz Kramp, which was also about a tyrant sultan. After basic changes to the story, and the addition of scenes that transformed the vicious ruler into a good one, the film was released at the end of the same year.

In general, the representation of the lower classes, social injustice, leftist, or nationalist topics had to fear censorship in pre-Nasserist Egypt. The censorship law, the so-called Faruq-Code, issued in 1949 by the Ministry of Social Affairs, excluded realism by equating it with subversive leftist trends and prohibited even the representation of oriental habits and traditions.

These regulations could be neglected by Egyptian cinema only after the abolition of the monarchy in 1952. In 1955, the revolutionary government issued a new censorship law annulling some of the restrictions of the 1947 law. However, it declared also the new law's objectives: "to protect public morals, to preserve security, public order and the superior interests of the state" (Lüders 1988, 227).

In spite of the new limits to democracy during the rule of Nasser, censorship was relatively permissive regarding foreign films. Many provocative art films, like some of those by Pasolini and Fellini, passed. Only a few local productions were subject to censorship, among others *God Is with Us/Allahu ma'na* (1952, released in 1955) by Ahmad Badrakhan and *Something Frightening/shay'un min al-khawf*

(1969) by Hussein (Husain) Kamal. Both were released after Nasser had watched them. Political censorship was most severe during the reign of Sadat, particularly before the October, or Yom Kippur, War in 1973. From Sadat's ascent to power in 1970 until 1973, all films that addressed the defeat in the 1967 war with Israel were prohibited, including *Shadows on the Other Side* (1971, released in 1975) by Ghaleb Chaath and *The Sparrow/al-'usfur* (1972, released in 1974) by Youssef Chahine. Moreover, political films like *Visitor at Dawn/za'ir al-fajr* (1973) by Mamduh Shukri, addressing the abuses of the state security service, did not receive permission until 1975. *The Culprits/al-mudhnibun* (1976) by Sa'id Marzuq, which criticized spreading corruption and nepotism, was forbidden on a moral pretext. No film has actually been banned since 1984, yet changes were sometimes imposed. Thus the images of a Central Security Service (*al-amn al-markazi*) soldier protesting with a machine gun in his hands against the authoritarian and inhumane methods used in an internment camp had to be removed in the final scene of Atef El-Tayeb's *The Innocent/al-bari'* (1986) before the film could be released locally.

Religious-oriented censorship led by the al-Azhar institution (and university) interfered for the first time in 1926 when Yusuf Wahbi was asked by Wedad Orfi to represent the Prophet Muhammad on the screen. Al-Azhar protests were so strong that Wahbi withdrew his earlier acceptance of the role. Since then, the representation of the Prophet as well as the four righteous Caliphs is forbidden. This decision was extended in 1976 with the prohibition to represent any of the other prophets in the Koran, including 'Issa, that is, Jesus Christ.

In subsequent decades films started to be affected by religiously motivated social censorship. The 1980s and 1990s were marked by a new morality on the screen, in dress and behavior, as censorship became more internalized and less official. In the 1970s, sexually relatively permissive films, such as Sa'id Marzuq's *The Fear/ al-khawf* (1972) and Abu Seif's *The Malatili Bath/hamam al-Malatili* (1973), were common. But increased migration to the conservative Gulf States and the spread of Islamism led to a clash between filmmakers, public opinion, and censors in the early 1980s. At the same time, Egyptian cinema had become more dependent on exports to the Gulf States, and with the petrodollars prudishness moved into Egyptian movies. While Hussein Kamal's *My Father Is Up the Tree/abi fawq al-shajara* (1969) had been an attraction in 1969 because of its supposedly 100 kisses, now hardly a kiss passed on the screen, and female clothing became less revealing.

The new morality reached one of its peaks in 1983 with an outraged debate sparked by the prohibition of two mediocre productions, *Alley of Love/darb al-hawa*

by Husam al-Din Mustafa and *Khamsa Bab* by Nadir Galal. Most journalists and officials spoke in favor of the verdict and demanded more respect for traditions and good morals. In fact, since that time the press and the courts have sometimes pushed harder for censorship than the authorities, initiating furious media campaigns by suing certain films and their makers. In 1984, lawyers instituted proceedings against Ra'fat al-Mihi's *The Advocate/al-afukatu* (1984). Another spectacular process was initiated in 1994 by Muslim fundamentalists against Youssef Chahine after the screening of *The Emigrant* (1994), which was accused of presenting one of the Koran's prophets. Noteworthy in these cases is the silence of concerned institutions under the new government of Hosni Mubarak, such as the Chamber of Industry and the Cinéastes Syndicate, the latter having been politically chained since 1987.

A complementary phenomenon related to the new morality was the decision of Egyptian actresses working in cinema, theater, and television to retire for religious reasons. From 1987 to 1994 about twenty-five actresses declared their retirement from show business and veiled themselves, complying with calls of Muslim fundamentalist teachings. The reasons are various: increasing morality, family pressures, age, and maybe even, as some newspapers suspected, bribery. True, Islamists circulated black lists of performers in the 1990s, but most of those who retired were not really the most exposed ones, and none of them was a top star. The top stars did not retire. Since 1994, and with the heavy government crackdown on Islamists in the early 1990s, these retirements have become very exceptional.

Instead, in a sort of moral self-censorship some segments of mainstream cinema started following "clean cinema" in an attempt to save film on the moral level. New-millennium stars like Mona Zaki, Ahmad Hilmi, Ahmad al-Saqqa, Muhammad Sa'd, and Muhammad al-Hinidi have become the backbone of this type of cinema, which decidedly refrains from showing any signs of eroticism, be it kisses or sexy outfits. Their attitude is based on the consciousness that audiences create an imagined persona of popular stars merging their fictive and real, that is, their on- and off-screen characters. Consequently, performers who want to appear morally respectable try to avoid playing loose characters. This has made it very hard for directors like Daoud Abd El-Sayed, for instance, who consciously tackles political and moral taboos, to get his films made. El-Sayed's *Messages from the Sea/rasa'il al-bahr* (2010) thus remained for many years in the pipeline, for none of the above-mentioned stars was ready to accept the lead role, rendering the raising of the necessary funding almost impossible. The film was later realized with less-known actors.

Conservatism and a new morality that goes beyond that of official censorship have not been confined to Egypt's Muslim community but have included Copts as well. Already in 1951 the melodrama *Sheikh Hassan/al-Shaykh Hasan* by Husain Sidqi, the story of a Christian woman who falls in love with and marries a Muslim, only to get separated from him by her family until her tragic death, caused such a public controversy that its release was postponed for three years (Qasim 1997, 212). After the turn of the millennium, Copts too joined in the legislative and mass-mediated rally against films considered detrimental to religious belief and/or the image of their community. Thus in 2000 several Copts filed lawsuits against the TV serial *Season of Roses/awan al-ward*, the drama of an offspring of a cross-religious marriage. The movie *I Love Cinema/bahib al-sima* (2004) led to demonstrations at the main Coptic cathedral because it supposedly demeaned the image of the Coptic community—disregarding the fact that this film was about a Protestant family. The censors refused releasing the film before submitting it to the Coptic Church, which is not a legal requirement and was feared to open the door to more religious interference. The producer as well as intellectuals objected, and submission to the church was eventually prevented.

In general, however, official censorship during the last decade up to the revolution was relatively lenient. *The Night Baghdad Fell/laylat suqut Baghdad* (2006) by Muhammad Amin, a film highly critical of U.S. intervention in the region that uses a number of sexualized allegories within a quite comic plot, received permission. Objections to the homosexual relationship displayed in *The Yacoubian Building/'imarat Ya'qubyan* (2006) by Marwan Hamid came again from private persons and were subsequently exaggerated for promotional reasons. Also, films of overt political criticism, such as *Terrorism and Kebab/al-irhab wa-l-kabab* (1992) by Sherif 'Arafa, which made fun of the government's terror-phobia, and *Chaos/hiyya fawda* (2007) by Youssef Chahine and Khaled Youssef, which exposes human rights violations by the current political system, were not banned. After the 2013 military coup, the minister of culture tried to ban a sexually permissive film by Samih 'Abd al-'Aziz, *Rawh's Beauty/halawit Rawh* (2014), starring Lebanese vamp Haifa' Wahbi and produced by El-Sobky Productions, whose productions rely basically on spectacularity and exploitation. The matter was hotly debated and the controversial scenes accessibly on YouTube until a court lifted the ban with the argument that the minister had exceeded his powers.

However, it is not just the question of screening licenses that could be and has sometimes been solved with regards to violence and sexuality by introducing

age limits. In reality, there is also a much more serious obstacle, location security clearances. Even if a screenplay has been approved by censorship, it still has to acquire shooting permissions for outdoor locations and is thus dependent on the minister of interior and the military for approval. It is this aspect, too, that some of the independent filmmakers have been opposing on top of screenplay approval. Former news reporter and TV cameraman Ibrahim El-Batout decided to shoot in 2008 his film *In the Eye of the Sun/'Ayn Shams* without any location shooting permissions. As the digital material was transferred to 35mm with the help of a Moroccan postproduction fund, the film received its screening license as a foreign film, but the director refused to submit a script even in retrospective as a matter of principle. Others have made the issue become part of their film narratives, like Ahmed Abdalla in his films. One of the main characters in *Heliopolis* (2009) is a photographer who is trying to document the history of the old bourgeois Cairo neighborhood Heliopolis, with its very special and beautiful neo-Islamic architecture. In the film, the police stop him for questioning and prevent him from making pictures. In Abdalla's *Microphone* (2011), security forces intervene when a group of musicians try to present their music in public. During and after the revolution, shooting with or without permission has become extremely difficult if not dangerous because of state propaganda that juxtaposed foreign spying and shooting so that regular citizens have started to intervene whenever they see a person with a camera.

Dissidence and Alternative Film Forms

In general, cultural and politically dissident films—in other words, attempts to create an alternative artistically innovative cinema—are not new in Egypt. Politically critical films have been exceptional but recurrent, for example, *The Rebels/al-mutamarridun* (1966) by Taufiq Salih, *Visitor at Dawn/za'ir al-fajr* (1973) by Mamduh Shukry, *The Bullet Is Still in My Pocket/al-rasasa la tazal fy jaybi* (1974) by Husam al-Din Mustafa, to name only some of the early ones. Particularly after the military defeat in 1967 new ideas and artistic orientations spread that departed to some extent from the mainstream. In particular, the members of the New Cinema Society, founded in 1969, were inspired by European New Wave cinemas, and most prominently by the ideas of the Oberhausen Manifesto. The society included script-writers, directors, and film critics who intended to produce politically committed

films that deviated from the prevailing Egyptian mainstream cinema. They tried to gain economic independence by working on the basis of deferments and soliciting financial assistance from the General Film Organization. Its members directed two full-length feature films, *Song on the Passage/ughniyya 'ala al-mamar* (1972) by 'Ali 'Abd El-Khalek (al-Khaliq) and *Shadows on the Other Side/zilal 'ala al-janib al-akhar* (1975) by Ghaleb Chaath. Both films were based on literary works and announced on the narrative level a certain "polyphony," disrupting the omniscient realist discourse and creating a variety of subjective voices and perspectives. The most interesting Egyptian art movie of that period was also a public production, *The Mummy* (1969) by Chadi Abdessalam, primarily because of its stylistic achievements. Yet the film was only released in 1975 due to the neglect of the film by its producer, the General Film Organization. The immediate impact of this eventually highly acclaimed film remained small.

The major problem hampering the development of an Egyptian art-cinema has always been economic. Decisive individual attempts were nonetheless made within the industrial framework, such as Hussein Kamal's *The Impossible/al-mustahil* (1965), Youssef Chahine's *The Sparrow/al-'usfur* (1972), and Sa'id Marzuq's *My Wife and the Dog/zawjati wa-l-kalb* (1971). The extensive use of flashbacks, daydreams, and nightmares gave these films their special character. *My Wife and the Dog* seems particularly successful in leading the spectator astray, as the largest part of the film's action turns out to be a fantasy, imagined by its main character, the warden of a lighthouse who has sent his colleague with a message to his young wife and is tortured by the idea of the latter making love to the messenger. Stylistically less eccentric, but highly critical of social conditions, was Khairy Beshara's *Houseboat #70/al-'awama 70* (1982), the portrait of a young filmmaker who is confronted with a political murder. He turns out to be mentally paralyzed, unable to respond, being caught in emotional and political contradictions, and torn between his personal predilections and the ideal of social responsibility. Exceptional, both on the narrative and thematic level, were two works by Daoud Abd El-Sayed, *The Search for Sayyid Marzuq/al-bahth 'an Sayyid Marzuq* (1991) and *Land of Fear/ard al-khawf* (1999). Both have plots structured around the motif of existential journeys in which an individual tries in vain to retrieve his own identity. *Land of Fear* may be considered one of the most accomplished Egyptian films of the last decade on the cinematic as well as on the narrative level. It manages to dress up the metaphysical quest for the truth in a thrilling gangster film plot, featuring Ahmad Zaki as an undercover agent who becomes an influential drug dealer, loses track of his superiors, and finally

comes to lose confidence in his real identity. Abd El-Sayed's films fuse an auteur motivation with genre cinema in order to keep audience interest alive.

Youssef Chahine, of course, has become the embodiment of Egyptian *cinéma d'auteur*. He was the first to introduce a radically personal cinema with his semi-autobiographical *Alexandria Why?/Iskandariya lih?* (1978), which earned him the Silver Bear at the Berlin Film Festival. It is not only one of his most accomplished films, but it encouraged young directors across the Arab world, such as Mohammed (Muhammad) Malas in Syria and Nouri Bouzid in Tunisia, to move in similar directions. Chahine continued in the autobiographical vein with two other films, *An Egyptian Fairytale/haduta misriyya* (1982) and *Alexandria Now and Forever/ Iskandariya kaman wa kaman* (1990). This trilogy was characterized by its narrative and stylistic hybridity, mixing genres and film types, from archival documentary footage to theater performances, songs, dances, and flashbacks, all adding up to a subjective statement on his personal family as well as sociopolitical surroundings. It was eventually followed by a third sequel, *Alexandria—New York* (2004), which drew on Chahine's experiences as a student in the United States. Chahine's special achievement was the introduction of the concept of foreign coproduction to Egypt, first with *The Sparrow*, which was coproduced with the former Algerian public organization ONCIC. For all his subsequent films he was able to approach various French cultural and official institutions as well as European television programs. Since the beginning of the new millennium Arab TV channels, among others Maroc 2 and ART, have also agreed to coproduce his films.

Another Egyptian director who also made more or less successful attempts to tell his life story, or at least to enrich his films with autobiographic elements, was Yousri Nasrallah in *Summerthefts/sariqat sayfiya* (1988) and in a strongly coded way in the original *Mercedes* (1993), both foreign coproductions. His literary adaptation *The Gate of the Sun/bab al-shams* (2003) on the Palestinian question was financed by the French-German cultural channel Arte as well. Nasrallah's early films in general were not particularly successful with local audiences, for stylistically they address themselves rather to an international art house audience, like his *Aquarium/ junaynat al-asmak* (2008), which was also foreign funded and is centered around two highly alienated bourgeois individuals whose difficult human relations make the tension that prevails prerevolution society become overt.

Since the late 1990s new media, the digital format, and new independent galleries and art institutions have not only helped to install a new art form in Egypt, that is, video installation and media performance that has distanced itself

from the former state-run art establishment. Some video artists, most notably Amal al-Kenawy (al-Qinawi), Sharif al-'Azma, and Hassan Khan, have crossed into the field of animation and experimental documentaries. These films, and recent independent short films in general, have a tendency not only to be socially and politically critical but are also daring in their approach to sensitive issues, such as veiling, sexuality, and state oppression.

Ibrahim El-Batout has criticized in his slightly autobiographically oriented film *The Magician/al-hawi* the oppressive state apparatus under Mubarak, something he continued in his more mainstream-oriented *Winter of Discontent*. Also independent fiction films that rely on good character studies, such as Ayten Amin's charming and autobiographically inspired portrait of an aging capricious man in *Villa 69* (2014), belong to this new wave of independent films. *Harag wa Marag* (2013) by Nadine Khan is worth mentioning because of its unconventional narrative despite of a rather clumsy mise-en-scène. A laudation to diversity and collectivity are certainly Ahmed Abdalla and Maggie Morgan's films, which developed the parallel stories of their films *Microphone* (2011) and *Asham—A Man Called Hope/'Asham* (2012) collectively with the artists and performers involved.

The real change since the mid-2000s, however, is a stronger detachment from the established film industry and shooting without passing censorship or acquiring any location shooting permissions, as in the case of numerous video films but also the first cinematic works of Ibrahim El-Batout and Ahmed Abdalla. Doubtless digital technology, which is more affordable and accessible than celluloid formats, has become a catalyst for independent filmmaking. Some of the established filmmakers have started using the digital format for a full-length fiction quite early to reduce their budgets: Yousri Nasrallah with the French TV coproduction *al-Madina* in 1999 and Mohamed Khan, who took up again his New Realist style for *Klephty* (2004), which, however, was not released in theaters. Meanwhile the new technology has been also adopted by the industry.

Moreover, after the turn of the millennium the emergence of independent filmmakers was encouraged by new funding opportunities created with the Arab Fund for Arts and Culture but also through film festivals in the Gulf States, Enjaaz (Dubai), Sanad (Abu Dhabi), and the Doha Film Institute. Ibrahim El-Batout (al-Batut) and Ahmed Abdalla, who have meanwhile assimilated both relatively to more stringently narrated films, were rightly evaluated as forerunners of current alternative filmmaking, especially since they also sought to move into new terrain with narrative style and collective production methods. Ibrahim El-Batout's *In the*

Eye of the Sun/'Ayn Shams was shot without stars and very few professional actors. Some scenes were completely improvised. The parallel stories in *Microphone* (2011) by Ahmed Abdalla were commonly developed by the different artists, musicians, fine artists, and actors who featured in the film.

The independent collective spirit extended also to comprise training and alternative distribution. The oldest and best-known Egyptian example so far is the film cooperative Semat, founded in 2001, today directed by Hala Galal. It was funded for a while by the Euromed Audiovisual Programme and ran among others the interregional Arab distribution initiative Caravan (not to be confused with the Moroccan independent distributor of the same name) touring with European and independent Arab films. In Alexandria, film production cooperatives were created before the revolution too. The two collectives Figleaf Studios and Rufy's coproduced in 2010 an original short-film compilation under the title *Mice Room/ udat al-firan* (2010). It made use of props and equipment its members provided by the production of Ibrahim El-Batout's *The Magician/al-hawi* (2010), which was shot on location in Alexandria.

Another film production, the full-length docudrama by Tamir al-Sa'id, *The Last Days of the City/akhir ayam al-madina*, which started to go into production in 2008 and and premiered only in 2016, resulted in the creation of two initiatives, an independent production house owned by al-Sa'id and actor Khalid Abdalla (*The Kite Runner*, 2007) as well as the collectively run alternative film center Cimatheque, which is equipped with projection, lab, archive, and library, and also offers training opportunities.

The most artistically exceptional recent work that was produced by a cooperative is Hala Lotfy's (Lutfi) *Coming Forth by Day/al-khuruj illa al-nahar* (2012). It was a work in progress already years prior to the revolt, but could only be completed in 2012. For its production, Lotfy and a number of colleagues created the collective Hassala (*The Money Box*), which has meanwhile completed two documentaries and is involved in the production of a number of other films. In her film, the filmmaker follows a young woman for a day and a night while, between the health care needs of her father, bedridden and near death, and the moods of her exhausted mother, she tries to inject a little joy and dignity into her own daily routines. As its title suggests, the film builds on the ancient Egyptian idea of the soul's journey after death, and thus is also intended as a meditative confrontation with the experience of parting and death. Close to what André Bazin describes as realist cinema, this film uses primarily long shots and long takes, thereby embedding characters in their social

environment. It is one of the most radical and unconventional Egyptian art house films particularly because of the complete absence of any references or elements of Egyptian genre cinema.

Genre and Social Distinction

'Ali Abu Shadi (1996, 85), an influential Egyptian film critic and high-ranking cultural functionary who served also as head of film censorship and director of the National Film Center before the 2011 revolution, observed: "The harshest criticism of genre cinema in general is that genres have usually affirmed the status quo and its existing values, and have resisted any innovation or change. More often than not, these values express dominant mores and ideology. They provide easy formulaic answers to difficult questions in order to please their audiences. The exceptions are far and few in the history of cinema." This essentializing view simplifies the dynamism of film genres and underestimates their negotiating character, failing to recognize their multilayered intersection with social and cultural struggle.

In reality, Egyptian film genres have become part of an ideologically tainted conflict, visible in the setting apart of realism from the formerly most popular genre of all, melodrama. Particularly in the postrevolutionary era,[3] realism and melodrama have been largely conceived as exclusive by Egyptian and foreign leftist film criticism—a move that runs parallel to developments in Western theory (Hallam and Marshment 2000, 98). The assumption was that the two genres are representing divergent class interests as well as different Egyptian historical eras, namely pre- and postrevolution.

National and international criticism of the postcolonial era spoke enthusiastically in favor of realism, like the French critic Claude Michel Cluny (1985, 46) in his *Dictionnaire du cinéma arabe*. Melodrama was in general relegated to commercial orientation, schematized repetitiveness, and lack of authenticity. Egyptian critics had started spreading this view earlier, describing "prerevolutionary" cinema as marked by misguided consciousness, such as its preference for splendid upper-class settings, those "feudal palaces" that were later in more realist accounts replaced by "the apartments of employees and the alleys of Cairo" (Farid 1973, 150).

Egypt's most popular melodramas featured more often than not stories of romance thwarted by class difference. If not with fate in general, disability, diseases, or sexual oppression such as rape and seduction, the loving young man or woman

was confronted by familial authority. Their major opponent was the authoritarian father, or a person related to that authority, the wicked character who helps to impose the father's law, like the cousin in *Mortal Revenge/sira' fil-wadi* (1954) by Youssef Chahine, or the uncle in *The Cry of the Plover/du'a' al-karawan* (1959) by Henri Barakat. His task was to hinder the couple in love from reuniting. Moreover, melodrama's adversaries have been commonly linked to ideological binarism, "a Manichean battle between good and evil which infuses human actions with ethical consequences and therefore with significance" (Peter Brooks quoted in Gledhill 1991, 209). The "utopist" reconciliation between rich and poor in the often indispensable happy ending was made out to discredit these films as products of the dream factory, the product of a "false consciousness."

Melodrama's basic opposition to realism has been disputed in more recent film theory. The dramatic discontinuity or arbitrariness of the action, expressed in sudden drops of expectation and emotional twists underlined by gestures and orchestral music, were now seen to reflect the arbitrary character of class justice (Mulvey 1989, 66). The discursive split between realism and melodrama is seen to have occurred in Europe, for example, at the end of the nineteenth century, linking realism to the intelligentsia (Hallam and Marshment 2000, 19). The schism was perpetuated later during the 1910s, particularly in the United States where the nickelodeons were denounced as "dens of vice, breeding grounds of physical and moral degeneracy, their lower-class immigrant audiences overly susceptible to the 'immoral' and corrupting influence of melodrama" (Hallam and Marshment 2000, 22). By 1912, realism was strongly advocated, with critics increasingly demanding "natural, sincere, unmelodramatic acting in popular film" (Hallam and Marshment 2000, 21).

In Egypt, in contrast, realism soon became linked to the idea of cultural authenticity and the "truthful" representation of lower-class life conditions as a sign of the filmmaker's social commitment. According to the film historian Ahmad al-Hadari (personal communication, 2006), the issue of authenticity was first raised regarding Ibrahim Lama's *Kiss in the Desert/qubla fil-sahra'* (1928). In an attempt to copy Rudolph Valentino's character in *The Sheikh* (United States, 1921), Lama equipped the main character, his brother Badr Lama, with a patterned vest entirely untypical for Arab Bedouins, a fact that was faulted in the Egyptian press of the time. An Egyptian magazine in 1928 dismissed the whole work as inauthentic, stating: "only the images of the Sphinx and the Pyramids give you a sense that this is an Egyptian film, otherwise it does not relate to us at all" (quoted in Saif 1996, 104).

The representation of rural and urban lower classes and interests in social problems became a powerful and indispensable criterion for cinematic realism in Egypt. Al-Hadari (personal communication, 2006) conjectures that this criterion was established around 1939 when Niazi Mustafa's *The Doctor/al-duktur* and Kamal Selim's *Determination* were released, both revolving around educated young men from modest social backgrounds. On the other hand, early press reviews of Salah Abu Seif's films, like *Master Hassan/al-usta Hasan* (1952), were primarily concerned with technical quality and acting. Only some critics, most notably leftist Ahmad Kamil Mursi (Yusuf 1992, 57) and al-Sa'id Sadiq, did dwell upon the films' relation to reality as well. Of Abu Seif's *Your Day Is Coming/lak yaum ya zalim* (1950), an adaptation of Emile Zola's *Thérèse Raquin*, Sadiq wrote, "watching this film, you see a truthful picture of events in Egyptian society, you see alive characters, whom you meet everywhere and you find society's problems being treated" (quoted in Yusuf 1992, 84).

The notion of realism being capable of representing "objective reality" has been popular with Egyptian critics until recently. In Magda Wassef's *100 ans de cinéma*, film critic Kamal Ramzi (1995, 144) stated that melodrama implies "sympathy for the hero's misery but does not lead this misery back to objective reasons," while still holding that realism "consists of seeing reality, comprehending it, discovering the objective reasons for a phenomenon, displaying the moments of its transformation on the individual and collective level, taking position for the forces that shape life."

This position did not comprehend realism just as a specific discourse on reality with its own set of conventions like other genres,[4] but rather as a means to represent reality in an "objective" and presumably more adequate way. It neglected furthermore the fact that cinematic realism is a far more diffuse category than melodrama. While realism became a formal paradigm for popular cinema, it has also lent its name to various cinematic trends, such as socialist realism in the Stalinist era, French "poetic realism" during the 1930s, post–World War II Italian neorealism, and British "kitchen sink" New Wave, as well as different "Third Worldist" realisms in, for example, Mexico and India.

Egyptian Realism of the 1950s and 1960s was represented primarily by the work of Salah Abu Seif, Taufiq Salih, Youssef Chahine, and Henri Barakat. It remained marginal in numbers and impact, with around one or two outspoken realist films among the thirty-five to fifty films produced every year. Egyptian Realism did, moreover, remain attached to melodrama to the extent that it may be characterized as melodramatic realism. Realist films used popular stars and were rarely shot on

location. What earned them the respect of the critics though was their concern with the underprivileged classes, focusing largely on various members of the urban lower class, only rarely on workers and peasants.

Some argued that what unites different realist waves is less form and style but rather an ideological orientation (Williams 1977, 64), also described as "realistic motivation" (Hallam and Marshment 2000, 15), that operates with a changing set of references regarding what is understood as reality. In contrast, popular realism in acting style and mise-en-scène aims to achieve a "real-ization" of fantastic environments, on making scenarios that are visually and aurally credible (Hallam and Marshment 2000, 64). The schism between realism and melodrama in Egyptian film is indeed a difference in "motivation" rather than form.

The realism that has prevailed in Egyptian film was commonly "rhetorical" in nature. This realist form, in contrast to so-called expositional and spectacular realism, proposes an argument about the conditions of the real, mostly through the heroic actions of an individual caught in a sociopolitical dilemma, borrowing stylistic means from popular genres (Hallam and Marshment 2000, 101).

Egyptian criticism has paid little attention to the affinity between realism and melodrama and failed to explore that pre- and post-"revolutionary" ideological tensions may have been the real source for setting the two genres apart as supposedly contrasting systems of representation. Egyptian Realism thus became one of those "symbolic goods" (Bourdieu 1984, 66) to be used as an ideological marker for those who considered themselves enlightened, progressive quasi-leftists and those with a heart for the national cause, always entitled to dismiss popular films like *al-Limbi* (2002) for their triviality.

Raped Class/Raped Nation: From Melodrama to Realism

The strong affinity between realism and melodrama in the Egyptian context is illustrated by the migration of one of the most recurrent themes of melodrama, namely seduction and rape, to "revolutionary" realism. According to Galal al-Sharqawi (1970, 109), more than half of the Egyptian films presented seduced or raped women in the season 1942–43. In the majority of these films, different class affiliation—that is, upper- and lower-class status—was crucial to plot construction and the abuse theme, so that cross-class seduction and rape could be read as "the metaphorical interpretation of class conflict," to use Thomas Elsaesser's (1985, 185) words.

Among the early examples of such films were musicals like *Fatima* (1947) by Ahmad Badrakhan, starring Umm Kulthum, and *Fate's Stroke/darbat al-qaddar* (1947) by Yusuf Wahbi, with Layla Murad, both presenting poor lower-class girls duped and seduced by upper-class men. The seduction/rape motif was also employed to denounce colonial oppression, as in Bahiga Hafiz's 1937 spectacle *Layla the Bedouin* (released only in 1944). Female passivity and weakness became an allegory meant to criticize social underdevelopment, injustice, and political domination. The motif resurfaced in quite a number of so-called realist works, such as Taufiq Salih's *Diary of a Country Prosecutor/yaumiyat na'ib fi-l-aryaf* (1968), adapted from a novel by Taufiq al-Hakim, in which the powerful head of a village tries to rape a beautiful peasant girl. In Henri Barakat's *The Sin/al-haram* (1965), a poor peasant woman gets raped and dies in the aftermath of a secret child delivery after having unintentionally suffocated her newborn child; a revealing investigation ensues. *Beginning and End/bidaya wa nihaya* (1960) by Salah Abu Seif, adapted from a Naguib Mahfouz (Nagib Mahfuz) novel, also represents a powerful merger between the two genres. Set in prerevolutionary days, it portrays a petty bourgeois family composed of four siblings driven into misery after their father's death. The family's decline is sealed by the only girl. Having failed to attract a good match because of her mediocre looks, Nafisa has taken on the responsibility of supporting her mother and her youngest brother studying at the prestigious military academy by working as a seamstress. When she gives in to the son of a prosperous neighborhood grocery owner and he refuses to marry her, she turns to the streets, prostituting herself. One evening she gets detained, and her brother is asked to pick her up from the police station. Paralyzed by the shock, he drives to the riverside as she demands, and there she drowns herself, eventually followed by him. The nocturnal suicides focus on the expressions of Omar Sharif and Sana' Gamil as the two siblings. This finale is accompanied by bombastic orchestral music, while the largely tilted camera is set in dramatic low-key lighting. *Beginning and End* thus musters a striking array of stylistic melodramatic means all the while denouncing social inequality through cross-class seduction.

The rape-seduction theme appeared also in more progressive works, for example, *The Cry of the Plover* (1959). Adapted from the eponymous novella by Taha Husain, the film features a poor orphaned girl of rural origin who has acquired some basic education while serving a bourgeois family. When her sister, also a housemaid, gets raped by her employer, a young engineer, her uncle kills her for the sake of their honor. Thus the Heroine decides to take revenge and seeks employment with the

same master. She makes him fall in love with her, until in the moment of his first sincere embrace he dies in her arms hit by a bullet meant for her. What turned this film into a modernist text was its denouncing of "traditional" crimes of honor and its emphasis on one of the pillars of modernist thinking, education. It is through her education that the heroine becomes more of a match for the engineer and is able to resist his attempts at seduction.

New Alliances—New Enemies: From Melos to Action

The Cry of the Plover was not the only film to envision a positive role for modern education. In the fairly melodramatic plots of *The Land of Dreams/ard al-ahlam* (1957) by Kamal El-Cheikh, it is the young engineer, son of an ordinary peasant, who uncovers the dirty games initiated by the feudal landowner and his followers. In the modernist-oriented *Umm Hashim's Lamp/qandil Umm Hashim* (1968) by Kamal 'Attiya and *Struggle of the Heroes/sira' al-abtal* (1962) by Taufiq Salih, it is always doctors who, by means of their enlightened knowledge and modern education, try to beat the vicious circle of ignorance and traditional power, represented in the case of *Struggle of the Heroes* by the alliance a feudal landlord, the village head, and a midwife.

Education as a means of social ascent or resistance had been already proposed by the first so-called realist films, *Determination* (1939) and *The Black Market/ al-suq al-sawda'* (1945) by Kamil al-Tilmissani. Indeed, after the 1952 coup, the government promoted free education (including cinema studies) and guaranteed state employment, both of which became instrumental in forming the new state bourgeoisie and offering an opportunity for social ascent until the Sadat government worked to reverse much of these innovations of the Nasser era.

The nationalization of industry and the continuation of the substitute policy initiated previously by the "national" bourgeoisie put Nasser's state functionaries in a favorable position to accumulate capital for themselves, redirect public investment, and gradually eclipse the former traditional elite, infiltrating them first, then turning them into companions (Hussein 1973, 186).

On the screen, too, pashas became increasingly dispensable. Doctors and engineers embodied the new social order either positively or negatively, be it in melodrama or realism, before they were joined by the bureaucrats, who emerged during the 1970s after the defeat in 1967. They were eventually eclipsed by mafioso-like

businessmen who were seen to be a product of the post-Nasserist Open Door Policy. Mushrooming in the 1980s in particular, they lacked social status and education, and appeared in a negative moral light.

Education and class affiliation were not always equated with a high moral standing. And while upper-class representatives, the pasha and his companions, were increasingly pictured as greedy, unscrupulous, and despotic villains after 1952, there had been negative portrayals during royalist times as well; the intrigues of the opportunistic relative who wants the rich beauty for himself was a familiar part of many melodramatic plots. After 1952, the middle class was not necessarily virtuous, as can be seen in *The Cry of the Plover*. And despite the official quasi-socialist orientation, some quite popular works started presenting utterly vicious and unredeemable lower-class men, among others *Hamidu* (1953) by Niazi Mustafa, starring Farid Shauqi in a story that he authored himself about a criminal fisherman; *The Beast/al-wahsh* (1954) by Salah Abu Seif, featuring a village dominated by a criminal rural character (in cooperation with a big landowner); and *Abu Hadid* (1958), again by Niazi Mustafa, set in a fishermen's community with an evil thug trying to monopolize the fishing trade.

Just like melodramas, these action-oriented films tended to rely on "Manichaean battles," presenting adversaries representing vice and virtue. The figure of the despot was constitutive to quite a number of works, the quasi-historical spectacle *Lashin* (1939) by Fritz Kramp for one. After 1952, the despot, an arriviste now, remained a recurrent figure, as in Salah Abu Seif's realist *The Thug/al-futuwwa* (1957), picturing the struggle of market vendors against the "King of the Market" who dictates commerce and prices. Marxist-oriented works, such as *Struggle of the Heroes* (1962) and *al-Sayyid al-Bulti* (1969), both by Taufiq Salih, and *The Earth/al-ard* (1970) by Chahine, focused on the battle of a heroic figure against the dominance of a group with shared interests, such as landowners, village heads, and officials.

The disastrous defeat in 1967, which resulted in the Israeli occupation of Egyptian and Syrian territory as well as the rest of Palestine, marked the final decline of the era of Nasserism. It brought about a clear tendency to hold the system as a whole responsible. Quite a number of films labeled as political dealt with social struggle but were eager to divert the binary moral and social construction of earlier realist films toward a stronger focus on the failure of the system in general (Abu Shadi 1996). *Miramar* (1969) and *Adrift on the Nile/tharthara fauq al-Nil* (1971) by Hussein Kamal, both films based on the writings of Naguib Mahfouz, gave a more complex

answer to the question of "who is to blame?" by focusing on the concerted action of several social actors. Within this constellation, the character of the opportunist gained a special weight, such as the crooked young Sarhan in *Miramar*, a member of the ruling party who tries to dupe Zahra, a poor country girl, into marriage.

At the same time, there was a change in style, with an increased use of action film elements. Numerous works in the 1970s returned to the lonely upright hero who is confronted with irresolvable corruption as *The Bullet Is Still in My Pocket* (1974) by Husam al-Din Mustafa, *On Whom Shall We Shoot?/'ala mann nutliq al-rasas?* (1975) by Kamal El-Cheikh, and *The Culprits/al-mudhnibun* (1976) by Sa'id Marzuq. They were continued in the 1980s by the New Realist *The Busdriver/sawaq al-utubis* (1982) by Atef El-Tayeb and *Houseboat No. 70* (1982) by Khairy Beshara. These films were quite unlike melodramas in that their heroes, still caught in almost irresolvable conflicts, displayed a clear readiness to fight back and not surrender to circumstances, reinforcing the action elements.

The "Fat Cat" Narrative

In his study on the development of action in Egyptian film, director Samir Saif (1996, 74) argued that, unlike melodrama, where class conflict is metaphorically inscribed in class representatives themselves, the action film depends much more on the social environment as such, the latter being a decisive factor in engendering its hero's conflict. This is the closest meeting point with the New Realism that dominated the 1980s. It was represented by the "core" group of Atef El-Tayeb, Bashir al-Dik, Khairy Beshara, Mohamed Khan, Daoud Abd El-Sayed, 'Ali Badrakhan, and Ra'fat al-Mihi, who pursued certain recurrent themes and employed formal approaches that helped define them as "realists," such as shooting on location, reduced music, sober acting, and socially committed themes, including moral conflicts.

One of the most lauded works of New Realism was the highly allegorical *The Vagabonds/al-sa'alik* (1983) by Daoud Abd El-Sayed, which focused on the unexpected ascent of two uneducated workers, alluding to the real-life success story of the supposedly illiterate Rashad 'Uthman, who became an influential businessman and a member of parliament. The two friends live on the streets of Alexandria before they start trafficking drugs and become two of the most prosperous businessmen in town. Subsequently, one of them courts an educated woman from an old bourgeois family that has become impoverished. Their story emphasizes the gap between

the uneducated criminal nouveau riche and the "respectable" middle class, which is unable to perform successfully in the new economic system engendered by the Open Door Policy.

Notwithstanding its realist discourse and the fact that *The Vagabonds* alluded to a "real" story, its narrative has to be considered rather mythical. As a matter of fact, the post-Nasserist new ruling class has been "a merger between fractions of the old traditional bourgeoisie, who were restricted under Nasser and once again revived with the 'open door' economic policy, fractions of the bureaucratic bourgeoisie born with the state sector under Nasser and finally businessmen performing new activities and stepping in areas of investment with the least risk and the highest profits" (Zaalouk 1989, 133). In short, this class was eventually embodied by the commercial agent.

This did not preclude the nouveau riche or "fat cat" being endlessly featured in the commercial cinema of the 1980s. The fat cat was by and large pictured as a crook ascending from the margins of society to become part of the powerful economic elite, a disrespectable figure from the margins making it to the top through illegal practices, such as theft, nepotism, and bribery. *Attention, Ladies and Gentlemen/ intabihu ayuha al-sada* (1980) by Muhammad 'Abd al-'Aziz, *The Servant/al-khadima* (1984) by Ashraf Fahmi, and *The Door Keeper Holds the Building's Management/ sahib al-idara bawab al-'imara* (1985) by Nadia Salim featured ruthless lower-class protagonists managing to sneak into the life of bourgeois families and dominate them step by step. New Realism took up some of the same motifs and dwelled on them, even if in a less exploitative manner.

New Realism and the action films of the 1980s were obviously directed against the *Infitah* initiated by the Sadat administration in the 1970s. On the political and economic level, it meant leaving the socialist orbit and approaching the United States, a change that allowed the ascent of an Islamist segment represented by the Islamic investment companies that started to mushroom during the 1980s and an unprecedented accumulation of wealth, reversing many of the economic and social "achievements" of the preceding era. These films explained the ascent of the nouveaux riche in terms of criminal practices, and denounced their morals, dwelling on their materialism and lack of any traditional sense of community. Screen *Infitahis* were devalued on the "ethical" level in a way similar to what Zaalouk (1989, 131) has described in her study of the old elite among the so-called commercial agents who distinguished themselves strictly from the "newcomers" who had made their way in the mid-1960s. In a similar move, the 1980s generation of directors, realist

and mainstream alike, themselves members of the less prosperous bourgeoisie, but well equipped with cultural means of expression, were denouncing the more affluent bourgeoisie for their excessive possession of economic means and their "lack of culture."

Social Struggle, Deficient Male-Bodied and Global Heroes

With their disguised representation of struggles within the bourgeoisie, films in the 1980s expressed skepticism about the social mobility previously vividly depicted in melodramatic terms, either sarcastically negotiating reconciliation, as in *People from the Top/ahl al-qimma* (1981) by ʿAli Badrakhan, or more often ending up in a final and devastating confrontation, as in *The Vagabonds*, when at the peak of their economic success the two former friends turn against each other in a deadly confrontation. The conflict concluding in a bloody showdown was a feature in numerous other films of the time, such as in Atef El-Tayeb's *The Innocent* as well as in his *The Prison Cell/al-takhshiba* (1984) and *The Execution Squad/katibat al-iʿdam* (1989), where female avengers hunt down their oppressors.

The question presents itself why after 1952 an increasing number of films resolved narratives with a violent showdown, most prominently in Youssef Chahine's *Struggle on the Nile* (1954), in which the representatives of the old unjust "evil" social system are eliminated, paving the way for the pasha's daughter and the young engineer to come together. Is this a sign of a real-life class struggle, indicative of a more general sociopolitical transition in Egyptian society from social reconciliation to resistance and violent confrontation? The emphasis on violent resolutions in *Infitah*-critical films in particular could be read allegorically as a sign of a boiling social and political situation (Ramzi 1987), given the unrest that characterized the post-1967 era, first in consecutive student protests between 1968 and 1973, then the bread riots in 1979, the assassination of Sadat in 1981, and the numerous Islamist assaults ending with the Luxor massacre in 1996. Yet it could be argued that the Egyptian "street" was already boiling before 1967, starting with the 1919 revolution, the assassinations of Prime Ministers Ahmad Mahir in 1945 and Nuqrashi Pasha in 1948, the Lavon Affair in 1954, and the cleansing of the political scene during the reign of Nasser from any opposition, to state only a few of the most salient events. Moreover, the much more "democratic" and stable systems in the West have produced an abundance of extremely violent films, whose horrifically graphic

killings and mutilations display a much more ferocious, bloody, homophobic, and misogynist attitude than Egyptian film ever did.

"Global" interpretations related to the international "mediascape" have offered more universal explanations for violence in the media in general. Paul Virilio (1989), for example, placed the cinematic invention itself, its preoccupation with mobility, image "shooting," and an increasing "objectivation" of the world, into the context of modern warfare that produces a shattered human perception. Jean Baudrillard (1983) in turn described the media as a simulacrum, in which a constant ongoing stream of factual (violent) news imagery and fictional images melt into a completely undistinguishable "simulation" to which viewers succumb. Yet these theories presuppose a passive and unspecified spectator, untouched by class and gender. Richard Dyer (2002, 66), in contrast, proposed that the secret of action film lies in the active-passive nexus, offering the "reproduction of a masculine structure of feeling" that "is represented as experienced not within the body but in the body's contact with the world, its rush, its expansiveness, its physical stress and challenge," reminding us also of the fact that speed and motion are important aspects of cinematic pleasure, from the time when the Lumière brothers' train first approached audiences.

Speedy mechanized motion is doubtless one of the most common characteristics of modern times and implies meanwhile virtual effects that may create similar body sensations experienced when in motion. A "masculine" structure of feeling along with "lower-class" attitudes may be one factor responsible for the increased use of action in popular Egyptian films as a result of the exposure to modern technology. However, the Egyptian action film has not been as much devoted to the machismo of a "failed masculinity" embodied in Hollywood's muscular heroes of the Reagan era, such as Rambo (Tasker 1993, 121). Instead, it has focused on a dual narrative concept, which is women-inclusive, like many Hollywood films "combining a story vehicle for male heroism and spectacular action with a heterosexual romance of cross-class conflict" (Hallam and Marshment 2000, 66). This I would describe as the double strategy of popular Egyptian film: keeping its films family-friendly while bowing to the urban lower-class males of the *tirsu* audiences.

This double strategy of popular films can be traced back to the first signs of adventure and action—picturing the male figure in a landscape, to use Laura Mulvey's (1989, 20) feminist interpretation—in Bedouin films such as *A Kiss in the Desert* (1928) by Ibrahim Lama and *Lady of the Desert* (1929) by Wedad Orfi. They evolved around romance rather than "broader conflicts," crime, or deadly

male competition. Their production ceased in the early 1950s. At the same time, less "folkloric" genres such as police films and thrillers appeared along with a local subgenre, the thug (*futuwwa*) film, starting with *The al-Husainiyya Thugs/ futuwwat al-Husainiyya* (1954) by Niazi Mustafa. The thug cycle developed soon a recurrent schema involving an urban lower-class character who, thanks to his physical capabilities, including traditional stick fighting, comes to hold power in the alley and embraces the urban lower-class *awlad al-balad* honor codex. It reached a peak in the 1980s with *Mountain Thugs/futuwwat al-gabal* (1982) by Nadir Galal and several similar films by Samir Saif.

Egyptian action films began to address the lower class early on. Farid Shauqi, one of the biggest stars related to the genre in the late 1940s, was conscious of displaying "lower-class virility." In his 1978 biography, written by Iris Nazmi, he dubbed himself "King of the Tirsu" (*mallik al-tirsu*) (Armbrust 2000), referring to his assumed popularity with audiences of third-class movie theaters, the urban lower class of workers, craftsmen, peddlers, and servicemen.

Shauqi had to share his self-assumed kingdom with Rushdi Abaza during the 1960s and 1970s. It was then taken over by 'Adil Imam in the 1980 and 1990s. At that time the former first-class theaters in downtown Cairo had deteriorated to the point of being almost equivalent to the *tirsu* in serving a predominantly male working-class clientele, and Imam's films were released there regularly.

Egyptian action films were usually confined to brawls and fist fights; they included hardly any exciting gun fights, and the car chases did not result in big casualties. This low level of action increased, at first relatively slowly, but then accelerated until by the late 1970s brawls and chases were complemented by greater physical challenges, modern weapons, and fast-changing sceneries, especially in the films of Samir Saif. However, action films presented a major economic problem for the relatively poor Egyptian industry because of their high cost and a lack of technical expertise to produce special effects. Car crashes and explosions in particular, when featured at all, tended to be short, with a lot of empty cardboard boxes flying around after the collision.

The cost of featuring expensive action sequences, a problem for horror films, science fiction, and historical spectacles as well, reflected in an almost allegorical sense on the heroes of the genre. First and foremost among them was 'Adil Imam, who portrayed a certain type of lower-class masculinity and who openly admitted not to "read the criticisms of his films . . . , because his real audience does not know how to read and write" (Taufiq 1984, 52). Imam started out as a comic underdog in

his first box office hits, *The Wallet Is with Me/al-mahfaza ma'aya* (1978) and *Rajab on a Hot Tin/Rajab fauq safih sakhin* (1979), both directed by Muhammad 'Abd al-'Aziz. He appeared as a duped fraud, a sympathetic lower-class crook, who gets outwitted by more powerful professional gangsters. The crushing of his aspirations to better himself implied skepticism in any prospect of social mobility. In the 1980s, Imam went on to present himself as an action hero in films with the directors Nadir Galal and Samir Saif. His persona shifted to more of an unambiguous "good" hero, as an undercover policeman in *The Leopard and the Woman/al-nimr wa-l-untha* (1987) and as a fictive national hero in *Shams al-Zinati* (1991), both directed by Samir Saif. He also embraced the action film more unequivocally. In Sherif 'Arafa's *The Forgotten/ al-mansi* (1993), he featured as a lonely railway switcher whose solitude and sexual fantasies (a pinup girl on his wall starts dancing) are suddenly interrupted by a "real" beautiful female fugitive, who works as a secretary for a rich businessman and who, when invited to a luxurious party in the countryside, had refused to prostitute herself to her boss's clients. Imam, a chivalrous and hospitable urban lower-class *ibn balad*, of course takes up her cause and defends the honor of this nighttime beauty against the muscular thugs of the businessman.

Imam's films have generally been characterized by a quite meaningful inability to meet the genre's standards. He is not handsome. And his characters' insistence on getting involved in direct physical confrontations with much more muscular adversaries, whom he amazingly manages to beat up, is simply not convincing. These scenes linger therefore at the fringe of comedy even when they are not intended in an ironic or alienating way. In *The Forgotten* and the historical spectacle *Message to the Ruler/risala illa al-wali* (1997) by Nadir Galal, the audience had to overlook the obvious signs of Imam's age and his weight more than once and believe that he was young, strong, and muscular.

In some Imam vehicles comic effects are clearly intended. Thus the story of the *Seven Samurai* remake *Shams al-Zinati* appears serious and spectacular for being set in World War II, featuring the patriotic Zinati's ferocious battle against a wicked gang that took over a desert oasis. However, the comic effects in acting and mise-en-scène tell otherwise. The choice of second-rate comedians as al-Zinati's cofighters, their various funny character traits, some slapstick situations, the inappropriate historical set design, and anachronistic costumes all convey a profound "deficiency" and divert the pleasure from mobility and physical power during the action scenes.

Often futile attempts to display technical prowess and male-defined potency, embodied by special effects and "masculinity" (that is, muscular masculinity

[Tasker 1993, 132]), have pushed Imam's films into the realm of masquerade. As much as muscular actors, such as Sylvester Stallone and Arnold Schwarzenegger, can be seen to slip into a "parodic performance of masculinity" (Tasker 1993, 111) through overstatement, Imam's persona can be read as a carnivalesque insistence on masculinity that is constituted by *lack* and points very much in the direction either of an inability or a refusal to confront technology and bodily efficiency successfully. Imam's performance is overtly situated in the realm of wish fulfillment and imagination. Imam's vivid but ineffective physical fantasies can be read as the dreams of the lower-class underdog whom he has so often chosen to embody vis-à-vis the country's elite. Interestingly, these fantasies extend into the international arena too.

At the turn of the millennium Imam joined the new wave of immigration films with *Hello America/halu Amrika* (2000) by Nadir Galal. It featured Bakhit ('Adil Imam), a former member of parliament (dismissed because of his honesty) and his fiancée, 'Adila, two characters who had already appeared in Nadir Galal's *Bakhit and 'Adila/Bakhit wa 'Adila* (1997), which featured the role of nepotism in parliamentary elections. As Bakhit comes from a poor neighborhood and has no financial means to wed 'Adila, the couple decides to head for Bakhit's cousin in New York, yet after a series of ups and downs they end up again on the street. Social equality is pictured as a goal too hard to achieve.

Not all immigration films share such a skeptical view. Most can be even interpreted as a dream of longing for recognition, asserting a presumably Egyptian supremacy and efficiency. Sa'id Hamid's *An Upper Egyptian at the American University/sa'idi fi al-jami'a al-amirkiyya* (1998) heralded this orientation. Starring the relative newcomer Muhammad al-Hinidi, the film was so popular that it initiated a whole al-Hinidi cycle. The film turned out to be the prelude to the advent of a new star generation that appeared in so-called new comedy courting the shopping mall audience, and took over the Egyptian film industry.

The Upper Egyptian in *An Upper Egyptian at the American University* is Khalaf, who lives in a village in Upper Egypt. An exceptionally high score at his high school graduation allows him to enter the American University in Cairo. Yet the gap between him and his fellow students is all too evident. He differs in everything: language, clothing, behavior, and thinking. But eventually Khalaf manages to find not only friends at the university but also a suitable match among his female classmates. The film's form is highly stylized; it has farcical sketches, musical numbers, and numerous stereotypical characters. The Egyptian social fissure, the gap that the hero eventually manages to bridge, is complemented by an international dimension

with the Americanized teacher Sirag, who becomes Khalaf's fiercest opponent. Their conflict is ignited by their opposing positions on the Palestinian question. Sirag, clearly marked as pro-American, tries to subvert the students' efforts to mobilize in solidarity for Palestine and organize a demonstration on campus. Eventually, the malicious teacher gets exposed, and the students succeed in launching their protest.

An Upper Egyptian at the American University renews the old motif of the ever-present Zionist that had already been introduced by numerous espionage films, such as *A Task in Tel Aviv/muhimma fi Tall Abib* (1992) by Nadir Galal, starring Nadia al-Gindi, nurtured by the post-1948 phobia of foreign conspiracy (*mu'amara*) against the Arab world. If there is no Zionist or Israeli adversary visible, then at least a plot waits to be uncovered, as in the recent action film *Mafia* (2002) by Sherif 'Arafa, which resolves the mystery of a planned terrorist attack on the pope's life during his visit to Egypt as an Israeli plot. In a more recent film, *Cousins* (2009), directed by Arafa, an Egyptian mother of two children wakes up to find herself hijacked and brought to Israel as her husband turns out to be an Israeli undercover agent. Of course she is saved after some car trashing and physical confrontations between the two main male opponents, her dour husband and a smart and kind Egyptian agent.

An Upper Egyptian at the American University heralded the production of a series of films that, drawing on larger budgets, unlocked Egyptian cinema's seclusion and its confinement to its region as a location, with films being shot for the first time beyond Egypt and neighboring Mediterranean countries such as Lebanon and Greece, and instead being filmed in the Netherlands, Ukraine, the United States, South Africa, and Thailand. One of the most popular new "globalizing" comedies, *Hamam in Amsterdam/Hamam fi Amsterdam* (1999) by Sa'id Hamid, recycled motifs of the espionage films in presenting the character Yuda, an Arabic-speaking Israeli who claims the Pyramids to be his and tries to hamper Hamam's ascent from a marginalized immigrant to first a successful hotel employee and then restaurant owner. As Hamam succeeds economically, he insists on his Egyptian identity, an identity rooted in the lower-class Cairo alley from which he came. His moral conviction sets him in (friendly) opposition to the second film lead, strongly Westernized Adriano played by Ahmad al-Saqqa, whose career as an action film performer took off with this film. Adriano's entanglement with organized crime leads to a violent showdown, including an almost deadly car chase. Being hot abroad and its action scenes realized with Dutch know-how, *Hamam in Amsterdam* could finally compete with Western cinematic representations.

Apart from their reliance on the "glocal" nexus, these new millennium action films have worked hard to resolve the decade-long technological problem of the Egyptian film industry through investment and the importation of know-how by shooting scenes abroad, like the car chases in *Hamam in Amsterdam* and in *Mafia* shot in South Africa, and by successfully using computer graphics realized abroad. This increased technical "efficiency" is complemented in performance as in the modern and sportive appearance of al-Saqqa, who displays a much more convincing "body machine" than Imam.

Ibrahim Labyad (2009) by Marwan Hamid had one of the highest budgets of the time. It features al-Saqqa as a kind-hearted but angry young man, Ibrahim Labyad, from a Cairo shantytown who becomes a dreaded drug dealer and thug because, during his childhood, he witnessed his innocent father killed. At one point he is drawn into an increasingly violent confrontation with his big boss, an old cunning man who lives in a villa overseeing the whole neighborhood, because both of them fall for the same woman. Unlike earlier *futuwwa* or thug films, *Ibrahim Labyad* doesn't end with the deposition of the dictator but with the hero being ambushed and killed instead. Before that, however, al-Saqqa and his sidekick, Amr Waked, have to prove themselves several times in brawls and physically graphic and violent confrontations.

The efficient male body as represented by al-Saqqa did not completely replace the parodic representation of masculinity, or male masquerade, in other films. The erstwhile success of al-Hinidi's comic persona may be regarded as an indicator. In his role as a cowardly offspring of a gangster and thug family in Sherif 'Arafa's *China's Magnificent Beans* (2003), he unwillingly comes to master Chinese martial arts and wins the heart of an Asian beauty. Al-Hinidi's character refuses to become a gangster like the rest of his family because he is so scared of brawls and weapons. Nonetheless, he keeps being haunted by criminal activities even during his accidental trip to China (predominantly shot in Thailand), where he takes part in a cooking contest. There he meets a beautiful young Chinese translator and is eventually introduced to martial arts by her father. The importance that director Sherif 'Arafa attached to the acquisition of this particular action film technology becomes evident in the epilogue of the film. The end credits are intercut with shots of the making of the film, showing al-Hinidi being pulled high up in the air by strings for the Asian fighting scenes while helplessly crying out the director's name, an image that may be also read as a humorous metaphor of the urban Egyptian underdog who has been unwillingly catapulted onto the global arena.

Yet toward 2010, the wave of merry global heroes had more or less died out. Instead, films presented morally ambiguous characters and protagonists who came home empty-handed after having had a devastating experience abroad, like the hero of *Ant Scream* (2011). Khaled Youssef's *Until Further Notice/hina maysara*, released in 2008, used the same motifs. Its temporal framework extends from the first Gulf war in 1990 until the invasion of Iraq in 2003, and it presents a quite ambiguous thug hero and a fairly bleak image of life in Cairo's shantytowns. Densely populated with entire families cramped in one room, barely educated, hardly working in a regular profession, making ends meet day by day, that is the environment in which the film's meandering story unfolds. 'Adil, a young mechanic, lives with his mother, Umm Rida, in a small room around a courtyard shared with a number of other families. The two are in charge of a bunch of children, the offspring first of Adil's sibling Rida, who traveled to Iraq in search of work and has neither be seen nor heard of since then, and his sister, who had been killed by her jealous husband. The course of events portray the family's life as a downward spiral. To compensate for her miserable life, Umm Rida never stops dreaming of her eldest son, Rida, to come back from Iraq and to shower the neighborhood with gifts and money. 'Adil, who lacks Rida's aura, gets his first prison sentence when he tries to rescue Nahid, a runaway girl, from sexual harassment. Upon his release, he falls for the girl, then fathers a child whom he refuses to accept because of his economic situation. As he abandons Nahid, he also loses track of his child. Frustrated, he attempts to join a hashish trafficking gang, and when he fails he starts to fight the gang until he become the *futuwwa* of the neighborhood. At that point he is forced to cooperate with the police in reporting clandestine activities of Islamists who are hiding in the slums. Years pass, while we see the tragic fate of Nahid and her son unfolding, sweeping them onto the streets. 'Adil in contrast gets caught between the front lines of police and fundamentalists, each side trying to manipulate and abuse him and his family. This conflict extends in the end to the whole community as the militants start bombing security forces and the latter reply by bulldozing and demolishing the entire shantytown. Thus, the situation explodes, and the inhabitants get caught between Islamist radicalism and the cynical inhumanity of the state. This ending comes like an allegorical anticipation of the dynamics of the political unrest that started in 2008 with workers' protests in al-Mahalla al-Kubra and is still going on in Egypt.

'Adil in essence represents a defeated and morally ambiguous *futuwwa*. The latter signified originally a member of a brotherhood that was governed by chivalrous

precepts. On the screen, it carried the rather negative connotation of thug, bully, or racketeer but has fused also in some representations with the positively coded *ibn al-balad* character (literally: son of the country) and has been linked to the trope of the poor traditional neighborhood as an allegorical image of the nation. Thus, narratives set in such places usually found a way for the so-called *awlad al-balad* honor codex to succeed and reinstall order. Not so in the case of *Until Further Notice*. It is rather telling to see at what occasions its hero follows or deviates from the original ideal. In fact, rescuing Nahid and taking his just revenge from the police in an attempt to safeguard the honor of his family puts him in line with this tradition, while refusing to acknowledge his son, trying to steal his mother's gold bracelets in one instance, leaving his mother to take her heroic position in the end alone, contradict it. This contradictory depiction of the hero reflects also on his neighborhood. It is part of his failed compartment; his flaws and social conditions are one.

Conclusion

The Egyptian film industry is regarded by many Egyptians as one of the national achievements that has distinguished its people for a long time from the rest of the Arab countries. However, the industry itself but also the form and content of films have always been subject to social and political changes the country has experienced since the introduction of film. Direct and indirect criticism of social and political injustice, in combination with the dream of social mobility, has been expressed through Egyptian fiction filmmaking since the beginning. The hierarchical social organization has informed the star system as the film distribution network reflected and cemented geographic and infrastructural inequalities. Along with the ideological conflicts created through the shift from colonial to postcolonial times, social distinction has also shaped the status of film genres, such as realism and melodrama, and has helped to polarize their perception and the discourses developed around them.

Commercial or mainstream films, even though discredited as being part of the dream factory, have regularly voiced criticism of the political system without necessarily being hampered by official censorship, which in turn displayed a tendency to act either arbitrarily or only at times of deep crisis, such as after the defeat in 1967. Artistically alternative and avant-gardist attempts have often been prevented by the prevalent film-industrial structure and until they could be more

readily circumvented with the recent advent of the far less expensive new digital technology. The rigid star system and the distribution guarantee system linked to it have played a major role in upholding this general commercial structure. Nonetheless, Egyptian film underwent various changes and developments, primarily on the formal and technical levels, while reflecting the needs and preferences of local audiences. It may be considered a more or less outspoken witness to the country's social and political history since the advent of cinema.

NOTES

This chapter draws on material I published previously in "Egyptian Cinema" (Shafik 2001a) and in *Popular Egyptian Cinema: Gender, Class and Nation* (Shafik 2007b).

1. Years stated in relation to films are usually the year of release, not production, unless otherwise indicated.
2. Numbers of annual production rates in Egyptian film historiography tend to differ from one source to the other due to the fact that usually releases are counted and not productions and that there are at times different opinions on the exact date of release, so that the same film might be counted in a different year depending on the source. In order to avoid confusion, I decided to stick to Mahmud Qasim's work, even though it is also not altogether free of mistakes. It is the latest pertinent publication, and Qasim made the effort to include the day and place of release for each film.
3. "Revolution" is a misleading term. The mass-supported protests against colonialism and the social system took place in 1919, while the overthrow of the monarchy in 1952 was rather a coup d'état, undertaken by the self-proclaimed Free Officers, which later came to be labeled a "revolution."
4. For a more comprehensive discussion, see Shafik (1998, 126).

FILMOGRAPHY

'Abd al-'Aziz, Muhammad. 1978. *The Wallet Is with Me/al-mahfaza ma'aya*. Egypt.

———. 1979. *Rajab on a Hot Tin/Rajab fauq safih sakhin*. Egypt.

———. 1980. *Attention, Ladies and Gentlemen/intabihu ayuha al-sada*. Egypt.

'Abd al-'Aziz, Samih. 2011. *Ant Scream/sarkhat namla*. Egypt.

———. 2014. *Rawh's Beauty/halawit Rawh*. El-Sobky Productions, Egypt.

Abdalla, Ahmed. 2009. *Heliopolis*. Egypt.

———. 2011. *Microphone*. Egypt.

'Abd El-Khalek, 'Ali. 1972. *Song on the Passage/ughniyya 'ala al-mamar*. Egypt.

Abd El-Sayed, Daoud. 1983. *The Vagabonds/al-sa'alik*. Egypt.

———. 1991. *The Search for Sayyid Marzuq/al-bahth 'an Sayyid Marzuq*. Egypt.

———. 1999. *Land of Fear/ard al-khawf*. Egypt.

Abdessalam, Chadi. 1969, released 1975. *The Mummy: The Night of Counting the Years/al-mumya'*. The National Film Center, Egypt.

Abu Seif, Salah. 1950. *Your Day Is Coming/lak yaum ya zalim*. Egypt.

———. 1952. *Master Hassan/al-usta Hasan*. Egypt.

———. 1954. *The Beast/al-wahsh*. Egypt.

———. 1957. *The Thug/al-futuwwa*. Egypt.

———. 1960. *Beginning and End/bidaya wa nihaya*. Egypt.

———. 1973. *The Malatili Bath/hamam al-Malatili*. Egypt.

Abu Zekry, Kamla. 2009. *1:0*. Egypt.

Ahmad 'Ali, Magdi. 2001. *Girls' Secrets/asrar al-banat*. Egypt.

Amin, Ayten. 2014. *Villa 69*. Middle West Films and Film Clinic, Egypt.

Amin, Muhammad. 2005. *The Night Baghdad Fell/laylat suqut Baghdad*. Egypt.

———. 2013. *Black February/Fibrayir al-aswad*. Egypt.

'Arafa, Sherif. 1992. *Terrorism and Kebab/al-irhab wa-l-kabab*. Egypt.

———. 1993. *The Forgotten/al-mansi*. Egypt.

———. 2002. *Mafia*. Egypt.

———. 2003. *China's Magnificent Beans/ful al-sin al-'azim*. Egypt.

———. 2007 and 2014; 1 and 2. *The Island/al-jazira*. Egypt.

———. 2009. *Cousins/wilad al-'amm*. Egypt.

———. 2011. *X-Large*. Egypt.

'Attiya, Kamal. 1968. *Umm Hashim's Lamp/qandil Umm Hashim*. Egypt.

Badrakhan, Ahmad. 1947. *Fatima*. Egypt.

———. 1952, released 1955. *God Is with Us/Allahu ma'na*. Egypt.

———. 1952. *Mustafa Kamil*. Egypt.

Badrakhan, 'Ali. 1981. *People from the Top/ahl al-qimma*. Egypt.

Barakat, Henri. 1959. *The Cry of the Plover/du'a' al-karawan*. Egypt.

———. 1965. *The Sin/al-haram*. Egypt.

Batout, Ibrahim El-. 2008. *In the Eye of the Sun/'Ayn Shams*. Egypt.

———. 2010. *The Magician/al-hawi*. Egypt.

———. 2012. *Winter of Discontent/al-shita illy fat*. Egypt.

Beshara, Khairy. 1982. *Houseboat #70/al-'awama 70*. Egypt.

Bonvelli. 1920. *The American Aunt/al-Khala al-amirikaniyya*. Egypt.

Chaath, Ghaleb. 1971, released 1975. *Shadows on the Other Side*. Egypt.

———. 1975. *Shadows on the Other Side/zilal 'ala al-janib al-akhar*. Egypt.

Chahine, Youssef. 1954. *Struggle on the Nile/sira' fil-wadi* (also *Mortal Revenge*). Egypt.

———. 1963. *Saladin Victorious/al-nasir Salah al-Din*. Egypt.

———. 1970. *The Earth/al-ard*. Egypt.

———. 1972, released 1974. *The Sparrow/al-'usfur*. Egypt.

———. 1978. *Alexandria Why?/Iskandariya lih?* Misr International, Egypt.

———. 1982. *An Egyptian Fairytale/haduta misriyya*. Egypt.

———. 1990. *Alexandria Now and Forever/Iskandariya kaman wa kaman*. Misr International, Egypt.

———. 1994. *The Emigrant/al-muhajir*. Egypt.

———. 1997. *Destiny/al-masir*. Misr International, Egypt.

———. 1999. *The Other/al-akhar*. Misr International, Egypt.

———. 2004. *Alexandria—New York*. Misr International, Egypt.

Diab, Mohamed. 2010. *678*. Egypt.

Cheikh, Kamal El-. 1957. *The Land of Dreams/ard al-ahlam*. Egypt.

———. 1969. *Miramar*. Egypt.

———. 1975. *On Whom Shall We Shoot?/'ala mann nutliq al-rasas?* Egypt.

Fahmi, Ashraf. 1984. *The Servant/al-khadima*. Egypt.

Farid, Akram. 2007. *Omar and Salma/'Umar wa Salma*. Egypt.

Fawzi, Ussama. 2004. *I Love Cinema/bahib al-sima*. Hany Fawzi, Egypt.

Foster, Marc. 2007. *The Kite Runner*. United States.

Galal, Nadir. 1983. *Khamsa Bab*. Egypt.

———. 1992. *A Task in Tel Aviv/muhimma fi Tall Abib*. El-Sobky Productions, Egypt.

———. 1997. *Bakhit and 'Adila/Bakhit wa 'Adila*. Egypt.

———. 1997. *Message to the Ruler/risala illa al-wali*. Egypt.

———. 1982. *Mountain Thugs/futuwwat al-gabal*. Egypt.

———. 2000. *Hello America/halu Amrika*. Egypt.

Galal, Ahmad Nadir. 2007. *Keda Reda/kidda Ridha*. al-Ikhwa al-Muttahidun li-l-sinima, Egypt.

Hafiz, Bahiga. 1937. *Layla Daughter of the Desert/Layla bint al-sahra'*. Released only in 1944 under the title *Layla, the Bedouin/Layla al-badawiyya*. Egypt.

Hamid, Marwan. 2006. *Yacoubian Building/'imarat Ya'qubyan*. Good News, Egypt.

———. 2009. *Ibrahim Labyad*. Egypt.

———. 2014. *The Blue Elephant/al-fil al-azraq*. Egypt.

Hamid, Sa'id. 1998. *An Upper Egyptian at the American University/sa'idi fi al-jami'a al-amirkiyya*. Egypt.

———. 1999. *Hamam in Amsterdam/Hamam fi Amsterdam*. Egypt.

Hetata, Atef. 2000. *Closed Doors/al-abwab al-mughlaqa*. Misr International, Egypt.

Ihsan, Wa'il. 2002. *El-Limby /al-Limbi*. Egypt.

Imam, Hasan al-. 1972. *Take Care of Zuzu/khalli balak min Zuzu*. Egypt.

'Iryan, Tariq al-. 2001. *Snakes and Ladders/sulum wa thu'ban*. Egypt.

'Izz al-Din, Ibrahim. 1951. *The Appearance of Islam/zuhur al-Islam*. Egypt.

Kamal, Hussein. 1965. *The Impossible/al-mustahil*. Egypt.

———. 1969. *My Father Is Up the Tree/abi fawq al-shajara*. Egypt.

———. 1969. *Something Frightening/shay'un min al-khawf*. Egypt.

———. 1971. *Adrift on the Nile/tharthara fauq al-Nil*. Egypt.

Kapoor, Raj. 1964. *Sangam*. India.

Karim, Muhammad. 1930. *Zaynab*. Egypt.

Khalifa, Hani. 2003. *Sleepless Nights/sahhar al-layali*. Egypt.

Khan, Mohamed. 2004. *Klephty*. Egypt.

———. 2014. *Factory Girl/fatat al-masna'*. Egypt.

Khan, Nadine. 2013. *Harag wa Marag*. Egypt.

Kramp, Fritz. 1936. *Widad*. Studio Misr, Egypt.

———. 1938. *Lashin*. Studio Misr, Egypt.

Lama, Ibrahim. 1928. *A Kiss in the Desert /qubla fi-l-sahra'*. Lama Brothers, Egypt.

Lotfy, Hala. 2012. *Coming Forth by Day/al-khuruj illa al-nahar*. Hassala (*The Money Box*), Egypt.

Marei, Khaled. 2010. *Molasses/'assal aswad*. Egypt.

Marzuq, Sa'id. 1971. *My Wife and the Dog/zawjati wa-l-kalb*. Egypt.

———. 1972. *The Fear/al-khawf*. Egypt.

———. 1976. *The Culprits/al-mudhnibun*. Egypt.

Melford, George. 1921. *The Sheikh*. Famous Players-Lasky, United States.

Mihi, Ra'fat al-. 1984. *The Advocate/al-afukatu*. Egypt.

Morgan, Maggie. 2012. *Asham—A Man Called Hope/'Asham*. Film Clinic, Egypt.

Mustafa, Husam al-Din. 1974. *The Bullet Is Still in My Pocket/al-rasasa la tazal fi jaybi*. Egypt.

———. 1983. *Alley of Love/darb al-hawa*. Egypt.

Mustafa, Niazi. 1937. *Salama Is Fine/Salama fi khayr*. Studio Misr, Egypt.

———. 1953. *Hamidu*. Egypt.

———. 1954. *The al-Husainiyya Thugs/futuwwat al-Husainiyya*. Egypt.

———. 1958. *Abu Hadid*. Egypt.

———. N.d. *The Doctor/al-duktur*. Egypt.

Nash'at, Sandra. 2001. *Thieves in KG2/haramiya fi KG 2*. Egypt.

———. 2003. *Thugs in Thailand/haramiyya fi Thailand*. Egypt.

———. 2007. *The Hostage/al-rahina*. Egypt.

Nasrallah, Yousri. 1988. *Summerthefts/sariqat sayfiya*. Misr International, Egypt.

———. 1993. *Mercedes*. Egypt.

———. 1999. *al-Madina*. Egypt.

———. 2003. *The Gate of the Sun/bab al-shams*. Egypt.

———. 2008. *Aquarium/junanynat al-asmak*. Egypt.

———. 2009. *Sheherzade, Tell Me a Story/ihky ya Shahrazad*. Egypt.

———. 2012. *After the Battle/ba'd al-mawqi'a*. Egypt.

Nasrallah, Yousri, Kamla Abu Zekry, Marwan Hamid, Sherif 'Arafa, et al. 2011. *18 Days/18 yaum*. Egypt.

Nermeen, Salem, Mohamed Zedan, Mohamad El-Hadidi, Mayye Zayed, Hend Bakr, and Ahmed Magdy Morsy. 2010. *Mice Room/udat al-firan*. Figleaf Studios and Rufy's, Egypt.

Orfi, Wedad, and Ahmad Galal. 1929. *Lady of the Desert/ghadat al-sahra'*. Egypt.

Orfi, Wedad, and Stéphane Rosti. 1927. *Layla*. Egypt.

la Ricci, Leonard. 1919. *Madame Loretta*. Egypt.

Rosti, Stéphane. 1928. *Why Does the Sea Laugh?/al-bahr biyidhak lih?* Egypt.

Sa'id, Tamir al-. 2016. *The Last Days of the City/akhir ayam al-madina*. Zero Production, Egypt.

Saif, Samir. 1987. *The Leopard and the Woman/al-nimr wa-l-untha*. Egypt.

———. 1991. *Shams al-Zinati/Shams al-Zinati*. Egypt.

Salama, 'Amr. 2011. *Asmaa/Asma'*. Film Clinic, Egypt.

Salih, Taufiq. 1962. *Struggle of the Heroes/sira' al-abtal*. Egypt.

———. 1966. *The Rebels/al-mutamarridun*. National Film Center, Egypt.

———. 1969. *al-Sayyid al-Bulti*. Egypt.

———. 1968. *Diary of a Country Prosecutor/yaumiyat na'ib fi-l-aryaf*. Egypt.

Salim, Nadia. 1985. *The Door Keeper Holds the Building's Management/sahib al-idara bawab al-'imara*. Egypt.

Sayed, Daoud El-. 2010. *Messages from the Sea/rasa'il al-bahr*. Egypt.

Selim (Salim), Kamal. 1939. *Determination/al-'azima*. Studio Misr, Egypt.

Shukry, Mamduh. 1973, released 1975. *Visitor at Dawn/za'ir al-fajr*. Egypt.

Sidqi, Husain. 1951. *Sheikh Hassan/al-Shaykh Hasan*. Egypt.

———. 1952. *Down with Colonialism/yasqut al-isti'mar*. Egypt.

Tayeb, Atef El-. 1982. *The Busdriver/sawaq al-utubis*. Egypt.

———. 1984. *The Prison Cell/al-takhshiba*. Egypt.

———. 1986. *The Innocent/al-bari'*. Egypt.

———. 1989. *The Execution Squad/katibat al-i'dam*. Egypt.

Tilmissani, Kamil al-. 1945. *The Black Market/al-suq al-sawda'*. Egypt.

Tukhi, Ahmad al-. 1952. *The Victory of Islam/intisar al-Islam*. Egypt.

Unknown. 1918. *Mortal Flowers/Les fleurs mortelles*. Egypt.

Volpi, Mario. 1932. *Song from the Heart/unshudat al-fu'ad*. Egypt.

Wahbi, Yusuf. 1932. *Sons of Aristocrats/awlad al-dhawat*. Egypt.

———. 1947. *Fate's Stroke/darbat al-qaddar*. Egypt.

Youssef, Khaled. 2006. *Ouija*. Egypt.

———. 2008. *Until Further Notice/hina maysara*. Egypt.

Youssef, Khaled, and Youssef Chahine. 2007. *Chaos/hiyya fawda*. Misr International, Egypt.

zu-l-Fiqar, Mahmud. 1948. *A Girl from Palestine/fatat min Filastin*. Egypt.

BIBLIOGRAPHY

'Abd al-Rahman, Magdi. 2002. *Ra'idat al-sinima fi Misr*. Alexandria: Bibliotheca Alexandrina.

Abou Chadi, Ali. 1995. "Chronologie 1896–1994." In *Égypte: 100 ans de cinéma*, ed. Magda Wassef, 18–39. Paris: IMA.

Abu-Lughod, Lila. 1995. "Movie Stars and Islamic Moralism in Egypt." *Social Text* 42 (1): 53–67.

Abu Shadi, Ali. 1996. "Genres in Egyptian Cinema." In *Screens of Life. Critical Film Writing from the Arab World*, ed. Alia Arasoughly, 84–129. Quebec: World Heritage Press.

Ali, Sahar. 2013. *Statistical Data Collection Project on Film and Audio-visual Markets in 9 Mediterranean Countries. Country Profile: 1. EGYPT*. Strassbourg: Euromed Audiovisual III CSU.

Altman, Rick. 1999. *Film/Genre*. London: BFI.

Armbrust, Walter. 2000. "Farid Shauqi: Tough Guy, Family Man, Cinema Star." In *Imagined Masculinities*, ed. Mai Ghassoub and Emma Sinclair-Webb, 199–226. London: Saqi Books.

Baker, Raymond. 1995. "Combative Cultural Politics: Film Art and Political Spaces in Egypt." In *Alif*, no. 15/1995, 6–38. Cairo: AUC.

al-Bandari, Munna et al., eds. 1994. *Mawsu'at al-aflam al-'arabiyya*. Cairo: Bayt al-ma'riffa.

Baudrillard, Jean. 1983. *Simulations, Semiotext(e)*. Cambridge, MA: MIT Press.

Bourdieu, Pierre. 1984. *Distinction. A Social Critique of the Judgment of Taste*. Cambridge, MA: Harvard University Press.

Cluny, Claude Miche. 1984. "Al-sinima al-maghribiya." In *Al-sinima al-'arabiya wa-l-afriqiya*, edited by Muhammad al-Qalyubi, 44–52. Beirut: Dar al-Hadatha.

Cultural Development Fund. 1994. *Panorama of Egyptian Cinema 1992*. Cairo.

Darwich, Mustafa. 1989. "Censure et espace." In *Le Caire et le cinéma égyptien des années 80*, ed. Marie-Claude Bénard et al. Cairo: CEDEJ.

Dyer, Richard. 2002. *Only Entertainment*. London: Routledge.

Elsaesser, Thomas. 1985. "Tales of Sound and Fury. Observations on Family Melodrama." In *Movies and Methods*, ed. Bill Nichols, 165–89. Berkeley: University of California Press.

Euromed Audiovisual II Programme. 2007. *MEDA Countries' Fact Sheets*. Berlin: Berlin Conference, February 10–11.

Farid, Samir. 1973. "Nahw manhaj li-kitabatin 'ilmiyyatin li-tarikhunna al-sinima'i." *al-Tali'a* 3 March 1973: 149–57 (Cairo).

———. 1987. "al-Fidyu." *Sinima* 84–86 (Cairo).

Franken, Marjorie. 1998. "Farida Fahmi and the Dancer's Image in Egyptian Film." In *Images of Enchantment*, ed. Sherifa Zuhur, 265–81. Cairo: AUC-Press.

Gaffney, Jane. 1987. "The Egyptian Cinema: Industry and Art in a Changing Society." *Arab Studies Quarterly* 9(1): 53–75.

Gledhill, Christine. 1991. "Signs of Melodrama." In *Stardom. Industry of Desire*, ed. C. Gledhill, 207–29. London: Routledge.

Al-Hadari, Ahmad. 1989. *Tarikh al-sinima fi Misr*. Cairo: Matbu'at nadi al-sinima bi-l-Qahira.

Hallam, Julia, and Margaret Marshment. 2000. *Realism and Popular Cinema*. Manchester: Manchester University Press.

Hillauer, Rebecca. 2006. *Encyclopedia of Arab Women Filmmakers*. Cairo: AUC-Press.

Hussein, Mahmoud. 1973. *Class Conflict in Egypt 1945–1970*. London: Monthly Review Press.

Landau, Jacob. 1958. *Studies in the Arab Theater and Cinema*. Philadelphia: University of Pennsylvania Press.

Lüders, Michael. 1988. *Gesellschaftliche Realität im ägyptischen Kinofilm. Von Nasser zu Sadat (1952–1981)*. Frankfurt am Main: Peter Lang Verlag.

Malkmus, Lizbeth, and Roy Armes. 1991. *Arab and African Filmmaking*. London: Zed Books.

Menicucci, Garay. 1998. "Unlocking the Arab Celluloid Closet. Homosexuality in Egyptian Film." *MERIP* 1.

Mitchell, Timothy. 1988. *Colonizing Egypt*. Berkeley: University of California Press.

Mulvey, Laura. 1989. *Visual and Other Pleasures*. Bloomington: Indiana University Press.

Al-Naggar, Ahmad al-Sayyid, ed. 2002. "Sina'at al-sinima fi Misr." In *al-Iitijahat al-iqtisadiyya al-istratijiyya 2001*, ed. Ahmad al-Sayyid al-Naggar, 301–33. Cairo: al-Ahram Center for Political and Strategic Studies.

Qasim, Mahmud. 1997. *Surat al-adyan fi-l-sinima al-misriyya*. Cairo: al-Markaz al-qaumi li-l-sinima.

———. 2002. *Mawsu'at al-aflam al-riwa'iyya fi Misr wa-l-'alam al-'arabi.* Cairo: al-Hay'at al-misriyya al-'ama li-l-kitab.

Ramzi, Kamal. 1987. "Arba'at qadaya jadida fil-sinima al-misriyya. Al-'unf, al-infitah, marakiz al-quwa, al-thawra al-mudada 1975–1985." Unpublished study for the fifth Damascus Film Festival.

———. 1995. "Le réalisme." In *Égypte: 100 ans de cinéma,* ed. Magda Wassef, 144–59. Paris: IMA.

Richter, Erika. 1974. *Realistischer Film in Ägypten.* East Berlin: Henschelverlag Kunst und Gesellschaft.

Saif, Samir. 1996. *Aflam al-haraka fi-l-sinima al-misriyya 1952–1975.* Cairo: al-Markaz al-Qaumi li-l-Sinima.

Shafik, Viola. 2001a. "Egyptian Cinema." In *Encyclopedia of Middle Eastern Cinema,* ed. Oliver Leaman, 23–129. London: Routledge.

———. 2001b. "Prostitute for a Good Reason: Stars and Morality in Egyptian Cinema." *Women's Studies International Forum* 24(6): 711–25.

———. 2007a. *Arab Cinema: History and Cultural Identity.* Rev. ed. Cairo: AUC-Press.

———. 2007b. *Popular Egyptian Cinema: Gender, Class and Nation.* Cairo: AUC-Press.

al-Sharqawi, Galal. 1970. *Risala fi tarikh al-sinima al-'arabiyya.* Cairo: al-Hay'a al-misriyya al-'ama li-1-kitab.

Shusha, Muhammad al-Sayyid. 1978. *Ruwwad wa ra'idat al-sinima al-misriyya.* Cairo: n.p.

Tasker, Yvonne. 1993. *Spectacular Bodies: Gender Genre and the Action Cinema.* London: Routledge.

Taufiq, Ra'uf. 1984. "hall yastahiq 'Adil Imam hadha al-ajr?" *Sabah al-Khayr,* February 2, 52–53.

Thabet, Madkour. 2001. "Industrie du film égyptien." In *Cinéma & Monde musulman. Cultures & interdits,* ed. Wafik Raouf, 26–53. Neuilly: Euroorient/no. 10.

Virilio, Paul. 1989. *Krieg und Kino: Logistik der Wahrnehmung.* Frankfurt am Main: Fischer Verlag.

Wassef, Magda, ed. 1995. *Égypte: 100 ans de cinema.* Paris: IMA.

Williams, Raymond. 1977. "A Lecture on Realism." *Screen* (Spring): 61–74.

Yusuf, Ahmad, ed. 1992. *Salah Abu Saif wa-l-nuqqad.* Cairo: Apollo li-l-Nashr.

Zaalouk, Malak. 1989. *Power, Class and Foreign Capital in Egypt: The Rise of the New Bourgeoisie.* London: Zed Books.

The Rise and Fall and Rise Again of the Cinemas of the Maghreb: From the 1960s to the New Millennium

Valérie K. Orlando

This chapter offers a reflection on the constantly shifting parameters of the film industry in the countries of the Maghreb[1]–Algeria, Morocco, and Tunisia—since the dawn of their revolutionary movements and subsequent independences. The "cinemas of the Maghreb" is a term imbued with significant meanings, as notes Patricia Caillé, who contextualizes the region and its film culture in the following manner:

> The "cinemas of the Maghreb" refer by default to a common geographical area (the Maghreb) as well as to a common language (Arabic) even though different dialects are used in different countries, to a series of colonizations, the Berbers by the Arabs, and obviously to French colonization, Amazigh cinema and colonial cinema often being dealt with in one section of the publications. . . . Consequently, the term brings together three relatively new national cinemas whose coming into being is associated with national independence, the demise of the French empire and a particularly conflicted relation to national models. . . . As such, while the national film histories of Algeria, Morocco and Tunisia may run parallel as postcolonial cinemas, all three are deeply entwined with a national project. (2013, 243)

This chapter underscores not only the regional similarities such as "common themes of geography, the desert and history, and a shared concern with specific political issues [such as] exclusion, censorship, repression and, most importantly the condition of women in Maghrebi society," but also the vast differences that make each of these cinemas unique (Caillé 2013, 249). Therefore, in order to understand these differences, each country's historical cinematic trajectory will be explored as infused with the events, social movements, political hurdles, and cultural clashes that have occurred and affected the way filmmakers make their films. The conception of cinema as the "7ème Art" (the Seventh Art) has remained a defining quality in the development of these countries' postcolonial national cinemas. The Maghrebi region, independent by the mid-1960s—Morocco 1956, Tunisia 1956, and Algeria 1962—nevertheless continued to maintain the cinema models left by the French at the time of each nation's liberation.[2] As Denise Brahimi notes in her work *50 ans de cinéma maghrébin*, although a celebrated art form, films of the Maghreb since the mid-1970s have also developed through "national disenchantment." "Critical will and blunt expression of disillusionment, or even of discontentment" are reoccurring in film scripts by filmmakers who must live with the challenges they face every day to free speech, political enfranchisement, and social mobility in their societies (Brahimi 2009, 11).

Film as a Reflection of History

Maghrebi film history must be studied through the history of the region. The sociopolitical upheavals, the colonial legacy, as well as the postcolonial challenges that the region has faced since independence, all have played a role in how these countries' respective cinemas have developed. "Le Maghreb," colonized in the nineteenth century at various periods by the French, is often thought of as one massive region, a holdover conception from France's colonial rule that endured from 1870 (Tunisia) to 1962 (Algeria). Studying the region in the postcolonial context compels us to realize how important the colonial past is when considering the nuances of each country's cinema. Michael J. Willis, citing well-known Maghrebi historian Benjamin Stora, notes that when looking into the colonial past, we have to remember that

> French colonial control of the Maghreb can be divided into two phases. The first phase, beginning around 1870 and lasting until 1930, is characterized by expansion

and consolidation of the French presence and dominance in economic, political, demographic and military terms.... 1930 marked the high point of colonial rule and was symbolized by the high-profile celebrations held by the French administration and the *colons* in Algeria.... The second phase of colonial rule ... commencing from 1930 is conversely characterized by a decline in power, eventually culminating in independence being granted to the region in the 1950s and 1960s. (Willis 2014, 22–23)

The independences of these three countries were molded by the three national-ist movements that instigated decolonization: "Tunisia's being reformist, Morocco's conservative and Algeria's radical" (Willis 2014, 28). Interestingly, Tunisia was able to wrestle an independent government from an antiquated system held over from the Ottoman empire of corrupt beys. This system had been co-opted for seventy-five years (1881–1956) by the French protectorate set up there. Independence leaders were able to finally establish a presidential republic orchestrated by the charismatic Habib Bourguiba in 1956. He led the country as president until 1987, when he was deposed in a coup d'état led by Zine El-Abadine Ben Ali (whose presidency lasted until he was ousted after violent protests erupted in 2011).

Algeria, also once part of the Ottoman empire, under French rule was fully divided into three integrated departments of metropolitan France (unlike Tunisia and Morocco, which were only protectorates). These were heavily colonized and settled by white Europeans, predominantly French, from 1830 forward. In 1954, Algerians exploded the first bombs, which ignited the revolution inspired by radical Marxist-socialist thinkers who had spent time in France (for the most part as migrant workers). In the beginning, they also were inspired by, and had strong ties to, the Communist party (Willis 2014, 27). The Front de libération nationale (FLN, the National Liberation Front) during the revolution "avoided appointing a single figurehead" and instead "was careful to maintain a strictly collective leadership throughout the period of struggle against the French" (Willis 2014, 31). Although highly effective when leading a revolution, the loose, chaotic organization of the FLN led to many problems once the bloody revolution came to a close in 1962, and later as the independent nation moved forward (Willis 2014, 31).

Morocco, never a part of the Ottoman empire, maintained its sultans (although Mohamed V was sent into exile) while ruled by the French (1912–1956), and then, upon independence, reinstated King Mohamed V, assuring and subsequently maintaining a monarchal system to this day. Although in the 1960s and 1970s certain activists worked to challenge the monarchy and to establish a multiparty political system, they were never able to change the status quo. King Hassan II's

(son of Mohamed V) rule from 1963 to 1999 marked the most repressive period in Morocco's postcolonial history. These decades were known as *Les Années de plomb* (the Years of Lead) and designated a time when thousands of people were imprisoned, tortured, and made to disappear.

Maghrebi cinema in the years since each country's independence has also closely reflected the changing tides of each nation's history. Although all three national cinemas at the outset were conceived of in more or less the same terms, they have nevertheless since the mid-1960s been molded in very different ways by the sociocultural and political dynamics, events, and challenges taking place in each nation. All three countries shaped their national cinemas on the French institutional model (which meant setting up an institution funded by the state, usually overseen by a Ministry of Culture) that would provide subsidies to filmmakers to make their films. This model was used by all three nations from the mid-1960s forward to hone a "new sense of national identity [by] seeking new forms of expression" through film (Armes 2005, 8). Film would be a way to further the ideologies of the individual nation's ruling body while also giving to the world for the first time the expression of "a reality as seen from a specifically Algerian, Moroccan [and] Tunisian perspective" (Armes 2005, 8). What is interesting is how each model, conceptualized similarly at the founding of each nation, is later challenged at various moments in history in very different ways. These challenges thus prove to what extent the national film industries were, and continue to be, influenced by the sociocultural and political dynamics that each country has confronted since the era of decolonization.

"Algerian cinema was born out of the war of independence and served that war," notes Guy Austin in his book *Algerian National Cinema* (2012, 20). Algerian cinema served to capture the horrors of the war of liberation as well as to mythologize the FLN's struggle to free the country of French colonial rule and its subsequent establishment of the Algerian nation. From the first years after independence in 1962, the "'*cinéma moudjahid*' or 'freedom fighter cinema' of the 1960s and 1970s was central to post-independence cultural policy" (Austin 2012, 20). Over the last five decades, we can say that Algerian cinema has always celebrated "the new nation-state but also interrogates the discontents of the new Algeria" (Austin 2012, 20).

Algeria's cinematic production was viable and imaginative from 1962 to the late 1980s, but then was virtually halted during the bloody civil war, which endured from roughly 1990 to 2003. By 1993, at the height of some of the bloodiest years of this conflict, the Algerian film industry and all film productions were seriously threatened (Armes 2005, 55). It is only recently, with, for example, the debut film

by Lyès Salem titled *Mascarades* (Masquerades) and the 2013 film *La Preuve* (The Proof) by Amor Hakkar, that Algerian filmmakers have been able to safely film and produce films domestically. Subsequently, these films were shown at international festivals, drawing much critical acclaim.

Although ruled since independence in 1956 by a monarchy, the king of Morocco invested heavily in the film institution established by the French in 1947 known as the Centre cinématographique marocain (CCM). Since 1957, the state has subsidized films now for over fifty years. Today, Moroccan filmmakers enjoy the most freedom of expression anywhere in the Arab world. Since 2000, they have been repeatedly defended by the CCM against radical calls for censorship from the Islamic PJD party (Le parti de la justice et du développement/Party for Justice and Development) of certain films deemed risqué and sexually explicit. Controversial films, challenged by the Islamists, have included *Marock* (Leila Marrakchi 2005), *Hijab al-Hob* (Veils of Love, Aziz Salmy 2009), and, most recently, *Much Loved* (Nabil Ayouch 2015), which is currently banned in Morocco. Despite this recent setback to thematic openness, King Mohamed VI, who is divinely ordained as "The Leader of the Faithful," has interfered very little with the film industry, preferring to remain outside the censorship debates.[3] His more democratic rule counters the very repressive era of his father, King Hassan II. During the Lead Years (1963–1999), Moroccan film was viewed as a media form that was particularly dangerous. It was censored heavily and suffocated with scenarios that were shackled, unable to probe the sociopolitical topics of the era. Before 2000, Moroccan films would metaphorically or symbolically propose ideas criticizing social woes, but filmmakers rarely dared to be overtly critical, as filmmaker Mustapha Derkaoui suggests in an interview from the late 1990s: "We don't want to make subversive cinema. . . . It's more that we must make cinema an adequate means of denunciation, and not a force with the goal of blind and intolerable subversion. . . . [In the past] . . . cinema was constrained by the government's fears at the time. . . . Officials allowed much less experimentation and innovations in films" (Carter 2000, 68).

Tunisia, at the outset of its new nationhood in 1956, was the most liberal and forward thinking country of the Maghreb. Led by the modernist Habib Bourguiba (who often referred to himself as the "Supreme Warrior"), the Tunisian government invested heavily in its film industry, creating a national cinema that was second only to Egypt's for the most films per year made in the Arab world. Over half a century later, and since the country's 2011 Arab Spring, exploding in January of that year, Tunisia's filmmaking has virtually come to a halt. The insecurity in the country,

mainly due to a "sense [that] Islamists [are] hijacking the revolution [of 2011]," has created a climate of fear that has closed down both domestic and foreign filmmaking investment.[4] Thus, Tunisia now lags behind Morocco in the number of films made per year. In 2014, Morocco produced the most films of any country in the Maghreb and in the Arab world, including Egypt.

This chapter considers the historic ups and downs of three countries that have, since their independences, at one time or another been subject to sociocultural and political unrest. Sociocultural, political, and economic challenges have molded Maghrebi film industries, dictating not only how films are made but also their subjects. Audiences, too, have changed, as have the availability of funds provided by the state and the number of cinema houses still standing and open to show films. However, despite economic setbacks, coups d'états, civil war, and "Arab Springs," Maghrebi cinemas have and will continue to thrive.

In order to study the expanse of the region's film history, it is best to start with the legacy of French colonialism, since, for better or worse, the French imprint still remains on Maghrebi film. The industry, however, was also shaped by the Third World movements of the 1960s. These gave birth to new visions for the role of cinema in the latter part of the twentieth century. Filmmaking was viewed, from the mid-1960s forward, as an extremely useful tool for the documentation and exploration of emerging, developing economies challenged with the burden of imperialist capitalism meted out by the West through the dynamics of the Cold War. Since the late 1970s, Maghrebi film has developed not only through the pursuit of artistic expression but also because of the need to protest both egregious human rights violations and socioeconomic failures in what often filmmakers pessimistically note are countries that have failed their revolutionary missions, so touted during the throes of decolonization. Therefore, in light of Maghrebi history and sociocultural challenges, "any analysis of 'cinemas of the Maghreb'" must thus consider "the way that specific regional denomination acquires meaning within a particular set of relations structured not only in relation to film, but also to historical and cultural elements outside films" (Caillé 2013, 243).

In order to explore to the fullest the wealth and richness of themes and scope contained in the body of work designated as "Maghrebi cinema," this essay is divided into the following parts: France's cinematic footprint on films made in the Maghreb; the Third World movements taking place in the 1960s–1970s, which were an important historical moment in world history and, subsequently, shaped the development of the cinematic industry and the themes of Maghrebi cinema;

from colony to postcolonial nation explores the sociocultural and political tides of each country that led to the making of an internationally recognized cinema industry; themes of postcolonial Maghrebi Cinema from the mid-1960s to the present considers how the societies of the region are reflected in social-realist themes contextualizing the sociopolitical climates of each independent nation; future challenges explores funding and ticket sales as well as the current political hurdles in the Maghreb that are affecting their respective cinemas.

France's Cinematic Footprint on Films from the Maghreb

Unlike Britain, which, upon independence in many of its former African colonies, left little in the way of a film industry, preferring to invest in television and radio, France did leave an enduring model. Countries such as Nigeria, Kenya, and Zimbabwe did not cultivate national cinema models like those found in West and North Africa, which had been under French colonial rule (Ukadike). This historic fact attributes to the general consensus underscored by Manthia Diawara that countries with national film institutions established at the time of independence led more quickly to "films directed by Africans." Diawara emphasizes that films made in "the former French colonies are superior, both in quality and in quantity, to those by directors in other sub-Saharan countries formerly colonized by the British" mainly due to the institutional models that support filmmakers (1992, 21). Even long after decolonization, for better or worse, France has continued to subvention African cinema in its former colonies and, therefore, "it [is] easier for French distributors to maintain their monopoly on the African market" (Diawara 1992, 31). Investment of this type is not mirrored in former British, Anglophone regions; thus many scholars have argued that France's omnipresence in "Francophone" cinema on the continent has contributed to the different, some say, even neocolonial, tendencies represented in postcolonial films, as notes Frank Ukadike in his work *Black African Cinema*:

> Different patterns of film production within Francophone and Anglophone regions derive from the contrasting ideological pursuits of the colonial French and British governments. For example, while the French pursued the so-called assimilationist policy, British involvement with its colonies was pragmatic business. Similarly, observers point out that while the French "gave" feature film to its colonies, the British "gave" theirs documentary. This notion supports the argument that the

cultural policy adopted by France encouraged film production in the Francophone region whereas in the Anglophone region, where film production did not pass the economic priority test . . . the tradition of British documentary filmmaking [remained]. (1994, 109)

From the 1890s to the mid-twentieth century, film in North Africa played a role in visually depicting the colonial world for the *Métropole* (metropolitan France). Sending cameramen to the most remote outposts of the French colonies, the brothers Louis and Auguste Lumière became the leading visual ethnographers of North Africa. The environments they filmed were exotic, representing a colonial world on the move not only in Africa but also in Asia and the Middle East. Cameramen sent film stock back home to be shown in cinemas, garnering crowds whose desire to travel to colonial lands after their cinema experience became all the more acute. These early films fueled the fire of colonial desire and were thus a determining pillar of the French Mission Civilisatrice of the nineteenth century. One of the first Algerians to write and publish a retrospective overview of French colonial film after independence, Abdelghani Megherbi, notes in *Les Algériens au miroir du cinéma colonial* (Algerians in the Mirror of Colonial Cinema) that in 1896, when the first Lumière productions were shown in Lyon, *les chasseurs d'image* (image hunters) were enlisted in droves for new projects throughout North Africa (Megherbi 1982, 13). Films made in Algeria in the early decades of the twentieth century included titles such as *Visages voilés, âmes closes* (Veiled Faces, Closed Souls, Henry Roussel 1921) and *Sarati le terrible* (Sarati the Horrible, René Hervil 1922), based on a novel by French author Jean Vignaud. These films painted a cinematic picture of Algeria that "inspired numerous filmmakers, both European and American . . . by offering a '*pittoresque*' view of Algeria that was exotic and captivating" (Megherbi 1982, 77). *Sarati le terrible* was so popular that it was remade in 1937 by André Hugon from Algiers, who, although French-Algerian, shot most of the scenes in Paris. The film focuses on a colonial white man from the underclass (known as a *petit blanc*; little white man)[5] who desires his adopted daughter, but whose marriage to someone else leads him to commit suicide. The tragic melodrama, writes Megherbi, revealed a "colonial universe [that was] brutal, in its virulence, its injustice, and its arbitrariness and its distain for the colonized 'Other'" (1982, 98).

The iconic *Pépé le Moko*, filmed in Algiers in 1937 by Julien Duvivier, was based on a detective novel by Henri La Barthe (O'Riley 2010, 129). His previous film, *La Bandera*, filmed in Morocco in 1935, was also immensely successful with audiences

at the time. *Pépé le Moko* is the story of a small time bandit played by Jean Gabin, the heartthrob of 1930s French film, who, after committing petty crimes in Marseille and serving jail time, seeks out a gangster he has met in prison. When Pépé goes to find him, he meets the mother of the gangster, who tells him that his inmate-friend has gone to Algiers. Thinking he can make money by following in his footsteps, Pépé secures false papers and goes to Algeria to seek him out. Through mishaps, Pépé is tracked by the police, lives on the lam, becomes destitute in the streets of Algiers, before falling in love with a French female tourist who has been hired by the police to trap him. Pépé's indigenous Algerian lover, learning of the other woman, betrays him to the police instead. Refusing to surrender, the hero stabs himself (Megherbi 1982, 246–47). Many film scholars have read *Pépé le Moko* metaphorically as a harbinger of the revolution that would materialize less than thirty years later. Algeria, the temptress who betrays the "benevolent" colonizer in order to seek and fulfill her own interests. Duvivier's film "serves as the basis for commentary on the pervasiveness of the victim's attitude in North Africa" (O'Riley 2010, 20). O'Riley notes that this "cyclical vision of colonial victimization" has served filmmaking on both sides of the Mediterranean even since independence (2010, 129). For the French, victimization is represented in later films such as *pied-noir* Brigitte Rouan's *Outremer* (1990) as loss or "haunting" by what was given and left *there*.[6] For Algerians, victimization is still colonial brutality, manipulation, and exploitation that endured for 132 years. Algerian Rachid Bouchareb's *Indigènes* (Days of Glory, 2006) aptly describes this victimization when revealing the inequality of the French colonial era that reigned in Algeria. He retells the story of Maghrebi conscripts in the French army who were sent to France to fight against the Germans during World War II only to find that they not only had to fight "the enemy" but also French racism.

Despite the brutal history of colonialism, French film institutions, know-how, and a general French imprint remain on the cinemas of the Maghreb. La Fémis (L'école nationale supérieure des métiers de l'image et du son), formerly known as the IDHEC (Institut des hautes études cinématographiques), and L'école supérieure d'études cinématographiques (ESEC) have been the leading schools of training for Maghrebi filmmakers since independence.[7] Férid Boughedir (Tunisia), Merzak Allouache (Algeria), and Farida Benlyazid (Morocco) have all studied film in Paris. Through these nationally funded schools, France established filmmaking as a national institution, which meant that the state would always contribute funds to making films. The subsidy model, known as *l'avance sur recettes* (advance on ticket sales), was also adopted by Maghrebi industries in all three countries.

The French filmmaker's belief that film should perform as an art form in society continues to influence the national cinemas of Morocco, Algeria, and Tunisia. Despite taking to heart revolutionary Frantz Fanon's plea to cultural producers (in film, the arts, and literature) to help express the culture of new nations, national film industries still relied on France's institutional model. Nevertheless, these institutional models were instrumental in helping to define the agendas of new nations in the early 1960s, which used them to inspire their peoples to think about the future to come. Using their cameras, postcolonial filmmakers sought to live up to Fanon's challenge. The formerly colonized "must get away from white culture. He must seek his culture elsewhere, anywhere at all," and the "style" of the artist, intellectual, and, of course filmmaker,

> is harsh . . . full of images, for the image is the drawbridge which allows unconscious energies to be scattered on the surrounding meadows. . . . This style . . . has nothing racial about it . . . it expresses above all a hand-to-hand struggle and it reveals the need that man has to liberate himself from a part of his being which already contained the seeds of decay. (Fanon 1965, 220)

Films such as *Rih al-awras* (Wind from the Aurès, Mohamed Lakhdar-Hamina, Algeria, 1966), *Al-fajr* (The Dawn, Omar Khlifi, Tunisia 1966), and *Inticar al-hayat* (Conquer to Live, Mohamed Tazi and Ahmed Mesnaoui, Morocco 1968) all imparted to audiences the winds of change that filmmakers hoped would come with independence in order to build a strong and powerful postcolonial state (Armes 2005, 213). Films also were used as a means of forgetting colonial brutality and of moving on in the early days of postcolonial nation building. Many themes searched to help work through the trauma of the bloody battles of decolonization, particularly in Algeria, as Austin notes:

> The function of Algerian films on the liberation struggle [in the 1960s] seems closer to the narrativisation of trauma as a means of remembering to forget, hence a "working through," an articulation of national identity that seeks to commemorate suffering but thereby to move onwards and to build new power structures (the FLN state), rather than as a traumatized perpetual present. (2012, 35)

In contrast to what Maghrebi cinema would become in the 1960s, historically the French films of the first decades of the twentieth century depicted the Maghreb

and the Middle East as a vast uncharted land ripe for colonial conquest. The seduction, reminiscent of what cultural theorist Edward Said explains as "Orientalism" in his seminal 1979 work, was evoked in lavish settings depicting turbaned men, camels, and palm trees. These regions "served as subjects . . . for the film industries of Europe and the United States" (Ghareeb 1997, 120). The Maghreb was a commodity, packaged in "standardization and cultural stereotyping" that only "intensified" the mystique of the "mysterious Orient" as time under colonial rule marched forward (Said 1979, 26).

While the Lumière brothers and their European and American counterparts dominated the films made in North Africa at the time, there were a few indigenous filmmakers who were able to make several films. In 1922, Tunisian Albert Samama Chikly made *Zohra*. The first full-length Egyptian film, *Layla*, was produced by one of the first women in the industry, Aziza Amir, who also starred as the lead. Amir's film was released in November 1927 and is credited with having helped launch the Egyptian film industry (Shafik 2007). These indigenous filmmakers' films stood out against the overwhelming number of "French imperial" films that gave audiences in Europe what they expected from the "dark continent," construed "in France's imperial 'mythistory'" (Slavin 2001, 35). Films such as *L'Atlantide* (Pierre Benoit, 1932) depicted veiled Tuareg nomads, cast against the backdrop of the Maghreb, Sahara, and Sahel, where "the gleaming sun and sand . . . fired the imaginations of French audiences" (Slavin 2001, 35). Other films from the 1930s empire era include *L'Esclave blanche* (The White Woman Slave, Jean-Paul Paulin,1939), which featured the seductive scenario of a white European woman being captured and then "enslaved" and thrown into a harem by a "Muslim Bey" (Slavin 2001, 94). Some films made by *pieds-noirs* Algerians who were sympathetic to the FLN rebel leaders' cause did overturn the colonial exotic. *Algérie en flames* (Algeria Burning, René Vautier 1959), discussed below, is one of the best-known films for its support of the Algerian cause for independence. Several films made in the late 1960s and early 1970s attempted to destabilize "the mirror image of resistance that many French people had of the nation under occupation" in order to cast a more sympathetic view of the Algerian rebellion—for example, Claude Chabrol's *La Ligne de demarcation* (Demarcation Line, 1966), Marcel Ophüls's *Le Chagrin et la Pitié* (Chagrin and Pity, 1969), and Louis Malle's *Lacombe Lucien* (1973). "These works ushered in a new period when France's troubled relation to its wartime past became a central cultural concern manifested on screen" (O'Riley 2010, 49). Yet in France, despite these few films, for the most part, Algeria remained "largely invisible behind the stories of returning

soldiers, a traumatizing absence that haunts the French settings of *Ascenseur pour l'échafaud* (Elevator to the Gallos, Louis Mall 1957), *Les Parapluies de Cherbourg* (The Umbrellas of Cherbourg, Jacques Demy 1964) and *Le Bouché* (The Butcher, Chabrol, 1969)" (Austin 2009, 116).

In divergence from the above-mentioned French films, over the last fifty years, and certainly more recently, there has been a particular nostalgia for the lost colony that borders on a "fetishization of national memory" in films that do speak about the Algerian conflict (O'Riley 2010, 50). For the Algerians, the struggle against the French has always been, from the first day, termed a "revolution," a "war" for independence. For the French, the war was never called anything other than *un maintien de l'ordre* (a maintaining of order) until September 1997, when Lionel Jospin, then prime minister of France, compelled Jean-Pierre Masseret, secretary of state charged with taking care of the affairs of Les Anciens Combattants (former soldiers), to change the annals of history in order to acknowledge what was really a war: "Permettez-moi d'utiliser l'expression guerre d'Algérie, je sais bien que c'était une guerre, tout simplement" (Allow me to use the expression 'the war of Algeria,' I know that it was a war, clearly).[8] Subsequently, in 1999, France officially recognized in the French courts the "principal allegations relating to the involvement of former Paris Prefect of Police Maurice Papon in the massacre of Algerian demonstrators in the city on 17 October 1961," an event that had been constantly denied up to this time (Dine 2002, 256). During the evening of October 17, 1961, approximately 500 Algerians were thrown into the Seine and drowned by the French police. No officials before 1999 were tried in the courts. In 2000, *Le Monde* published several articles on torture that seemed to characterize the French government as wanting to come clean on many historical events with respect to Algeria previously either covered up or flatly denied. Documentaries and feature-length films reflect this French political climate. *Nuit noire, 17 octobre 1961* (2006) by Alain Tasma is an attempt to document for the first time the obfuscated events of October 1961 (Austin 2009, 115). The documentary *Ici on noie les Algériens* (Here We Drown Algerians, 2011) by Yasmina Adi also details the events surrounding the murders of October 17, 1961. Despite these efforts for historical rectification, the war that ripped apart colonial Algeria as well as France continues to be an open wound in the psyche of the French nation. In its own postcolonial era, French film continues to cast Algeria in nostalgic terms. In France, the French-Algerian war has become a *lieu de mémoire* (a memory space), to use French philosopher and historian Pierre Nora's famous concept (Dine 2002, 255), where Algeria is forever fixed in this very painful moment

in French memory. Guy Austin remarks that recent films made in the 2000s—such as Philippe Faucon's *La Trahison* (The Betrayal, 2005), Laurent Herbiet's *Mon colonel* (My Colonel, 2006), and the documentary made by Florent-Emilio Siri, *L'Ennemi intime* (Intimate Enemies, 2007)—demonstrate French filmmakers' fascination with "returning to the places where the conflict happened" as they have returned to Algeria to recast the events in their rightful places (Austin 2009, 115).

Philip Dine's work on how the Algerian war is represented in films made by predominantly *pied-noir* filmmakers is revealing of a historical era that refuses to die. The war has "entered both the mainstream of French historiography and the broader national consciousness" as a staid moment in history (Dine 2002, 256). Dine notes that in 1992, coinciding with the thirty-year "anniversary" of Algerian independence, there were a plethora of films and documentaries made by the French *pieds-noirs* and Algerians residing in France. These included Bridgitte Rouan's *Outremer* (1990), the title of which evokes a play on words that sound the same orally: "*mer*" (sea) and "*mère*" (mother) as well as the word "*Outremer*," which means "outer ocean" or, if written as "*outre-mère*," "beyond mother." These connotations evoke "maternal and geographical losses and displacements" that "imbue the film with a sense of broken attachments." The film is about decolonization as seen through colonial women's perspectives. Women "of the colony" portrayed in the film act as "*occupants féminins* [feminine occupiers] ... implicated in [the colony's] conflicts." They are passive and complicit in the general trauma of the social unrest that characterized the colony at the end of the war (Dine 2002, 258). Other more recent nostalgic films include *Caché* (Hidden, 2005) by Michael Haneke. This film "builds the very issue of a haunting victimization from the colonial era into both its form and content" (O'Riley 2010, 80).

Language Use: French or Indigenous?

Senegalese filmmaker Sembène Ousmane, considered by most to be the father of African film, was one of the first filmmakers from a former French colony to decolonize his filmic works of the French language when he made *Mandabi* (The Money Order) in 1968. He made two versions of the film, one in French and one in Wolof. The film marked the beginning for West African filmmakers' *retour aux sources* (return to the sources) of their culture and heritage after colonialism. "The audience had to recognize themselves in films, to feel involved and ask themselves the questions the filmmaker wants to raise." This is exactly what *Mandabi* accomplishes (Bartlet 2000,

21). Yet for many filmmakers, both from North and sub-Saharan Africa, French and English are viewed as "no one's property" (Bartlet 2000, 197). Immediately following Algeria's independence in 1962, the famous Algerian author, Kateb Yacine, noted that "le français est le butin de guerre" (French is the booty of war). Kateb wrote both in French and, later, in his native Algerian Arabic. For filmmakers, though, the important thing after the revolution was "what to do" with French. Well-known Mauritanian filmmaker Med Hondo once noted: "It has become my language and my tool. I sweated blood to acquire it, and no one's going to take it away from me. It wasn't a gift, it was an achievement. Even though I am a user of French, I don't feel any calling to become an activist for the French language." Whereas Ivorian filmmaker Kitia Touré states, "We are told . . . that making a film in French means alienating African culture to the French language. Bullshit!" (Bartlet 2000, 197). Touré raises an interesting point about French use in the former colonies of Africa and one that is applicable to Maghrebi films as well. The populations of these countries are overwhelmingly urban, particularly those going to see films, and "used to French as an everyday language" (Bartlet 2000, 197). So what to do with the colonial language has been the conundrum for many filmmakers, particularly when seeking international funding and distribution. What is still true today is that if filmmakers want to become internationally recognized, they must pass through European film distribution networks. Although founding the Pan-African Filmmakers' Federation (FEPACI) in 1969, establishing the Festival Panafricain du Cinéma de Ouagadougou (FESPACO) in 1966 where films from all over the continent are shown, international recognition is still achieved through ties with Europe. The question of how much French to add to a film to make it sellable internationally, particularly in the United States and Europe, is still open for debate.

France continues to cultivate its ties with its former colonies through film. One of the ways to assure the continued use of French in the world, so it was thought, was to invest in African cinematic projects that relied on international funding. In 1963, the French Ministry for Cooperation and Development, "set up specifically to oversee cooperation between France and the African states, established a film bureau in Paris" (Armes 2006, 54). But, as Roy Armes notes, "it must be borne in mind that the relationship between France and its former African colonies is not one between equals" (2006, 54). France's efforts to create "la francophonie," a concept promoted most heavily between 1963 and 1979 as a means to unify the former French-speaking colonies (as well as European nations that use French), and thus propagate the use of the language across the world through particularly

sub-Saharan African films, is fraught with inequalities. "When one considers the economic exchanges between the members of 'la Francophonie,' one is struck by the frightening imbalance benefiting the rich countries which are members" (Armes 2006, 54). Since the early 2000s, France has continued to fund African filmmaking on the continent in an effort to define what some term as "exotic film with French cultural affinities [or] as an adjunct to French cinema within a global struggle for existence in [international] film markets" (Armes 2006, 58). Some scholars and filmmakers themselves have noted the "usefulness of such a scheme" for both African and French domestic films. Roy Armes cites Dominique Wallon, head of the now defunct Ecrans Nord-Sud (1998–2001), which was set up to promote and distribute African films, as best assessing the climate of African filmmaking in the new millennium:

> Whether we're talking about Europe, the Maghreb or Black Africa, whatever the
> differences in cultural identity, there exists cultural familiarities, especially filmic
> ones, which mean that spectators who go to see *Halfaouine* [Ferid Boughedir's
> 1990, highly successful Tunisian feature film] are more willing to see French films.
> It's evidence of the absolute solidarity of national cinemas resisting American
> pressure. Hence the strategy of helping co-productions, [and] projects with Africa
> and Eastern Europe. (Armes 2006, 58)

The fact that all three Maghrebi countries founded national institutes of film shortly after independence has set them somewhat apart from other African countries that have had to rely more heavily on funding from France. Indeed, Maghrebi cinema as "Francophone" has generated much debate, particularly in academic French departments in the United States that have sought to claim the region's films for their own in order to increase interest in literatures and cultures from the former "French-speaking" colonial world. Francophone scholars note that today, two-thirds of all writing published in French is produced outside the nation of France–from Africa, the Caribbean, North America, and Oceania. While the case can be made to claim literature written in French from the former colonies, leading to easily incorporating them into French courses, lines become blurred as to whether or not the same can be done for films from the former colonies. The debate is still open and readily discussed by many academics in Francophone literatures and cultures. There is a noticeable "continuous presence of the colonial language" in the Maghreb (Laroussi 2003, 81). Still today, one can travel with ease throughout

Tunisia, Morocco, and Algeria using French. Although, particularly in Algeria, Arabization programs instigated by the Boumediene government in the 1970s tried to eradicate the use of the former colonizer's language from the country, they were basically unsuccessful. With respect to literatures and authors, playwrights, journalists, and various forms of media that still use French, the Maghreb has not been able to *decolonize* linguistically. Knowing and speaking French well are still perceived as a means to power, access, and privilege, and this has not lessened in our era, as Laroussi notes:

> The Maghreb demonstrates that the considerable historical, social, [and] linguistic significance of what France was, and to a certain degree still is, can be displaced. However, the lasting use of French in Algeria, Morocco, and Tunisia should not be underestimated and shows as well that literature from these nations gives an unimpeachable credential to all expression of power. In a context in which North African peoples are struggling to win a measure of democratic rule and to gain economic independence, the continuous presence of the colonial language has created new cultural forms within each society. This is a paradox that most clearly stands out in the field of literature. (2003, 81)

Use of French in many sociopolitical realms allows cultural producers to break down barriers that are often rooted in tradition and beliefs, certainly those that are religiously defined. Although Arabic is the "official language" of all three Maghrebi nations, French "allows tactical transgressions" of the mother tongue (Laroussi 2003, 81). Adding more complexity to the language question, when we are discussing what is really the "mother tongue" of the Maghreb, opinions will vary. The need to use language as a means to return to the past, before colonialism, in order to found the postcolonial nation-state, part of the FLN's program in Algeria, was hypocritical. "Islam is my religion, Algeria is my nation, and Arabic is my language," the original, revolutionary slogan of the FLN *maquis*, has, since decolonization, been viewed with skepticism. Arabic for many was a forced, colonial language just as French was. The true, indigenous language is Berber, which, until recently, was not politically recognized in Algeria and Tunisia. Only Morocco has added the Berber language to the "official" languages of the country in recent reforms to the constitution (discussed below). Thus, promoting the past, before colonialism, as some pure notion of identity through all things indigenous has, for Maghrebi artists, authors,

and filmmakers, been fraught with contradiction. Authors and writers who persist on writing in French, even today, make the claim that Arabic as much as French is a colonial language and thus is open to be exploited in the same ways.

Classical or Modern Standard Arabic in the Maghreb is predominantly used only in political or formal settings. The various dialectical Arabics spoken in all three countries are used only in oral settings (although some writers have begun writing in indigenous Arabic) and have been influenced by European, Berber, and Arabic languages that have crisscrossed the Maghreb since the dawn of time. In Morocco and Algeria, many people will claim Amazigh as their language, spoken in Berber communities. In the Kabyle region of Algeria, the Berber language heavily displaces use of Arabic. Use of Berber languages in Algeria up to the millennium was heavily suppressed. In 1998, during some of the most vicious killings of the civil war, Lounès Matoub, well-known Berber singer and activist for the Berber Cultural Movement and an outspoken critic of the government's repression of Berber language, was assassinated in eastern Algeria (Silverstein 1998, 1).[9] "Matoub was a stalwart supporter of efforts to change the status of Tamazight. Kabylian activists want their language to become, alongside Arabic, an 'official' and 'national' language of Algeria . . . young Kabyles have transformed Matoub's death into political inspiration, utilizing his assassination to advance their cultural and linguistic demands" (Silverstein 1998, 1–2).[10]

In 2011, Morocco's king Mohamed VI reformed the nation's constitution to officially recognize Berber as one of the "languages of the country. . . . As part of the constitutional reform, Tamzight (also Amazigh), the Berbers' language, was raised from national to official language status, meaning it will now be taught in Moroccan schools along with Modern Standard Arabic."[11] This reform has been met with mixed reviews, but it does show that the monarchy is more willing than in the past to embrace Morocco's diversity instead of claiming one view of identity for everyone. Since the 1960s, there has been a strong "revival movement . . . striving for official recognition of Berber" (El Aissati 2001, 57). The claim for *Berberisme* across the Maghreb is an ongoing battle. Certainly this is the case in Algeria, where nascent movements have been, in recent years, only moderately effective in convincing Algerian authorities that there is diversity in the country that needs to be recognized. The FLN slogan of the revolution, "Islam is my religion, Algeria is my nation, and Arabic is my language," has never, for most, been a truism, as Paul Silverstein notes:

The place of Berber language and culture in Algeria has been fiercely debated since the early nationalist movement of the 1930s and 1940s. After independence, the ruling National Liberation Front (FLN) incorporated the slogan "Islam is my religion, Algeria is my nation, and Arabic is my language" into its national charters. In the late 1960s, the FLN began progressively to Arabize the state apparatus, the justice system and primary education. (1998)

Of the three Maghrebi countries discussed in this essay, Morocco has been the most forthcoming in its cultivation of Amazigh film, particularly since the enthronization of King Mohamed VI, who has, himself, actively advertised his own Berber roots. The Tenth Annual Festival of Cinema at Sidi Kacem (April 23–27, 2009) devoted an entire week to honoring Amazigh films such as *Itto titrit* (Mohammed Oumouloud Abbazi, 2008), *Tamazight oufella* (Mohammed Mernich, 2008), and *Sellam Dimitan* (Mohammed Amin Benamraoui, 2008). This film festival and others that have become increasingly visible all over Morocco are sponsored in part by the Amazigh Film Festival (*Amazigh: Tafaska n Ufilm Amazigh*), which is a nongovernmental and independent film festival organized by Amazigh cultural associations and independent, for the most part amateur, Amazigh filmmakers in Morocco. Much of the media coverage of the festivals in Morocco is provided by Amazigh-language newspapers and websites. The goals of the festivals are to contribute to the promotion of Amazigh cinema and to help rectify financial and technical problems encountered by filmmakers making solely Amazigh films. The organization's efforts have made Amazigh film more mainstream throughout the country. Berber films are now often shown in some of the leading film festivals, such as the Festival de Tanger and Marrakech. The young filmmaker Hicham Lasri, one of the leading supporters of Amazigh culture working in Morocco today, made *Tiphinar* (2008). The more recent film by Yuba Ouberka, *Carte mémoire* (Memory Card, 2013), also made in Amazigh, was widely shown in Morocco and internationally.[12]

In Algeria in 2013, where *Berberisme* has been very oppressed in the past, it is only recently that the Festival Culturel National Annuel du Film Amazigh (FCNAFA) has been able to support a festival, the most recent of which was held in the capital of the Amazigh people in Tizi-Ouzou in March 2013. Despite civil war and the oppression of Berber communities, there have been several very influential Amazigh films made in the last twenty years. *La Colline oubliée* (The Forgotten Hill, Abderrahmane Boughermouh, 1996) was the first feature-length Berber film to be made in Algeria (Austin 2012, 106). The film was based on famous Berber Algerian

author Mouloud Mammeri's novel of the same title published in 1952. In the film, careful consideration of the Berber Kabyle language is noticeable: "It is not the modernized version of Kabyle spoken by younger generations, but a historical, impeccable Kabyle" (Austin 2012, 107). Other notable Algerian Berber films include the internationally acclaimed *La Montagne de Baya* (Baya's Mountain, Azzedine Meddour, 1997), Belkacem Hadjadj's recent *Fadhma N'Soumer* (Le Burnous embrasé, The Burning Burnoose, 2012), and his earlier *Machaho* (1994).[13] What is interesting about these films is their subversion of Arab–male dominant themes. In Arab cinema, the household is patriarchal, whereas in Berber scenarios, the home is noticeably "ruled by the wife or mother of the eldest male and . . . a tradition of monogamy which reinforces the unity of the household" (Austin 2012, 100). Berbers represent 20–30 percent of the Algerian population, so it goes without saying that Algerian film should represent them. In the last decade, Berber filmmaking has been increasing. In Algeria, recent films include: *La Chine est encore loin* (China Is Still Far, Malek Bensmaïl, 2008), *Mimezrane, la fille aux tresses* (Mimezrane, the Girl with Braids, Ali Mouzaoi, 2008), *La Maison jaune* (The Yellow House, Amor Hakkar, 2007), *Si Mohand U M'hand, L'Insoumis* (Mr. Mohand U M'hand, Insubordinate, Liazid Khoja and Rachid Benallal, 2004), and *Arezki l'indigène* (Arezki the Native, Djamel Bendeddouche, 2008). Yet despite this plethora of films, "the relation between Berger regions–Kabylia in particular—and the Algerian state remains problematic" (Austin 2012, 117).

In Tunisia, on the other hand, Berber filmmakers have made only minor gains. In efforts to unify and wipe the slate clean of any multiethnicity in the country, all the while touting Tunisia's multicultural, Mediterranean identity, President Ben Ali made it part of his political platform to deny Berber heritage.[14] Since 2011, though, the situation seems to be changing. In "Maghreb Film Festival Celebrates Amazigh Culture" by Houda Trabelsi, published in *Magharebia* (September 12, 2011), the author touts the recent "Jasmine Revolution" in Tunisia as responsible for having "ushered in a new era for the nation's movie industry. Organizers of the third Maghreb Film Festival of Nabeul (FFMN) used the opportunity to celebrate Amazigh cinema for the first time in Tunisia." Anis Lassoued, director of the 7thArt–11th Film Festival in 2011, remarked that he had "discovered Amazigh cinema at the Azzefoun festival in Algeria, and . . . was impressed by their culture." This inspired him and his fellow organizers to "add this aspect to the Maghreb Film Festival in Nabeul" (Tunisia), noting that "we can't exclude Amazigh culture in the Maghreb because there is an important class of Amazigh people here." In order to

promote Amazigh films, Tunisia has partnered with Algeria and Mauritania to host film festivals and fund Berber films. Despite these references, very few Tunisian Berber films are listed on the Internet or in film databases. It seems the "Amazigh films" made in Tunisia are primarily documentaries, such as the recent *Azul* by Wassim Korbi (2012). This film documents the marginalized Berber enclaves living in Taojout, Tamerzet, and Zraoua. In sum, Tunisia seems to be still at odds with its multiethnic and linguistic national identity, preferring to continue the belief that unity and cohesiveness of the state, promoting *Tunisianité* (Tunisianess), must win out. Kchir Bendana Kmar explains that the conception of *Tunisianité*, as defined as a "certain Tunisian ethic," has fashioned cinema as a "national cinematographic aesthetic" that prefers to explore the "nuanced . . . ambiguities and difficulties of being Tunisian" rather than the essentialities of other possible qualifiers, such as Berber, Islamic, or Maghrebi (2003, 37).

In Morocco, where filmmaking in-country without funding from international interests has been growing in the last fifteen years, language has become less of an issue. Now, more than in the past, Moroccan films are made only in Moroccan Arabic. Many films never leave the shores of the country, thus attesting to the fact that the industry does not feel the need to export its films in order to keep film culture alive. Indeed, the question as to whether or not Moroccan cinema can be considered "Francophone" depends on which Moroccan cinema is being discussed. Despite a large number of Moroccan-language films, and the growing number of films made in Amazigh, the debate about language does still persist in Morocco's culture wars. Language tends to dictate the paradigms of class, region, and social strata and how these are depicted in film. A telling example of this is Leila Marrakchi's *Rock the Casbah* (2013), in which French is a dominant language spoken by the affluent family on which the film focuses (the patriarch is in fact played by Egyptian Omar Sharif). The family's maids and various house help speak only in Moroccan Arabic because, as the class divisions show, this native language is the only one available to the uneducated and the economically challenged. In a 2005 interview, well-known Moroccan film critic Mustapha Mesnaoui reflects upon the split identity in the cinematographic industry stemming from the language question that traverses social classes in interesting ways:

> Moroccan society is composed of two principal clans. The first is francophone, the second is arabophone. I'm not talking just about the language used but also about the lifestyle and the mentality, which change according to these milieus. In effect,

on the one hand we have people who use French in order to transmit their ideas and thoughts . . . on the other, the arabophones who have done the same thing. In the case of the first, they have more choice as far as newspapers and magazines; the others are condemned to lapping up theoretical books from the East or works with religious tendencies. Moreover, each regards the other as foreign and not as co-citizens unified by the same visions and goals. What is considered entertainment by one may be perceived by the other as depravity, even danger. (Zaine 2005)

Mesnaoui alludes to much more than language choice as being at the core of the debate characterizing "the malaise of Moroccan culture." He faults Moroccan cinema for not really having enough "principles" to respond to the shifting socio-cultural and political phenomena fueled by language debates occurring in the country today (Zaine 2005). One of these phenomena, of course, is the rise of Islamic fundamentalism (*intégrisme islamique*) in Morocco. Islamic radicalism is associated with highly rhetorical and inflammatory classical Arabic shouted from the minarets of mosques by radicalized imams. Most Moroccans feel that this Arabic does not reflect the morals and values of their country or their religion. Cinema is a highly effective medium through which to analyze and isolate religious radicalism, while promoting the exceptional *Marocainité* (Moroccanness), on which Moroccans pride themselves. Interestingly, unlike Tunisianité, Marocainité characterizes a population that sees its country and culture as Berber and Arab, multilingual, multicultural, Islamic, Jewish, and animist.

The use of French in Moroccan film has also served politically to criticize authority. Nabyl Lahlou's film *Tabite or Not Tabite* (2007) explores reality through the surreal. The film depicts the real-life personage Tabite, a corrupt police officer and sexual predator who in the late 1980s raped hundreds of girls and filmed his evil deeds. "Tabite" in Arabic means "straight up, inflexible, and solid," reflecting, of course, a sexual innuendo. In rather vulgar slang, *ta bite* in French means "your dick (penis)," and of course "to be or not to be" implies the stage of Shakespeare and classical Western theater. Lhalou, considered the "Woody Allen" of Moroccan cinema, was barred from making films for ten years in the 1990s because of several works in which he proposed controversial subjects that often criticized the political status quo in Morocco. Formulated within the framework of the crime-spy genre, *Tabite or Not Tabite* scrutinizes dirty politics, human rights abuse, and torture during the Years of Lead. The perpetrator, Tabite, like so many other abusers of power, was able to avoid punishment until the early 1990s when two of his victims

happened to be the daughters of rich and influential men. The back and forth between languages is particularly interesting in this film. Lhalou's film within a film features Ali Brahma, a young filmmaker who lives in France, but decides to return to Morocco to make a film about the high-profile case of Tabite. He can't read Arabic and only speaks a smattering of the local dialect, doesn't observe Ramadan, and is accused of not being a "true Muslim" by family members. As the director gathers information about the story, French is the language of choice when characters discuss the abuse of human rights surrounding the Tabite drama, and when they comment on the existing social injustices of their country. For example, the statement "les barbes qui poussent comme des champignons" (beards that spring up like mushrooms) reveals one character's concern for the increasing evidence of Islamic "intégrisme" (fundamentalism) evident in the country. "Les barbus" (the bearded ones) is a synonym for religious fanatics in a country that has been battling Al Qaeda–like factions since the late 1980s. What is interesting, too, is that Lahlou's films (he has made eight) have only rarely been screened abroad. The complexity of their messages and their mixed use of French and Moroccan Arabic, as well as his very controversial political views, make his films some of the most daring and unconventional in Morocco today.

Questions surrounding language as it molds contemporary Moroccan identity also influence cinematic funding. Whether or not a film's dialogue is primarily shot in French or Arabic has created a two-tier system that hinders the development of original film styles. Films predominantly shot in French are usually funded, in part, by France, other European-Francophone countries, and/or Canada. Domestic productions, particularly Berber-language films, rely on the CCM and the filmmakers' private resources (many filmmakers working at home have their own production companies). This does not, however, preclude the CCM from proudly listing all Moroccan films in its annual catalog, even those funded internationally and made by filmmakers living abroad. For example, in its 2008 report, "Cinéma Marocain Filmographie Générale: Long Métrages, 1958–2008" (Moroccan Filmography: Feature-Length Films, 1958–2008), the CCM makes no distinction between films made and funded solely at home and those produced with monies primarily from foreign backers (France, Spain, Canada). In 2008, "50 Years of Filmmaking" was celebrated with special editions of the filmography report promoted in posters touting the CCM's success in maintaining since independence a viable film industry in Morocco.

The brochure for "Du fonds d'aide et l'avance sur recettes" (funding and subsidies), listing films made from June 2003 to November 2005, such as *Le Grand*

Voyage (The Long Journey, Ismaïl Ferroukhi, 2004), *Marock* (Leïla Marrakchi, 2005), and *J'ai vu tuer Ben Barka* (I Saw Ben Barka Get Killed, Serge Le Péron and Saïd Smihi, 2005), indicates that all these feature-length films received only minimal CCM funds (Orlando 2011). These films made by MREs (*Marocains résidants à l'étranger*, Moroccans living abroad) incorporate a significant amount of dialogue in French, opened almost simultaneously in Morocco and France, and were screened immediately at international film festivals such as Cannes, Venice, Montreal, and Toronto. Conversely, films such as Nabyl Lahlou's *Tabite or Not Tabite*, solely funded by CCM funds and not as of yet screened outside Morocco, use both French and Moroccan Arabic. The dual-language screenplay, according to Lahlou, artistically fulfilled the goals of his film, but did not aid in facilitating distribution outside Morocco, even though subtitles were provided each time the dialogue switched languages (Orlando 2011). The seemingly split Arab-French personality of Moroccan cinema does present difficulties in distribution, but ultimately contributes to its sustained vitality, as Rachid Chenchabi pointed out more than twenty years ago: "French is the language that has been the most successful in profoundly penetrating the Maghreb. The result is that it is a daily instrument of communication for a significant part of the population in the three countries, with regard to mass media: journalism, radio, television and cinema" (1984, 231).

Since the late 1980s, "cinéphiles maghrébins" (Maghrebian filmgoers) have acquired their cinematic knowledge through Moroccan and Tunisian cinema journals and reviews modeled after founding film texts such as *Cahiers du cinéma* in France. These journals are, for the most part, written in French or are bilingual, and have promoted increased international critique and analysis of Maghrebi cinematography. In general, Maghrebi cinema is discussed in the context of world cinema as the reviews in cinema journals seek to encourage readership from abroad.

In Morocco, cinema magazines evolved in the late 1970s when most Moroccan newspapers also began dedicating pages to cinema news (Carter 2009, 331). *Lamalif* and *Kalima*, two outstanding newsmagazines, also habitually included cinema sections in their pages. Magazines devoted exclusively to film included *L'Ecran marocain* and *Cinéma 3*. Although *Cinéma 3* had a short run in the 1980s, producing only four issues under the supervision of Noureddine Sail, it did succeed in establishing a homegrown film critique forum that was later continued in Moroccan national papers such as *L'Opinion* (Carter 1999, 331). The more recent French-language *Ciné Mag: Magazine du Cinéma et de l'Audiovisuel au Maroc* (first edition published in 2006) is the first Moroccan magazine of the millennium dedicated solely to cinema

that offers in-depth interviews with filmmakers, both at home and abroad, and critical analyses of current films (Orlando 2011).

In Tunisia, ciné-clubs have fostered important dialogue about filmmaking in the country. The Federation of Tunisian Cinema Clubs (FTCC) has hosted a number of film screenings and debates about film in the last ten years.[15] Notable in both countries is the use of the Internet to promote discussion about film. In Tunisia, such sites as Sugarcane Magazine have discussed film and promoted filmmakers from all over the country. Overall, film criticism is primarily written in French. A cadre of Maghrebi critics, ranging from students to professors in both Morocco and Tunisia, has succeeded in founding a vibrant milieu of discussion. The open forums reflect the extended freedom of the press and the influence of capitalist consumption (more so in Morocco than Tunisia), which, for better or worse, increasingly drives the industry in the current era.

With respect to French, Moroccan film has played an interesting game. Because the industry has now surpassed Egypt and Tunisia in the number of films produced each year, Moroccans have tended to make more films in Moroccan Arabic. Even coproductions, particularly with Spain, the Netherlands, and Belgium, have been shot primarily in Moroccan Arabic and have still seen international distribution and critical acclaim. Films such as Yasmine Kassari's *L'Enfant endormi* (The Sleeping Child, 2004), funded primarily through Belgian auspices, was shot in Moroccan Arabic, although the lead role was played by Richida Brakni, an Algerian-French actress who had to learn Arabic in order to play the part (Orlando 2011, 139). Recent films shown at prestigious film festivals such as Washington D.C.'s "Arab Sights Film Festival," the Toronto Film Festival, and others, have been solely shot in Moroccan Arabic and sent to the West with subtitles. Narjiss Nejjar's *L'Amante du Rif* (The Rift Lover, 2011) and Mohamed Mouftakir's *Pegase* (2010) are good examples of Moroccan Arabic–language films with culturally rooted themes that have, nevertheless, gleaned international critical acclaim.

Films made by Maghrebi-French exiles are often interestingly divided with respect to languages used. Merzak Allouache's film, *Les Terrasses* (The Rooftops, 2013), was shot in Algiers and made entirely in Algerian Arabic, which is of course peppered heavily with French. Moroccan Ismaïl Ferroukhi's *Le Grand voyage* (The Long Journey, 2004) was made in Europe and uses French while incorporating some Moroccan Arabic.

Confusion surrounding national identity and origins has become more noticeable in the globalization of the film industry and the effacement of national

boundaries. In our era of porous borders, crossed over and through by social media, YouTube, Twitter, and Facebook, filmmakers' nationalities seem increasingly less important. Filmmakers often offer a more critical eye of their home nations from outside rather than inside, as Allouache's and Ferroukhi's works attest. Like many Maghrebi authors writing without borders or limiting themselves to one language, filmmakers' "consciousness very rapidly [has] moved beyond the limits of national boundaries to become open to–as well as to open—a field that is planetwide" (Bensmaïa 2003, 6).

In his work, *New Tunisian Cinema: Allegories of Resistance*, Robert Lang notes that in the case of Tunisian cinema, certainly in the last decade or so, the language question has focused more on "translating" "into the first-world language of. . . . film" the very universal themes of our age (2014, 17). He writes, "Tunisian cinema has never been only, or even primarily, about entertaining local audiences, or seeking to 'travel beyond' the country's borders in order to generate margin of profit for its producers." Rather, it has been about offering "allegories" that "speak the public culture and society" of Tunisia—this can be done in many languages (Lang 17–18). Nadia El Fani's *Bedwin Hacker* (2002) promotes a theme that resonates on both sides of the Mediterranean and globally, in the East and West. In an interview, she notes that at the time it was made, her film about a young woman "cyber-activist," Kalt whose computer-savvy skills make it easy to hack Western media outlets, also was meant to send messages to audiences about the repressive Ben Ali regime as the world was gripped in the invasions in Iraq and Afghanistan: "I am supposedly addressing the West, when in fact I am directly talking about contemporary society" (cited in Lang 2014, 191). As a harbinger of things to come in Tunisia less than ten years later, the film resonates as not only a scenario of resistance to the oppression of the global stage but also to a national government that in 2011 was overturned by the people who were fed up with it.

Third World and Third Cinema Movements and the Maghreb

The Third World movements across Africa, Latin America, and Asia of the mid-1960s and 1970s were influential in shaping the themes of nascent postcolonial national cinemas of the Maghreb. Although there is little scholarship directly connecting the movements and their ideologies and philosophies of the period to themes in Maghrebi films, I do believe that there is a case to be made. Perhaps the dearth

of scholarship linking the two is due in part to the vagueness of the term "Third World," as well as the ensuing pejorative meaning it has cultivated over the last forty years. In general, poststructuralists have condemned the concept "Third World" as essentialist, vague, and too Eurocentric (Kalter 2013, 41). "Given the paramount importance of the cosmology of the three worlds for the second part of the twentieth century," writes Christopher Kalter, "comparatively little historical research has been done on the genealogy of the concept and its myriad effects on political, social and cultural representations and actions" (2013, 25). Use of the term "Third World" with respect to the movements of the 1960s' influence on postcolonial cinema is best contextualized according to Ella Shohat and Robert Stam's exploration of global media production. They argue that Third World Cinema, in fact, "did not begin in the 1960s" but existed "before the beginning of the twentieth century" due to film's "world-wide phenomena, at least in terms of consumption" (Shohat and Stam 1994, 28). Thus they argue for a more nuanced understanding of these terms in their work *Unthinking Eurocentrism*, wherein they explain that in the postcolonial era the term "Third World" can refer to many contexts: "the colonized, neocolonized, or decolonized nations and 'minorities' whose structural disadvantages have been shaped by the colonial process and by the unequal division of international labor" (Shohat and Stam 2013, 25). Their emphasis that Third World identity in the 1960s was enmeshed in "nationalist discourse" that "often assumes an unquestioned national identity [when in fact] most contemporary nation-states are 'mixed' formations" (Shohat and Stam 2013, 26) is particularly true of Tunisia and Algeria.

Regardless of the nuances that characterize use of these terms, Roy Armes notes that "there were many factors involved in this 1960s mood: the anticolonial struggle, opposition to the Vietnam war, student revolt, a new consciousness on the part of American blacks, the emergence of armed guerilla groups in Latin America, developments within the communist world opposing China to the USSR in terms of revolutionary strategy" that created a climate that was ideal for the reconceptualization of the important role film could play in documenting upheaval (1987, 88). The "myth of a Tricontinental Revolution," where revolutionaries such as Frantz Fanon, Che Guevara, and Ho Chi Minh played active roles on the world's stage, certainly influenced "the work of many of the filmmakers who began in the 1960s" (Armes 1987, 89). Argentinian Fernando Solanas and Octavio Getino[16] were among the first filmmakers to ask the question: can film capture sociopolitical and cultural movements as well as trauma on screen? In their now historic essay "Towards a Third Cinema" (1973), they proposed to dismantle what they viewed

as the dominant bourgeois quality of cinema, purported by Hollywood films up to the 1960s, in order to conceptualize film as sociorealist and critically engaged. For the two authors, film would and should be a tool through which to define the emerging postimperialist struggle. "A reformist policy" was needed for film in order to document Third World peoples' socioeconomic, revolutionary agendas as they fought to counter "two supposedly unique blocs—the USSR and the USA"—that were "unable to produce anything but a cinema within the System itself." Particularly, Solanas and Getino noted that

> questions that were recently raised [in the films of Third World filmmakers] appeared promising; they arose from a new historical situation to which the filmmaker, as is often the case with the educated strata of our countries, was rather a latecomer: ten years of the Cuban Revolution, the Vietnamese struggle, and the development of a worldwide liberation movement whose moving force is to be found in the Third World countries. The existence of masses on the worldwide revolutionary plane was the substantial fact without which those questions could not have been posed. A new historical situation and a new man born in the process of the anti-imperialist struggle demanded a new, revolutionary attitude from the filmmakers of the world.[17]

Teshome H. Gabriel's now well-known article "Towards a Critical Theory of Third World films" (1989) was the first to couch films of the previous twenty years within the framework of Third World movements using not only Solanas and Getino's framework but also Frantz Fanon's "Three Phases of Cultural Evolution." As explored in Fanon's 1961 *Les Damnés de la terre* (*The Wretched of the Earth*), Gabriel maintains that Third World film, like writing from the former colonial world, "followed a path from domination to liberation," mapping a "genealogy [that] moves from the First Phase in which foreign images are impressed in an alienating fashion on the [indigenous] audience, to the Second and Third Phases in which recognition of 'consciousness of oneself' serves as the essential antecedent for national, and more significantly, international consciousness" (1989, 31). Gabriel further explains that "there are, therefore, three phases in this methodological device" which can be used to track the development of sociopolitical consciousness in films made by *cinéastes* from the Third World (1989, 31).[18]

With respect to Maghrebi film of the late 1950s to the end of the 1960s, I would argue that the essence of the movements of the era, if not the ideologies purported

outright, did influence a certain Marxist-revolutionary view of how film should/ would be used to contribute to the burgeoning liberated nations of the three Maghrebi countries. Films such as *Le Fils maudit* (The Damned Son, Mohamed Osfour, Morocco, 1958), *L'Aube des damnés* (Dawn of the Damned, Ahmed Rachedi, Algeria 1965), *Le Rebelle* (The Rebel, Tunisia, 1968), and of course the celebrated *The Battle of Algiers* by Italian neorealist Gillo Pontecorvo (1966) contributed to the concept of "Third Cinema" in the Maghreb. Though it must be noted that Maghrebi cinemas, unlike other growing Third Cinemas in Latin America, for example, were not as interested in cultivating a "countercinema" that refuted the styles and aesthetics of French national cinema, still the dominant model. Latin American filmmakers of the 1960s tended to look to Third Cinema as a means to challenge "hostile . . . dominant cinemas but refused to let the industrially and ideologically dominate cinemas dictate the terms in which they were to be opposed" (Pines and Willemen, 1989, 7). Maghrebi filmmakers, though, never refuted the ideology of the "7ème art"—film as art form—which is at the heart of French national cinema. Rather, they sought to meld art with sociocultural and political messages, thus producing a particular style of film quintessentially Maghrebi. Thus, within the scope of Third Cinema, Maghrebi filmmakers differ here from their counterparts elsewhere in the developing world. Inflecting what had been learned via European cinema was integral in Maghrebi filmmaking from the outset. With respect to the filmmakers mentioned above, they were inspired by European directors such as Greek-born Constantin Costa-Gavras. His films *The Sleeping Car Murders* (1965) and *Shock Troops* (1967), as well as the celebrated 1969 film *Z*, the story of a judge who, as an investigator, tries to uncover the facts surrounding the murder of a leftist politician in an unnamed country, resonated in similar scenarios in films across the Maghreb (Armes 2005, 16). The major themes of the era—"the search for identity, social injustice (particularly with regard to the status of women), and the suffocation of the individual"—would develop as leitmotifs in the films of the 1960s and 1970s, enduring to the present (Armes 2005, 37).

Third World Marxism was particularly appealing to the Algerian FLN's newly seated government, whose primary goal was to unify a country that had been divided linguistically and ethnically by French colonialism and also by indigenous tribalism (Berbers, Arabs, Muslims, and Jews). "Indeed, for several years after 1968 the Third World–oriented Marxist and revolutionary nationalist currents developed in tandem and interpenetrated to such an extent that the boundaries between them were quite unclear" (Ebaum 2002, 41). The didactic, socialist style of many

of the films of the era, touting Marxist concepts purporting the importance of social identity, were used by nascent independent governments to encourage their populations to invest cohesively in building their countries. The question of how to use social ideology of the early 1960s movements in order to create cohesion and a "public" that was educated enough, not only to understand the polemics of the ideology but also to put it into practice in public space, was paramount for artists, filmmakers, and cultural producers. Scholar Réda Bensmaïa explores this idea through Minister of Education Mostefa Lacheraf's speech at the first Algerian National Colloquium on Culture in the late 1970s,

> The aftermath of Algerian independence, as we all know, was fraught with conse-
> quences: the countryside, men and women were completely uprooted from their
> culture; in the cities and towns, the "public" consisted "of mostly uneducated
> people." . . ." Can a milieu (in particular the rural milieu) that has been seriously
> uprooted from its culture and neglected for so long manage to unite the conditions
> necessary to become a public in the active sense of the term . . . ?" This, then, is
> the catastrophic situation that Algeria inherited with independence. (2003, 12)

Lacheraf, appointed at the end of the Boumediene years, was perhaps the "first Algerian intellectual in the French sense of the word" to ponder the effects of total Arabization on Algeria. He "pursued a sustained reflection on the prospects of both bilingualism and Arabization in Algeria within the framework of a larger political and anthropological study of modern society" (Berger 2002, 7). Writers, artists, and filmmakers thus were faced with the question of how to create meaningful art and film in a multilingual structure that would transmit to the people the essence of their culture. In addition, these cultural producers were also challenged with how to tout the tenants of modern socialist ideals that the Algerian government hoped would help ground a viable nation-state for the future.

In the 1960s, pioneer Algerian filmmakers, who were overwhelmingly Fran-cophone, had close ties with the FLN. René Vautier and Jacques Charby "were both FLN activists." Ahmed Rachedi, Mohamed Lakhdar-Hamina, and Mohamed Slim Riad worked with the provisional government. "These filmmakers' desire to deal with the colonial past coincided precisely with the needs and demands of the new government of Houari Boumediene, who had seized power in a military coup in 1965" (Armes 2006, 74). Films such as Rachedi's *L'Aube des damnés* (Dawn of the Damned, 1965), the later *L'Opium et le baton* (Opium and the Stick, 1969),

and Lakhdar-Hamina's *Chronique des années de braise* (Chronicle of the Years of Embers, 1975) served to show to the public what the population had endured during the revolution as well as to demonstrate the might and the glory of the new nation (Armes 2006, 74–75).

Among these films, the most telling example used as propaganda to unify the population is Rachedi's *L'Opium et le baton* (1969). The film is based on the 1965 novel of the same title by celebrated Francophone author Mouloud Mammeri. The book and film tell the story of one family, caught up in the throes of the revolution, "who are both separated and united by the liberation war: one [family member] has joined the French military . . . another, Ali, has enlisted in the resistance; a third, an urban doctor, has difficulty in shifting from thinking about the situation to becoming actively involved" (Spaas 2000, 136). The film was used as a retelling of the revolution to reinforce and glorify "the image of the Algerian fighter or *Mudjahid*," thus helping the FLN government more convincingly to make the case for the importance of national unity (Spaas 2000, 137). Erasing the ethnic and tribal ties inherent in indigenous Algerian society was of the upmost importance, as the FLN sought to create a unified postcolonial state that would not be fractured by, in particular, Berber interests. In the film, all three men "belong to the same Berber family," which they place secondary to preparing "the way for a new Algerian national identity" (Spaas 2000, 137).

In Morocco, while Morocco's king Mohamed V was vehemently opposed to the Marxist radicals and Moroccan Communist party challenging his monarchy in the late 1950s and early 1960s, he nevertheless believed that film would be useful in helping to "contribute to national consciousness and national awareness [by offering a means] to construct a nation from a population accustomed to thinking only of tribal and regional loyalties" (Carter 2000, 66–67). Moroccan films made in the late 1950s and early 1960s consisted primarily of documentaries made by government employees that concentrated on regional development issues: poverty, illiteracy, water projects, and so forth (Carter 2000, 67). In the 1970s, the film *Mille et une mains* (A Thousand and One Hands, 1972) directed by Souheil Benbarka, who had studied film in Italy and worked under Pier Paolo Pasolini, "attacked the Western exploitation of those who weave the Moroccan carpets so prized by foreign buyers" (Armes 2006, 83). Known for his socially rooted themes about economic exploitation, and particularly critical of Western models of capitalism, Benbarka's second film, *La Guerre du pétrole n'aura pas lieu* (The Oil War Will Not Take Place,

1974), was described at the time of its release as a "political film" shot in the "manner of Yves Boisset and Costa-Gavras" (Armes 2006, 83).

The 1960s in Tunisia were "the years when things were constructed and put into place" (Armes 2005, 21). What was most important during this time, as in Morocco and Algeria, was using film as a tool to unite the country and to show the public the strength of the nation (Armes 2005, 21). In Tunisia at the time, filmmakers were much more wary about the authoritarian powers of the state and somewhat more critical than their Algerian counterparts. Although in the first years following independence, films focused on collaborative projects made with primarily French directors, social messages were at the core of film scenarios. Brahim Babaï, who had studied film at the French IDEC, made *Et demain?* (And Tomorrow?, 1972), "which as its title indicates offers no solution for its uprooted protagonist . . . and is intended as a warning to politicians and those in authority about problems in Tunisian society" (Armes 2006, 83). By the 1990s, "despite its limited number of cinemas [at the time of independence] . . . [Tunisia] had a vibrant film culture, with a ciné-club movement which dated back to 1950" (Armes 2005, 21). Films of the late 1960s, such as Omar Khlifi's *al-Fajr* (The Dawn, 1966) and the later *Le Rebelle* (The Rebel, 1968), return to history to make sense of the present. *Le Rebelle*, in part, "looks back to an earlier Tunisian struggle in the 1860s under the rule of the beys," thus attesting to a need to relive the past before moving forward. As Armes suggests, Tunisian films of this genre and era "offer an image of a Tunisia which is independent but not yet free from the aftereffects of colonialism and confronted with the problems of economic and cultural development" (2005, 21). The 1970s continued these themes with *Les Fellagas* (The Fellagas, Omar Khlifi 1970), *Sous la pluie d'automne* (Under the Autumn Rain, Ahmed Khechine, 1970), *Hurlements* (Screams, Omar Khlifi 1972), and *Yusrâ* (Rachid Ferchiou 1972). The films of the 1960s and 1970s overwhelmingly took on the subject of "the political history of nationalism, exalting with a certain gusto a glorious national history, relating the struggle for the country's political liberation from colonialism" (Kmar 2003, 36). Films in the 1970s tended to recognize "forgotten aspects of official history, revisited it, [in order to attempt to] repair earlier omissions" (Kmar 2003, 36). Abdellatif Ben Ammar's 1973 film *Sejnene* (the name of a small mining town in northern Tunisia) dealt with the struggle of the Tunisian General Workers' Union to fight for workers' rights during the anticolonial struggle for liberation from 1952 to 1954. The condition of immigrant workers in France was documented in *Les Ambassadeurs* (1975) by Naceur Ktari, one of the first filmmakers

to bring attention to the plight and exploitation of Maghrebi manual laborers in Europe after decolonization (Kmar 2003, 36).

Although the goals of the three nations differed immensely on the political level after colonialism, the three countries did share a strong will to unify their nations in order to move forward in the late 1960s–early 1970s era. Third World socialist movements taking place globally primarily helped to shape film as an art form that could promote didactic messages used as propaganda to serve authorities well. Films were efficient as a means to propagate the particular Maghrebi sociocultural ideologies of the day—at least for a time before disillusionment set in among intellectuals, artists, authors, journalists, and filmmakers who sought to preserve human rights, ground a strong civil society, and ensure the free will and political enfranchisement of all.

From Colony to Postcolonial Nation: Film Industries as Essential to National Culture

Although Algeria was a colony and Morocco and Tunisia protectorates, France was equally devoted to establishing film studios in each country. French filmmakers as well as some indigenous Arabophones were making films in all three countries before decolonization. However, once the colonizer left, what was left in the way of institutionalized filmmaking in each country differed immensely among the three nations. Again, it must be stressed, each film industry was, and continues to be, molded by the socioeconomic and political tides that occurred during decolonization and in the subsequent postcolonial era of the Maghreb.

Algeria

In the 1950s leading up to the outbreak of the revolution as well as after 1954, when the first bombs were ignited by the FLN in Algiers, some French filmmakers continued to make films in the country. Previously mentioned René Vautier's *Algérie en flammes* (Algeria Burning, 1957), "made at the request of Frantz Fanon," was sympathetic to the FLN's cause. During the war, Vautier "joined the resistance in the Aurès mountains and was wounded" (Spaas 2000, 134). He later edited the film in Germany, and it was released in 1957. It was not shown in France until 1968, well after Algeria's independence (Spaas 2000, 134). As Roy Armes and Guy Austin

haven noted in their scholarship, Algeria's cinema was born out of the war (Armes 2005, Austin 2012). Algerian cinema in the postcolonial period had three distinct periods that were closely linked to the political climate of the country, as Lieve Spaas explains in her book *The Francophone Film: A Struggle for Identity*:

> The first, from 1964 to 1971, sought to preserve the memory of the Liberation War. Most of the films made in that period attempt to come to an understanding of the events which preceded the war and to develop a notion of a new Algerian identity. ... The second phase, from 1971 to 1976, was influenced by the Agrarian revolution of 1971 and the nascent industrialization under the Boumediene government. . . . The third phase of Algerian cinema, starting in 1976 and lasting until the early 1980s, introduced new themes ... including the problems of young people, women and marginal groups. (2000, 135)

The first efforts made by the FLN government to set up a national film production company had mixed results. The CAV (Centre audiovisuel), developed by the Ministry of Youth and Sport in 1962, and the subsequent Offices des Actualités Algériennes/Algerian Newsreel Office (OAA) directed by Mohamed Lakhdar-Hamina, one of the first Algerian filmmakers working after independence, opened in 1963 but then closed in 1974 (Spaas 2000, 134). These efforts were followed by the 1964 Ministry of Information's establishment of the Centre National du Cinéma Algérien (CNCA). The CNCA did develop a film distribution system, created a film archive, and set up a training institute to school budding young filmmakers. The television system, expanded and nationalized after 1962, contributed to the cinema industry. In 1967, the Office National du commerce et de l'industrie cinématographique (ONCIC) replaced all "earlier organizations and was responsible for virtually all Algerian feature film productions" (Spaas 2000, 134). In the 1960s–1970s, these industries wrestled with not only the form the institutions would take but also the language to be used. Of all three countries, Algeria was the most Francophone at the time of independence. Writing in 1965, the Turkish journalist, historian, and social scientist Arslan Humbaraci comments on the entrenched use of French, even after the colonizer had left, in *Algeria: A Revolution That Failed, a Political History since 1954*:

> Algeria—urban Algeria, at least—speaks French. In parliament, in the ministries, in the streets, the language is French. Books, magazines and newspapers are in French, and Algeria's own publications are in the same language. Algerians think in French;

their minds and reflexes are French. The country they know and love is France. When a fashionable Algiers restaurant with a floorshow tried to introduce sugary Egyptian music, the clients clamored for "Les Feuilles mortes." As well as French music, they like French food, French drinks and the French approach to making love. Out of any ten foreign women married to Algerians, nine are Frenchwomen. . . . It is difficult to think of two other peoples as closely linked as the Algerians and the French. (1966, 30–31)

Despite efforts to "Arabize" Algeria in the 1960s, the French language remained prevalent, influencing the sociocultural spheres of the country long after the colonial structure had been dismantled. "The paradox was . . . France had imparted to [Algerians] the modern concept of national consciousness" (Humbarraci 1966, 25). Although viewed as a Westernized, avant-guard Third World nation "that had effectively rid itself of the imperial machine and was working on an Islamic social model to build the state in a manner that would value the work done by men and women alike during the war of independence," its overall cultural identity, influencing thus its cinematic mission, was fragmented and schizophrenic (Khanna 2008, xiii). In addition to the linguistic paradox, financial difficulties, increasing social fragmentation, and political unrest in the late 1970s and early 1980s weakened the country's film industry. The ONCIC, like other African film institutions in the past, was dissolved in 1984 and replaced by the CAAIC (Centre Algérien pour l'Art et l'industrie cinématographique) in 1987 (Spaas 2000, 134; Armes 2005, 39). These organizations were also undermined by financial difficulties, although filmmakers continued to further their careers in the difficult climate (Armes 2005, 39).

By 1988, the growing social and political unrest in the country that would eventually drive Algeria to civil war fragmented the frail cultural institutions of the nation. Despite the dire times and the lack of institutional support, films such as *Hassan Taxi* (1982) by Mohamed Slim Riad and Ghaouti Bendeddouche's *Hassan Niya* (1989), although "minor" productions, captured the stresses of the time. In the first film, unemployed Hassan is reduced to driving a taxi to make a living. The second film also depicts a young man out of work who cannot make a living by any other means but by being a waiter in his sister's restaurant (Armes 2005, 39). These socioeconomic, hardship films reflected the social crises of Algeria at the time, which included shortages of housing in urban areas, overpopulation, dire unemployment, and few social welfare programs. The unrest and general riots in

October 1988 led to the massacre by the state's army of approximately 500 young people protesting for access to jobs and housing. During the 1980s, "the descent into violence in Algeria was not immediate but grew gradually" (Willis 2014, 172). To appease international condemnation for the massacre as well as to mollify growing support of political parties other than the FLN, a new constitution was ratified granting the right to form new political parties. This led to challenges by the FIS (Front Islamique du Salut) and its subsequent electoral win in 1992. The FLN-led government retaliated by imprisoning FIS leaders and nullifying the elections. It was at this point that the country sank into civil war (Willis 2014, 170–72). The period of civil war, known now as the "black decade" (Willis 2014, 186), significantly impacted filmmaking in Algeria. Up to the late 1980s and early 1990s, an "average of almost five" feature-length films were produced in Algeria per year (Armes 2005, 56). "After a very bright start in the early 1990s, production [in Algeria] was virtually extinguished by the latter years of the decade: only one Algerian-made feature was released in 1998 and 1999" (Armes 2005, 55). This film was a coproduced Algerian-Vietnamese work entitled *Fleur de lotus* (Lotus Flower) made by Amar Laskri (Armes 2005, 55). At this point, Algerian film, like literature (certainly by Francophone authors) became an art form produced almost exclusively in exile. Since 2007, some funding of films has occurred through the office of the Fund for the Development of the Arts, Techniques and the Film Industry (FDATIC), and the Algerian Agency for Cultural Influence (AARC). Making up for lost time since the "black decade" (officially ending with an armistice signed in 2005 between the Algerian government and the Front Islamique du Salut), FDATIC has subsidized ninety-eight films (feature films, documentaries, and short films). In mid-2013, the Algerian Agency for Cultural Influence (AARC) reports having funded a total of seventy-eight films, including forty-two feature films, six short films, and thirty documentaries.[19] Whether this constitutes a revitalization of the Algerian national film industry is subject to debate.

Since the early 2000s, several internationally recognized films have been made by Algerian exiled filmmakers such as Yamina Bachir-Chouikh (*Rachida*, 2003), Mohamed Rachid Benhadj (*Mirka*, 2000), and Merzak Allouache (*L'Autre monde* [The Other World], 2002; *Bab-el-Web*, 2005; and *Les Terrasses* [The Rooftops], 2013). The recent *L'Oranais* (The Man from Oran, 2015) by Lyès Salem, his second feature-length film, has contributed to the revitalization of Algerian cinema in the post–*années noires* millennium. The fact that *Les Terrasses* and *L'Oranais* were made in Algeria, shown internationally, and gleaned critical acclaim demonstrates that a

violence-fatigued Algeria seems, in 2016, finally to be able to offer filmmakers the opportunity to make their films without risk of assassination.[20]

Tunisia

Tunisian cinema has often been characterized as the "most daring of all the Arab cinemas, reflecting the country's widely perceived status as the most 'open' and 'tolerant' of the twenty-two Arab states," notes Robert Lang in his work *New Tunisian Cinema: Allegories of Resistance* (2014, ix). As a modern nation-state, crafted immediately after decolonization by forward thinking Habib Bourguiba, the country has been viewed as well balanced between modernity and tradition. It is celebrated for the "secular and liberal ideas" that have made it popular in the West (Lang 2014, ix). Tunisia's dedication to "its national motto, inscribed in the Constitution: 'Liberty, Order, Justice,'" was viewed during Habib Bourguiba's time as the perfect blend between East and West (Lang 2014, ix). Unfortunately, Bourguiba's progressive thinking eroded by the end of the 1980s. The country slipped from a modern, secular, liberal postcolonial nation to one ruled by a dictator who, it is rumored, battled dementia in his final years. Since Ben Ali's coup d'état in 1987 and subsequent almost twenty-five-year dictatorship, which greatly reduced freedom of speech and human rights (rivaling Moroccan king Hassan II), Tunisia lost its status as being a unique gem in the Arab world. The overthrow of Ben Ali in 2011, which in turn ignited the Arab Spring movements across the Arab world, has significantly hampered cultural production, particularly cinema (Lang 2014).

As mentioned previously, Tunisian filmmaking began in the early 1920s under colonial rule with Chenama Chikley's 1924 short film, *Chezal, la fille de Carthage* (Chezal, Daughter of Carthage). At this moment Tunisian cinema was at the forefront of African cinema, hosting the biannual film festival Journées de Carthage. Like Algeria, Tunisia established a state-owned production company, Société Anonyme Tunisienne de Production et d'Expansion Cinématographiques (SATPEC), immediately after independence in 1957 to "manage import, distribution, and exhibition of films" (Armes 2005, 20). SATPEC has remained a viable entity up to the present, assuring a monopoly on filmmaking in Tunisia. At one point, it set its sights on buying some U.S. distribution agencies, United Artists and Cinema International Corporation in 1975 and Warner Bros. and Columbia in 1979, but these efforts never materialized (Armes 2005, 32). Due to financial difficulties and the import of international films to the detriment of the domestic market, SATPEC was thought

to have faced inevitable financial ruin. Yet the entity has managed to survive. The Secrétariat d'Etat aux Affaires Culturelles et à l'Information (SEACI), a government office designated with the charge of supervising culture and information, headed in the 1960s by Tahar Cheriaa, "a key influence on Maghrebian cinema," also played a role in the continuing vitality of SATPEC (Armes 2005, 20). As the corresponding Algerian CNCA, the Tunisian SATPEC, in order to recover from financial failure, was forced to work with the national television service. In 1957, it did set up a film production site at Gammarth (Armes 2006, 43). At the end of the 1980s, SATPEC closed down and was absorbed into the television company Canal Horizon. During its existence, the organization worked with individual filmmakers and their own production companies and "was jointly responsible for twenty-nine of the forty-nine Tunisian features produced over [the] period" 1969–1990. Many of these features were coproductions with foreign film companies (Armes 2006, 43).

In the early 1960s, Tunisian films promoted images of a country that had gained independence yet "was not yet free from the aftereffects of colonialism" and faced "all the problems of economic and cultural development" characteristic of the early postcolonial era (Armes 2006, 21). Films as late as 1977 reflect "a divided country" that was "prey to internal contradictions and confronted with crucial hurdles that made it difficult to move forward in many respects" to found an individual identity (Spaas 2000, 154). Films such as *Soleil des hyènes* (Hyenas' Sun, Ridha Behi, 1977) called "attention to the crucial problems caused by the modernization of the country" while also criticizing the shortcomings of the government's policy on tourism. The film criticizes the exploitive holiday resorts popping up at the seaside, which resulted "in the destruction of a fishing village" (Spaas 2000, 154). Tunisia's heavy investment in the tourism industry set it apart from other economic models in North Africa at the time of independence.

Many Tunisian films from the outset have been cofunded with European countries. Omar Khlifi's *Les Fellags* (The Fellagas, 1970) was coproduced with Bulgaria and depicts Tunisians' struggle against the French in the 1950s. Ferid Boughedir, one of the most celebrated Tunisian film directors who has had success with international collaborations that have assured him a transnational reputation, began making films in the early 1970s and has continued up to the present. His *La Mort trouble* (Murky Death, 1970), made with French filmmaker Claude d'Anna, helped launch his film career on the international stage. Boughedir is known for making one of the first documentaries about African cinema in 1983, *20 Years of African Cinema*, followed by *Caméra arabe* (1987) and the celebrated films *Halfaouine* (Halfaouine: Boy of

the Terraces, 1990), *Un Été à la Goulette* (A Summer in La Goulette, 1996) and, most recently, *Villa Jasmine* (2008).

In the 1980s–1990s, Tunisian-produced films declined slightly. However, at this juncture in time, younger filmmakers who were born after independence were developing their craft. Many of their films evoke "a desire for self-expression using a personal language and style" (Armes 2005, 52). Nacer Khemir's *Les Baliseurs du desert* (The Searchers of the Desert, 1984) is described as an exploration of self-identity through memory and dream as a "young schoolteacher . . . sent to a remote village in the desert experiences a succession of events which successively come into view and then fade from sight" (Armes 2005, 49). In general, realities that could not be quite grasped and dreams that fade characterized 1980s cinema in Tunisia as filmmakers alluded to larger questions associated with a widespread Tunisian crises of identity. In 1994, filmmaker Nouri Bouzid notes:

> This question of identity keeps recurring: Are we Arabs? Are we Tunisians? What does it mean to be Arab? What is being Tunisian? Where do I come from? Why have we always been ruled? Are we Berbers? Are we a mixture? And these films search for identity, especially cultural identity. It's not a national identity, it's very often a cultural identity. We are forced to take this step, especially coming from a Francophone culture; we have gained our knowledge through the medium of language which is not our mother tongue. (cited in Spaas 2000, 171)

Since 2000 and up to the most recent events of the Arab Spring, for which Tunisia was ground zero, filmmakers in the country produced an average of two feature-length films a year. These included Naceur Ktari's *Sois mon amie* (Be My Friend, 2000), Nidhal Chatta's *No Man's Love* (2000), Khaled Ghorbal's *Fatma* (2001), and the celebrated *Les Mille et une voix* (A Thousand and One Voices 2001) by Mahmoud Ben Mahmoud. Young female *cinéastes* such as Nadia El Fani (*Bedwin Hacker*, 2002), Raja Amari (*Satin Rouge*/Red Satin, 2002), and the well-known and established Moufida Tlatli (*Nadia et Sarra*, 2004) contributed films as well.

Morocco

Cinema in Morocco has a long history, stretching back over a century to the filming of *Le Chevrier Marocain* (The Moroccan Goatherd) by Louis Lumière in 1897. From colonial times to the present, many foreign films have been shot in the country,

especially in the Ouarzazate region. This region's popularity, as a perfect desert space, endures today.[21] Due to its relative stability, Morocco is the country of choice for many Western filmmakers seeking the particular desertlike backdrops that resemble many places in the world. In recent years, with unrest plaguing the rest of the Maghreb, Morocco has offered an ideal film location for Western filmmakers.[22]

Founded in 1947 while Morocco was still a protectorate, the CCM, with studios in the Rabat suburb of Souissi, became more active as a state agency immediately after independence. In the beginning, it timidly funded only short films and documentaries, but later took over distribution and funding projects for Moroccan films in the 1980s (Tebib 2000, 60). The development of the industry spans three different eras and two monarchies (King Mohammed V and his son, Hassan II): 1956–1970, 1971–1985, and 1986–1999. These time periods reflect technical advances, funding development, and certain political influences that have shaped the industry in interesting ways. This past laid the groundwork for the vibrant film industry of the new Moroccan cinematographic millennium (Orlando 2009, 2011). Since 2000, in the more liberally progressive climate of the monarchy of Mohamed VI, the Moroccan film industry has made some of the most thought-provoking films to emerge from the Arab world.

During the first era of Moroccan filmmaking (1956–1970), the national industry employed filmmakers as government employees who were concerned with making documentaries and newsreels that would promote the postcolonial ideology of King Mohamed V. The CCM sent filmmakers abroad to France, Russia, and Italy to study filmmaking. At home, CCM personnel established a studio, lab, film stock and trained personnel (Orlando 2011, 8). From 1971 to 1985, the industry sought to encourage filmmakers to develop innovative styles. They mainly followed the *auteur* movement in France, first launched by the Nouvelle Vague (New Wave) filmmakers of the 1950s and 1960s. Auteur, artistically made films faced an uphill battle with audiences that increasingly desired purely entertainment films. Under King Hassan II, censorship also played a role in dictating subject matter. The influx of films from the United States, India, and Egypt cultivated a vision of cinematic productions among audiences who increasingly expected to be entertained. Viewed as too "intellectual" and too European, Moroccan films made during this time, despite being heavily subsidized by the CCM, drew only small audiences (Carter 2000, 67). From the mid-1980s forward, middle-class viewers became a significant force that shaped the parameters of filmmaking. Bollywood and Hindi films, certainly since the late 1980s, have cultivated Moroccan audiences' tastes for lighthearted,

entertaining films that draw the masses to theaters (Orlando 2011, 9). During the 1980s, films made in the social-realist style became the "central core" of Moroccan cinema (Armes 2006, 90), thus encouraging audiences to think about being less entertained and more informed about the social ills in society during some of the most repressive years of *Les Années de plomb*. Jillali Ferhati and Mohamed Abderrahman Tazi were leading filmmakers who sought to champion, in particular, women's issues in a country that was hyperpatriarchal, dominated by tradition and religion. Ferhati made three films during the 1970s through the 1990s focusing on the plight of women in society: *Une Brèche dans le mur* (A Hole in the Wall, 1977), *Poupées de Roseau* (Reed Dolls, 1982), and *La Plage aux enfants perdus* (The Beach of Lost Children, 1991). These films' scenarios focus on women who are repeatedly victimized by men.

By the late 1980s, and in the wake of the Third Cinema movement, revolutionary and daring young filmmakers began to make more socially critical films. Social awareness, activism, and increased sociopolitically engaged filmmaking became the norm in Morocco. Filmmakers began to experiment with themes, challenging the politics and conventions of their society as they sought answers, as in Tunisia and Algeria, to postcolonial problems such as poverty, illiteracy, and corruption. Under Hassan II, film subjects, if political, could only be metaphorically or symbolically rendered. Morocco's youthful population in the late 1980s, as well as the slow crumble of *Les Années de plomb* beginning in the 1990s, influenced changes in themes (Orlando 2011, 9). Gradually, filmmakers pushed the envelope to touch on sensitive issues such as the large number of the unemployed, tensions between sexuality and religion, political corruption, imprisonment, and torture. Films such as Ahmed Kacem Akdi's *Ce que les vents ont emporté* (Talk Is Easy, 1984), Mohammed Aboulouakar's *Hadda* (1984), and Mustapha Derkaoui's *Titre provisoire* (Provisionally Titled, 1985) countered some of the oppressive climate meted out during the Years of Lead. By the mid-1990s, social-realist, politically committed films documented once-taboo subjects. Hakim Noury's *Voleur de rêves* (Thief of Dreams, 1995) tells the story of a man who confronts life after prison, Fatima Jebli Ouazzani's *Dans la maison de mon père* (In My Father's House, 1997) discusses the very sensitive subject of lost virginity before marriage, and Nabil Ayouch's *Mektoub* (Destiny, 1997) depicts drug use and police corruption (Orlando 2011, 10).

Although the Years of Lead were oppressive, the Moroccan film industry, unlike that of Tunisia, never "officially" succumbed to state censorship. As Shirin Ghareeb notes, up to 2011 "Tunisia [was] regarded as the Arab state with the lightest film

censorship. But films [still had to] be submitted to the Ministry of Culture and a department of censors for approval" (1997, 123). Conversely, Morocco developed no such oversight of the CCM by the Ministry of Culture. There does exist, though, a "red line," as journalist Driss Ksikes notes, that "is alive and well in Morocco" and used by most cultural producers working in the country.[23] Well-known director Mohameed Tazi also evokes the "red line" when explaining how censorship works in the country: "One can criticize many aspects of life in one's country as long as [the] red line is respected. The red line involves respecting the state, religion, relations between men and women and the classes.... However... this red line can be and is moved around" (Ghareeb 1997, 123). In an interview, Kamal Mouline, adviser to the CCM's marketing department, explained that Morocco has never maintained a state censor. Filmmakers, he emphasized, "just know" not to tread heavily on "religion, the monarchy, or into the realm of pornography."[24] Mouline expressed these views in 2009; however, in the years since, the red line of these hot-button issues has definitely been crossed in several films, and the CCM, as well as filmmakers and their films, has not been prosecuted or censured. Some of the most daring films made in the last few years explore sexuality and coming of age as well as interfaith couples (*Marock*, Leila Marrakchi, 2005) and premarital sex in films such as *Hijab al-Hob* (Veils of Love, 2009) and *Les Ailes de l'amour* (Wings of Love, 2011). Only Ayouch's 2015 *Much Loved* has been banned from Moroccan screens this decade. The film's subject matter—prostitution and corrupt police practices in Marrakesh—coupled with the increasing power of the PJD Islamic party, condemned the film to the closet. Nevertheless, it has been shown widely internationally at Cannes and at festivals in the United States and elsewhere in Europe.

Themes of Postcolonial Maghrebi Cinema

The themes of postcolonial Maghrebi film are as diverse as the countries in which the films are made and reflect the constantly changing sociopolitical, historical, and cultural contexts of each nation as time has progressed since independence. As mentioned above, film helped to coalesce a nascent postcolonial identity for each country striving to, as the citation from Roy Armes suggests, express "reality as seen from a specifically Algerian, Moroccan, or Tunisian perspective" (2005, 8). This view of reality has constantly transformed over the years, evoking filmmakers' works as sociopolitical, engaged agents of change. Films made in the 1960s reflected the

ideology of newly formed governments that, following the prescriptions of Frantz Fanon, did invest initially in their respective national film institutes as a way to unify culture in the new nation. However, as disillusionment and disappointment with governments continue, filmmakers, like authors, artists, and journalists, have become more critical of the postcolonial state. These cultural producers, often risking their lives in order to speak out against human rights abuses, corruption, poverty, and illiteracy, to name just a few topics, are in many respects now more than ever responsible as moral keepers of the collective social conscious of their countries.

The Social-Realist Text of Maghrebi Film

Social-realist frameworks characterize Maghrebi films from the late 1970s forward and have been used to document the changing times of the Maghreb despite periods of censorship, war, and civil strife. Characteristic of films made by other filmmakers on the African continent, social-realism has been a defining framework of Maghrebi cinema. Film scholar Manthia Diawara defines social-realist films as those that "thematize current social issues" that are particularly relevant to the audiences who are watching them:

> The films in this category draw on contemporary experiences, and they oppose tradition to modernity, oral to written, agrarian and customary communities to urban and industrialized systems, and subsistence economies to highly productive economies. The filmmakers often use a traditional position to criticize and link certain forms of modernity to neocolonialism and cultural imperialism. From a modernist point of view, they also debunk the attempt to romanticize traditional values as pure and original. The heroes are women, children, and other marginalized groups that are pushed into the shadows by the elites of tradition and modernity. (1992, 141)

The groundbreaking filmmakers of the late 1970s and 1980s, Tunisian Férid Boughedir, Moroccan M. A. Tazi, and Algerian Mohamed Slim Riad, to name only a few, have inspired younger filmmakers up to the present day. Although perhaps less than their sub-Saharan counterparts, Maghrebi filmmakers have used didactic dialogues to portray the realities of their societies and cultures, debating current social issues in their countries as well as internationally.

Women at the Heart of Themes

"Despite making often substantial contributions to the anti-colonial struggles in the region, women were effectively excluded from elite politics in the three countries in the decades that followed independence" (Willis 2014, 4). Since independence, women of the Maghreb have fought tirelessly to insert themselves into every aspect of sociocultural and political realms of society. The depiction of women (specifically their conflicted roles and places in society) has been one of the most dominant themes in the cinemas of the three countries since the late 1960s. Women as keepers of the "purity" of the nation and also as barometers useful for assessing change have made them ideal subjects and an integral part of the "articulation of national identity" since independence (Discacciati 2000, 37). Exploring the sociocultural and political hurdles that women face, pulling them between tradition and modernity, Islam and secularism, rural and urban milieus, has been the thematic current for numerous films that tackle the subject of feminine enfranchisement in society (Discacciati 2000, 37).[25]

Since independence, the roles of women in films have been mostly defined as mother, wife, and daughter as they serve in didactic films that represent particular sociopolitical discourses within society. National identity has often been represented both in literature and film through "the familial sphere," where women's roles are distinctly rendered "by their relationships with male figures, [and] consolidated [by] religious, social and political values" (Discacciati 2000, 37). Women, particularly in Algeria and Tunisia, were linked directly to the new vision of the nation as emerging from colonialism into a solid family structure, purporting the importance of collective unity in order to assure the sociopolitical agenda of the state. In Tunisia and Algeria, both countries desired to ground a new nation and postcolonial government in the tenants of modernity, thus women were touted as being integral to future progress. Morocco, on the other hand, exchanging French colonial patriarchal power for an ancient system of patriarchy–the sultanate of the pre-French colonial past—posited women less as pivotal figures in the building of the postcolonial state and more as the sacred keepers of tradition.

In the 1960s, women in Tunisian films were represented as strong, positive characters, reflective of the modernity President Bourguiba wished to promote in his postcolonial state. Tunisia's constitution, ratified in 1959, gave wide-sweeping powers to the president to mold the country to his will (Willis 2014, 51). Bourguiba's plan for Tunisia at the outset consisted of creating a solid middle class that was

well-educated, modern, and progressive. Within this plan, women were linchpins who would reflect the contours of a new nation and a new model of Arab society. "Bourguiba introduced some of the Arab world's most extensive reforms to the legal status of women in the early years of his rule" (Willis 2014, 4). These "reforms" included the abolishment of polygamy in the constitution, guaranteed equal pay for equal work, the interdiction of the Islamic veil (*hijab*) in public offices, and access to equal justice under the law. The women's movement in Tunisia was also a major factor in promoting and gaining women's access to public space and the roles they played in it. Films of the 1960s (by both female and male filmmakers) cast women as "dominating and self-confident" mothers who "enjoy considerable decision-making power within the family" (Discacciati 2000, 37). *Shams al-diba* by Behi (Soleil des hyènes, Hyenas' Sun, Ridha Behi, 1977) "show[s] wives who are attentive to the needs of their children, husbands and families, thus consolidating the identity of the Arab family nucleus" (Discacciati 2000, 37). Other films, preaching a more modern vision of women in Tunisian society, include Abdellatif Ben Ammar's *Aziza* (1980). The socioeconomic and cultural struggles women face in society that push them to immigrate also have been depicted in Tunisian film. At the end of Néjia Ben Mabrouk's *Al-Sama* (The Trace, 1982), "the protagonist, suffocated by a restrictive environment, burns her textbooks from the exams she has failed and leaves for Europe" in the hope of making a better life for herself (Discacciati 2000, 37). The celebrated 1994 film *Samt Al-Qusur* (The Silences of the Palace, Les Silences du palais) by Moufida Tlatli bridges the past and the present in order to study the "social and juridical condition of women in society" (Discacciati 2000, 37). The engaging film *Bent Familia* by Nouri Bouzid (1997) presents multiple aspects of women's lives "through . . . the painful memories of the past" that perturb their day-to-day existence and "fragment the flow of the film's narrative" (Armes 2006, 92). Spaas suggests that this film also "investigates the inability of Arab men to accept the modern Arab woman." Each of the three characters is a facet of female crisis: "Amina feels oppressed by her husband; Aida is divorced and suffering from society's contempt for divorcees; the third, a young Algerian, has fled from her country and is awaiting a passport and visa to go to Europe" (Spaas 2000, 167).

The acclaimed *Satin Rouge* (Red Satin, 2002) by Raja Amari (one of the leading female filmmakers of the 2000 generation) offers a daring depiction of contemporary women who explore sexuality and sexual freedom with multiple male partners as they reject the traditional roles of motherhood and spouse, preferring to live

alone as they follow untraditional careers. The scenario of *Satin Rouge* focuses on "Lilia, a gorgeous 'woman of a certain age,' who has suppressed her own desires all her life. When her daughter falls for a cabaret musician, Lilia goes to the nightclub to confront the man. Once there, however, she finds herself drawn to the shady, tantalizing world of the cabaret, which opens up a whole new universe to her that she is powerless to resist."[26] The 2013 film *Le Challat de Tunis* (a "Challat" is a social satire) by female Tunisian director Kaouther Ben Hania was praised at the twentieth MedFilm Festival in Rome during July 2014. *Le Challat de Tunis* presents a story about women in a world of men who are often backward in their thinking. Kaouther Ben Hania, through this pretend documentary (although many people in it, especially women, are the real protagonists of the film's stories), tells the tale of an elusive person (or persons) who slashed the backsides of eleven women a decade ago. It is unclear what the victims were "guilty" of, given that one of them was wearing traditional Muslim clothing, although others were wearing clothes considered "immodest." In an interview, the filmmaker states: "I wanted to use the story of the slasher to talk about the relationship between men and women in my country." In the film, Ben Hania looks for the so-called challat, by meeting several men who claimed they were the attackers. She discovers along the way that many Tunisians applauded the slasher for his actions. She remarks that "not all Tunisian men are like that, like those who talk in my film, but they certainly are a part of society that needs to be described." *Le Challat*, as one film critic affirms, "has become a case in post-revolution Tunisia, where hope that the strictest traditional mentality will change is strong—though often frustrated."[27]

In Algeria, women are known to have contributed and sacrificed immensely for the freedom of the nation during the war against the French from 1954 to 1962. The famous film *The Battle of Algiers* (1965) remains iconic even today in its depiction of Algerian women on the front lines, planting bombs, hiding arms under their *haïks* (traditional garb), and sacrificing themselves for the FLN's cause. In *A Dying Colonialism* (*L'An cinq de la révolution algérienne*, 1959), Frantz Fanon predicted that the Algerian woman would be liberated during the struggle as she had to "invent new dimensions for her body, new means of muscular control," so that she could "create for herself an attitude of unveiled woman-outside," thus countering the French image of her as cowed, submissive, and unable to exercise her own agency (1965, 59). Fooling the French, as she took up arms to fight, "the Algerian woman [was] at the heart of the combat. Arrested, tortured, raped, shot down, she testifie[d] to the violence of the occupier and to his inhumanity" (Fanon 1965, 66).

Attesting to this revolutionary woman persona, *Rih al-Awras* (Le Vent des Aurès, The Wind from the Aurès, 1966) depicted a woman whose political conscience becomes more and more public and engaged as she searches for her son who has disappeared. This film reflects the period of agrarian reforms in the 1970s, as the nation built itself according to a strict socialist model. This model became the norm for the Boumediene postcolonial state in which women were "considered an active part of the economic process for development" (Discacciati 2000, 37). In *Al-Fahham* (The Charcoal Burner, 1972), a woman rejects "her traditional role as a housewife" in order to become more sociopolitically engaged. This change is "for reasons linked to an economic change" as women in Algeria during the 1970s were encouraged to contribute to the national economy (Discacciati 2000, 37). One of the most famous films of the era, *La Nouba des femmes de Mont Chenoua* (1978), made in a documentary style by celebrated author and member of the Académie française Assia Djebar, took two years to make. The film traces the forgotten voices of women who participated in the struggle for independence in the rural mountain communities of Algeria. Fragmented by numerous stories told from different perspectives, the film leaves audiences perplexed and confused. Its nebulous female accounts mirror the sociopolitical confusion of the postcolonial Algerian nation which, as Réda Bensmaïa notes, is disunited, offering only a "universe that. . . . invites us to contemplate. . . . a world in progress, in gestation. . . . this universe is not a totality that preexists the elements that constitute it; rather, it is an apparently chance juxtaposition or dissemination of dispersed fragments (of [hi]stories and events) in search of a unity to come (or to be created)" (2003, 84). Djebar's 1982 made-for-television film *La Zerda, ou les chants de l'oubli* (Zerda and the Songs of Forgetting) is a sixty-minute documentary that is highly avant-garde and experimental. The film melds colonial images and film footage from the early twentieth century as Algerians narrate the scenes from the perspective of the colonized. Women again are highlighted as Djebar seeks to capture their presence in a history that effaced them.

Films by Algerian women filmmakers have been particularly successful at telling undocumented stories from the recent past, certainly during *les années noires* of the civil war (roughly 1992–2002) and the present. *Algérie, la vie quand même* (Algeria, Life All the Same, Djamila Sahraoui, 1998) documents the filmmaker's return to Kabylia, whereupon she gives the camera to her cousin in order to give a voice to disenfranchised youths. Habiba Djahnine's 2008 film-documentary *Lettre à ma sœur* (Letter to My Sister) tells the story of the filmmaker's sister, Nabila Djahnine,

a feminist civil rights advocate working in Tizi-Ouzou who was killed in 1996 by Islamists during the civil war.

The social discourse of Algerian films changes in the late 1970s–early 1980s to focus on women who rebel against paternal authority in order to pursue individualistic goals of education and emancipation. Films like *Rih al-Janub* (Wind from the South, 1975) by Mohamed Slim Riad and the later *Houria* by Sid Ali Mazif (1986) are viewed as offering positive social commentaries on women wanting to pursue individual growth for themselves as well as economic well-being (Discacciati 2000, 37). Ironically, these emancipatory films furnished different scenarios for women during a decade that was marked by the repressive reform of the Algerian Family Code in 1982, legislation that greatly restricted women's rights in public and domestic space in Algeria (Lazreg 1994, 151).[28] The Family Code was a legislative concession to the rise of Islamic fundamentalism that had been steadily increasing since the late 1970s. Islamists called for strict adherence to *Sharia'a* law as a means to thwart what was perceived as the growing Westernization of the country. As mentioned previously, the 1990s and early 2000s marked a bleak period for Algerian film, which was impacted by the social unrest and civil war raging in the country. For women and their representations on the screen, the situation was no different. "The psychological and physical violence that blocks and forms an obstacle to women's progress in society . . . is often generated by strictly political reasons" (Discacciati 2000, 37), and this is most definitely the case during the Algerian civil war in the 1990s between Islamist groups, notably the FIS (Front Islamique du Salut), and the national government. The civil war's outbreak, following the suspension of the 1992 elections and the declaration of a state of emergency during the following years of bloodshed, killed, by some estimates, 200,000 people (Austin 2009, 119). The films of this period depicted women as victims of repression—social, political, cultural—as the country sank into religious fervor meted out by the fundamentalists. Films such as Mohamed Rachid Benhadj's *Touchia* (1992) and the earlier *Al-qal'a* (The Citadel, 1988) by Mohamed Chouikh reflect the tense climate of the era. Nadir Moknèche's *Viva Laldjérie* (2004), raw and brutal in its depiction of women living on the edge of a psychological abyss caused by the violence reigning in Algeria during the civil war, was one of the first films to be filmed in Algiers after the unrest. Told from a young woman's point of view, Yamina Chouikh's *Rachida* (2003) documents women's resistance to the Islamic fundamentalism wielded by the FIS in in the 1990s. Rachida is the victim of a gunshot to the stomach in the streets of Algiers by members of a local terrorist band because she dares to counter their plans to plant bombs for their

Islamic cause. Her recovery, and then her perseverance as a teacher who refuses to wear the *hijab* (veil), and who is dedicated to instructing girls as she hides in a mountain village after her escape from Algiers, becomes a symbol for justice for many Algerian women who lived through the time (Brahimi 2009, 154–55).

It is most certain that active Maghrebi feminist movements have had a significant influence on the cinemas of Algeria, Morocco, and Tunisia. Women filmmakers such as Moufida Tlatli, Nadia El Fani, and Raja Amari, from Tunisia; Leila Benlyzid and Narjiss Nejjar, both from Morocco; and young, new-to-the scene Algerian filmmaker Sofia Djama, all of whom began working in the mid-1990s, have "traumatized male cineastes" who see the absence of male presence as a "loss of masculine identity" that has, they claim, been a direct result, certainly with respect to Tunisia, "of the power and autonomy of Tunisian women . . . creating cultural trauma" (Brahimi 2009, 59–60).

Although they came relatively late to filmmaking, Moroccan women filmmakers have set their cinematography apart from their contemporaries in Algeria and Tunisia. Yet, at the same time, the "militancy levels in women's films in Morocco," as I have argued elsewhere, differ from those of Algeria and Tunisia (Orlando 2011). In the new millennium, numerous films made by women have been socially engaged and thought-provoking, promoting women's emancipation and free speech, social enfranchisement, and equality. Denise Brahimi explains: "When comparing Moroccan cinema to Algerian [we note] . . . pain is expressed by silence, rather than by screams" (2009, 35). This might be true to a certain extent for films made in the 1980s–1990s, certainly those made by men about women. Mohamed A. Tazi's *Badis* (1989), for example, explores the seaside village Badis, where an old Spanish colonial fortress was founded, as a metaphor for "the way the female protagonists are blocked and fenced in by their surroundings" (Khannous 2010, 455). Not only are women "occupied" by the colonizer, the very space of their surroundings is a prison where patriarchal traditionalism is inherent in life in Badis itself. "The configuration of space in the film shows that women are likely to be spied on and reported to their captors; that they feel oppressed, and if they try to escape, are likely to be caught and punished even more vigorously, and that punishment may even be lethal" (Khannous 2010, 455). As a Moroccan who also endured the waning years of King Hassan II's rule, Tazi's films are clandestine projects, forged in code allowing for a "socio-realist representation of a Morocco in urgent need of change" (Khannous 2010, 460).

Moroccan women in the 2000s, headed by trailblazers Farida Benlyazid (*Women's Wiles*, 1999; *Door to the Sky*, 1988), Farida Bourquia (*Deux femmes sur la route*

[Two Women on the Road], 2007, and *Al jamra* [Pebbles], 1982), and Zakia Tahiri (*Number One*, 2004), made the most films by women in the Arab world. Films such a *Les Yeux secs* (Dry Eyes, 2002) and *L'Amant du Rif* (The Rif Lover, 2012) by Narjiss Nejjar and *L'Enfant endormi* (The Sleeping Child, 2002) by Yasmine Kassari promote the enfranchisement, socially, culturally and, to some extent, politically of women in contemporary Morocco (Orlando 2011, 125). Moroccan women filmmakers of the millennial generation fault male filmmakers for casting women in pessimistic roles as victims of sociocultural mores, misery, and poverty. Films such as Hassan Benjelloun's *Jugement d'une femme* (Woman Judged, 2000) and Jillali Ferhati's *La Plage des enfants perdus* (The Beach of Lost Children, 1991) tend to fit this mold. However, *L'Os de fer* (The Iron Bone, 2007) by Hicham Lasri, one of the newer generation's filmmakers, depicts a young heroine who is sure of herself and is able to stand up and hold her own with the male characters in her entourage (Orlando 2011, 82).

Millennial Films: Global Issues

With the opening up of Maghrebi cinema to the universal, global issues of our time that are important not only to the Maghreb but to the world as a whole, the 2000s have brought a plethora of socially engaged films to the fore. The Moroccan film *Ali Zaoua: Prince de la rue* (Ali Zaoua: Prince of the Street, 1999) by Nabil Ayouch, although revealing the desperate plight of street children and the poor in Casablanca, also has resonance in Brazil, India, and other parts of Africa facing growing numbers of young people who have no family, source of income, or ways to avoid living on the streets. Ayouch's *Les Chevaux de Dieu* (God's Horses, 2013) treats the Islamic radicalization of young men in Morocco who join the jihad launched by al-Qaeda factions in recent years. The film was inspired by Moroccan author and painter Mahi Binebine's novel *Les Étoiles de Sidi Moumen* (The Stars of Sidi Moumen, 2010). The story is about two brothers who grow up in a poor neighborhood in Casablanca and are victims of unemployment, petty crime, and prison. The years from the late 1970s to the early 2000s see the brothers' poverty and disaffection grow ever direr. In the late 1990s, as Islamic radicals infiltrate poorer communities to find converts, the young men are impressed and eventually co-opted by the Islamic rhetoric of the Salafia Jihadia group. By the early 2000s, influenced by the anti-Muslim fervor fueled by the U.S. invasions in Iraq and Afghanistan, the young men of Sidi Moumen have decided to become martyrs for Al Qaeda. On May 16,

2003, five suicide bombers from the group of converted set off several bomb attacks in some of the most populated areas of downtown Casablanca. The attacks, to date the deadliest in Moroccan history, killed forty-five people (twelve suicide bombers and thirty-three victims). Although Ayouch's film speaks specifically about religious radicalism of youth in Morocco, the narrative resonates worldwide in our era of the "War on Terror." The film is particularly poignant in its description of the steps to radicalization that have led young men all over the world to heed the zealous religious calls of al-Qaeda and ISIS (Islamic State in Iraq and Al Sham [the Levant region]) to fight in Afghanistan, Iraq, and Syria.

Universal themes about sexuality and homosexuality have also been debated on Maghrebi screens. As mentioned earlier, the groundbreaking *L'Armée du Salut* (Salvation Army, 2013) debuted in February 2014. The film thus far has been widely shown in theaters across the country, as well as abroad. Taïa's film miraculously skirted censure despite pressure from the PJD Islamic party in Morocco. Although considered a somewhat moderate party, its officials were still outraged by what they deem is a film promoting values that are un-Islamic. Taïa explains in an interview that even though the film was finally shown in theaters, it was not without controversy from the first moments he began shooting. During filming in El-Jadida on the Atlantic coast, Islamist-leaning students organized demonstrations at the university there against the filmmaker and his production staff. Despite this setback, *L'Armée du Salut* was ultimately made and, subsequently, was one of the twenty-two films nominated for the Grand Prix at the Tangiers Film Festival held in February 2014. Such an honor reflects the consistent schizophrenic sociocultural and political reality of a country in transition in an era of rapid globalization. While one of the most progressive nations dedicated to improving human rights in the Arab world, it is still a country that considers homosexuality a crime as prescribed in article 489 of Morocco's penal code, which criminalizes "lewd or unnatural acts with an individual of the same sex." Those condemned of "homosexual acts" can serve up to nine months in prison and suffer significant fines.[29] *L'Armée du Salut* is partly autobiographical. It is a coming-of-age story about a young boy who becomes a man, embracing his homosexuality and the difficulty of expressing his sexual orientation in a society that is very much entrenched in and structured by traditional gendered roles. For many Moroccans, upholding the sociocultural divisions between men and women is imperative. These divisions, though, certainly for younger generations, are becoming increasingly difficult to accept. In an interview, Taïa suggests that his film is not only about social alienation because of sexual orientation but also about

the disenfranchisement of young people who seek to be different by challenging traditional mores. "This film corresponds to my vision about life in Morocco and how this country treats its individuals, whether hetero or homosexual ... [and] in how it strangles their aspirations and their true freedoms."[30]

In 1990s Algeria, certain directors risked their lives to continue their work. However, major filmmaking was virtually halted. In 2000, "not a single film image was shot in Algeria, then a return to filmmaking occurred" that has picked up speed in the years since (Austin 2012, 179). Several films made in the last ten years have reignited film production in Algeria and gleaned international acclaim. Nadir Mokneche's Algerian-French-Belgian coproduction *Viva Laldjérie* (Viva Algeria, 2004) was shot in Algiers and was considered highly controversial for its sexually explicit scenes (Austin 2012, 178). Tariq Teguia's *Rome plutôt que vous* (Rome More Than You, 2006) "was exclusively screened at the Algiers Cinématèque before it was distributed in France," thus supporting the fact that there is an audience for film in the aftermath of the civil war (Austin 2012, 178). In addition to *Rachida* (2003), *Mascarades* (Lyès Salem, 2008), about a couple trying to get married in a village, offers a tongue-in-cheek comedy. A gardener in a socioeconomically depressed village, Mounir (played by Salem) seeks to improve his family's fortune by marrying off his narcoleptic sister, Rym, to a respectful "gentleman." However, Rym has other ideas and dreams of marrying her brother's best friend, Khliffa, her sweetheart who has courted her for years in secret. When Rym realizes her fate, she switches into action and cures her sleepiness in order to marry the man of her dreams. The film is hopeful and symbolically marks a kind of new beginning for Algeria, promoting a message that young people should follow their hearts and not let family, state oppression, or radical Islam pressure them to be something that they do not want to be. The film won "Best Film" at the Washington, D.C., annual "Arab Sights" Film Festival in 2009.

The trauma of returning from France to Algeria in the aftermath of the civil war has also been a meaty subject in recent years. *Bled Number One* (Back Home, 2006) by Rabah Ameur-Zaïmeche denotes one young man's impossibility of leaving behind his French-influenced identity in order to go back home to Algeria. In the end he finds the foreignness of the *home*land impossible to adapt to. French-Algerian Merzak Allouach's *Harragas* (2009) tells the tale of those who are economically forced to embark on dangerous Mediterranean crossings to follow promises of a better life in Spain and France. The film captures the economic desperation of young Maghrebis who have few prospects at home. In the 2000s, the plight of Maghrebi

boat people and, indeed, those who are fleeing the wars of North Africa has been the theme of many works of literature in French, Spanish, and English as well as in film. Allouach's most recent film, *Les Terrasses* (The Rooftops, 2013), was made entirely in Algiers and depicts, in several stories, the everyday lives and hardships of contemporary Algeria from the perspective of the rooftops of the city where young and old, rich and poor, men and women, evil and good, congregate. The film is raw and visceral, but truthful, revealing an Algeria in 2013 that is challenged by the hardships of global economics. These adversities include rising unemployment and the growing gap between the very rich and the very poor, topics that resonate throughout the contemporary developing world.

Amor Hakkar's *La Preuve* (2013), also made in Algeria, tackles contemporary issues of identity, the pressures of family tradition, and lineage. The story centers on Ali, a taxi driver in Algeria, and his wife, Houria. They are childless, and it seems they will never be able to have children. Ali decides to travel to another city in order to be tested for fertility instead of claiming, as is the case in many traditional scenarios, that it is his "wife's fault." However, while away, Fatima, who is pregnant, accuses Ali of being the father of her child. The news drives Houria to leave him. Ali is confronted with either revealing his infertility, an aggression against his manhood, or admitting to the alleged infidelity.

Tunisian films have also captured the international climate, stressed by the first Gulf War of the early 1990s as well as the recent "War on Terror" and global economic challenges resulting in the ever widening gaps between the haves and the have-nots. *La Guerre du Golfe et après . . .* (The Gulf War and After . . . , 1992) by Nouri Bouzid addresses the 1991 Gulf War as "an event [that] translated into a spectacular, worldwide phenomenon by its televisual hyper-mediatization" captured on the television set of an everyday Tunisian family (Kmar 2003, 41). Although set regionally, the film "succeeded in exposing a larger reality, one which gained the film a considerable audience" (Kmar 2003, 41). *Bedwin Hacker* (2003) by Nadia El Fani, like Ayouch's commentary on Islamic radicalism, offers a film that resonates internationally. Made at the height of the U.S.'s "War on Terror" during the George W. Bush years, the film's goal is to broadcast political messages that offer a more sympathetic view of Muslim countries—their desires, needs, and hopes—than the Western stereotypical ones plastered across the Internet. These universally driven topics have made Tunisian film highly accessible on a global scale (Kmar 2003, 41).

Robert Lang's very informative book *New Tunisian Cinema: Allegories of Resistance* (2014) chronicles the development of Tunisian film, focusing in particular on

films made from the 1990s up to the launch of the Arab Spring on January 14, 2011, when President Ben Ali was forced out by Tunisian protestors. "He and his immediate family fled the country of which he had been the dictator for twenty-three years" (Lang 2014, 259). The collapse of the dictator followed the protests stemming from the December 2010 self-immolation of Tarek al-Tayeb Mohamed Bouazizi, a twenty-six-year-old street peddler of fruits and vegetables who had been hassled by the police. Since the first protests, film has helped capture the transitions taking place in the country. Lang underscores the fact that since the 2011 uprising, it is "Tunisian national cinema that . . . has most consistently and effectively articulated for the Tunisian people an image of themselves . . . giving them a coherent sense not only of what they were protesting against in the early months of 2011, but of what kind of Tunisia they feel they deserve and are willing to fight for" (2014, 261). Also of note in these turbulent times is Nadia El Fani's 2011 documentary, *Ni Allah, ni maître!* (Neither Allah, Not Master!, 2011), which films the crowd scenes at the Place du Gouvernement in downtown Tunis as struggles between protesters for supporting secularism and Islamists unfold (Lang 2014, 266). For Lang, El Fani's documentary announces the era of a "new" Tunisian cinema that will have to negotiate "a balance between reclaiming a national identity, reaffirming progressive elements of the indigenous culture, and the struggle to create a democratic, just, and coherently developed society" (2014, 279).

Challenges, Funding, and Ticket Sales: Predictions for the Future

By the 1980s, Maghrebi films were making inroads into the international market. Increasingly, as with films from other countries in Africa, Maghrebi films became more readily available in the United States and Europe, thus fostering cinematographic exchanges that were transatlantic and transnational. As elsewhere in Africa, social awareness, activism, and technology contributed to encouraging a new vision of cinema in Algeria, Morocco, and Tunisia that was more connected to an increasingly social-realist worldview. In all three Maghrebi countries, *cinéastes* began to experiment with themes, challenging the politics and conventions of their respective societies as they sought answers to postcolonial problems such as poverty, illiteracy, corruption, and religious and ethnic tensions. Today, all three countries continue to produce films that are screened for the most part in-country.[31] According to Caillé, 60–85 percent of "films produced totally or in

part by the countries of the Maghreb are not distributed outside the region, with Europe (in particular France) constituting the main partner for co-production and distribution" (2013, 244). Despite hindrances to widespread distribution, increasingly films are making their way beyond Europe to film festivals in Canada and the United States.

With respect to Maghrebi films shown in France and/or made with French funding, Caillé notes former colonial ties as being the main reason for a strong, postcolonial cinematic relationship:

> The stronger presence of Moroccan, Algerian and Tunisian films in France is the combined outcome of a dynamic and international French film culture and a postcolonial relationship with France, that have generated a fairly sustained interest amongst French audiences in Maghrebi films. (2013, 245).[32]

Since 2000, Morocco has led the way in Maghrebi filmmaking, molding its industry to reflect the shifts and transitions in society as well as on the international scene. In Washington, D.C., and New York City, for example, the Moroccan embassy and various government consulates have played a huge role in promoting the country's film industry by funding Moroccan films at festivals across the United States.

Although overall attendance in theaters in Morocco has decreased in the 2000s, several films have been exceedingly popular, rivaling records for North American, European, and Egyptian imports. *Marock* (Leila Marrakchi, 2005), *Casanegra* (Noureddine Lakhmari, 2008), and *Hijab el Hob* (Veils of Love, Aziz Salmy, 2009) have sold more tickets than any other films in Moroccan history. Despite these positive sales, since the 1980s attendance has been regularly falling. Kamal Mouline, with the CCM, indicated that videotaping and rentals significantly reduced theater attendance. In the 1990s, the "invasion" of the satellite dish allowed families to stay at home and watch films from Europe and the Arab world on satellite TV. And in the 2000s, DVDs and downloads from the Internet, as well as theater owners' lack of foresight in changing single-screen movie houses to multiplexes, have contributed to lackluster theater attendance (Orlando 2011, 11–12). Morocco's CCM also cannot seem to establish a viable distribution system that would foster manufacturing DVDs to sell by local distributors. To counter these challenges, Mohamed Zemmouri and Alexandre Piovesan launched "Cinémaghrébia" in 2014. Their site, a kind of YouTube for Morocco, offers Moroccan films, old and recent, such as Hamid Bennani's *Wechma* (1970) and Ahmed Boulane's *Ali Rabea et les*

autres (Ali Rabea and Others, 2001), for streaming. Every five days a new film is streamed on the channel. "We want to promote national cinema in this manner," notes Zimmouri. He stresses that proceeds through advertisement will be given back to the cinema industry.[33]

Since the end of the civil war with the official signing of the armistice with the FIS in 2005, Algerian officials' efforts to encourage interest in cinema have increased. *Rachida* was the first film to spark renewed interest in going to the cinema after the bloody civil war years when the FIS had condemned film and "Algerian cineastes [were] sentenced to death" (Shafik 2007, 43). Between 1997 and 2002, "not a single feature film was made in Algeria. The country [therefore] risked cinematic amnesia" (Austin 2012, 24). As noted above, the dearth of actual cinema locations negatively influenced the industry. Despite some renewed efforts in the last ten years to rebuild two cinemas in Algiers, the general well-being of the industry seems like it will depend more on cyberspace in the coming decades. Internet sites such as Algeria movies and News[34] offer films in streaming mode. It is evident that the Internet will be the savior of both Algeria and Morocco filmmaking in the years to come. The current sociopolitical unrest in Tunisia has made the film industry and the making of films uncertain. The "New Tunisian Cinema," which Lang announces in his work, will come about in an age where not only Tunisia is transforming, but the whole Arab world is as well. Tunisian films have always shown what is "'meant to be' or 'used to be,' before it became a police state under Ben Ali." Tunisian filmmaking during its long history never ceased to inquire and demand tolerance and the right to freedom of speech (Lang 2014, 279). It is hoped that once the current unrest in the wake of Tunisia's Arab Spring subsides, the film industry in the country will once again be vibrant.

Concluding this overview of the cinemas of the Maghreb is no easy task. Yet, if one must make one overarching statement, it would be as follows. Since the 1960s, the films of Algeria, Morocco, and Tunisia have served as a mirror for societies that have been constantly remaking themselves. Like literature, the press, and other forms of media that are invested socioculturally and politically in the dynamics and debates currently taking place in all three countries, cinema is an essential tool to use in the documentation of past history and present realities. The medium of film provides a forum through which to analyze, reflect, and discuss the contemporary issues that are present in society and that contribute to the shaping of the contours of the contemporary Maghreb.

NOTES

1. Michael Willis notes in *Politics and Power in the Maghreb: Algeria, Tunisia and Morocco: from Independence to the Arab Spring* that although the Maghreb has often included Libya and Mauritania, due to the 1989 creation of the Arab Maghreb Union (comprising also Algeria, Morocco, and Tunisia), "their substantially different nature . . . [and] recent political histories and political systems" set them apart from a comparison with the other three nations. Although Mauritania, for example, "shared the experience of French colonialism with Algeria, Tunisia and Morocco . . . its complex and pivotal ethnic politics have no immediate parallel in the rest of the Maghreb" (Willis 2014, 5). Additionally, Libya, also coastal and urban, like Morocco, Algeria, and Tunisia, was more influenced by Italian colonialism than French and thus comparisons from a linguistic standpoint set it apart from the more French-influenced Maghreb (Willis 2014, 5).

 As Patricia Caillé points out in "Cinemas of the Maghreb," "in English the term 'North Africa' refers to a geographical rather than a cultural space. In French it carries strong colonial overtones" (2013, 243). Therefore, when discussing the specific term "the Maghreb," immediately the region is conceptualized in terms of its past colonial French history and its diverse makeup, setting it apart from the rest of the Arab world. This makes the region unique in this sense in every way: linguistically, the Arabic dialects spoken in the three countries are infused with French words and terms; and ethnically, because of the large percentages of Berber populations, which make the region not quite 100 percent Arab.

2. The French granted full independence to Tunisia in an accord that was reached on March 20, 1956, and Habib Bourguiba was chosen prime minister. The rule of the beys was subsequently abolished, and on July 25, 1957, a republic was declared, with Bourguiba as president. In February 1956, Morocco acquired limited home rule. Further negotiations for full independence culminated in the French-Moroccan Agreement signed in Paris on March 2, 1956. King Mohamed V returned to the throne. In Algeria, French president Charles de Gaulle called for the first referendum on the self-determination of Algeria. In April 1961, the "putsch" led by the French military sought to cancel the government's talks with the FLN. Talks reopened with the FLN at Evian in May 1961, and finally a ceasefire was decreed on March 18, 1962. Following the second referendum held in April 1962, 91 percent of the French electorate approved the Evian Accords. On July 1, 1962, some 6 million of a total Algerian electorate of 6.5 million cast their ballots. The vote was nearly unanimous. See Willis (2014).

3. Unfortunately, I cannot claim that the suppression of freedom of speech still doesn't occur. In a recent article entitled "Morocco: The Government's War on Filmmakers" (July

2014), it was reported that young filmmakers, actors, and hip-hop artists were arrested for making edgy films about the crime and violence associated with street gangs in urban settings. Authorities seem to think the filmmakers are supporting the violence and are members of the gangs. In actuality, the filmmakers claim that they are trying to bring urban violence to the attention of everyone so that something will be done. This incident, as note many cultural producers working in the country, proves that there is always a fine line between free speech and prison time that they must worry about crossing (http://artsfreedom.org/?p=7751).

4. See "Tunisia Needs a *Return of the Jedi* to Save Its Film Industry," *The National*, November 28, 2013.

5. *Petit blanc* is a derogatory term for white settlers generally of the lower classes who are often illiterate or have limited schooling. In colonial Algeria, many of these *petits blancs* lived in the poorest areas of Algiers. Albert Camus, the famous Algerian-French author, comes from this milieu, but was able to escape it through education.

6. *Pied-noir*, plural *pieds-noirs* (literally meaning black feet), is a term referring to people of French and other European ancestry who lived in French North Africa, particularly French Algeria, and the French protectorates in Morocco and Tunisia. The name has persisted, characterizing still today the descendants of the former colonizers who left in 1962 to return to France and other parts of Europe because they were no longer welcomed in the Maghreb.

7. La Fémis is public, and the ESEC is private.

8. For more information, see http://felina.pagesperso-orange.fr/doc/alg/guerre_alg.htm.

9. During this same week, it was reported that seventeen men and women in the village of Hammar El-Hes in western Algeria had their throats slit by FIS assassins. This was the third such massacre during the same week of killing. For more information on Matoub's assassination, see Paul Silverstein's article at www.merip.org/mer/mer208/rebels-martyrs.

10. See www.merip.org/mer/mer208/rebels-martyrs.

11. Http://www.ibtimes.com/moroccan-constitutional-reform-berbers-say-battles-just-begun-296479.

12. See http://www.amazighnews.net/films/Fiction.html and http://people.stock.eu.org/yt/People/film-carte-memoire-2013-,nQlHORkI5PO. Both list many Berber Moroccan films.

13. My thanks to Denise Brahimi, who furnished this information in an email, June 3, 2014.

14. In email correspondence with Robert Lang (June 1, 2014), author of *New Tunisian Cinema*, he emphatically states: "In Tunisia, as you know, there are almost no Berbers left, and those who do live there, have been thoroughly Arabized. Off-hand, I can't think of any

scenes—or even characters—that appear in Tunisian cinema to keep alive the *idea* of the Berber presence in the country. . . . There's a folkloric aspect to the handful of Berbers in Djerba and Matmata, and of course the tiny, almost non-existent Berber villages of Douiret and Chenini are exploited for touristic purposes."

15. See http://www.cafebabel.co.uk/culture/article/the-cinema-clubs-of-tunis-art-and-resistance.html.

16. Originally born in Spain, he later immigrated to Argentina in 1950. He then went into exile, living in Paris until 1983, when he returned to Argentina.

17. First published in *Cine: Cultura y Descolonización* (Buenos Aires: Siglo XXI Argentino Editores, 1973). See http://documentaryisneverneutral.com/words/camasgun.html.

18. The specific stages for the indigenous author are explained by Fanon in *The Wretched of the Earth* as: "in the works of native writers the different phases which characterize this evolution we would find spread out before us a panorama on three levels. In the first phase, the native intellectual gives proof that he has assimilated the culture of the occupying power. . . . In the second phase we find the native is disturbed; he decides to remember what he is. . . . Sometimes this literature of just-before-the-battle is dominated by humor and by allegory; but often too it is symptomatic of a period of distress and difficulty. . . . Finally in the third phase, which is called the fighting phase, the native, after having tried to lose himself in the people and with the people, will on the contrary shake the people. . . . he turns himself into an awakener of the people" (1965, 222–23).

19. This information is available through the European Audiovisual Observatory, http://www.obs.coe.int.

20. When I visited Algeria in November 2013, it was relatively calm. Yet I was saddened to see very little taking place in the way of Algerian cinema, particularly in Algiers. The dearth of art houses, cinémathèques, and even small-scale theaters was disheartening. I did see one cinémathèque in the Kabyle mountain town of Tizi-Ouzou. Friends there told me that the cinémathèque does regularly run festivals. However, overall, the state of all things cinema in Algeria at the present time seems somewhat dismal to me.

21. Ouarzazate is something like Hollywood with numerous sets and film sound stages. Films such as *Raiders of the Lost Ark* and *Babel* have been filmed there.

22. For a complete list of films filmed in Morocco in the last fifteen years, see http://www.moroccofilmlocation.com/films-list.htm.

23. Ksikes emphasized this in a February 2007 symposium held by journalists at the annual Salon de Livre in Casablanca, which I attended while living in Morocco in 2007.

24. Kamal Mouline expressed these views in an interview with me on June 1, 2009, at the CCM in Rabat, Morocco.

25. Http://www.library.cornell.edu/colldev/mideast/cinmwmn.htm.

26. Http://www.flicks.com/movie/review/S/Satin_Rouge_(2002).asp.

27. See http://www.lacid.org/les-films-42/le-challat-de-tunis. Many thanks to Tunisian film critic Mohsen Redrissi, who made me aware of this film in a July 7, 2014, email.

28. Marnia Lazreg notes that "the draft of the family code, euphemistically entitled 'personal status,' contained a number of articles that violated the letter and spirit of the 1976 constitution which, in the mind of the new leadership, was already a doomed document, soon to be changed. The . . . code institutionalized the unequal status of women in matters of personal autonomy, divorce, polygamy and work outside the home. . . . Article 32 enjoins a wife 'to obey her husband whom she must consider the head of the household'" (1994, 151).

29. Http://www.hrw.org/news/2007/12/11/morocco-overturn-verdicts-homosexual-conduct.

30. "Le film de Abdellah Taïa sélectionné au festival de Tanger," http://www.tanger-experience.com/?p=7331.

31. One of the biggest challenges facing filmmakers is finding theaters to show their films. The few that exist tend to show films from predominantly Europe and the United States (this is certainly the case in Morocco). Since the 1990s, the Maghreb, as elsewhere in Africa, has witnessed the decline of investment in theaters and cinema houses. Morocco boasts the most theaters (there are only fifty, and these are limited to the large cities of Casablanca, Rabat, Fes, and Marrakech). In Tunisia, the number is a paltry fifteen. In Algeria, a country whose infrastructure and civil society were practically decimated during the civil war of the 1990s–early 2000s, there are hardly any active cinemas, cinémathèques, or art houses in which to show films (Caillé 2013, 246).

32. French interest is, of course, ironic in the context of the massive anti-Maghrebi immigrant sentiment and general backlash against North Africans residing in France that has been escalating since the mid-1990s.

33. Http://telquel-online.com/content/youtube-le-cin%C3%A9ma-marocain-en-streaming.

34. Http://www.sbs.com.au/movies/country/algeria.

FILMOGRAPHY

Abbazi, Mohammed Oumouloud. 2008. *Itto titrit* (Morning Star). Morocco/Amazigh.

Aboulouakar, Mohammed. 1984. *Hadda*. Morocco.

Adi, Yasmina. 2011. *Ici on noie les Algériens* (Here We Drown Algerians). France.

Akdi, Kacem. 1984. *Ce que les vents ont emporté* (Talk Is Easy). Morocco.

Allouache, Merzak. 2002. *L'Autre monde* (The Other World). Algeria.

———. 2005. *Bab-el-Web*. Algeria/France.

———. 2013. *Les Terrasses* (The Rooftops). Algeria/France.

Amari, Raja. 2002. *Satin Rouge* (Red Satin). Tunisia.

Ayouch, Nabil. 1997. *Mektoub* (Destiny). Morocco.

———. 1999. *Ali Zaoua: Prince de la rue* (Ali Zaoua: Prince of the Street). Morocco.

———. 2013. *Les Chevaux de Dieu* (God's Horses). Morocco.

———. 2015. *Much Loved*. Morocco.

Bachir-Chouikh, Yamina. 2003. *Rachida*. Algeria.

Behi, Ridha. 1977. *Shams al-diba* (*Soleil des hyènes*, Hyenas' Sun). Tunisia.

Ben Ammar, Abdellatif. 1974. *Sejnene*. Algeria.

Ben Hania, Kaouther. 2013. *Le Challat de Tunis* (The Challat of Tunis). Tunisia.

Ben Mahmoud, Mahmoud. 2001. *Les Mille et une voix* (A Thousand Voices). Tunisia.

Benamraoui, Mohammed Amin. 2008. *Sellam et Dimitan* (Sellam and Dimitan). Morocco/
 Amazigh.

Benbarka, Souheil. 1972. *Mille et une mains* (A Thousand and One Hands). Morocco.

———. 1974. *La Guerre du pétrole n'aura pas lieu* (The Oil War Will Not Take Place). Morocco.

Bendeddouche, Djamel. 2008. *Arezki l'indigène* (Arezki the Native). Algeria.

Bendeddouche, Ghaouti. 1989. *Hassan Niya*. Algeria.

Benhadj, Mohamed Rachid. 2000. *Mirka*. Algeria.

Benjelloun, Hassan. 2000. *Jugement d'une femme* (Woman Judged). Morocco.

Benlyazid, Farida. 1988. *Door to the Sky*. Morocco.

———. 1999. *Women's Wiles*. Morocco.

Bennani, Hamid. 1970. *Wechma*. Morocco.

Benoit, Pierre. 1932. *L'Atlantide*. Algeria/France.

Bensmaïl, Malek. 2008. *La Chine est encore loin* (China Is Still Far). Algeria.

Bouchareb, Rachid. 2006. *Indigènes* (Days of Glory). Algeria/France.

Boughedir, Ferid. 1970. *La Mort trouble* (Murky Death). Tunisia.

———. 1983. *20 Years of African Cinema*. Tunisia/France.

———. 1987. *Caméra arabe*. Tunisia/France.

———. 1990. *Halfaouine* (Halfaouine: Boy of the Terraces). Tunisia.

———. 1996. *Un Été à la Goulette* (A Summer in La Goulette). Tunisia.

———. 2008. *Villa Jasmine*. Tunisia.

Boughermouh, Abderrahmane. 1996. *La Colline oubliée* (The Forgotten Hill). Algeria.

Boulane, Ahmed. 2001. *Ali Rabea et les autres* (Ali Rabea and Others). Morocco.

Bourquia, Farida. 1982. *Al jamra* (Pebbles). Morocco.

———. 2007. *Deux femmes sur la route* (Two Women on the Road). Morocco.

Bouzid, Nouri. 1968. *Le Rebelle* (The Rebel). Tunisia.

———. 1992. *La Guerre du Golfe et après . . .* (The Gulf War and After . . .). Tunisia.

———. 1997. *Bent Familia* (Tunisiennes/Tunisian Women). Tunisia.

Chabrol, Claude. 1966. *La Ligne de démarcation* (Demarcation Line). France.

———. 1969. *Le Bouché* (The Butcher). France.

Chatta, Nidhal. 2000. *No Man's Love*. Tunisia.

Chikly, Albert Samama. 1922. *Zohra*. Tunisia.

———. 1924. *Chezal, la fille de Carthage* (Chezal, Daughter of Carthage). Tunisia.

Demy, Jacques. 1964. *Les Parapluies de Cherbourg* (The Umbrellas of Cherbourg). France.

Derkaoui, Mustapha. 1985. *Titre provisoire* (Provisionally Titled). Morocco.

Djebar, Assia. 1978. *La Nouba des femmes de Mont Chenoua* (The Nouba of the Women of Mount Chenoua). Algeria.

———. 1982. *La Zerda, ou les chants de l'oubli* (Zerda and the Songs of Forgetting). Algeria.

Duvivier, Julien. 1935. *La Bandera*. Algeria/France.

———. 1937. *Pépé le Moko*. Algeria/France.

El Fani, Nadia. 2002. *Bedwin Hacker*. Tunisia.

Faucon, Philippe. 2005. *La Trahison* (The Betrayal). France.

Ferchiou, Rachid. 1972. *Yusrâ*. Algeria.

Ferhati, Jillali. 1977. *Une Brèche dans le mur* (A Hole in the Wall). Morocco.

———. 1982. *Poupées de Roseau* (Reed Dolls). Morocco.

———. 1991. *La Plage des enfants perdus* (The Beach of Lost Children). Morocco.

Ferroukhi, Ismaïl. 2004. *Le Grand Voyage* (The Long Journey). Morocco/France.

Ghorbal, Khaled. 2001. *Fatma*. Tunisia.

Hadjadj, Belkacem. 1994. *Machaho*. Algeria.

———. 2012. *Fadhma N'Soumer* (*Le Burnous embrasé*, The Burning Burnous). Algeria.

Hakkar, Amor. 2007. *La Maison jaune* (The Yellow House). Algeria.

———. 2014. *La Preuve* (The Proof). Algeria.

Herbiet, Laurent. 2006. *Mon colonel* (My Colonel). France.

Hugon, André. 1937. *Sarati le terrible* (Sarati the Horrible). Algeria/France.

Kassari, Yasmine. 2002. *L'Enfant endormi* (The Sleeping Child). Morocco.

Khechine, Ahmed. 1970. *Sous la pluie d'automne* (Under the Autumn Rain). Algeria.

Khemir, Nacer. 1984. *Les Baliseurs du desert* (The Searchers of the Desert). Tunisia.

Khlifi, Omar. 1966. *Al-Fajr* (The Dawn). Algeria.

———. 1968. *Le Rebelle* (The Rebel). Algeria.

———. 1970. *Les Fellagas* (The Fellagas). Algeria.

———. 1972. *Hurlements* (Screams). Algeria.

Khoja, Liazid, and Rachid Benallal. 2004. *Si Mohand U M'hand, L'Insoumis* (Mr. Mohand U M'hand, Insubordinate). Algeria.

Korbi, Wassim. 2012. *Azul.* Tunisia/Amazigh.

Ktari, Naceur. 1975. *Les Ambassadeurs.* Tunisia.

———. 2000. *Sois mon amie* (Be My Friend). Tunisia.

Lahlou, Nabyl. 2007. *Tabite or Not Tabite.* Morocco.

Lakhdar-Hamina, Mohamed. 1966. *Rih al-awras* (*Le Vent des Aurès,* Wind from the Aurès). Algeria.

———. 1975. *Chronique des années de braise* (Chronicle of the Years of Embers). Algeria.

Laraki, Abdelhaï. 2011. *Les Ailes de l'amour* (Wings of Love). Morocco.

Laskri, Amar. 1998. *Fleur de lotus* (Lotus Flower). Algeria/Vietnam.

Lasri, Hicham. 2007. *L'Os de fer* (The Iron Bone). Morocco.

———. 2008. *Tiphinar.* Morocco/Amazigh.

Le Péron, Serge, and Saïd Smihi. 2005. *J'ai vu tuer Ben Barka* (I Saw Ben Barka Get Killed). Morocco/France.

Malle, Louis. 1957. *Ascenseur pour l'échafaud* (Elevator to the Gallos). France.

———. 1973. *Lacombe Lucien.* France.

Marrakchi, Leila. 2005. *Marock.* Morocco.

———. 2013. *Rock the Casbah.* Morocco.

Mazif, Sid Ali. 1986. *Houria.* Algeria.

Meddour, Azzedine. 1997. *La Montagne de Baya* (Baya's Mountain). Algeria/Amazigh.

Mernich, Mohammed. 2008. *Tamazight oufella.* Morocco/Amazigh.

Moknèche, Nadir. 2004. *Viva Laldjérie.* Algeria.

Mouftakir, Mohamed. 2010. *Pegase* (Pegasus). Morocco.

Mouzaoui, Ali. 2008. *Mimezrane, la fille aux tresses* (Mimezrane, the Girl with Braids). Algeria.

Nejjar, Narjiss. 2002. *Les Yeux secs* (Dry Eyes). Morocco.

———. 2012. *L'Amant du Rif* (The Rif Lover). Morocco.

Noury, Hakim. 1995. *Voleur de rêves* (Thief of Dreams). Morocco.

Ophüls, Marcel. 1969. *Le Chagrin et la Pitié* (Chagrin and Pity). France/Switzerland.

Osfour, Mohamed. 1958. *Le Fils maudit* (The Damned Son). Morocco.

Ouazzani, Fatima Jebli. 1997. *Dans la maison de mon père* (In My Father's House). Morocco.

Ouberka, Yuba. 2013. *Carte mémoire* (Memory Card). Morocco.

Paulin, Jean-Paul. 1936. *L'Esclave blanche* (The White Woman Slave). Algeria/France.

Pontecorvo, Gillo. 1966. *The Battle of Algiers.* Algeria/Italy.

Rachedi, Ahmed. 1965. *L'Aube des damnés* (Dawn of the Damned). Algeria.

———. 1969. *L'Opium et le baton* (Opium and the Stick). Algeria.

Riad, Mohamed Slim. 1975. *Rih al-Janub* (Wind from the South). Algeria.

———. 1982. *Hassan Taxi*. Algeria.

Rouan, Brigitte. 1990. *Outremer* (Outer Sea). Algeria/France.

Roussel, Henry. 1921. *Visages voilés, âmes closes* (Veiled Faces, Closed Souls). Algeria/France.

Sahraoui, Djamila. 1998. *Algérie, la vie quand même* (Algeria, Life All the Same). Algeria.

Salem, Lyès. 2008. *Mascarades*. Algeria.

———. 2015. *L'Oranais* (The Man from Oran). Algeria.

Salmy, Aziz. 2009. *Hijab al-Hob* (Veils of Love). Morocco.

Siri, Florent-Emilio. 2007. *L'Ennemi intime* (Intimate Enemies). France.

Tahiri, Zakia. 2004. *Number One*. Morocco.

Taïa, Abdellah. 2013. *L'Armée du Salut* (Salvation Army). Morocco.

Tasma, Alain. 2006. *Nuit noire, 17 octobre 1961* (Black Night, October 17, 1961). France.

Tazi, Mohamed A. 1989. *Badis*. Morocco.

Tazi, Mohamed A., and Ahmed Mesnaoui. 1968. *Inticar al-hayat* (Conquer to Live). Morocco.

Teguia, Tariq. 2006. *Rome plutôt que vous* (Rome Rather than You). Algeria.

Tlatli, Moufida. 1994. *Les Silences du palais* (Silences of the Palace). Tunisia.

———. 2004. *Nadia et Sarra* (Nadia and Sarra). Tunisia.

Vautier, René. 1959. *Algérie en flames* (Algeria Burning). Algeria/France.

BIBLIOGRAPHY

Armes, Roy. 1987. *Third World Film Making and the West*. Berkeley: University of California Press.

———. 2005. *Postcolonial Images: Studies in North African Film*. Bloomington: Indiana University Press.

———. 2006. *African Filmmaking: North and South of the Sahara*. Edinburgh: Edinburgh University Press.

Austin, Guy. 2009. "'Seeing and Listening from the Site of Trauma': The Algerian War in Contemporary French Cinema." *Yale French Studies* 115:115–25.

———. 2012. *Algerian National Cinema*. Manchester: Manchester University Press.

Barlet, Olivier. 2000. *African Cinemas: Decolonizing the Gaze*. London: Zed Books.

Bensmaïa, Réda. 2003. *Experimental Nations: Or, the Invention of the Maghreb*. Princeton, NJ: Princeton University Press.

Berger, Anne-Emmanuelle. 2002. *Algeria in Others' Languages*. Ithaca, NY: Cornell University Press.

Bouzid, Nouri. 1994. *Ecrans d'Afrique* 9/10:14–23.

Brahimi, Denise. 2009. *50 ans de cinéma maghrébin*. Paris: Minerve.

Caillé, Patricia. 2013. "'Cinemas of the Maghreb': Reflections on the Transnational and Polycentric Dimensions of Regional Cinema." *Studies in French Cinema* 13(3): 241–56.

Carter, Sandra. 2000."Moroccan Cinema, What Cinema?" *Maghreb Review* 25(1–2): 66–97.

———. 2009. *Moroccan Cinema, What Cinema?* Lanham: Lexington Books.Chenchabi, Rachid. 1984. "Le cinéma maghrébin, une dimension francophone." *Franzosisch heute* 15, no. 2: 224–33.

Cheriaa, Tahar. 1973. "Le Cinema en Tunisie." *Africa: Rivista trimestrale di studi e documentazione dell'Instituto italiano per l'Africa e l'Oriente* 28(3): 431–38.

Christiansen, Samantha, and Zachary A. Scarlett, eds. 2013. *The Third World in the Global 1960s*. New York: Berghahn Books.

Diawara, Mathia. 1992. *African Cinema: Politics and Culture*. Bloomington: Indiana University Press.

Dine, Philip. 2002. "(Still) à la recherché de l'Algérie perdu: French Fiction and Film: 1992–2001." *Historical Reflections/Réflexions Historiques* 28(2): 255–75.

Discacciati, Leyla. 2000. "The Image of Women in Algerian and Tunisian Cinema." *ISM Newsletter 5/00*. "Visual Arts," 37.

Ebaum, Max. 2002. *Revolution in the Air: Sixties Radicals Turn to Lenin, Mao and Che*. London: Verso.

El Aissati, Abderrahman. 2001. "Ethnic Identity, Language Shift, and the Amazigh Voice in Morocco and Algeria." *Race, Gender & Class* 8(3): 57–99.

Fanon, Frantz. [1959]. 1965. *L'An V de la révolution algérienne*. Paris: Maspéro. *A Dying Colonialism*. New York: Grove.

———. [1961]. 1965. *Les Damnés de la terre*. Paris: Maspero. *The Wretched of the Earth*. New York: Grove Press.

Gabriel, Teshome. 1989. "Towards a Critical Theory of Third World Films." In *Questions of Third Cinema*, ed. Jim Pines and Paul Willemen, 30–52. London: British Film Institute.

Ghareeb, Shirin. 1997. "An Overview of Arab Cinema." *Critique* (Fall):119–27.

Guneratne, Anthony, and Wimal Dissanayake. 2003. *Rethinking Third Cinema*. New York: Routledge.

Hamil, Mustapha. 2009. "Itineraries of Revival and Ambivalence in Postcolonial North African Cinema: From Benlyazid's 'Door to the Sky' to Moknèche's 'Viva Laldgérie.'" *African Studies Review* 52(3): 73–87.

Humbaraci, Arslan. 1966. *Algeria: A Revolution That Failed, a Political History since 1954*. London: Pall Mall Press.

Kalter, Christoph. 2013. "A Shared Space of Imagination, Communication, and Action:

Perspectives on the History of the 'Third World.'" In *The Third World in the Global 1960s*, ed. Samantha Christiansen and Zachary A. Scarlett, 23–38. New York: Berghahn Books.

Khanna, Ranjana. 2008. *Algeria: Cuts: Women and Representation, 1830 to the Present*. Stanford, CA: Stanford University Press.

Khannous, Touria. 2010. "Themes of Female Imprisonment and Rebellion: M. A. Tazi's Film *Badis*." *Journal of North African Studies* 15(4): 451–63.

Kmar, Kchir Bendana. 2003. "Ideologies of the Nation in Tunisian Cinema." *Journal of North African Studies* 8(1): 35–42.

Lang, Robert. 2014. *New Tunisian Cinema: Allegories of Resistance*. New York: Columbia University Press.

Laroussi, Farid. 2003. "When Francophone Means National: The Case of the Maghreb." *Yale French Studies* 103:81–90.

Lazreg, Marnia. 1994. *The Eloquence of Silence: Algerian Women in Question*. New York: Routledge.

Megherbi, Abdelghani. 1982. *Les Algériens au miroir du cinéma colonial*. Algiers: SNED.

Naficy, Hamid. 2008. "For a Theory of Regional Cinemas: Middle Eastern, North African and Central Asian Cinemas." *Early Popular Visual Culture* 6(2): 97–102.

O'Riley, Michael. 2010. *Cinema in an Age of Terror: North Africa, Victimization, and Colonial History*. Lincoln: University of Nebraska Press.

Orlando, Valérie. 2009. *Francophone Voices of the "New" Morocco in Film and Print: (Re)presenting a Society in Transition*. New York: Palgrave Macmillan.

———. 2011. *Screening Morocco: Contemporary Film in a Changing Society*. Athens: Ohio University Press.

Pines, Jim, and Paul Willemen, eds. 1989. *Questions of Third Cinema*. London: British Film Institute.

Said, Edward. 1979. *Orientalism*. New York: Vintage.

Shafik, Viola. 2007. *Arab Cinema: History and Cultural Identity*. Cairo: American University of Cairo University Press.

Shohat, Ella, and Robert Stam. 1994. *Unthinking Eurocentrism: Multiculturalism and the Media*. New York: Routledge.

Silverstein, Paul. 1998. "Rebels and Martyrs: The Mobilization of Kabyle Society and the Assassination of Lounès Matoub." *Middle East Research and Information Project*. http://www.merip.org/mer/mer208/rebels-martyrs.

Slavin, David. 2001. *Colonial Cinema and Imperial France: 1919–1939*. Baltimore: Johns Hopkins University Press.

Solanas, Fernando, and Octavio Getino. 1973. "Towards a Third World Cinema." *Cine: Cultura y*

Descolonización. Buenos Aires: Siglo XXI Argentino Editores.

Spaas, Lieve. 2000. *The Francophone Film: A Struggle for Identity*. Manchester: Manchester University Press.

Stora, Benjamin. 1994. *Histoire de l'Algérie depuis l'Indépendance*. Paris: La Découverte.

Tebib, Elias. 2000. "Panorama des cinémas maghrébins." *Notre Librairie* 149:60–66.

Trabelsi, Houda. 2011. "Magreb Film Festival Celebrates Amazigh Culture." *Magharebia*. September 12. http://magharebia.com/en_GB/articles/awi/features/2011/09/12/feature-03.

Ukadike, Frank. 1994. *Black African Cinema*. Berkeley: University of California Press.

Willis, Michael J. 2014. *Politics and Power in the Maghreb: Algeria, Tunisia and Morocco from Independence to the Arab Spring*. Oxford: Oxford University Press.

Zaine, Nadia. 2005. "Mustapha Mesnaoui: 'Nous n'avons pas de cinéma marocain.'" *Le Matin*. August 22. http://www.lematin.ma.

Film Production in South Africa: Histories, Practices, Policies

Jacqueline Maingard

W hen the entrepreneur Isidore W. Schlesinger began the steady construction of his cinema empire in South Africa in 1913, which was to last more than four decades, he perceived, and believed in, the economic potential of the new tools of modernity and their ability to attract audiences. His enterprise was first geared to white audiences in the form of lavish feature film productions, as well as shorts and newsreel. By the 1920s, he was already turning his entrepreneurship not only to the service of the state but also the industrial and commercial sectors. Schlesinger's African Film Productions (AFP) played a major role in producing films aimed at recruiting Africans to work on the mines that were seen by many thousands across the rural reserves within South Africa and in other recruiting territories across its borders. Schlesinger's was a conservative engagement with the potential of cinema, so that following his death in 1949, the Schlesinger Organization, under the leadership of his son, John, almost missed the opportunity for attracting black audiences to entertainment film that independent filmmakers were exploiting. A cluster of films focusing on black experience produced independently of AFP subsequently in the late 1940s and early 1950s resonated powerfully with black audiences. AFP produced two films that were geared toward black audiences, but by then its main production focus was in the support of the

apartheid state. Schlesinger's films had supported successive governments across the first half of the twentieth century.

By the late 1950s, Twentieth-Century Fox (Fox) had purchased the film-related assets of the Schlesinger Organization. *Come Back, Africa*, a searing exposé of apartheid that was produced in 1959, was banned and not seen in South Africa until 1982. Subsequently the increasingly repressive apartheid hegemony in the 1960s, coupled with the banning of political organizations and the banning and imprisonment of political leaders, including Nelson Mandela, forced many black cultural artists and filmmakers into exile. Apart from a government-sponsored, propagandistic form of film production aimed at black audiences, produced mostly by white-owned companies, and a few critical anti-apartheid films made by filmmakers in exile or within the country, there were no further political, resistance films produced before the late 1970s and 1980s. With the shifting political dynamics of the late 1980s and the formation of the Film and Allied Workers Organisation (FAWO), there were moves to consider how the media landscape of a post-apartheid South Africa might look. Ultimately, these debates fed into processes toward the first democratic elections in 1994, particularly in campaigns to "free the airwaves," which helped to ensure free and fair elections. Subsequently, the post-apartheid government has created strategies toward advancing economic growth and increased employment opportunities while simultaneously focusing on nation-building and social cohesion. Film inevitably has a role in all of these goals, but there are concerns as to the extent to which the rights of all to engage in the arts and culture might be constricted by these overarching government-determined aims. At the same time, government has a responsibility to shift historical legacies of advantage and disadvantage and to extend potential funding opportunities for creative enterprise to all, as well as to ensure the creation of local product for local audiences. These concerns form the backdrop to the discussion that follows.

The chapter is presented in two parts: the first focuses on film production histories and practices, the second on policies. Practices and policies go hand in hand, both in the widest frameworks where hegemonies dictate the horizons of possibility for everyday life and in specific legal formulations that produce opportunities and challenges, inclusions, and exclusions, for cultural and creative expressions. Tracing lines across histories, practices, and policies, the chapter extends an overview of film production in South Africa from its early beginnings in the late 1890s to recent imbrications of production practices and policies in the second decade of the twenty-first century. A shadow runs through the chapter in the form of questions of

audience. While opportunities for watching films are arguably greater in the digital era, experiences and pleasures of going to the cinema are more limited, if present at all. While making local films is paramount, ensuring cinema audiences is surely the necessary B-side, without which the dreams and dramas of local filmmakers will fail to create resonance where they matter most.

Film Production: Histories and Practices

In 1898 and 1899, Edgar Hyman produced the first moving images in South Africa, with a camera purchased from the Warwick Trading Company in England. These included scenes of Johannesburg and activities on the mines, with such titles as *A Rickshaw Ride in Commissioner Street* (1898/99) and *The Cyanide Plant on the Crown Deep* (1898/99) (Gutsche 1972, 31). Hyman was also one of eight British cameramen who filmed scenes of the South African War (also known as the Anglo-Boer War), 1899–1902. He was managing director of the Empire Theatres Company from 1895 until the entrepreneurial Schlesinger saved it from liquidation in 1913, when he purchased the company, as well as the Amalgamated Theatres Trust, and formed the African Theatres Trust.

Schlesinger was the prime mover in South Africa's cinema development through to his death in 1949. He was a first-generation American with Jewish-Hungarian parents and traveled to South Africa in 1894 from the United States. He built his entrepreneurship primarily on insurance but also acquired land through his African Realty Trust, and developed a top exporting farm, Zebediela Citrus Estate, where he is buried. Of his ambitious building acquisitions, two are notable examples: the Carlton Hotel in central Johannesburg purchased in 1922, which he extended with three additional stories, and the Polana Hotel in then Lourenço Marques (now Maputo) in Mozambique, which he purchased in 1936. His operations in the cinema industry were based on vertical integration, owning the means of production, distribution, and exhibition like his Hollywood studio counterparts. He thus created a monopoly over the cinema industry starting from 1913, when he first formed African Theatres Trust and subsequently African Films Trust, which took over the production of the newsreel *African Mirror*.

In 1915, Schlesinger bought land north of Johannesburg center, called the area Killarney, and built the Killarney Film Studios. He established African Film Productions (AFP) at the same time, which continued the weekly production of *African*

Mirror until 1956, "the world's longest running commercial newsreel" (Sandon 2013, 661). Schlesinger declared that he would produce "South African films for South African audiences" (Gutsche 1972, 311), emulating Prime Minister Barry Hertzog's call, "South Africa for South Africans," when he formed the National Party in 1914 (Sandon 2013, 674). The coincidence of Schlesinger's phrase echoing that of the prime minister of the time provides a clue to his continuing economic success. He astutely read the political allegiances of those in government at any given point and proffered cinematic representations to match their ideological interests.

Schlesinger attempted to position himself not only as a major investor in South African cinema but also as an influential player in the global sphere. His early successes in film production can be attributed partly to the invitations he extended to international film directors, actors, and actresses to join AFP. These included the directors Lorimer Johnston and Harold M. Shaw, and the actresses Mabel May and Edna Flugrath. May was to become Schlesinger's wife, and Flugrath was Shaw's life partner, whom he later married. In the period from 1913 to ca. 1921, AFP produced a range of short and feature-length fiction films, including melodramas and historical epics. A key example is *De Voortrekkers* (1916), which Shaw directed, based on the "Great Trek" and the murder of the Zulu chief Dingane in 1838. It attained cult status in Afrikaner circles, where it was screened annually on December 16 to celebrate the *voortrekkers'* defeat of the amaZulu on that day in what became known as the "Battle of Blood River" (the Ncome River). *The Symbol of Sacrifice* (1918), AFP's next epic, based on the 1879 war between the British and the amaZulu, was also meant to be directed by Shaw. He and Schlesinger had an "acrimonious personal dispute" (Parsons 2009), however, and Shaw departed for Cape Town in 1917, where he directed *The Rose of Rhodesia* (1918), and exhibited it through A. M. Fisher and sons, rivals of Schlesinger's African Theatres Trust.[1] Schlesinger's ambitions for feature film production were not wholly successful, and AFP's outputs became more varied, particularly from the 1920s, incorporating other types of film production for the state and the commercial and industrial sectors.

Despite his declaration about producing films for South African audiences in 1914, Schlesinger's projected audiences were not particularly inclusive of all South Africans in that AFP's film productions, particularly before 1920, were aimed primarily at white audiences. Nevertheless, large African audiences amounting to "tens of thousands" (Reynolds 2007, 144) were subsequently to see the instructional and propaganda films that AFP produced from the 1920s for the Native Recruiting

Corporation, an agent of the Chamber of Mines. One of AFP's major documentary film projects for this purpose was initially titled *Native Life in the Cape Province*, and subsequently changed to *From Red Blanket to Civilization* (1925). It was filmed under the direction of Henry Taberer, who also wrote the screenplay and was the adviser on African labor to the Native Recruiting Corporation. Another key recruitment film was subsequently developed, also under Taberer's direction, in response to proposals that the Chamber of Mines elicited from superintendents of so-called Native Locations in the rural reserves as to what should be included. A core segment focused on the mines was filmed, nicknamed *The Kernel* and completed in 1931. Specific regional sequences, sounded in regional languages, were added, some of which were only completed in the mid-1930s. The regional sequences were produced as a response to the perceived need for different ethnic and linguistic audiences to identify with footage screened (Reynolds 2007, 2015). These recruitment films were put to several uses, however, in that they were not only screened locally for Africans but also internationally, as part of Schlesinger's moves to screen AFP's films in the international sphere and aimed to some degree at attracting tourists and white settlers (Maingard 2014, 29).

In the early 1930s, AFP produced small-scale films in Afrikaans, such as *Moeder-tjie* (1931) and *Sarie Marais* (1931).[2] Surpassing both these earlier projects, however, and also to a degree *De Voortrekkers*, Schlesinger produced *They Built a Nation/Bou van 'n Nasie* in 1938. It was commissioned by Minister of Railways and Harbours Oswald Pirow, and was timed to coincide with the Afrikaner centenary celebrations of the 1838 trek and the *voortrekkers'* battle with the amaZulu, memorialized in the unveiling of the Voortrekker Monument, near Pretoria, in 1938. Filmed in both an English and Afrikaans version, this was a large-scale historical tribute to Afrikanerdom, as well as to the Union of 1910, in which the white political interests of Afrikaners and the British had conjoined. This is most clearly signified in the film's full-frame close-up of the British and Afrikaner representatives shaking hands at the point when the Union is established.[3] AFP continued to produce government-related documentaries in subsequent years for the Smuts government, which supported Britain and the Allied Forces in World War II. Following the whites-only elections in 1948, in the 1950s AFP was producing propaganda films for the apartheid government's State Information Services. Schlesinger's savvy engagements with those in government as well as others in civic society, whether pro-Afrikaner or pro-British, kept AFP in favor for the duration of Schlesinger's decades-long monopoly over film production in South Africa.

At the end of the 1940s and early 1950s, a clutch of films about black experience was produced independently of AFP: *African Jim* (aka *Jim Comes to Joburg*, 1949), *The Magic Garden* (1951), and *Cry, the Beloved Country* (1951). These proved to be successful with black audiences. Donald Swanson, a British, colonial filmmaker attached to Gaumont-British International in the 1940s, directed both *African Jim* and *The Magic Garden*, drawing on independent funding and showcasing rising black talents, particularly in jazz circles. These included Dolly Rathebe, who was to become a major star, in her first film appearance, as well as the popular African Inkspots and the talented Sam Maile on the piano. Rathebe also appeared in *The Magic Garden*. These stars were an important part of the films' appeal for black audiences, who recognized, and identified with, the star acts. Zoltan Korda, Hungarian-born and British-based, directed *Cry, the Beloved Country*, the eponymous adaptation of Alan Paton's 1948 novel. London Films, which Korda's brother, Alexander, had established in the 1930s, produced it.[4] Not to be outdone by these productions and, more particularly, to exploit the economic opportunity of attracting black cinema audiences, AFP produced two films that showcased black South African music in the same period.

The first of these films, *Zonk!* (1950), is presented in the format of a filmed variety concert, including a compère between acts, with insertions of occasional filmed, illustrative sequences. The film's title is taken from the magazine, *Zonk! African People's Pictorial*, which a former military lieutenant, Ike Brooks, established in 1949, and which was aimed at African readers. Brooks had previously led an ensemble of African musicians that had entertained troops during World War II. AFP and the film's director, Hyman Kirstein, clearly worked with Brooks to produce the film. It overtly celebrates AFP and the magazine, opening with the ensemble singing a song that is specially composed for the film and includes the lyrics: "Hats off to African Film Productions/Cheers to that wonderful *Zonk!*." There are also references to *Zonk!* in other numbers (Maingard 2007, 91–92). Kirstein was well established within AFP. He had edited *They Built a Nation/Die Bou van 'n Nasie* and had also directed the Afrikaans musical *Kom Saam Vanaand* (*Come Along Tonight*, 1949) for AFP. He was to produce and direct several further films in South Africa between the 1950s and early 1970s.

The second film that AFP produced for African audiences featuring black South African music of the period, *Song of Africa* (1951), is also in a variety concert format, but this time it constructs a plot about a young man, Daniel Mkhize, who creates a brass band in his rural village in order to enter a competition in Johannesburg.

Having won the competition, and then performed in a concert with other local talents, Daniel returns home to his village. The film's portrayal of Daniel's village draws on colonial, cinematic tropes in representing traditional African life, while at the same time reproducing the notion that the migrant would be happy to return to the reserves, no matter the attractions of the city.[5] Emil Nofal, who directed *Song of Africa*, was also strongly associated with AFP and had edited *Zonk!*. Nofal was to become a significant figure in South African cinema circles, as a writer, director, and producer of many further films. One of his notable later collaborations was with Jans Rautenbach, an Afrikaans film director, for whom Nofal wrote the screenplay *Katrina* (1969). This was based on Basil Warner's play *Try for White* (1959), controversially depicting an interracial relationship, which was illegal under apartheid law.[6] Nofal had also written the screenplays for two other films that Rautenbach directed, *Wild Season* (1967) and *Die Kandidaat* (*The Candidate*, 1968). All three of these films drew the attention of the censors and were not passed by the Publications Control Board (aka the Censorship Board) without cuts.

In the 1950s, several major shifts occurred in cinema's production, distribution, and exhibition, and the state intervened more forcefully for the first time in funding independent South African film production. Schlesinger had died in 1949, leaving his estate to his son, John. In 1955, the president of Fox, Spyros Skouras, brokered the purchase of the major cinema-related holdings of the Schlesinger Organization, and the deal was completed in 1956. The organization's production arm had virtually come to an end, with a few exceptions, primarily in documentary film. Under new ownership, the production of fiction film ceased, and Fox's efforts were focused solely on the distribution and exhibition of Hollywood product. There were continuities, however, between fiction film production under the umbrella of AFP and subsequent independent production, involving some of those who had worked for AFP in preceding decades. Indeed, the network of film-related personnel who had cut their teeth in AFP extended well beyond the life of the Schlesinger Organization into film production in South Africa through the 1960s and 1970s. In 1969, Fox was bought out by Afrikaner business interests through Sanlam, an Afrikaner insurance company that merged the already-established Ster Films with Sanlam's newly acquired assets to form Ster-Kinekor. This company, now owned by Primedia, is still one of two major film exhibitors in South Africa, the other being Nu-Metro.[7]

In 1956, the government created a film subsidy scheme. This was in response to filmmakers who had formed the Motion Picture Producers Association, chaired by filmmaker Jamie Uys, in order to negotiate with the government on plans to

develop a scheme (Tomaselli 1989, 32). Film production in the 1950s was primarily the domain of independent filmmakers. Jamie Uys, who was the most prolific at the time, produced many films mostly in the Afrikaans language. He was later to achieve international commercial success with *The Gods Must Be Crazy* (1980), which Fox distributed in the United States. After 1969, Afrikaans-language films received higher subsidy funding than English-language films (Maingard 2007, 126), from which Uys and others benefited. This was tied to the state's propaganda campaign, with a slate of Afrikaans-language films subsequently released, some of which demonized African guerrilla fighters—for example, *Kaptein Caprivi* (*Captain Caprivi*, 1972) and *Aanslag op Kariba* (*Attack on Kariba*, 1973) (Maingard 2007, 134). There was also a new version of *De Voortrekkers*, in the form of *Die Voortrekkers* (1973), which David Millin, another AFP stalwart, directed, and for which Swanson (who had directed *African Jim* and *The Magic Garden*) wrote the screenplay (Maingard 2007, 134; 2013). It played on contemporary perceptions of *swart gevaar* (literally, "black danger" or "black threat"). This fed into the apartheid government's propaganda campaign against the military wings of banned political organizations and acts of resistance against apartheid that were repressed under the wide powers of coercion and control incorporated into the Terrorism Act of 1967.

By comparison with the opportunities for white filmmakers developing in the 1950s, there were none for black filmmakers as such, and only occasional, albeit historically significant, opportunities for involvement in film production. One of these was through Korda's *Cry, the Beloved Country*, in which Lionel Ngakane performs as the young Absolom, who leaves his rural home in the (then) Natal region to find work in Johannesburg, where he falls foul of the law. Caught unawares while burgling a house in a white suburb, he murders the owner, a respected white man in the city, and is subsequently sentenced to death. Meanwhile his father, Reverend Stephen Kumalo (Canada Lee), leaves home to try to find Absolom in the city. The tragedy of Absolom's demise is contextualized in the film's social realism that creates a mise-en-scène of urban slumyards, and thus frames the young, job-seeking Absolom as a victim of social circumstance. Finally, the Reverend returns to his rural homestead, where he hopes to build a church, thus proffering a Christian solution to the vice and iniquity of the urban space. Ngakane left South Africa for the United Kingdom, where he made two short films, the documentary *Vukani!/Awake!* (1962) and the fictional short *Jemima and Johnny* (1966) (Maingard 2007, 123). He was later to play a significant role in building African cinema as a founding member of the Fédération Panafricaine des Cinéastes (FEPACI) and as

its first southern regional secretary, when he returned to South Africa after the first democratic elections in 1994 (Maingard 2007, 6). His contribution to African and South African film was immense, along with his support for aspirant filmmakers, honored by the establishment of a bursary fund in his name when he died in 2003.

The 1950s saw the hegemonic entrenchment of apartheid, following the government's rapid promulgation of apartheid legislation after coming to power in 1948. In response, the African National Congress (ANC) inaugurated the Defiance Campaign in 1952 and unveiled the Freedom Charter in 1955, whose principles were later enshrined in the new constitution following the first democratic elections in 1994. By 1956, 157 leaders and others aligned with the ANC had been detained and put on trial for treason, from which they were all acquitted. In this context of the late 1950s, a further opportunity for black involvement in film production occurred, represented by the docudrama *Come Back, Africa*, directed by the American documentary filmmaker Lionel Rogosin. It was cowritten by the *Drum* journalists Bloke (William) Modisane and Lewis Nkosi, who also appear in the film.[8] Miriam Makeba, celebrated African singer, makes her first cinematic appearance in this film.

Come Back, Africa is set at the time of Sophiatown's demolition under the Group Areas Act (promulgated in 1950, designating specific geographical areas to specific population "groups" categorized by race), which acts as a powerful backdrop, in the style of documentary realism. The city also features powerfully, with several images interspersed through the film of buildings and streets, people rushing to and from work from trains and the main city station, and crowds watching musicians, particularly young pennywhistlers. The film has a fictionalized plot centered around the key character, Zachariah (Zacharia Mgabi), who has moved from (then) Zululand to Johannesburg to seek work, and is subsequently joined by his wife, Vinah (Vinah Bendile), and two small children, including his son, Rams. Zachariah moves through different jobs, and Vinah gets employment as a domestic servant in a white suburb, while Rams plays on the street with pennywhistling boys. Shot within Sophiatown, the fictional elements allow audiences to experience a sense of everyday life under threat of destruction through location shooting in the style of documentary, while tracking the personal story of one family's painful experience of apartheid in the city in the late 1950s.

Over and above these features of the film, its centerpiece is a scene in a local *shebeen* (speakeasy), where the film's cowriters, Modisane and Nkosi, get together with fellow *Drum* journalist Can Themba and another friend, Morris Hugh. Zachariah arrives with a bloody face after a local gangster, Marumu, has picked a fight

with him. This leads to the tragic events of the film's fictional plot, when Marumu murders Vinah, and Zachariah finds her dead. But earlier, in the *shebeen* sequence, the conversation gets going around Marumu and the fact that he himself is a social victim. Themba is particularly vociferous, his perspective strengthened by the slightly high-angled, close-up shot that gives prominence to his facial expressions and the emphasis of his words: "We live in a world of violence" he opines, "and violence has become such an important part that people judge us according to our racial characteristics."

The conversation then segues through a discussion of the Group Areas Act and into a detailed critique of the liberal point of view represented in Paton's *Cry, the Beloved Country*. Modisane performs his impression of the Reverend Kumalo character, while simultaneously describing him as the "slimy, sickly Reverend Kumalo [who] came to town and said 'yes baas' to everyone, 'yes baas.'" Nkosi continues: "The chap never grew up, he went back to the country, still the old Reverend gentleman who thinks the world of the whites. He's still boss and what does he [the Reverend] do when he gets back to the country, he builds a church." This, says Modisane, is "the moral of the story."

At this point Nkosi extends his view of "the liberal" as embodied by Paton:

> [He] just doesn't want a grown up African. He wants the African he can sort of patronize, pat on his head you see, and tell him that with just a little bit of luck you see, someday you'll be a grown up man, fully civilized. He wants the African from the country, from his natural environment, unspoiled.

Come Back, Africa proves, as Ntongela Masilela (2003) asserts, to be a "landmark" in the history of the cinema in South Africa. He quotes Nkosi's comments in the documentary *In Darkest Hollywood* (1993), where he states that in the *shebeen* scene, "there was still a tremendous feeling of hope that it was possible to change South Africa through a passive resistance, and through the moral force of one's argument." In other words, Nkosi and Modisane believed that "rationalism . . . could overcome irrational practices and obstacles" (Masilela 2003, 27), in a nutshell, apartheid. They were part of the "last intellectual generation of New Africanism" (Masilela 2003, 27), represented by the Sophiatown Renaissance, in which they were immersed as writers and critics. New Africanism dates back to the 1880s and the African intelligentsia who were influenced by the New Negro movement in the United States and committed to the "forging" of modernity (Masilela 2003, 16).

In the *shebeen* scene in *Come Back, Africa,* where Nkosi derides the liberal point of view, he is not only using film as a "pedagogical instrument," Masilela suggests, but he is also asserting the centrality of modernity to the survival of Africans, and "film was clearly a part of that survival" (Masilela 2003, 28).

The film was banned. Modisane, Nkosi, and Themba left South Africa shortly afterward and went into exile, Modisane and Nkosi to Europe and the United States, and Themba to Swaziland. *Come Back, Africa* was seen for the first time in South Africa only in 1982, when it was screened in the Umlazi township, outside Durban, under the auspices of the Durban Film Festival (Maingard 2014, 46).[9]

In 1961, in a protest known as the "Sharpeville Massacre," police shot and killed sixty-nine people and seriously wounded 180 others, most of them in the back as they were trying to flee. They were protesting against the "pass laws," which forced Africans to carry an identity book ("passbook") that included permission to work in the city under the apartheid government's notorious "influx control" legislation. Both the Pan Africanist Congress, whose leaders had called the protest action, and the ANC were banned and went "underground." Each developed an underground military wing, Poqo (Pure) and Umkhonto we Sizwe (Spear of the Nation), respectively.

Nelson Mandela and eighteen others were arrested in 1963, ten of whom, including Mandela, were charged with sabotage. Mandela and most of the others were sentenced to life imprisonment. It was to be twenty-seven years before Mandela would be unconditionally released, after which he was elected president of the ANC and became the first president of the democratically elected government in 1994. South Africa had left the Commonwealth and had become a republic in May 1961. The 1960s was a decade of unchecked hegemonic control and violent repression. The repressive conditions of life under apartheid, including bannings and detentions, as well as deaths in detention, forced many black cultural artists and activists into exile. This had a severe impact on the production of films that related to black experience under apartheid and that protested against apartheid.

Apart from the two Ngakane films in the 1960s, there were three films that Nana Mahomo, a member of the banned Pan Africanist Congress, produced in the 1970s while living in exile: *Phela Ndaba/End of the Dialogue* (1970), *The Dumping Grounds* (1973), and *Last Grave at Dimbaza* (1974). All are scathing critiques of apartheid, its policies, and their dire consequences on African life, including the exceptionally high African infant mortality rate that the policy of "separate development" produced, particularly in the formation of racially and ethnically designed "bantustans."

Meanwhile within South Africa, independent, white filmmakers produced adaptations of the stories of the anti-apartheid writer Nadine Gordimer, who was awarded the Nobel Prize for Literature in 1991, and renowned playwright, Athol Fugard. The first of these is the feature *Dilemma* (1962) that a Danish filmmaker, Henning Carlsen, adapted from Gordimer's *A World of Strangers* (1958). In 1973, Ross Devenish directed the eponymous adaptation of Fugard's 1969 play, *Boesman and Lena*. He directed a further Fugard adaptation in 1980, *Marigolds in August*. A series of short films based on Gordimer's short stories was produced, *Six Feet of the Country* (1977), and *A Chip of Glass Ruby* (also directed by Devenish); *Good Climate, Friendly Inhabitants*; *City Lovers*; and *Country Lovers*, all in 1982. All these films focus on issues of politics and race.

In 1972–1973, the government changed the subsidy scheme to include what became known as "B-films," produced specifically for black audiences, which provided a form of anodyne, if at times, violent and gendered, film entertainment. These B-films are primarily located in township locales, denuded of political or historical contexts, and contained within an apparently "black" world that operates independently of the wider society governed by apartheid. While there are generic variances, in a broad sense they might be seen as films that followed the American "blaxploitation" model of the 1970s. Produced by white filmmakers or white-owned companies, they also sometimes incorporated black creatives in executive roles, one of whom was Simon Sabela, who directed several films in isiXhosa and isiZulu, under the B-scheme. These films were shown primarily in black residential areas, both urban and rural, in often roughly constituted spaces for the purpose. These makeshift arrangements also made possible alleged fraudulent applications for subsidies on the basis of tickets sold, without adequate records being kept or supplied. The government also channeled funds through its Department of Information to one of the key producers of these B-films, Heyns Films, specifically for the purpose of creating propagandistic imagery, which was revealed in what became known as the "Info Scandal" (Maingard 2007, 129).[10]

The 1970s also saw the rise of the Black Consciousness Movement, and related organizations such as Black Community Programmes, under the leadership of Stephen Bantu Biko, who was assassinated while in detention in 1977. In 1976, young black scholars in Soweto had protested en masse against Afrikaans as the medium of their school instruction. Police and the military had responded with characteristic brutality, and many of these young protestors were fatally shot or wounded. Despite ongoing repression, this sparked massive political protests in

many parts of the country that were to continue through the late 1970s and 1980s, when trade unions and civic organizations formed broad coalitions.

The Federation of South African Trade Unions was established in 1981, followed by the larger Congress of South African Trade Unions in 1985, allied with the Communist Party of South Africa and the ANC. The United Democratic Front, comprised of anti-apartheid organizations, was established in 1983. The Second Carnegie Commission of Inquiry into Poverty in South Africa in the early 1980s provided an opportunity for anti-apartheid filmmakers to produce documentaries, one of which was *Mayfair* (1984), about the relocation of residents under the Group Areas Act.[11] Anti-apartheid documentary photographers and filmmakers were documenting events through both still and moving images and formed the organizations Afrascope and Afrapix, in 1982 and 1983, respectively. There were other community-based programs starting up, such as the Community Video Education Trust in Cape Town, following the visit of members of the Challenge for Change program of the Canadian Film Board in the 1970s. It was thus not until the late 1970s and 1980s that political and community-based resistance films began to be produced internally (as against those produced by black filmmakers in exile; and the films produced within the country, adapting Gordimer's and Fugard's plays). These beginnings led to an anti-apartheid documentary "movement" (Maingard 1995) that had various arms. One of these was Video News Services (VNS), which created documentaries for the worker movement, predominantly represented by the Congress of South African Trade Unions. Another was Free Filmmakers, a collective of broadly based anti-apartheid filmmakers.

In fiction film, Darrel Roodt, a prolific filmmaker over several decades, cut his teeth as a director in the early 1980s on B-films in isiXhosa and isiZulu, which he followed with a powerful anti-apartheid film, *Place of Weeping* (1987). He has since made many more films, some with a critical representation of South African society. In the late 1980s, however, it was Oliver Schmitz's groundbreaking, overtly political film, *Mapantsula* (1988), that epitomized the anti-apartheid "struggle" for many South Africans. In the years between *Come Back, Africa* and *Mapantsula*, as we have seen, the repressive apartheid regime banned African political organizations, and their leaders were exiled or imprisoned. Apart from the handful of films made by Ngakane and Mahomo, and films by white, independent filmmakers, some of which extended anti-apartheid themes, as well as the growing documentary film "movement" in the 1980s, there was no further direct engagement of Africans in political, feature filmmaking until *Mapantsula*.[12]

The screenplay was cowritten by the film's director, Oliver Schmitz, with Thomas Mogotlane, who also performs the role of the key character, Panic, a township gangster of sorts. Mogotlane drew on his real-life experiences of township gangsterism in writing the script. Masilela describes *Mapantsula* as a "landmark" in the history of the cinema of South Africa, where, like *Come Back, Africa*, "Africans themselves played a major role in writing the screenplay" (2003, 26). Schmitz, meanwhile, relied on the gangster theme to have the film approved for a state subsidy. In doing so, he was ingeniously, and expediently, drawing a parallel between his film and the gangster fare supported by the government's subsidization of B-films that allocated funds to films produced for African audiences. He also tapped into audiences' fascination with the individual hero/antihero, most often represented in the gangster character, and popularized by Hollywood films. A number of key films produced in South Africa by South Africans testify to the abiding attractions of cinematic tales of the socially victimized gangster figure, who wreaks a violent path through life but ultimately chooses for the common good. In *Mapantsula*, that "common good" was the anti-apartheid "struggle."

The film's narrative structure knits together the story of a small-time township gangster and his torture in prison, with big-time politics. The plot revolves around Panic, who, through an uncanny set of circumstances, is detained, imprisoned, and tortured, the end game being his signature on a document naming a young activist, Duma (Peter Sephuma), as a "terrorist." His ultimate refusal to comply celebrates the anti-apartheid stance of an unemployed, streetwise township dweller who refutes all forms of authority, and thus, to a large degree, represents one kind of township "everyman." The Publications Control Board immediately "banned" the film. Thousands of people saw it, however, in that multiple VHS copies found their way to audiences across the country, including large events, such as community and trade union meetings, as well as small-group viewings in neighborhoods and private homes. Given the film's content and Schmitz's connections in the anti-apartheid video movement, as well as the film's availability on video for trade unions and community-based organizations to hire through the anti-apartheid Film Resource Unit, it was inevitable that it would be distributed widely despite being banned.

Schmitz also worked with the VNS collective, and he and Brian Tilley subsequently produced both documentary and fiction films, including the documentary *Fruits of Defiance* (1990) set in Cape Town, during a workers' stay-away, that captures police violence from within the interior of a "colored" community with a hidden camera,[13] and a fiction film, *The Line* (1994) (aka *In a Time of Violence*), for which

Channel 4 (UK) provided the funding. This was initially a three-part television series, set in a violent Johannesburg, seen through the eyes of residents of one apartment block, and depicted in a wider set of spaces, including the city center and Soweto. The film mirrors the reign of terror wreaked by supporters of the Inkatha Freedom Party in random killings in the early 1990s aimed at destabilizing progress toward the first democratic elections.[14]

After the transition to democracy, Schmitz directed a further film on the subject of young men and violence, *Hijack Stories* (2000), which cannily incorporates reflexive references to *Mapantsula*, through both the choice of actors and the plot. This includes cameo moments that remind audiences of the acts and behaviors of characters in *Mapantsula*, played by the same actors. For example, in *Hijack Stories*, a white man, played by Marcel van Heerden, comes out of his house in Rosebank, a white suburb of Johannesburg, one night to check a noise and is held at gunpoint on his knees while Zama (Rapulana Seiphemo) and his gang steal his car. Ten years earlier, van Heerden had played the police interrogator, Stander, in *Mapantsula*. Seen in *Hijack Stories* as a victim on his knees, audiences are reminded of Panic's position when the younger Stander tortures Panic in *Mapantsula*. In another such moment in *Hijack Stories*, Zama and the gang hijack the car (notably a coveted BMW) of a white woman, played by Vanessa Cooke, the actress who plays the part of Mrs. Bentley in *Mapantsula*, the white "madam" who exploits her domestic worker, and Panic's lover, Pat (Themba Mtshali).

Hijack Stories is a further example of the hero/antihero film with a gangster twist that had impact on audiences in South Africa, but it was in the first decade of the twenty-first century that the genre came fully into its own, drawing on its long-established precedents in Hollywood films. When *Tsotsi* (2005), directed by Gavin Hood, won the Oscar for the best foreign language film in 2006, it was a kind of international coming of age for films from South Africa, a little more than a decade after the first democratic elections in 1994 that had officially ended apartheid. It is tempting to think that *Tsotsi* had all the elements of what audiences in the United States would find exhilarating, being the story of a young, vulnerable, and violent man, Tsotsi, who discovers a baby in the back of the car he has hijacked. The film provides a redemptive ending, with Tsotsi encouraged to return the baby. This was one of three possible endings that was determined primarily through focus groups based in the United States. But the film also made a significant impact on South African audiences, and particularly young black audiences, as evidenced in audience research since the film was released. A study

of Johannesburg audiences across four different areas found that *Tsotsi* was the film that had been most watched (Parker 2014, 201).[15]

Tsotsi is the eponymous adaptation of Fugard's only novel, written between 1958 and 1962, but first published in 1980. Fugard set it in Sophiatown, which by then was condemned to demolition under the Group Areas Act. It is worth noting that when Fugard was beginning to write his story of the Sophiatown gangster embodied in the character of Tsotsi, Rogosin was developing the script for *Come Back, Africa* with his Sophiatown cowriters, Modisane and Nkosi. Indeed, the Tsotsi character is not so different to Marumu in *Come Back, Africa*, and both are represented as social victims despite the violence each perpetrates.

A few years after *Tsotsi*'s award, *Gangster's Paradise: Jerusalema* (2008) was released internationally and was entered for the Academy Awards in the best foreign language film category in 2009, which it did not win. Nevertheless, although the film has a rather lengthy and sometimes convoluted plot, it also draws on the gangster genre and its conventions, set in the gritty urban space of Hillbrow, in central Johannesburg. Its audience appeal was in part due to the performance of the talented film and television actor Rapulana Seiphemo, who plays the central character, Lucky Kunene, and who had also played the father of the hijacked baby in *Tsotsi*. His character in *Jerusalema* was now on the flip side of his middle-class life in the earlier film. *iNumber Number* (2013), the next major film spinning a gangster tale, this time turning cops into gangsters, won several international awards, and built on Presley Chweneyagae's fame as Tsotsi.

But the violent young man at the heart of a film was given a new and gruesome twist in Jamil Qubeka's *Of Good Report* (2013), which was intended to open the Durban International Film Festival (DIFF) in 2013, but instead the then festival director, Peter Machen, informed the full-capacity audience on opening night that the film had been "banned." The news went instantly viral on social media and the Internet, with YouTube footage showing the shocked director, Qubeka, and his wife, plus the film's producers and supporters, on the stage as the announcement was made to the audience. Qubeka had tape over his mouth, and his wife spoke on his behalf. The thrust of her speech was that she was speaking as a medical doctor who works in township clinics and knows the extent of young women's problems. The censors had clearly misunderstood the film, she said, and had banned it as pornography, when in fact it was highlighting the plight of young women. This was the first banning of a commercial, feature-length film since apartheid, and therefore a historically significant act. It caused a furor in academic, art, and film circles, and

across the media. DIFF appealed the decision, and the appeal was upheld, with the film then being classified as "16NSV" ("NSV" standing for nudity, sex, and violence).[16]

The reasons for the banning relate to what the board cited as pornography, some twenty-nine minutes into the film. A young black teacher, Parker Sithole (Mothusi Magano), and a young black scholar, Nolitha (Petronela Tshuma), engage in sexual activity after meeting in a local tavern. Nolitha is in Grade 9 at the school where Parker is about to begin a new teaching post. According to the board, a Grade 9 pupil is usually in the fourteen-to-sixteen-age range, and Nolitha is thus seen as underage, matching the board's definition of pornography. Had the board members continued to watch the full film, however, they would have seen that it is less about the sexual activity between Parker and Nolitha and more about Parker's interior, dystopian psychological state. This is conveyed in harsh, noirlike, black-and-white cinematography. The open-ended narrative structure sustains a psychological reading as against one rooted in historical reality, but the film's insistent edginess metaphorically clings to a discomforting sense of the world in terrible disarray.

This world is not as far a cry from that of the young black surfers in *Otelo Burning* (2011) as we might at first think, made a few years earlier and set, like *Mapantsula*, at the end of the 1980s. They, too, seek freedom, this time from the dystopian township landscape of Lamontville, on the outskirts of Durban, where the "comrades" aligned with the ANC and the *impimpi* of the Inkatha Freedom Party are at war with each other. Otelo (Jafta Mamabolo) and his friends escape the township's struggles through surfing the waves on the local beaches. But the price is heavy in that Ntwe (Tshepang Mohlomi), Otelo's much younger brother, is unwittingly caught up in the township conflict and is "necklaced," a tire is hung around his neck and he is burned to death, after he is mistakenly thought to be an apartheid spy. This human tragedy reflects the cheapness of life under apartheid, in the context of the high stakes attached to political identities, especially in KwaZulu-Natal, when thousands were killed in bloody battles between Inkatha and the ANC, fought mainly within black townships and surrounding rural areas.[17]

Mapantsula's enactment of police brutality in the townships and in the infamous John Vorster Square (Police Central Headquarters in Johannesburg up to 1997) remains unique, however. Eight detainees died in police custody at John Vorster Square under apartheid, some of whom the police assassinated. This is directly represented in the scene where Stander pushes and holds Panic's head outside the high window of his office in John Vorster Square, and the camera takes Panic's point of view as he sees the world swirling beneath him. In the twenty years that

followed, not only were further urban, gangster-related films produced, *Tsotsi* being a prime example, but also other films that visualize the violence of the apartheid era, through a wider set of stories and forms.

Zulu Love Letter (2004) is an especially important film in that it represents a deeply subjective experience of apartheid atrocities in which the assassination of a young anti-apartheid activist, Dineo (Lerato Moloi), is repeated in strobelike, slow motion "interludes," as the writer of the screenplay, Bhekizizwe Peterson, calls them, through the memories of journalist Thandeka (Pamela Nomvete), who witnessed the event. This is an extraordinary account of trauma that reflects upon such atrocities not only on the part of the witness as bystander but as a survivor herself of detention, solitary confinement, and torture. Moreover, not only has Thandeka also witnessed the torture and murder of her photographer friend, Michael (Richard Nzimande), but her thirteen-year-old daughter, Simangaliso (Mpumi Malatsi), is deaf and unable to speak as the result of beatings she endured in detention while pregnant. The film defies convention and makes a stand for alternatives to mainstream films with neat resolutions. The edgy style pushes audiences to consider the historical realities the film references and the responsibilities they have to find resolutions within life itself rather than only to rely on the disengaged comfort of narrative closure and resolution.[18]

In relation to such questions of reality and the role of film, it is important also to consider documentary film. Indeed, its claim to reality puts it in the unique position of a quick-form response in times of pressing crises, such as we have seen in the 1980s, with the rise then of an anti-apartheid documentary "movement." In 2008, South African filmmakers rose to new challenges by forming the organization Filmmakers Against Racism (FAR). This collaborative venture led to a series of documentaries about xenophobic attacks on migrants from neighboring countries, particularly Zimbabwe. It followed an urgent missive to South African filmmakers from Pedro Pimenta, then director of Dockanema, the Mozambique documentary film festival that had run for two years, from 2006.[19] He called upon South African filmmakers to flex their muscle and show their responses to these attacks that had led to the dispersal of 30,000 refugees across South Africa in May 2008. Within a short period, from May to August of that year, FAR had already planned to produce eight twenty-four-minute documentaries and eight thirty-second Public Service Announcements to be broadcast by the South African Broadcasting Corporation (SABC) and other networks and community TV stations. Some of the documentaries already produced were screened at DIFF in July 2008 and subsequently at the Tri

Continental Festival. The FAR website showed links to visual responses uploaded onto YouTube that delineated some of the extent and effects of the attacks on individuals and communities and the human rights issues that had emerged. The question of how to deal with refugees and refugee camps had also been raised. Most of the film work had been on a voluntary basis, relying on public donations and the use of equipment donated by production houses. Out of these initiatives, several painfully significant stories were told, including that of Ernesto Alfabeto Nhamuave, represented by a short twenty-four-minute film, *The Burning Man*, directed by Adze Ugah. Nhamuave, a Mozambican, had petrol poured on his body and had been set alight by a township crowd and subsequently burned to death.

The multiple award-winning film *Miners Shot Down* (2013) documents the brutal crushing of striking miners, known as the "Marikana Massacre," when police shot and killed thirty-four strikers in August 2012. The film has kept this tragic event and its aftermath in the public eye, and has also sparked protests about broadcasters in South Africa not screening the film, despite its multiple awards, including an Emmy in 2015. After amandla.mobi, an independent community advocacy organization, spearheaded an online campaign and wrote an open letter to the public broadcaster, SABC, and the free to air channel, e-tv, the film was screened on e-tv in January 2016, but has still not been broadcast by the SABC.

Film Production: Histories and Policies

Since South Africa is a relatively new democracy of just over twenty years, an overview of film production cannot ignore policies and legal frameworks, the opportunities they provide, the challenges they invoke, and the individuals and groups they include and exclude. Up to 1994 and the first democratic elections, there had been some film-related policies, but since then there have been influential strategic moves that are important to document as part of this broad overview. The historical backdrop that I briefly map below thus refers to the major part of the twentieth century up to 1994.

Virtually from cinema's beginnings, the involvement of black South Africans in film production was no minor thing. Black extras, sometimes en masse, as well as individual performers, were included in film productions from the early 1900s. Some, for example, the actor known as Goba, "Africa's first indigenous black star" (Parsons 2013, 646), appeared in many productions over a considerable length of

time. This involvement of black people in film production almost exclusively served the interests of white producers and directors, with a few notable exceptions. The political hegemonies of the decades leading up to 1994, particularly under the apartheid government after 1948, that determined power relations based on race and ethnicity thus necessarily form the overarching framework for understanding the conjunctions of politics and film in South Africa. Opportunities to produce films, as well as who saw them, where they were seen, and how they were seen were always based on race.

When it comes to specific policies, the area in which this first became significant was that of censorship, relatively early in the 1900s, most likely from the time when picture palaces gained prominence around 1910 (Gutsche 1972, 283). Gutsche (1972) provides substantial detail of concerns about the contents of films and their effects on audiences, leading to the creation of provincial censorship measures up to 1931, when the Entertainments (Censorship) Act was promulgated. Paleker (2014), focusing on African audiences, shows the levels of control exacted not only through regional authorities but also through white individuals screening films for African audiences. At the central level of control, however, the Censorship Act provided clear categories of film audiences and categorized "natives" on a par with "European" children under twelve years old (Gutsche 1972, 303; Ssali 1983, 118). There were subsequent amendments to the act, and after the apartheid government came into power in 1948, the Publications Control Board played an increasingly major role in both requiring cuts to films and banning films outright. It was only with the Films and Publications Act of 1996 that there was a shift from legislating for censorship to classification, which was primarily aimed at the protection of children.

Apart from the focus on censorship, there were other film-related debates in government, with the question of establishing a National Film Board starting in the 1930s, and a film subsidy scheme in the 1950s. With Afrikaner nationalism on the rise in the 1930s, the government appointed the Cilliers Committee to investigate the advisability of producing Afrikaans-medium films and their distribution on the basis of a quota system (Maingard 2007, 8). The committee's report in 1943 proposed the establishment of a National Film Board, which did not occur for almost two decades, despite its further recommendation by another government-appointed committee, the Smith Committee, in 1944. John Grierson, the celebrated British documentary filmmaker who had established the Canadian Film Board and had also influenced the establishment of the Australian Film Board, toured South Africa in 1949 at the government's invitation. He presented his report in 1954, also

recommending the establishment of a National Film Board. Following the report of a further government committee in 1955, the De Villiers Committee, a National Film Board was established in 1964, under the terms of the National Film Board Act of 1963. It operated until 1979, primarily producing state propaganda (Tomaselli 2014b). After its closure, its archival functions through the South African Film Institute were continued in the form of the National Film Archives, subsequently renamed the National Film, Video and Sound Archives (Maingard 2007, 10).

We have already seen how the government instituted a subsidy scheme from 1956, first in relation to films in the English or Afrikaans language. From 1969, Afrikaans-language films were awarded higher subsidies than English-language films. The B-scheme was developed in 1972, providing subsidies for films in African languages aimed at black audiences. As already discussed, this scheme was established as part of the apartheid state's propaganda machinery, notwithstanding the potential for these "black" films to be read against the grain, as Modisane (2013) shows. There were several amendments to the subsidy scheme up to 1989, when it floundered. Subsequently, a new scheme was announced, where films made in South Africa could qualify for a subsidy of 70 percent of internal box office income on certain conditions. By then, discussions in the anti-apartheid FAWO were well under way, advancing new approaches to the question of government subsidies that were subsequently taken into wider policy debates.

The period of the late 1980s was significant for advancing the political organization of the cultural sector against apartheid. The "Culture in Another South Africa" congress that was held in Amsterdam at the end of 1987, under the auspices of the ANC, had resolved that cultural sectors should become organized. Film workers subsequently established FAWO based in Johannesburg, and similar organizations in Cape Town and Durban. FAWO created a number of committees, including an Education Committee that ran weekly filmmaking classes in Alexandra township. On this foundation, the Community Video School was established in the center of Johannesburg, with funds from Channel 4 (UK) and other international funding bodies. This became the Newtown Film and Television School, which continued training filmmakers for almost twenty years afterward.

With a democratic government in place there have been various policy initiatives at all levels of governance—national, provincial, local—toward developing the cultural sector broadly and the film subsector specifically.[20] On the national economic front, the first major framework that the government established was the Cultural Industries Growth Strategy in 1998, where the Department of Arts, Culture,

Science and Technology (DACST, later the Department of Arts and Culture [DAC]) examined every cultural sector's capacity to expand economic strength. This was in line with government strategies for national economic growth.

Initial moves to secure new cultural policies were formulated in the draft "White Paper on Arts, Culture and Heritage" (DACST 1996), the result of a broadly consultative democratic process. More recently, the government published the "Revised Draft White Paper on Arts, Culture and Heritage" (DAC 2013), proposing to align these sectors with its primary imperatives toward economic development and the creation of employment opportunities alongside the goals of nation-building and social cohesion. Mike van Graan, a long-established cultural activist and commentator, has eloquently identified the "Revised Draft White Paper's" core problematics in several forums since 2013. This includes what he terms a "definitional mistake," namely, the collapsing of a definition of cultural and creative *industries* with the arts and culture more generally (van Graan 2013, 27). [21]

Van Graan draws on the values embedded in the 1996 white paper to identify how the "Revised Draft White Paper" has a different emphasis. In the "Revised Draft White Paper," "the overtly political imperative of creating jobs, decreasing poverty and creating a more equitable society," he contends, "differs fundamentally from the vision of the 1996 white paper, which was to ensure that "everyone has the right freely to participate in the cultural life of the community and to enjoy the arts" (van Graan 2015, 4). His comparison highlights how political contexts have shifted between 1996 and 2013, the first paper having come out of the initial drive to move from an apartheid to a democratic state, while the second is based on the government's priorities to eradicate poverty and create more employment opportunities, and, furthermore, to deploy all sectors toward these goals.

In any social formation, the arts and culture exist precisely to permit and sustain forms of creative expression about the very workings of that social formation. The wider question thus remains as to the extent that the cultural and creative arts can feasibly remain beyond the purview of state control, if they are only tied to the government's economic imperatives in respect of funding opportunities within national, provincial, and municipal policy frameworks for the arts and culture. Following van Graan, it could not be assumed that the cultural and creative arts will make a difference to the "triple challenges of unemployment, poverty, and inequality" (DAC 2013, 6), a catchall phrase with contemporary currency. Driving the cultural and creative arts into this mold, without also allowing for an open agenda, can only limit a field that by its nature needs to take its own paths and to

be supported to do so. Not only that, but the field is one that is defined more by its transitory nature, through projects, productions, and events, rather than by its stability, unless within established long-term companies or umbrella organizations.

Running through this discussion on policies is an overriding concern based on the questions raised in van Graan's critique of the "Revised Draft White Paper" pertaining to film production as an industry, as against a wider framework in which creative innovation might be more readily embedded. Nevertheless, there are overlaps between these two, and it is worth delineating the funding opportunities that do exist and can be exploited, whether or not broached from the perspective of film production as an *industry*. Before outlining the strategies developed for boosting the local film industry, it is important to map the role of the National Film and Video Foundation (NFVF), an agency of the DAC that has been key in several ways.

The NFVF was established through the National Film and Video Foundation Act of 1997, with the following objectives:

- To develop and promote the film and video industry.
- To provide, and encourage the provision of, opportunities for persons, especially from disadvantaged communities, to get involved in the film and video industry.
- To encourage the development and distribution of local film and video products.
- To support the nurturing and development of and access to the film and video industry.
- In respect of the film and video industry, to address historical imbalances in the infrastructure and distribution of skills and resources. (Republic of South Africa, National Film and Video Foundation Act, 1997, 2)[22]

Bridging the gap between former funding measures and policies still under discussion in the period immediately after the first democratic elections, the DACST made an initial R10 million available for filmmakers as an Interim Film Fund. This was one rather small arm of what developed into a multipronged approach that the government created after 1994, with the intention of simultaneously benefiting the film industry and the broader economy. Once the NFVF was established, it began to dispense funds channeled from the DAC, which continues to be part of its remit. Currently, the NFVF provides production funding in four broad categories:

Education and Training; Development (of feature films, documentaries, and TV concepts); Production (of feature films and documentaries); and Marketing and Distribution.

As South Africa has a recognizably developed film industry with a very strong infrastructure by comparison with most other African countries, the NFVF has been well-placed to drive not only the South African but also the continental advancement of cinema. From its beginnings, the NFVF has steered South Africa's entry into the international market, hosting a presence at Cannes, engaging with other major film festivals in Africa and the world at large, and nominating South African films for Academy Awards. The NFVF led the insertion of South Africa's presence at the biennial African film festival, FESPACO. It played a key role in reinvigorating FEPACI, hosting the first African Film Summit in April 2006, following which the secretariat was relocated to South Africa for two subsequent years as part of its rotating cycle. It has developed coproduction treaties with several countries, providing agreed mechanisms for a film to obtain "national" status in two countries, and thereby also enabling producers to receive financial relief benefits in both countries.[23]

Since 2000, the NFVF has organized four Film Indabas (a local term for "Conferences"), in 2001, 2005, 2009, and 2013, providing the basis for consultations among stakeholders in the sector. In 2006, following the 2005 Indaba, where funding was a key concern as the DAC had diminished the amount of funding channeled through the NFVF, filmmakers established the South African Screen Federation (SASFED), with the primary aim being "to unify the Film, Video, Distribution and New Media industries." Its establishment is a clear sign of the industry's maturity beyond apartheid, providing an organized forum for filmmakers' responses to government initiatives.[24]

As I have commented elsewhere (Maingard 2007), one of the key aspects of the NFVF is the explicit aim to fund short films. This had been discussed in FAWO when it was established in the late 1980s as an appropriate method for enabling aspirant filmmakers to begin crafting their stories in film. It was the basis on which the film training and education project in Alexandra was first developed and was continued in FAWO's Community Video School and the Newtown Film and Television School that followed. In any event, the short film is widely recognized as a method for developing and sharpening filmmaking skills, especially at the point of entry into film production. The M-Net "New Directions" program established in 1993 focused on developing short films.[25] A number of South African filmmakers and scriptwriters had their first opportunities for writing and directing in this program.

Other smaller-scale similar opportunities were offered by the SABC, "Dramatic Encounters" (1999), and by Channel 4 in the United Kingdom, "Short and Curlies" (1999), each resulting in five locally produced short films.

This format continues to be the basis for providing opportunities for aspirant filmmakers, as recognized in the NFVF's focus on the short film. More recently, this has been through specifically funded projects, including its Youth Filmmaker Project and its Female Filmmaker Project, both aimed at aspirant filmmakers with two years' experience in the industry. The Youth Filmmaker Project funded Natives at Large's (Bhekizizwe Peterson and Ramadan Suleman) and Jungle Works' (Neville Josie) training and mentoring of first-time filmmakers, who were born when Nelson Mandela became South Africa's first democratically elected president. They produced a feature-length anthology, *Rights of Passage* (2015), which is a thematic combination of eight short fiction films that celebrates the diversity of African identities.[26] A new NFVF project takes the concept of funding women filmmakers to greater heights in the Female Only Filmmaker Project, which offers ten women who have recently entered the film industry, particularly from historically disadvantaged backgrounds, the opportunity to work in collaboration with other women on the theme of "Negotiating Spaces." This theme, the NFVF proposes, is a means of avoiding the stereotypes and clichés usually attached to films for women (*Screen Africa*, 2016b).

Drawing on successful models elsewhere, the newly elected South African government, and subsequent governments, drafted a series of cross-cutting strategies aimed at serving several purposes: supporting nation-building; redressing the historical imbalances and disadvantages of the past, particularly with regard to race, and (to a lesser extent) gender; and stimulating the economic capacity of the film industry. As early as 2005, just over ten years into the democratic dispensation, the Department of Trade and Industry (dti) had already reported "strategy fatigue" in the sector. Nevertheless, it is important to identify some of the key constituents of the "package" of funding opportunities and "economic incentives" that have been established since 1994, beyond those available under the auspices of the NFVF. These incentives weigh in behind large-scale productions, rather than smaller, independent projects. Long-term goals are needed, however, to break down the predominance of white, male filmmakers; ensure diversity; and allow a broader field of local stories to reach screens and attract wider audiences. The focus of these incentives thus far is also primarily on production, with distribution and exhibition receiving far less focus than is needed for developing local audiences.

The first of the government incentives, through the South African Revenue Services (SARS), had already existed from as early as 1962 and was appropriated when the post-apartheid government was elected in 1994, allowing for tax relief to stimulate local production through the Income Tax Act of 1962, as amended. [27] Its subsequent repeal and replacement with a further section of the Act from December 2013 was aimed at facilitating not only film production but also international distribution (SARS n.d., 20). SARS has also negotiated Double Taxation Agreements (DTAs) with many countries across Africa and around the world.

In 2005, the dti, another important funder of film production, established financial incentives for both local and foreign investors through its Large Budget Film and Television Production Rebate. This was specifically aimed at "provid[ing] an additional incentive for the production of both foreign and domestic large budget film and television projects in South Africa" (*ScreenAfrica* n.d.), which it was hoped would retain South Africa's competitiveness in attracting bigger financial investments, particularly from foreign production companies. Three years later, in 2008, the dti announced a Revised Film and Television Production Incentive aimed at "increas[ing] local content generation and improv[ing] location competitiveness for filming in South Africa" (Variety 2008). This was partly in response to the high thresholds of financial input initially required, which had proved difficult for local investors, given the financial strictures under which local filmmakers generally operate, and an important recognition of the impact of its policies on local production. Subsequently, the Foreign Film and Television Production and Post-Production Incentive was established to attract big-budget international projects into South Africa in order to increase local employment opportunities and support the local advancement of skills as well as extend positive perspectives of South Africa's viability and desirability as a shooting location with excellent production and postproduction facilities (dti 2015a).

Attaining benefits in accordance with these incentives relies upon the qualification of production and postproduction expenditures, formally identified as Qualifying South African Production Expenditure (QSAPE) and Qualifying South African Post-Production Expenditure (QSAPPE). Eligible formats also vary across incentives, variously including animation, documentary, feature films, television dramas, and telemovies.[28]

A further innovative policy move on the part of the dti to advance film production specifically by black filmmakers led to the creation of the South African Emerging Black Filmmakers Incentive in 2015 for black-owned qualifying productions with

a total production budget of R1 million or more. This is in line with the government's Broad-Based Black Economic Empowerment policies aimed at redressing the historical imbalances of the apartheid past. Significantly, the objectives of this incentive are specifically to "nurture and capacitate *emerging black filmmakers* to take up big productions and contribute toward employment opportunities" (dti 2015b, 3; my emphasis).[29]

This significant incentive is based on research into the number of black producers or directors of South African films over the last ten years. The head of the Industrial Development Corporation's (IDC) Strategic Business Unit for Media and Motion Pictures, Basil Ford, states that since 2009, out of 128 feature films made and released in South Africa, "only 22 were made by black directors and in only 32 were there black producers involved" (SABC Digital News 2015). Meeting economic needs by making opportunities available to previously disadvantaged groups and individuals is clearly a difficult juggling act, and while this incentive is a welcome development, the plans for initially creating six films per year, and possibly up to ten, for the first three years, makes something of a difference but not necessarily a very big one.

Beyond government departments, the IDC, a parastatal entity, operates as a co-investor. It funds a wide range of productions and supports broadcasting and the establishment of township and rural cinemas, as well as new or alternative distribution systems, up to R1 billion (IDC, 2014).[30] The IDC also makes allowance for lowering the contribution of historically disadvantaged people, with a willingness in such instances to extend financial support that exceeds the owner's or shareholder's contribution.[31] This conglomerate of funding opportunities suggests that the IDC is alert to adjunctive facets of film production, without which potential successes might be limited. The focus on establishing digital cinemas and extending to rural audiences as well as urban ones is especially important, particularly since one of apartheid's sad legacies is a lack of cinemas in formerly black areas. The willingness of the IDC to risk the financial support for owners/shareholders who cannot meet the requirement to produce at least 51 percent of funding needed is also a significant contribution where there is widespread historical disadvantage.

South Africa's tiered governmental structure is deployed in the extension of opportunities for funding and developing the film industry through the provinces and their governments, in the form of provincial Film Commissions. These commissions champion the opportunities of specific regions of the country, marketing them for the film industry, as well as advancing the contribution the industry can

make to economic growth and job creation within these regions. The importance of Film Commissions is indisputable in promoting their regions to the film industry and to foreign film investors, including urban and rural locations for both local and foreign film productions, and enabling related potential benefits for regionally focused income generation and employment opportunities. The most prominent of these are the Gauteng Film Commission, the KwaZulu-Natal Film Commission, and, until recently, the Cape Film Commission.

The Gauteng Film Commission not only markets the region as a "world-class destination for film-making" but also "ensure[s] that people across Gauteng can experience the magic of cinema" (Gauteng Film Commission South Africa 2016). The focus on increasing local audiences is particularly important, especially since Johannesburg is located in the Gauteng province. The KwaZulu-Natal Film Commission also aims to draw global interest, while expressly providing opportunities for people from disadvantaged communities, and addressing "historical imbalances in the infrastructure and in the distribution of skills and resources in the film industry in the province" (KwaZulu-Natal Film Commission 2016). The Cape Film Commission was established in 2000 with a wide regional mandate covering the Western Cape, including Cape Town, Plettenberg Bay, and George (the latter two being on the southern Cape coast) (Cape Film Commission 2012). Since 2012, however, Wesgro has been the officially designated destination marketing, investment, and trade promotion agency of the Western Cape for the film industry.

The government's multiple approaches to developing the national film industry are predicated on a neoliberal approach to boosting the economy. The apparent fragmentation that this has eventuated is an indicator of the creation of solutions that are not paying enough attention to inherent contradictions in the package of concurrent strategies. An example is the provision of tax rebates for foreign investors to choose South Africa as a location for film production, while the local reach of films is diminished by economic strictures and the absence of viewing facilities. Juggling the imperatives internal to each of the elements of the government's multipronged approach at the international, national, regional, and local levels may ultimately prove more problematic than useful. Hence the concerns of SASFED and others to limit fragmentation and to create greater coherence across the provision of funding opportunities. The strategies and incentives already created nevertheless carry some potential for producing South African films in and for the international market as well as for local and continental markets. There are major questions attached, however, as we have seen, particularly in sustaining

a vibrant national film culture based on local content films, which would attract local audiences. These questions and their answers are inextricably imbricated with national policy frameworks.

Conclusion

It is clear that the potential for the film industry to create employment opportunities and generate income will no doubt remain a key feature of future policies and that inevitably large-scale projects will benefit, particularly through building on the economic incentives already in place. The NFVF's slate of funding opportunities, including individual bursaries and scholarships, and further measures specifically aimed at redressing historical disadvantage will add some long-term value. The promotion of the short film format as the entry-point mechanism for aspirant filmmakers to produce viable, manageable, smaller-scale projects will continue to be an important feature of the film production landscape. If, however, as the government's vision for 2030 proclaims, "as artists we express and celebrate, we expose and nurture, we explore, shift and change frontiers" (South African Government 2016), then a wider remit for making stories into films beyond narrow mainstream imperatives and big-budget projects will need to be incorporated far more extensively into future policies. Untying the links between the production of arts and culture and economic imperatives, significant as these are in broad visions for the future of South Africa, may well produce stronger results toward the dual goals of both freedom of expression and boosting the economy.

The short film is a crucial area of education and practice, particularly in light of the fact that it is white males who produce and direct the majority of films that reach the big screen. Indeed, as we have seen, this is a major reason for the recent development of the dti's incentive for emergent black filmmakers. *Rights of Passage* (2015), the collaborative project of Natives At Large and Jungle Works, is an exemplar for the work that experienced filmmakers can do in training and mentoring young, aspiring filmmakers. The exciting prospects for the future of film production in South Africa are visible in the diverse perspectives on the world that these young people present through a wide set of lenses. These are not narrowly focused through Hollywood-based, commercially orientated approaches, but are rather patently informed by histories of African literatures and cinemas, as well as traditions and folklore represented through African proverbs. *Rights of Passage*

promises a new future for filmmaking in South Africa, of which we have thus far seen too few glimpses.

A century after Schlesinger established AFP and positioned himself and his vertically integrated monopoly into the Western-orientated world of film production that entrenched white supremacy both locally and abroad, boundaries of race and gender, as well as form and content, are being traversed in new opportunities, in part with the support of the NFVF and other government bodies. Without the vision, creativity, and work of filmmakers themselves, whether established or emerging, none of these incentives would produce the results for which they are intended. Efforts continue, with their concomitant expenses, to locate the cinema of South Africa in the established structures of acclaimed international festivals in the West. But the coming of age of the cinema in South Africa is surely not so much a mechanism of winning Oscars in the Hollywood register of excellence. More pressingly, it needs to exploit its unique positioning within the African continent to bring to life the myriad stories that await the enchantment, magic, poetry, and power of the moving image, and its ability to remind us, as collective audiences, of our humanity.

NOTES

With grateful thanks to Jyoti Mistry, Bhekizizwe Peterson, and especially to Josef Gugler, Ken Harrow, and Emma Sandon.

1. See *Screening the Past*, Special Issue on "Colonial Africa on the Silent Screen: Recovering *The Rose of Rhodesia* (1918)," No. 25 (2009). My own contribution in this Special Issue reflects on the film as an example of colonial cinema (Maingard 2009a). The site also streams the film for online viewing.
2. For detailed readings, see Maingard (2007, 45–52).
3. For further detail of the production contexts and a detailed reading of the film, see Maingard (2007, 54–59). Gutsche (1972, 345–51) provides extensive detail of reactions to the film, particularly its pro-Afrikaner stance.
4. See Masilela (2003, 26), who comments that despite their popularity, these films never attracted critical responses from African intellectuals although they had "large African casts." He attributes this to the fact that they were "written and directed by Europeans." For further detailed readings of *African Jim* and *The Magic Garden*, see Davis (1996), and Maingard (2007, 77–89; 2014); and of *Cry, the Beloved Country*, see Maingard (2007,

106–11). For a discussion of Swanson's beginnings with Gaumont-British Instructional and his film made in (then) Northern Rhodesia, *Chisoko the African* (1949), see Maingard (2013).

5. For further detailed readings of *Zonk!* and *Song of Africa*, see Maingard (2007, 90–105).

6. The source text is not published, but a jointly edited version by Basil Warner, Petrus du Preez, and Edwin Hees is published in *South African Theatre Journal* (2003). A filmed version of the play was also screened on BBC2 in 1965 in the Theatre 625 series. See http://esat.sun.ac.za/index.php/Try_for_White.

7. In 2015, local filmmakers were up in arms as Ster-Kinekor had decided to reduce screenings of a popular local film, *Tell Me Sweet Something* (2015), from forty-seven to twenty-seven cinemas in the third week of its run, which highlighted questions of local content films and their exhibition. Minister of Arts and Culture Nathi Mthethwa met with industry stakeholders, where he announced that "our mandate . . . is nation-building and social cohesion. Our task is to tell the South African story and tell it well in all our art forms and all our genres. . . . At the heart of this agenda is the promotion of local content." See South African Government (2015).

8. *Drum* was a magazine aimed primarily at African readers that started in Cape Town as *The African Drum* in 1951. It was taken over by Jim Bailey after three issues, moved to Johannesburg, and henceforth called *Drum*. It also had a continental presence and a wider readership in other parts of the world.

9. See Maingard (2007, 111–22) for a detailed reading of the film.

10. There has been a recent revival of scholarly and public interest in these films, including programming on television and availability through online distribution circuits. A set of annual awards is now named after Simon Sabela, celebrating outstanding achievement in the local film industry, particularly in the KwaZulu-Natal province. For useful generic categorizations, see Tomaselli (1989). For detailed historical contexts and textual readings, see Paleker (2009, 2010, 2011). See also Maingard (2007, 126–133), including discussion of Sabela's *iKati Elimnyama* (*Black Cat* 1976); on Sabela's *uDeliwe* (1975), see Modisane (2013, 71–96).

11. The First Carnegie Commission of Enquiry in South Africa had been into the "poor white problem." Its report was published in 1932. The Report of the Second Commission of Enquiry was published in 1984.

12. There were, however, several films produced internationally focusing on South Africa and apartheid, including *A Dry White Season* (1989), *A World Apart* (1988), and *Cry Freedom* (1987).

13. See Maingard (1997) for a detailed reading of *Fruits of Defiance*.

14. As a result of Inkatha's protests, the first part of the series was initially pulled from its intended broadcast slot. Members of the cast and crew received death threats and went into hiding. As a result of counterprotests, the South African Broadcasting Corporation then screened all three parts together in the prime-time slot on a Saturday night, which ironically undermined the point of the Inkatha actions against it and had the effect of increasing the broadcast audience.

15. See also Parker (2016) for an original, in-depth study of local films and their audiences in Johannesburg.

16. See Tomaselli (2014a) for a full account of the banning of *Of Good Report*.

17. Jyoti Mistry's *Impunity* (2015) extends the list of films that present a disturbing, dystopian view of South Africa, in this case across a wide range of identities, including politicians, police, and "ordinary" people, as well as across gender and race.

18. For a detailed discussion of the film, see Maingard (2007, 168–78; 2009b). The Peterson and Suleman publication (2009) usefully contains the screenplay as well as commentary from the film's writer, Peterson, and director, Suleman.

19. He was subsequently the director of DIFF in 2014 and 2015, and founded the Joburg Film Festival in 2016 (*Screen Africa* 2016c.)

20. The film and television industries are not altogether separable in practice, but a full exposition of both is beyond the remit of this chapter.

21. Van Graan's critique is also premised on statistical evidence that shows that while the economy has grown an average of 3 percent per year since 1994, this has not led to increased employment. Where the unemployment rate was 16.9 percent in 1998, by 2013 it was 25.7 percent (van Graan 2015, 26).

22. The act was amended by the Cultural Laws Amendment Act of 2001.

23. The NFVF has brokered coproduction treaties with Canada (1997), Italy (2003), Germany (2004), the United Kingdom (2006), Australia (2010), France (2010), New Zealand (2011), and Ireland (2012). It also has had a Memorandum of Understanding with Kenya since 2013, which is expected to develop into a coproduction treaty.

24. In 2011, SASFED and the NFVF signed an agreement setting out their terms of engagement (SASFED 2011).

25. M-Net is a subscription-based television channel.

26. The NFVF describes the production further as follows: "[The films] delicately reflect on and explore the challenges of intimacy and change: the search for love, belonging and healing amidst the rites and turmoil of everyday life. It offers a rare, honest, resilient and creative insight into the concerns and experiences of youth in contemporary South Africa" (NFVF n.d.). *Rights of Passage* won the Production Merit Award at DIFF in 2015.

27. This allowed for tax relief through Section 24F of the Income Tax Act of 1962, as amended, to "stimulate" local production (SARS n.d., 3).

28. Depending on the extent of expenditures on production and postproduction in South Africa or in a foreign country, and up to a cap of R50 million, the incentive is calculated between 20 and 25 percent of qualifying expenditure (dti 2015a). A further measure exists in the form of the South African Film and Television Production and Co-production incentive "to support the local film industry and to contribute towards employment opportunities in South Africa" (dti 2015c), where the rebate is 35 percent of the first R6 million of qualifying expenditure and 25 percent on amounts above that on total production budgets of R2.5 million or more.

29. In this incentive, the rebate offered is 50 percent for the first R6 million of qualifying expenditure and 25 percent of anything above. Most important, there is no cap on the production budget (dti 2015b, 3). This incentive includes various additional aspects of eligibility that relate to the qualification of a black-owned production, for example, in the form of the service or holding company having at least 65 percent South African black shareholders and the Special Purpose Corporate Vehicle, which is a requirement for all these incentives, having at least 75 percent South African black shareholders. Of these, the majority are expected to "play an active role in the production and to be credited in that role" (dti 2015b, 4).

30. Significantly, in relation to audience development, its objectives include "grow[ing] the local audience by encouraging consumption of South African films and building township cinemas." The IDC also usefully incorporates a "wide range of [financial] instruments" including debt/equity, quasi-equity, bridging finance, and venture capital (IDC 2014b).

31. This needs to be viewed against the fact that the IDC prefers not to exceed the owners'/shareholders' financial contribution, thus normally not providing more than 49 percent of funding needed (IDC 2014a).

FILMOGRAPHY

African Film Productions (AFP)/Taberer, Henry. 1925. *From Red Blanket to Civilization*. South Africa.

African Films Trust/African Film Productions. 1913–1956. *African Mirror*. South Africa.

Albrecht, Joseph. 1931. *Moedertjie*. South Africa.

———. 1931. *Sarie Marais*. South Africa.

———. 1938. *They Built a Nation/Die Bou van 'n Nasie*. South Africa.

Attenborough, Richard. 1988. *Cry Freedom*. Italy/ South Africa/United States/United Kingdom.

Blecher, Sara. 2011. *Otelo Burning*. South Africa.

Carlsen, Henning. 1962. *Dilemma*. South Africa.

Cruikshanks, Dick, and Isidore Schlesinger. 1918. *The Symbol of Sacrifice*. South Africa.

Davis, Peter, and Daniel Riesenfeld. 1993. *In Darkest Hollywood*. South Africa/Canada.

Desai, Rehad. 2014. *Miners Shot Down*. South Africa.

Devenish, Ross. 1973. *Boesman and Lena*. South Africa.

———. 1977. *The Guest*. South Africa.

———. 1980. *Marigolds in August*. South Africa.

———. 1982. *A Chip of Glass Ruby*. South Africa.

De Wet, Pierre. 1949. *Kom Saam Vanaand (Come Along Tonight)*. South Africa.

Hall, Ivan. 1973. *Aanslag op Kariba (Attack on Kariba)*. South Africa.

Hood, Gavin. 2005. *Tsotsi*. South Africa.

Hyman, Edgar. 1898/1899. *The Cyanide Plant on the Crown Deep*. South Africa.

———. 1898/1889. *A Rickshaw Ride in Commissioner Street*. South Africa.

Kirstein, Hyman. 1950. *Zonk!*. South Africa.

Korda, Zoltan. 1951. *Cry, the Beloved Country*. United Kingdom.

Magagula, Ntombizodwa, Mapula Sibanda, Lerato Moloi, Valencia Joshua, Zandile Angeline Wardle, Tony Miyambo, Rethabile Mothobi, and Yashvir Bagwandeen. 2015. *Rights of Passage*. South Africa.

Mahomo, Nana. 1970. *Phela Ndaba/End of the Dialogue*. South Africa.

———. 1973. *The Dumping Grounds*. United Kingdom.

———. 1974. *Last Grave at Dimbaza*. United Kingdom.

Marsh, Donovan. 2013. *iNumber Number* (aka *Avenged*). South Africa.

Menges, Chris. 1988. *A World Apart*. United Kingdom/Zimbabwe.

Millin, David. 1973. *Die Voortrekkers*. South Africa.

Mistry, Jyoti. 2014. *Impunity*. South Africa.

Ngakane, Lionel. 1962. *Vukani!/Awake!* United Kingdom.

———. 1966. *Jemima and Johnny*. United Kingdom.

Nofal, Emil. 1951. *Song of Africa*. South Africa.

Omotoso, Akin. 2015. *Tell Me Sweet Something*. South Africa.

Palcy, Euzhan. 1989. *A Dry White Season*. United States.

Qubeka, Jahmil. 2013. *Of Good Report*. South Africa.

Rautenbach, Jans. 1967. *Wild Season*. South Africa.

———. 1968. *Die Kandidaat (The Candidate)*. South Africa.

———. 1969. *Katrina*. South Africa.

Rogosin, Lionel. 1959. *Come Back, Africa*. South Africa/United States.

Roodt, Darrell. 1986. *Place of Weeping*. South Africa.

Sabela, Simon. 1975. *uDeliwe*. South Africa.

———. 1976. *iKati Elimnyama (Black Cat)*. South Africa.

Schmitz, Oliver. 1988. *Mapantsula*. South Africa.

———. 2000. *Hijack Stories*. France/Germany/South Africa/United Kingdom.

Schmitz, Oliver, and Brian Tilley. 1990. *Fruits of Defiance*. South Africa.

Schwegmann, Wendy, Brian Tilley, and Paul Weinberg. 1984. *Mayfair*. South Africa.

Shaw, Harold. 1916. *De Voortrekkers*. South Africa.

———. 1918. *The Rose of Rhodesia*. South Africa.

Simon, Barney. 1982. *City Lovers*. South Africa.

Stephenson, Lynton. 1977. *Six Feet of the Country*. South Africa.

———. 1982. *Good Climate, Friendly Inhabitants*. South Africa.

Suleman, Ramadan. 2004. *Zulu Love Letter*. France/Germany/South Africa.

Swanson, Donald. 1949. *African Jim* (aka *Jim Comes to Joburg*). South Africa.

———. 1949. *Chisoko the African*. South Africa.

———. 1951. *The Magic Garden* (aka *Pennywhistle Blues*). South Africa.

Tilley, Brian 1994. *The Line* (aka *In a Time of Violence*). South Africa.

Ugah, Adze. 2008. *The Burning Man*. South Africa.

Uys, Jamie. 1983. *The Gods Must Be Crazy*. South Africa.

Van Rensburg, Manie. 1982. *Country Lovers*. South Africa.

Venter, Albie. 1972. *Kaptein Caprivi (Captain Caprivi)*. South Africa.

Ziman, Ralph. 2008. *Gangster's Paradise: Jerusalema*. South Africa.

BIBLIOGRAPHY

Cape Film Commission. 2012. "Filming in Cape Town." http://www.capefilmcommission.co.za/about.asp.

DAC. 2013. "Revised Draft White Paper on Arts, Culture and Heritage," Version 2. June 4. http://www.dac.gov.za/sites/default/files/REVISEDWHITEPAPER04062013.pdf.

DACST. 1996. "White Paper on Arts, Culture and Heritage." June 4. http://www.dac.gov.za/content/white-paper-arts-culture-and-heritage-0.

Davis, Peter. 1996. *In Darkest Hollywood: Exploring the Jungles of Cinema's South Africa*. Johannesburg: Ravan.

dti. 2015a. "Programme Guidelines: The South African Film and Television Production and Co-Production Incentive." March. http://www.dti.gov.za/financial_assistance/docs/

SA_Film_Guidelines.pdf/.

———. 2015b. "Programme Guidelines: The South African Emerging Black Filmmakers Initiative." March. http://www.thedti.gov.za/financial_assistance/docs/Emerging_Guide. pdf/

———. 2015c. "Programme Guidelines: The South African Film and Television Production and Co-Production Incentive." March. http://www.thedti.gov.za/financial_assistance/ docs/SA_Film_Guidelines.pdf.

Esat. 2015. "Try for White." http://esat.sun.ac.za/index.php/Try_for_White.

Gauteng Film Commission South Africa. 2016. "Who We Are." http://www.gautengfilm.org.za/ industry-development/gfc-services/34-about-us/who-we-are.

Gutsche, Thelma. 1972. *The History and Social Significance of Motion Pictures in South Africa, 1895–1940*. Cape Town: Howard Timmins.

IDC. 2014a. "Our Sectors: General Criteria." http://www.idc.co.za/.

———. 2014b. "Our Sectors: Media and Motion Pictures." http://www.idc.co.za/.

KwaZulu-Natal Film Commission. 2016a. "Mission and Vision." http://www.kwazulunatalfilm. co.za/about-us/.

———. 2016b. "Objectives." http://www.kwazulunatalfilm.co.za/about-us/.

Maingard, Jacqueline. 1995. "Trends in South African Documentary Film and Video: Questions of Identity and Subjectivity." *Journal of Southern African Studies*, Special Issue on "South African Literature: Paradigms Forming and Reinformed" 21(4): 657–67.

———. 1997. "Narrating Popular Consciousness: Testimony in *Fruits of Defiance*." *Current Writing* 9(1): 55–67.

———. 2007. *South African National Cinema*. New York: Routledge.

———. 2009a. "*The Rose of Rhodesia*: Colonial Cinema as Narrative Fiction and Ethnographic Spectacle." *Screening the Past*, Special Issue on "Colonial Africa on the Silent Screen: Recovering *The Rose of Rhodesia* (1918)," No. 25.

———. 2009b. "*Zulu Love Letter*: Love, Loss, Memory and Truth." In *Zulu Love Letter: A Screenplay*, ed. Bhekizizwe Peterson and Ramadan Suleman, 6–15. Johannesburg: Wits University Press.

———. 2013. "'Assignment Africa': Donald Swanson's Colonial Imaginary and *Chisoko the African* (1949)." *Journal of Southern African Studies*, Part Special Issue on "South Africa on Film" 39(3): 701–19.

———. 2014. "'Lost Classics' in Context: Film Production in South Africa 1920–1960." In *Africa's Lost Classics: New Histories of African Cinema*, ed. Lizelle Bisschoff and David Murphy, 35–48. Oxford: Legenda.

Masilela, Ntongela. 2003. "The New African Movement and the Beginnings of Film Culture in

South Africa." In *To Change Reels: Film and Film Culture in South Africa*, ed. Isabel Balseiro and Ntongela Masilela, 15–30. Detroit: Wayne State University Press.

Modisane, Litheko. 2013. *South Africa's Renegade Reels: The Making and Public Lives of Black-Centered Films*. New York: Palgrave Macmillan.

NFVF. n.d. "NFVF Filmmaker Project to Premiere at the Durban International Film Festival." http://nfvf.co.za/.

Paleker, Gairoonisa. 2009. "Creating a 'Black Film Industry': State Intervention and Films for African Audiences in South Africa, 1956–1990." PhD thesis, University of Cape Town.

———. 2010. "The B-Scheme Subsidy and the 'Black Film Industry' in Apartheid South Africa, 1972–1990." *Journal of African Cultural Studies* 22(1): 91–104.

———. 2011. "'Ethnic Films' for Ethnic Homelands: 'Black Films' and Separate Development in Apartheid South Africa, 1972–1979." *South African Historical Journal* 63(1): 127–47.

———. 2014. "The State, Citizens and Control: Film and African Audiences in South Africa, 1910–1948." *Journal of Southern African Studies* 40(2): 309–23.

Parker, Alexandra. 2014. "Images and Influence: The Role of Film in Representing Johannesburg and Shaping Everyday Practice in the City." PhD thesis, University of the Witwatersrand, Johannesburg.

———. 2016. *Urban Film and Everyday Practice: Bridging Divisions in Johannesburg*. New York: Palgrave Macmillan.

Parsons, Neil. 2009. "Investigating the Origins of *The Rose of Rhodesia*, Part I: African Film Productions." *Screening the Past*, Special Issue on "Colonial Africa on the Silent Screen: Recovering *The Rose of Rhodesia* (1918)," No. 25.

———. 2013. "Nation-Building Movies Made in South Africa (1916–18): I. W. Schlesinger, Harold Shaw, and the Lingering Ambiguities of South African Union." *Journal of Southern African Studies*, Part Special Issue on "South Africa on Film" 39(3): 641–59.

Peterson, Bhekizizwe, and Suleman, Ramadan, eds. 2009. Zulu Love Letter: *A Screenplay*. Johannesburg: Wits University Press.

Reynolds, Glenn. 2007. "'From Red Blanket to Civilization': Propaganda and Recruitment Films for South Africa's Gold Mines, 1920–1940." *Journal of Southern African Studies* 33(1): 133–52.

Reynolds, Glenn. 2015. *Colonial Cinema in Africa: Origins, Images, Audiences*. Jefferson, NC: McFarland.

SABC Digital News. 2015. "Basil Ford on NFVF, IDC Filmmaking Initiative." December 12.

Sandon, Emma. 2013. "*African Mirror*: The Life and Times of the South African Newsreel from 1910 to 1948." *Journal of Southern African Studies*, Part Special Issue on "South Africa on Film" 39(3): 661–80.

SARS. n.d. "Draft Guide to the Exemption from Normal Tax of Income from Films." http://www.sars.gov.za/.

SASFED. 2011. "SASFED Signs Historic Terms of Engagement (TOE) with NFVF." February 9. http://www.sasfed.org/2011/02/sasfed-signs-historic-terms-of.html.

ScreenAfrica. n.d. "dti Film Incentive." http://www.screenafrica.com/.

———. 2016a. "The Cape Film Commission Closes." February 1. http://www.screenafrica.com/page/news/business/1656754-The-Cape-Film-Commission-closes.

———. 2016b. "NFVF Presents Female Only Filmmaker Project." March 4. http://www.screenafrica.com/page/news/training/1657386-NFVF-presents-Female-Only-Filmmaker-Project.

———. 2016c. "Pedro Pimenta Announces the Launch of Joburg Film Festival." May 25. http://www.screenafrica.com/page/news/festivals/1658547-Pedro-Pimenta-announces-the-launch-of-Joburg-Film-Festival.

South African Government. 2013. "Fourth National Film Indaba, Emperors Palace Conference Centre." November 7. http://www.gov.za/fourth-national-film-indaba-emperors-palace-conference-centre.

———. 2015. "South Africa: Minister Nathi Mthethwa—South African Film Industry Stakeholders Meeting." October 7. http://www.allafrica.com.

———. 2016. "National Development Plan 2030." http://www.gov.za/issues/national-development-plan-2030.

Ssali, Ndugu Mike. 1983. "Apartheid and Cinema." *Ufahamu: A Journal of African Studies* 13(1): 105–30.

Tomaselli, Keyan. 1989. *The Cinema of Apartheid: Race and Class in South African Film.* London: Routledge.

———. 2014a. "Child Pornography and the Law: *Of Good Report* (2013). Reopening Debates on Secrecy, Information and Censorship." *Journal of African Cinemas* 6(2): 151–61.

———. 2014b. "Grierson, Afrikaner Nationalism, and South Africa." In *The Grierson Effect: Tracing* Documentary's *International Movement*, ed. Zoë Druick and Deane Williams, 209–21. New York: Palgrave Macmillan.

van Graan, Mike. 2013. "Oratio: A Non-Lawyer's Views on the Revised White Paper on Arts, Culture and Heritage of 2013." *Potchefstroom Electronic Law Journal/Potchefstroomse Elektroniese Regsblad* 16(3): 23–34.

———. 2015. "Revised White Paper On Arts, Culture, Heritage (2013): A Critique." http://www.afai.org.za/wordpress/wp-content/uploads/WHITE-PAPER-REVIEW-Mike-van-Graan.pdf.

Variety. 2008. "South Africa Helps Out the Little Guy: Low-Budget Projects to Get Film, TV Rebates." January 29. http://www.variety.com/.

Warner, Basil, Petrus du Preez, and Edwin Hees. 2003. "Playtext: *Try for White.*" *South African Theatre Journal* 17(1): 284–371.

About the Authors

Olivier Barlet is the author of *Les cinémas d'Afrique noire: Le regard en question* (1996) and *Les Cinémas d'Afrique des années 2000: Perspectives critiques* (2012). His work has been translated into German, Italian, Arabic, Spanish, and English, including *African Cinemas: Decolonizing the Gaze* (2000) and *Contemporary African Cinema* (2016). He has also written for such publications as *Afrique-Asie, Continental,* and *African International*. In charge of L'Harmattan's *Images plurielles* cinema collection and former chief editor of *Africultures* (1997–2004), he manages the cinema pages for *Africultures* and its website, where he has published more than 1700 articles, interviews, and film critiques.

Kenneth W. Harrow is a Distinguished Professor of English at Michigan State University. His work focuses on African cinema and literature, diaspora, and postcolonial studies. He is the author of *Thresholds of Change in African Literature* (1994), *Less Than One and Double: A Feminist Reading of African Women's Writing* (2002), *Postcolonial African Cinema: From Political Engagement to Postmodernism* (2007), and *Trash: African Cinema from Below* (2013). He has edited numerous collections on such topics as Islam and African literature, African cinema, and women in African literature and cinema.

Jonathan Haynes is a Professor of English at Long Island University in Brooklyn, where he teaches African and postcolonial literature and film. A former Guggenheim Fellow and Fulbright Senior Scholar, he cowrote *Cinema and Social Change in West Africa* (1995) with Onookome Okome and edited *Nigerian Video Films* (1997) and a special issue of *Journal of African Cinemas* (2012). His latest book is *Nollywood: The Creation of Nigerian Film Genres* (2016).

Jacqueline Maingard is a Reader in film at the University of Bristol and Honorary Research Associate in the Archive and Public Culture Research Initiative at University of Cape Town. She is a trustee of the Africa in Motion Film Festival. She is the author of *South African National Cinema* (2007). Her research on African and South African cinema histories and practices has been published in various academic journals and volumes, including *Screen* and *Journal of Southern African Studies*. She is currently conducting research on cinema's globalization in South Africa, 1920s to 1960s, and is a member of the History of Moviegoing, Exhibition, and Reception (HoMER) Network.

Valérie K. Orlando is a Professor of French and Francophone literatures in the Department of French and Italian at the University of Maryland, College Park, where she also serves as Department Head. She is the author of *New African Cinema* (2017), *Screening Morocco: Contemporary Film in a Changing Society* (2011), *Francophone Voices of the "New" Morocco in Film and Print: (Re)presenting a Society in Transition* (2009), *Of Suffocated Hearts and Tortured Souls: Seeking Subjecthood through Madness in Francophone Women's Writing of Africa and the Caribbean* (2003), and *Nomadic Voices of Exile: Feminine Identity in Francophone Literature of the Maghreb* (1999). She coedited with Sandra M. Cypess *Reimagining the Caribbean: Conversations among the Creole, English, French, and Spanish Caribbean* (2014). She has written numerous articles on Francophone writing about the African diaspora, African cinema, and French literature and culture.

Viola Shafik, a freelance filmmaker, film curator, and film scholar, works as a researcher at the art history department at Ludwig Maximilian University. She authored *Arab Cinema: History and Cultural Identity* (1998) and *Popular Egyptian Cinema: Gender, Class, and Nation* (2007). She lectured at the American University in Cairo, the University of Zurich, the Humboldt State University, and the Ludwig Maximilian University. She was the Head of Studies of the Documentary Campus

MENA program, 2011–2013. Currently she is a member of the selection committees of the al-Rawi Screenwriters Lab, the Doha Film Institute, and the World Cinema Fund (Berlinale). She directed several documentaries, most notably *Jannat 'Ali-Ali im Paradies/My Name is not Ali* (2011) and *Arij—Scent of Revolution* (2014).

Index